ABRAMS
NEW YORK

VOGUE on LOCATION

VOGUE
on LOCATION

PEOPLE, PLACES, PORTRAITS

GUE
ATION

Edited by CHLOE SCHAMA AND RICHARD ALLEMAN

Contents

Introduction

BY RICHARD ALLEMAN

I grew up in Hanover, Pennsylvania, noted for pretzels and potato chips, if it was known at all. We pretty much never went anywhere other than Cape May, New Jersey, for a couple of weeks every summer. But I had dreams. Fueled by our neighbors' *National Geographics*, I fantasized about taking the Super Chief train to California, flying to Paris on a sleek Constellation, sailing to Europe on a Cunard liner. Maps and travel posters—Eiffel Tower, Brussels World's Fair, Taj Mahal, Rio de Janeiro—covered the walls of my bedroom. I had curtained off the lower level of my bunk bed to turn it into a Pullman berth or a ship's cot, depending on where I was headed. Someday, I would go to the places I dreamed of. But what I didn't dream was that I would go to many of these places as the travel editor of *Vogue*.

In 1973, *Vogue* was hiring male editorial assistants for the first time in its history. One of the openings was too good to be true: assistant to the magazine's travel editor, Despina Messinesi. Depy, as she was widely known, was born in the U.S. to Greek parents, moved to Athens after marrying a Greek businessman, and had been American *Vogue*'s Paris editor in the late forties. She wore vintage Chanel suits to the office, but there were no white gloves for her. Despite her background, she was remarkably down to earth and looked at the world with a child's eyes, something I tried to emulate. Initially, I did the basics: answered the phone, typed copy, fact-checked, helped arrange Depy's travel. It would be a long time before I would get to write anything. Or so I thought.

About six months on the job, I took the overnight Amtrak train to Montreal for the weekend. I returned to the office Monday morning thrilled by my jaunt. I also returned to an unexpected hole in the travel section of the magazine. The art director at the time, Rochelle Udell, suggested I try my hand at documenting the trip. Which I did, and with the help of no less than three editors, the story got published. This led to more articles, more travel, and with Depy's retirement, the position of travel editor. Although I was on staff in that role until 1994, I was a contributing editor for the next two decades, divulging the latest hotel opening or farthest-flung new adventure in *Vogue*'s "People Are Talking About" pages.

I'm sometimes asked if I have a favorite place in the world. I've yet to come up with an adequate answer. The world is too vast, with too many wonderful places to

CLOCKWISE FROM TOP LEFT: Women with wanderlust featured largely in Art Deco–tinged artwork. *Illustrated by Georges Lepape, June 15, 1920.* Amelia Earhart models her "high-flown fashion" at New York's Radio City. *Photographed by Edward Steichen, January 15, 1933.* Luggage for up to six months, *June 15, 1928.* Egyptomania continued into the 1930s, evidenced by this sun-soaked illustration of a fashionable camel rider *by Pierre Mourgue, December 22, 1930.* Moments from Richard Alleman's peril-filled East African adventure: the amphibious plane at Lake Turkana, *photographed by Philippe Maille, April 1989;* the ancient city of Meroë in Sudan, *photographed by Alleman, April 1989.*

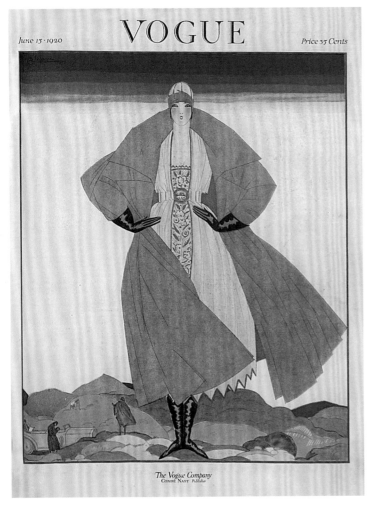

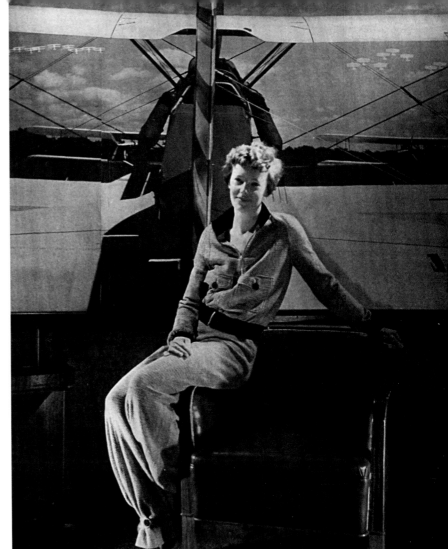

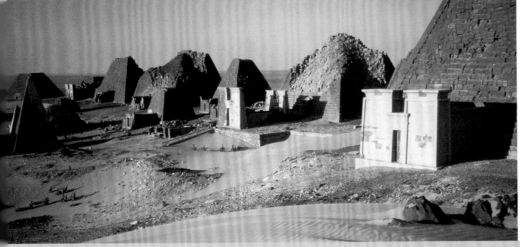

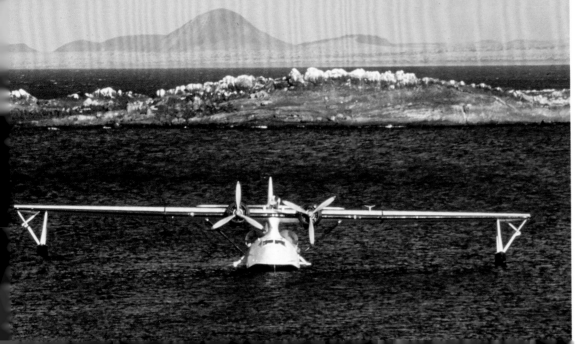

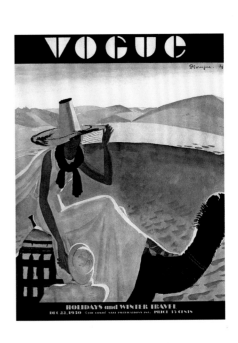

narrow it down to just one favorite. I prefer rephrasing the question to what has been my most memorable adventure—and it is my first encounter with East Africa in 1988 that still ranks highest in this regard. I was in Kenya to research a safari story, but the piece was not meant to be a rundown of the standard game-park circuit; this was an odyssey from Nairobi to Cairo in a restored 1940s-era amphibious airplane—a flying boat built during World War II for reconnaissance missions. Taking off from Nairobi, we were to fly to Kenya's Chalbi Desert and Lake Turkana; to Khartoum, Sudan; then on to Egypt—Aswân, Abu Simbel, Luxor, and ultimately Cairo—landing on lakes and branches of the Nile along the way. Often we flew low, as low as 1,200 feet, which afforded mesmerizing close-ups of deserts, oases, caravans, and biblical villages along the Nile.

I especially remember our first stop, in the Chalbi Desert, far from the crowded safari scene in the south. Landing on a sandy tarmac in the scruffy little town of Marsabit, we transferred to Land Cruisers for a bumpy three-hour ride to our campsite. That night, when everyone was sleeping in their tents, I slipped out to take in the night sky, which I described in my notebook as "a static blizzard of stars."

The next morning, I discovered that we really were in the middle of nowhere: The Chalbi Desert is a great chalk-white plain strewn with boulders, a Zen garden that appears to go on forever. It could almost be another planet, and I felt like an astronaut, picking up small stones and bits of weathered bone. After breakfast, we drove off in the Land Cruisers again, destined for Lake Turkana. The ride was another three-hour thriller as we skidded along sand that looked like snow, picnicked at an oasis crowded with camels, and raced a fleet of eight-foot-tall ostriches. And at the end of this: Lake Turkana, a luscious body of deep-green water that European explorers aptly dubbed the Jade Sea.

The flying boat safari was also the most dangerous assignment I have ever taken on. Earlier that year, a terrorist attack in Sudan's capital had killed seven people and wounded 21, and there had been other incidents since then, not to mention an ongoing civil war in the South. Indeed, I had thought twice about whether to go on this safari at all—and when we were delayed for two hours on the outskirts of Khartoum, bobbing on the White Nile while waiting to pass through the security tent, I started to question my decision. Eventually, once we surrendered our passports, we were allowed to enter the country and proceed to the Grand Hotel. Once *the* place to stay, the Grand was now in sorry shape: a swampy half-filled swimming pool, mushy mattresses, muddy shower water. The only hint of its former glory was the expansive black-and-white-tiled terrace café overlooking the Nile, a popular spot for well-to-do Sudanese to meet for mint tea.

Our group assembled on the terrace the next day, set to head into the Sudanese Sahara. But nothing was happening, and after an hour's wait, even our leader, an intense Frenchman named Pierre, seemed at a loss. This time, I was really afraid. I had picked up an English-language newspaper the night before and learned that a big anti-government demonstration had been planned for the following week. And here we were, a group of Americans, marooned in the Grand Hotel. Pierre continued to urge patience: He knew how things worked—but did he really? By around two in the afternoon, whatever was detaining us had been sorted out—probably with a wad of cash, many of us assumed. Never mind, we were soon off into the desert once again, albeit without passports.

The trip through Sudan culminated with two amazing days spent camped out among the spectacular ruins of Meroë, on the east bank of the Nile. An ancient but little-known Saharan civilization, Meroë produced pyramids that are not huge like the Egyptian ones but, in their own way, they are equally impressive—forming a surreal Daliesque landscape. From Sudan, I am happy to report, we flew on to Egypt without incident and with our passports.

When you think of travel in *Vogue*, you don't necessarily imagine death-defying flings through politically unstable countries. But the truth is that *Vogue* has a history of transporting its readers to all kinds of places that goes back to the beginning of the last century, when visionary publisher Condé Nast acquired a New York society weekly and turned it into a vibrant lifestyle magazine that encompassed not just the social scene, but also fashion, the arts, and travel.

Early travel stories covered the usual well-heeled watering holes—Paris, Biarritz, Deauville, London, Palm Beach, Newport—but as the magazine expanded, so did its range. Now there were stories on taking your own car to Europe, traveling without a guidebook, and exotic "new" destinations like Morocco, Egypt, and Argentina that no longer required lengthy train trips or ocean voyages to reach,

thanks to the advent of commercial air travel in the 1920s and 1930s. Indeed, *Vogue* was at the forefront of this new mode of travel, telling readers not just what to pack but what to do when they arrived. Or, in the case of a 1933 story featuring Amelia Earhart, what to wear while flying the plane: "The practical suit worn by Miss Earhart"—photographed by Edward Steichen (page 7)—"was designed for women pilots to wear when there's work to be done." By the 1960s, whole crews of editors, models, and photographers could fly to almost anywhere quickly and relatively economically. The era of the big-time foreign—*on-location*—fashion shoot was born. Over the subsequent decades, *Vogue* would send crews not just to cosmopolitan centers and temperate climes but to remote corners of the world like Patagonia, Timbuktu, and Iceland—or "the edge of the inhabitable world," as the magazine put it, for a shoot at "the Viking Riviera" in 1990.

And while we may not think of fashion shoots as historically groundbreaking, *Vogue* started to dispatch photographers and journalists to parts of the globe where rapid political and social change was unfolding. During and after World War II, *Vogue* reporters and photographers tracked the new world order. In 1979, just as President Jimmy Carter granted China full diplomatic recognition, *Vogue* sent photographer Arthur Elgort with Nancy Kissinger to the formerly forbidden destination. In 1995, a year after the end of apartheid in South Africa, the magazine sent photographer Bruce Weber with Iman to dance in the streets of a township outside Cape Town and shake hands with Nelson Mandela. A year later, Weber and Kate Moss said "Good Morning, Vietnam," in a shoot that followed the official normalization of relations between that country and the U.S.

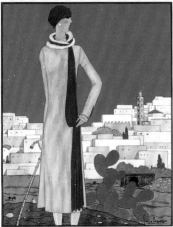

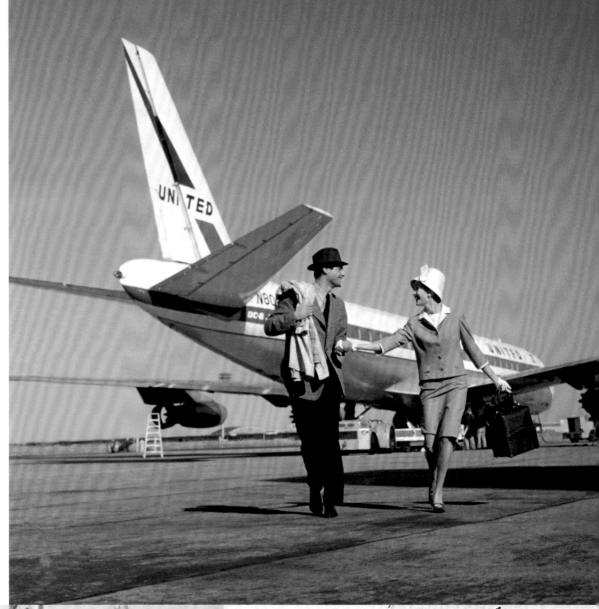

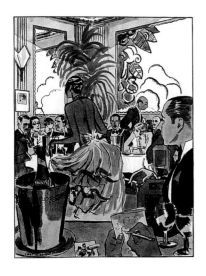

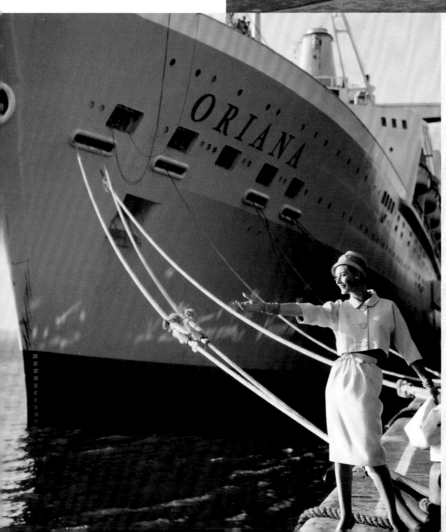

CLOCKWISE FROM TOP LEFT: A cloched woman surveys a mystical North African city. *Illustrated by Georges Lepape, January 1, 1926.* A great change in travel dressing modeled by a jet-setting couple. *Photographed by John Rawlings, January 1, 1960.* Wispy impressions from Palm Beach. *Illustrated by Constantin Alajalov, April 15, 1933.* The S.S. Oriana, fresh from its maiden voyage. *Photographed by Henry Clarke, March 15, 1961.* A scene from Josephine Baker's buzzy boîte in Paris. *Illustrated by Carl Erickson, June 1, 1927.*

In 1990, I found myself inadvertently positioned at one of these pivot points of history when I helped arrange a fashion shoot in the USSR, which, rather than opening up, was rapidly falling apart. It was an exciting, albeit confusing, period of history. Communication was almost impossible; phones didn't work half the time and cost a fortune when they did. Faxes were unheard of on the other side of the Iron Curtain. Instead, we relied on telexes, sent from an antiquated telegraph system, to contact hotels and tourist offices, as well as the various locations and celebrities we hoped to photograph.

For getting around, we had our own private guide, Vladimir, a friend of a friend of Condé Nast's legendary editorial director Alexander Liberman. Whether Vlad was a help or a hindrance I still don't know. Wildly camp, he was also outrageously outspoken, which was not appreciated by the Communist officials we had to deal with, not to mention by some of our team, which included Elgort, editor Grace Coddington, and Christy Turlington. We went everywhere, from backstage at the Bolshoi to the threshold of a Red Army barracks in St. Petersburg (then Leningrad). We made fast friends with a hip artist and his outrageously dressed cohorts, whom Vlad was sure were part of the secret police. It was weird, it was exhilarating, it was history unfolding, and of course it was over very quickly. As Russian novelist Victor Erofeyev told me at the time: "Russia today is paradise for writers…You don't need to invent anything. All the plots are here." Not just plots, but great photographs as well—like Turlington prancing in front of the Hermitage or cozying up to the young Russian soldiers in front of their barracks.

Often, *Vogue*'s travel photography made its own history, with images attaining an iconic status that carried over long after the issue was published. Along with Elgort's dramatic streetscapes, *Vogue*'s photographic travel legacy includes the exotic journeys of Henry Clarke, the erotic scenarios of Helmut Newton, the romantic interludes of Annie Leibovitz, the vibrant celebrations of Mario Testino, and, perhaps more than any other, the work of Irving Penn.

Known as "*Vogue*'s Photographer," Penn had a six-decade-long association with the magazine before his death in 2009. In addition to his fashion photography and his culinary still lifes for the magazine, Penn produced a body of work that documented populations such as the Kirdi of Cameroon, the Chhetri of Nepal, the Âït Yazza Berbers of Morocco's High Atlas, the Peruvian residents of Cuzco, and the mud-masked Highlanders of New Guinea. Some have criticized Penn and *Vogue* for what has been perceived as the exploitative nature of these shoots; others have praised him and the magazine for documenting and celebrating cultures and traditions that might otherwise have been lost. If nothing else, his photographs show the breadth of the magazine's ambitions when it comes to exploring the far corners of the world.

Of course, *Vogue* has mostly—and primarily—taken its readers to the land of fantasy, sending them on the kinds of trips most people wait their whole lives to take: on African safaris or Aegean cruises, to extravagant hotels or gem-like hideaways. Over the years, *Vogue* has also taken readers inside some of the world's most luxurious homes and gardens: Yves Saint Laurent's Marrakesh estate, Gianni Versace's Milan palazzo, Ralph Lauren's Jamaican bungalow, Elsa Peretti's private "village" in Spain, François Nars's island in French Polynesia, Christian Louboutin's Egyptian houseboat, Cindy Crawford's Canadian cottage, Madonna's British

countryside manor. Not just a collection of pretty exteriors and estates, *Vogue*'s lifestyle stories took readers inside the motivations, aspirations, and dreams of the homes' creators.

As the travel editor, I was in the extraordinary position of helping plan and sometimes participating in these ventures, but even for me, there was a great white whale: the Concorde. I had fantasized about traveling on the supersonic jet ever since it first started flying commercially in 1976. Eventually, a decade after its debut, it was my turn. I was researching a story so cushy that I was embarrassed to tell my friends about it: Fly to London on the giant stingray, spend two nights in England, and sail back to New York aboard the *QE2*. But for me the plane was the highlight of this dream itinerary. Never mind that it was an hour late taking off. I was there for the ride, not the time squeeze. The plane surprised me with its small interior: just two sections with 50 skinny leather seats, two abreast, on either side of a narrow center aisle. The windows were so tiny I wondered if we'd be able to see anything through them.

Because the plane carried so few passengers, boarding was remarkably fast. A minute or so after getting on, we were taking off. And what a departure. It was more of a liftoff actually, with the Concorde's g-force pushing my head and shoulders back against the seat. A feeling of both fear and ecstatic abandon; no stopping now, no going back. It was noisy, as I had been warned, a great rumble. And then the sonic boom, after which things smoothed out. My eyes fixated on the screen at the front of the cabin displaying our altitude and speed. Soon the captain came on the PA system to announce our impending arrival at Mach 2.04—as in 1,354 miles per hour, more than twice the speed of sound.

Back in my bedroom in Pennsylvania, I never dreamed I'd travel this fast or this high: 60,000 feet. I looked out the micro-window and could see the curvature of the Earth. Look left and it was still daylight; look right, it was night. Soon the flight attendants were serving champagne and perfect little canapés of caviar and Scottish salmon followed by poached Dover sole, a strawberry parfait, and finally a selection of cheeses. Before I knew it, we were landing. No half-hour descent; the craft simply dropped out of the sky and slammed down onto the tarmac. *Et voilà:* New York-London in three hours.

So, where to next? As I write this, twenty-first-century adventurers are plunking down massive sums for suborbital space flights. A few have even visited the International Space Station. Can a trip to the moon be far behind? And will *Vogue* go along for the ride? Stay tuned.

CLOCKWISE FROM TOP: Natalia Vodianova and Sean Combs play lovers mid-goodbye. *Photographed by Annie Leibovitz, February 2010.* Back in the USSR, Christy Turlington went behind the Iron Curtain and wore a lot of red. *Photographed by Arthur Elgort, September 1990.* Nancy Kissinger, shown here in Beijing, tours a just-opened China. *Photographed by Arthur Elgort, August 1979.*

1

1940 – 1959

At the start of the 1940s, much of the world was, of course, off-limits to travelers. But rather than ignoring the war, *Vogue* covered it with dispatches by journalists and writers such as Lesley Blanch, Vita Sackville-West, and Cecil Beaton. Reporting on a dusty, bombed-out London in the January 1945 issue of *Vogue,* Beaton underlined the ongoing struggles of his countrymen: "Let me be un-British for a moment and refuse to minimize the sufferings of the civilians at home," he wrote, "for I don't think nearly enough people realize just what the Londoners have been through." Making readers aware of the full scope of the war was, in fact, an imperative for the publication.

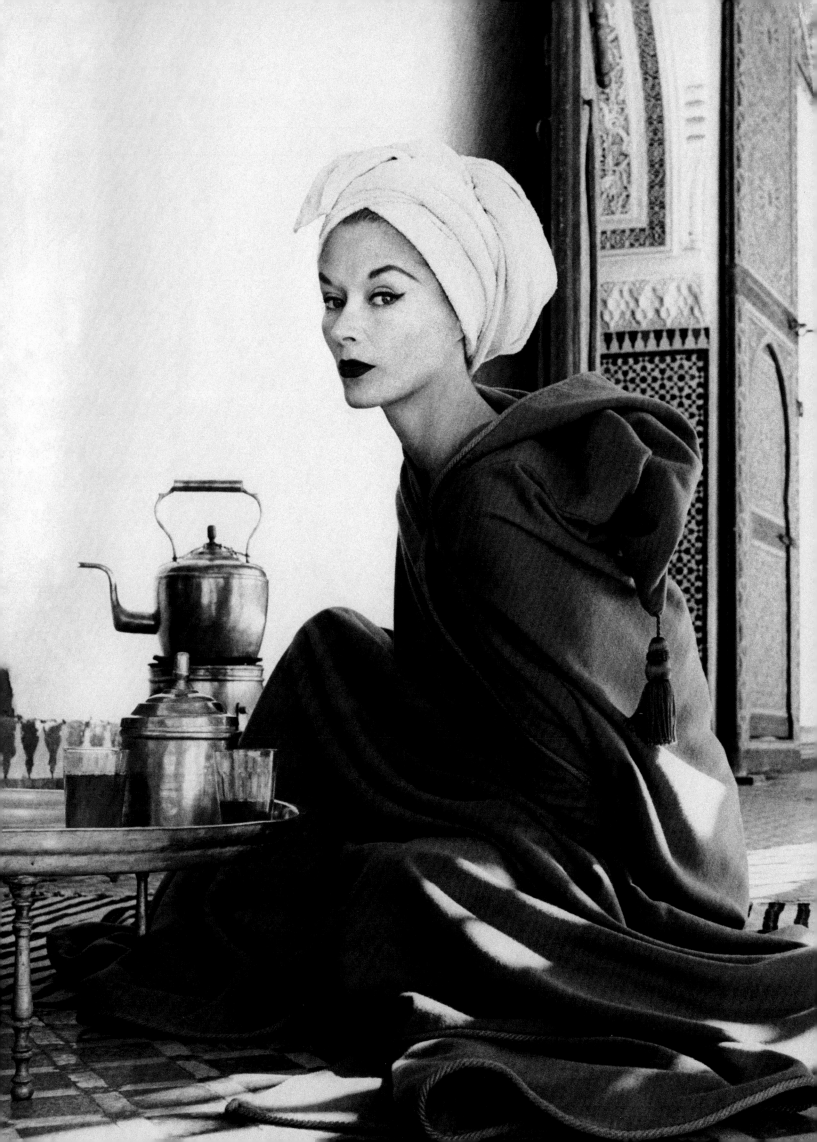

"What kind of a magazine do you think this is?" chided editor Edna Woolman Chase, justifying why a "mere" luxury magazine was covering the war. Toward the conclusion of the war, the publication sent *Vogue* editor Sally Kirkland to Pearl Harbor on "the largest flying boat in the world." She dined on scrambled eggs and steak in the plane's café compartments on the way, but was met with the stark reality of the brave uniformed men and women still stationed there when she arrived. "Whoever had to do with the selection of these young women did an extraordinarily good job," she wrote.

The best-known wartime correspondent published in *Vogue* was, of course, model-turned-photojournalist Lee Miller, who was attached to the 83rd Infantry Division of the U.S. Army as it swept across Europe in 1944. In Germany, the one-time *Vogue* cover girl documented the liberation of the Buchenwald and Dachau concentration camps as well as gruesome scenes of a defeated Germany— bodies of hanged prisoners, suicides, ruined cities. "I usually don't take pictures of horrors," Miller wrote in a cable to her editor that was eventually published in the magazine. "I hope *Vogue* will feel that it can publish these pictures." *Vogue* did in fact do so, in June of 1945, further establishing the far-reaching ambition of the magazine.

1952

Lisa Fonssagrives-Penn makes tea in a palatial Moroccan courtyard, swathed in a modern version of the hooded Arab cloak known as a burnoose.

Photographed by Irving Penn, January 1, 1952

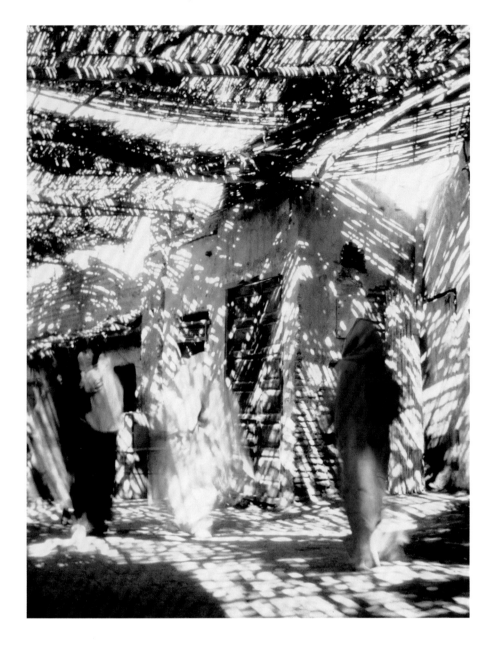

Accompanying a glossary of Moroccan terms for the intrepid traveler were scenes photographed by Irving Penn. Here, the reed-roofed market streets of Marrakesh.

Photographed by Irving Penn, May 15, 1952

After the war, not only was much of the world open again for travelers, but new aircraft such as the four-engine Douglas DC-4 and the sleek Lockheed Constellation, with its pressurized cabin, ushered in new levels of ease and comfort and allowed for a new kind of spur-of-the-moment jaunt. "You can leave the Coast Friday on an airline plane, spend Saturday and Sunday fishing the streams of Wyoming or Colorado, and be back in time to tell lies on Monday morning," the magazine informed its readers in 1946. *Vogue* took advantage of this exciting new potential by taking off not just for the continental states, but for the far reaches of the globe—and for one notable story, stitching together a multi-continent journey over the course of a month. For "Round the World Flight: 30 Days," feature editor Allene Talmey brought along her typewriter, a "lavender hat box," and the photographer Irving Penn, whose rich, varied photos illustrated the lavish portfolio. Following Pan American Airways' newly inaugurated global route, Talmey and Penn traveled to London, Istanbul, Kolkata (then Calcutta), Shanghai, Honolulu, and San Francisco. The trip was a showcase for the new luxurious possibilities of global travel, but it also underlined that the postwar recovery was only just beginning. "In addition to everything else that we learned, we learned all over again what everyone else in the world knows and most of us forget—Americans are incredibly rich," Talmey wrote. "The list of our riches is long, but the length of our memory of other nations' hardships is all too short."

A year later, Penn traveled to Peru for his first on-location fashion story. "Flying Down to Lima" depicted a "day in the life" of model Jean Patchett on holiday in the South American city, visiting the shoeshine boys and the mosaic-tiled cafés, indulging in the "baroque mix of Spanish and Moorish" architecture. Appearing in the February 1949 issue, the spread was meant as a "dress rehearsal of spring"—a showcase of "homemade" *Vogue* patterns that took advantage of the warmer climes. Fascinated by the indigenous people he encountered beyond Lima, Penn remained in Peru after the rest of the *Vogue* crew departed, traveling into the pre-Columbian city of Cuzco. There he rented a studio from a local photographer and recruited residents from the streets to sit for portraits.

The photographs, which appeared in December of 1949 as "Christmas at Cuzco" (alongside a short text by Edward Steichen), made up Penn's first ethnographic work. For the next two decades, he used this format, bringing subjects into (as he deemed it) the "neutral" space of the studio to document indigenous peoples for *Vogue*. When he was photographing these individuals, he wrote later, "there was for us both the possibility of contact that was a revelation to me and often, I could tell, a moving experience for the subjects themselves." These images can jar a modern sensibility, but at the time that they were published they were an unusual and striking foray into another kind of pictorial reportage for the magazine.

While air travel grabbed most of the attention in the 1940s and '50s, down on the ground, trains were dealing with their high-flying competition by upgrading equipment and services. In 1947, *Vogue* celebrated the recent debut of Vista Dome train cars—greenhouse-style cabins with panoramic-view potential—with a feature on the "New Train Clothes," showing models in chic suits posing in the glassy new carriages. A "train that takes a new view on travel" is also a train that requires a wardrobe "for those who make travel an end in itself; for a journey that is, actually, an en-route vacation," *Vogue* wrote. Seven years later the magazine again took readers on a "holiday in transit" on Canadian Pacific's brand-new fleet. "Since baggage weight's no problem on a train," the magazine reminded its readers, "she's dressing with slightly luxurious variety," with looks for every hour of the day.

But by the end of the 1950s, the days of many-trunk traveling were waning in favor of leaner, lighter airborne trips. The travel story for the January 1, 1960, issue was "1960 Jet Dressing: A Change of Plane." Somehow that said it all.

I HAD FORGOTTEN SO MANY THINGS: the enamel brightness of the colours, the quality of the light, the depth of the sky, and the bigness of the leaves: the banana leaf, the breadfruit, the wild tania. Even the grass on lawns had this astonishing quality of lushness. This wasn't the tamed turf of England.

V.S. NAIPAUL, 1959 **CARIBBEAN MEDLEY**

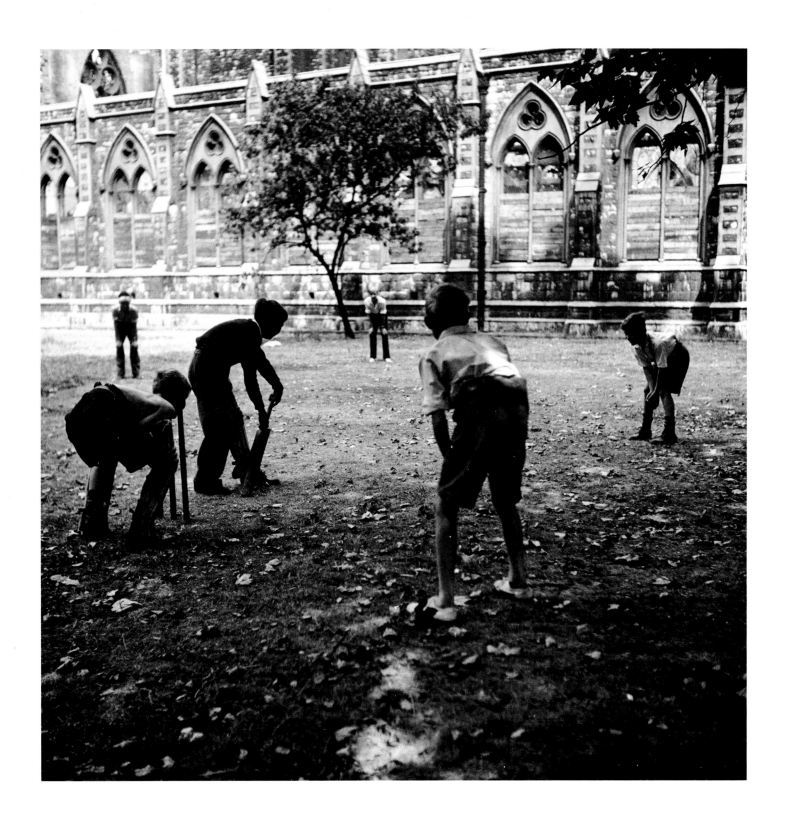

FOR THE FIRST TIME in the history of travel you
may buy, in New York, a ticket for a round-the-world flight;
you may fly under the aegis of a single company;
see for yourself, hear for yourself, within a month's space,
how much of the rest of the world lives and thinks.

ALLENE TALMEY, 1947 ROUND THE WORLD FLIGHT: 30 DAYS

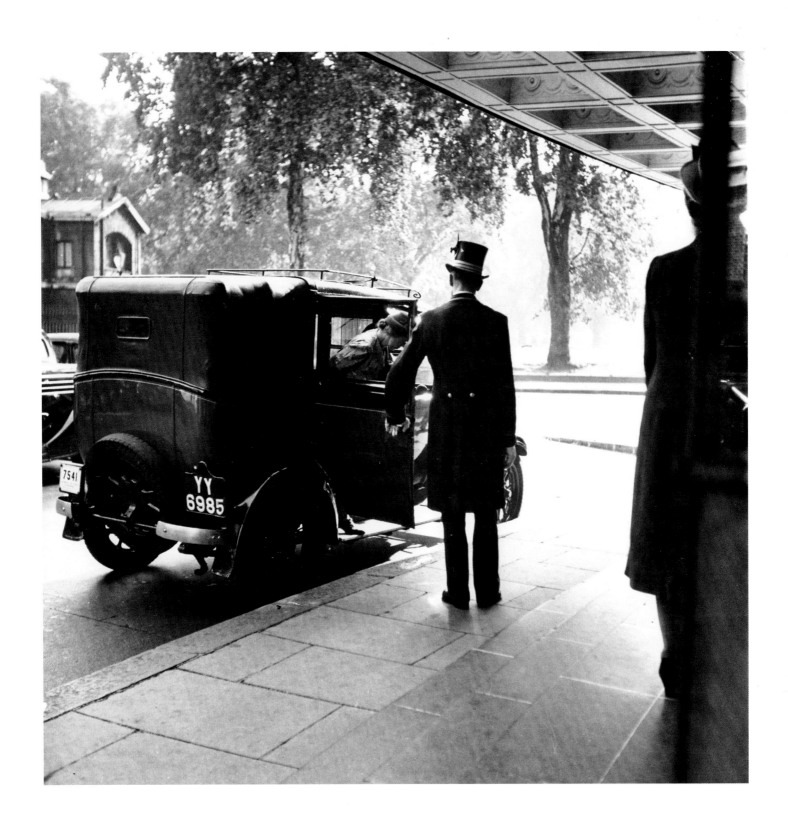

1947

In the wake of the Second World War, with wartime austerities still in effect, editor Allene Talmey and Irving Penn set out on a whirlwind monthlong journey with stops in London, Istanbul, Kolkata (then Calcutta), Dhaka (then Dacca, East Pakistan), Shanghai, Hangzhou (then Hangchow), Honolulu, and San Francisco. THIS PAGE: The green-liveried doorman at London's Dorchester Hotel. OPPOSITE PAGE: London boys play a game of cricket against a roofless, bomb-gutted church.

Photographed by Irving Penn, November 1, 1947

RESTAURANTS ARE CROWDED, and so are the hotels. It is impossible to secure a table at the one or a room at the other without previous warning. Theatres and cinemas are crowded also; there has been little entertainment during the war-years (bombs and black-outs don't encourage such things), so the demand now is enormous.

Perhaps the oddest effect of war's ending is that people no longer draw their curtains after dark. Americans never did draw their curtains—a charming symbol, I always thought, of their natural friendliness and neighbourliness—but the more secretive English always did....How far are all these changes superficial and temporary? And what has happened to the English underneath? What of their outlook? What of their renowned insularity? Has it been shaken by the war? Has their cosmopolitan consciousness been increased or even aroused.... In a sociological sense, the war has brought a new awareness to the English. We know now what a great opportunity offers, and we are determined to take advantage of it. Education, and the social services; housing; the abolition of slums...the Youth Movement with its clubs and lectures; the Women's Institutes, more active and resolved than ever to insist on better conditions for the working-woman in her cottage.... All this is a good outcome of the war, affecting the entire outlook of the country as a whole. This is fundamental, not superficial in the sense that the restaurants are crowded or that women no longer wear hats but bright scarves in the street; or that people now leave their curtains un-drawn.

A deep sociological change has come over England, even if she still mistakenly believes her Channel to be a moat defensive to her house. It is a change that may not be at first apparent to the visitor from overseas, but it is a change that will very sensibly affect the whole of our established life.

VITA SACKVILLE-WEST, 1945
ENGLAND: THE SAME BUT NOT THE SAME

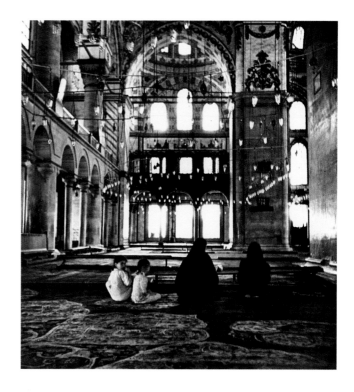

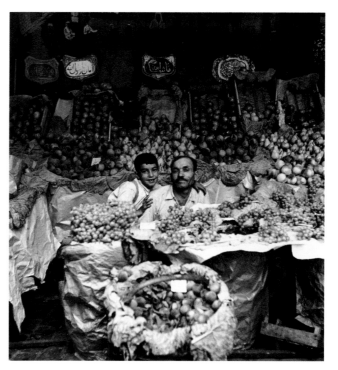

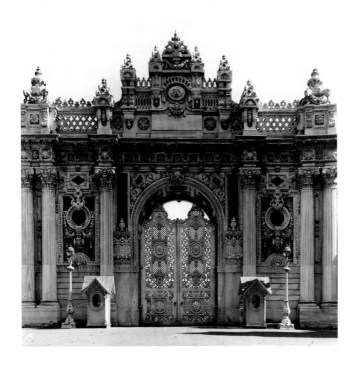

Moments from Allene Talmey and Irving Penn's
30-day sojourn. THIS PAGE, CLOCKWISE FROM TOP LEFT: Scenes
from Istanbul: The façade of the Dolmabahçe
Palace; bargainers at the Grand Bazaar; Byzantine
ruins border a dirt road; a shadowy figure by
an ancient Roman aqueduct. OPPOSITE PAGE, FROM TOP:
Women mid-prayer in the resplendent Fatih
Mosque. A street-corner market.

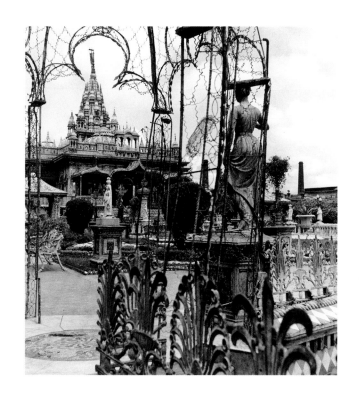

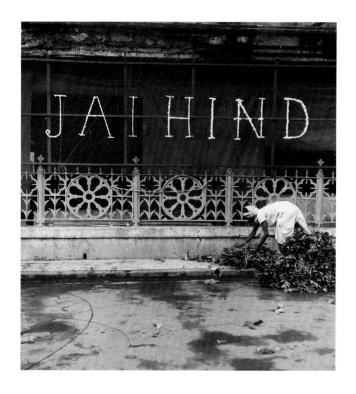

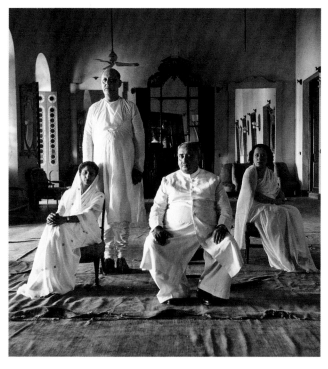

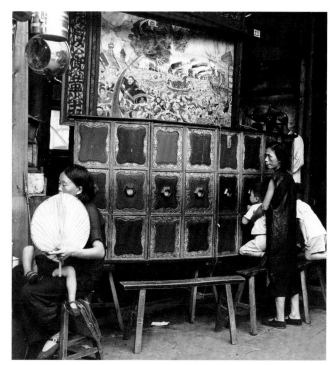

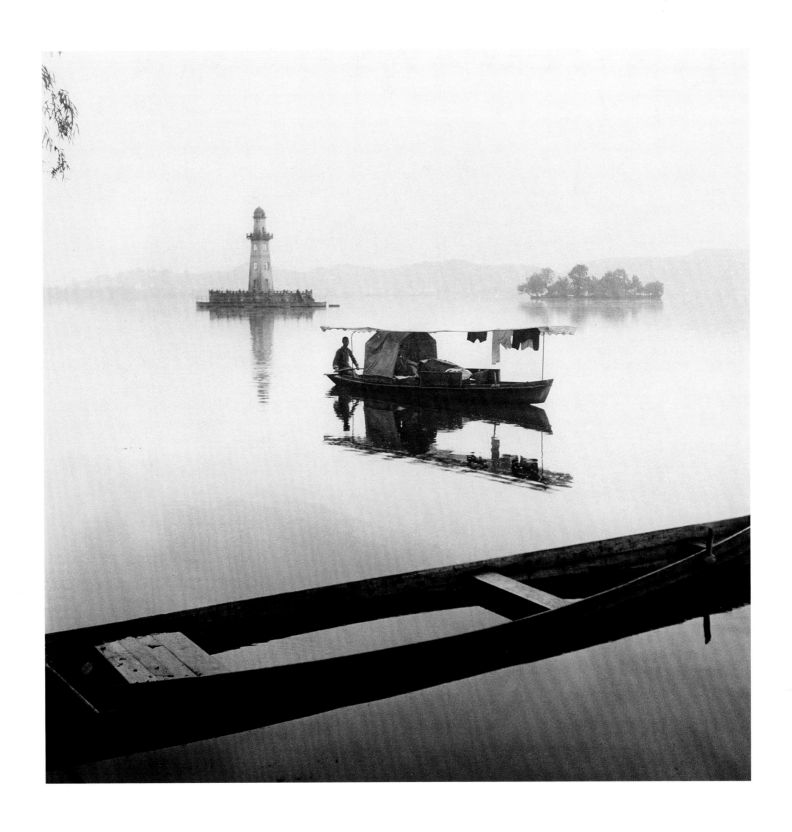

THIS PAGE: The rippleless West Lake of Hangzhou (then Hangchow). OPPOSITE PAGE, CLOCKWISE FROM TOP LEFT: The Jain Temple of Calcutta in then-newly independent India. Celebratory signage of "Jai Hind" or "Victory for India." Entertainment for children in Shanghai. Inside the palatial Ahsan Manzil in Dhaka (then Dacca), prominent figures of the just-formed Pakistan: Khawaja Nazimuddin (SEATED, CENTER) with Khawaja Habibullah Bahadur (STANDING) and his wife at left, and Mrs. Khwaja Nooruddin at right.

"Good News in the
American Collections"
featured women about
town: elegant ladies
in suits with the new
nipped-waist, rounded-
shoulder silhouette, and
the ubiquitous umbrella of
the '40s. Here, Norman
Parkinson captures
Lisa Fonssagrives-Penn
as a yellow cab whips by.

*Photographed by Norman
Parkinson, September 1, 1949*

IT IS A MYTH, the city, the rooms and windows, the
steam-spitting streets; for anyone, everyone, a different
myth, an idol-head with traffic-light eyes winking a tender
green, a cynical red. This island, floating in river water
like a diamond iceberg, call it New York, name it whatever
you like; the name hardly matters because, entering from
the greater reality of elsewhere, one is only in search of a
city, a place to hide, to lose or discover oneself, to make a
dream wherein you prove that perhaps after all you are
not an ugly duckling, but wonderful, and worthy of love,
as you thought sitting on the stoop where the Fords
went by; as you thought planning your search for a city.

TRUMAN CAPOTE, 1948 CALL IT NEW YORK

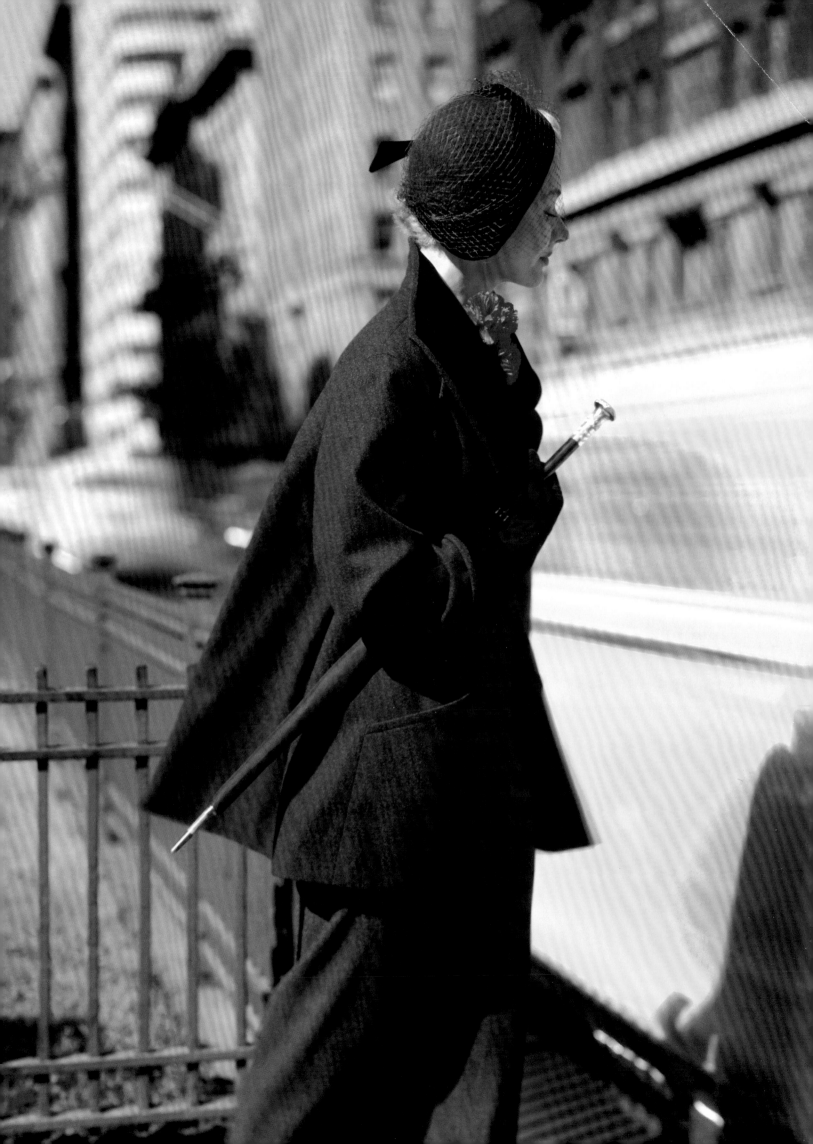

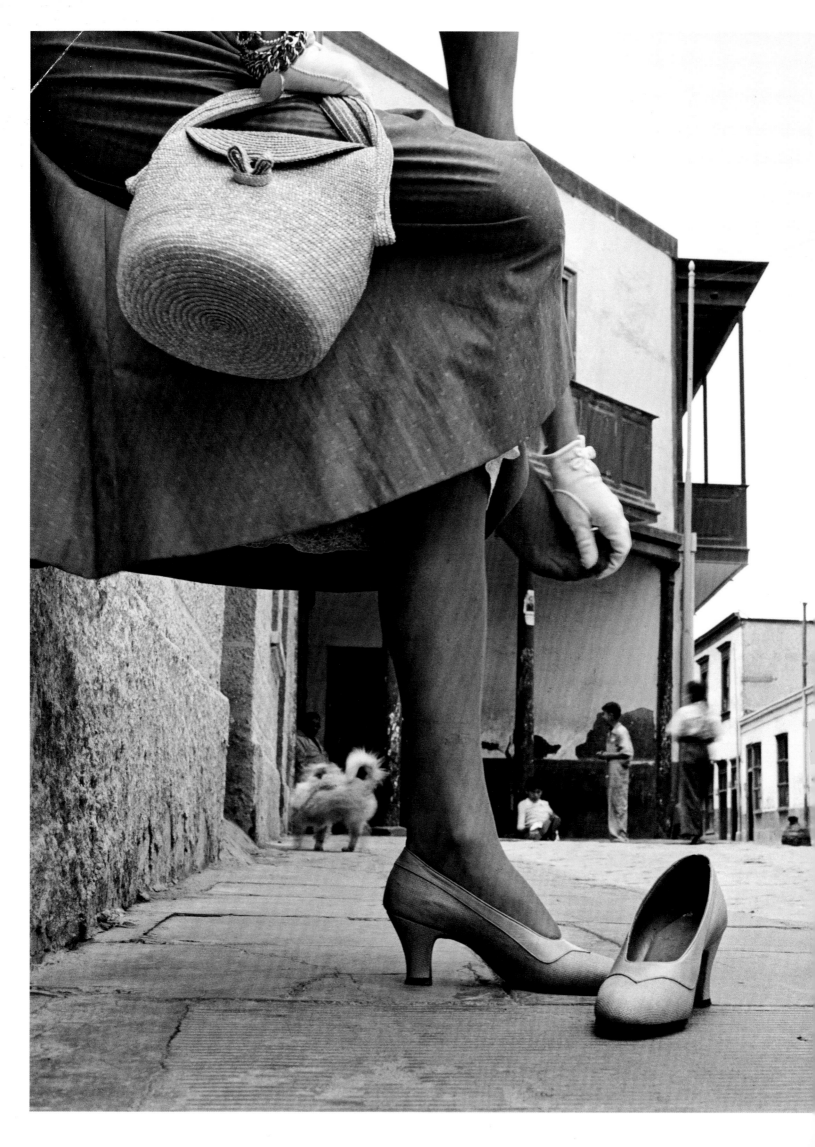

1949

A two-week trip to Lima would serve as Irving Penn's sole on-location fashion feature. Model Jean Patchett flitted through the Peruvian capital modeling designs from *Vogue* patterns rather than haute couture. Here, Patchett slips off her shoe in the seaside district of Callao.

THIS PAGE AND FOLLOWING PAGES:
Photographed by Irving Penn,
February 15, 1949

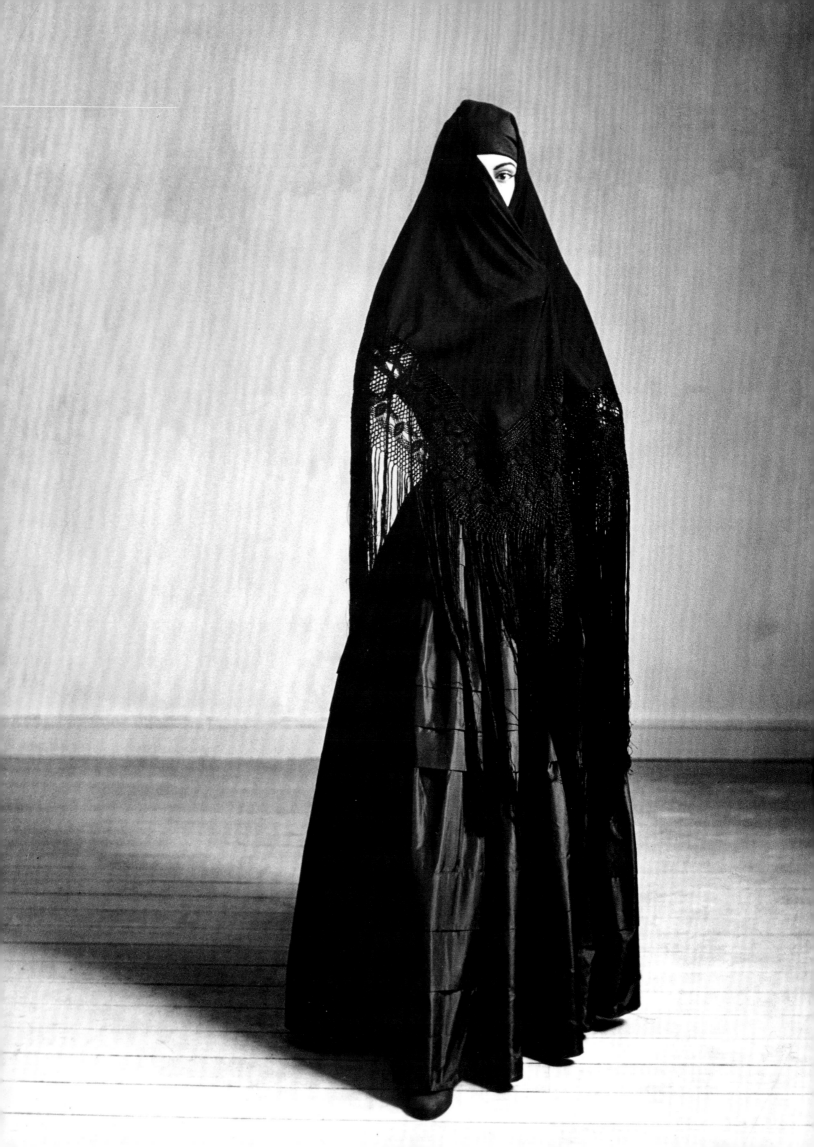

THIS PAGE: The model as matador in a borrowed hat (Peru boasts a long bullfighting history). OPPOSITE PAGE: Under the rule of the Spanish Empire, women known as Las Tapadas Limeñas famously promenaded in the parks of Peru wearing a black cloak arranged to display just one eye. Here, Jean Patchett plays the part.

AS FOR LIMA: you go there for eternal springtime with one slight departure from what spring usually means: in Lima, it rains about every three or four years, and then you can clock it with a sweep second-hand. Weather is California material: nippy mornings, hot midday, cool-to-shivery evenings (which meant to us, grey jersey to silk Shantung to fur). You might go to Lima to go beyond Lima into Inca history, to noble ruins, lost cities where "there is a fortune behind every hill."...You go to Lima for the only surf-boarding comparable to that of Hawaii; where bullfighting is the box-office fun from January through March, nudged for place by cockfighting the year around; where the architecture is a baroque mix of Spanish and Moorish and life is lived on Rome time, with a standard three-hour lunch hour for everyone, a short business afternoon, and dinner at nine o'clock at the very earliest. (The late afternoon, from after six o'clock until dinner, is called "Vermouth," and Vermouth is when the movies, concerts, and theatre go on...)

1949 FLYING DOWN TO LIMA

A now iconic image of Jean Patchett, her legs extended over the tile-work as she toys with her pearl necklace in a Peruvian café.

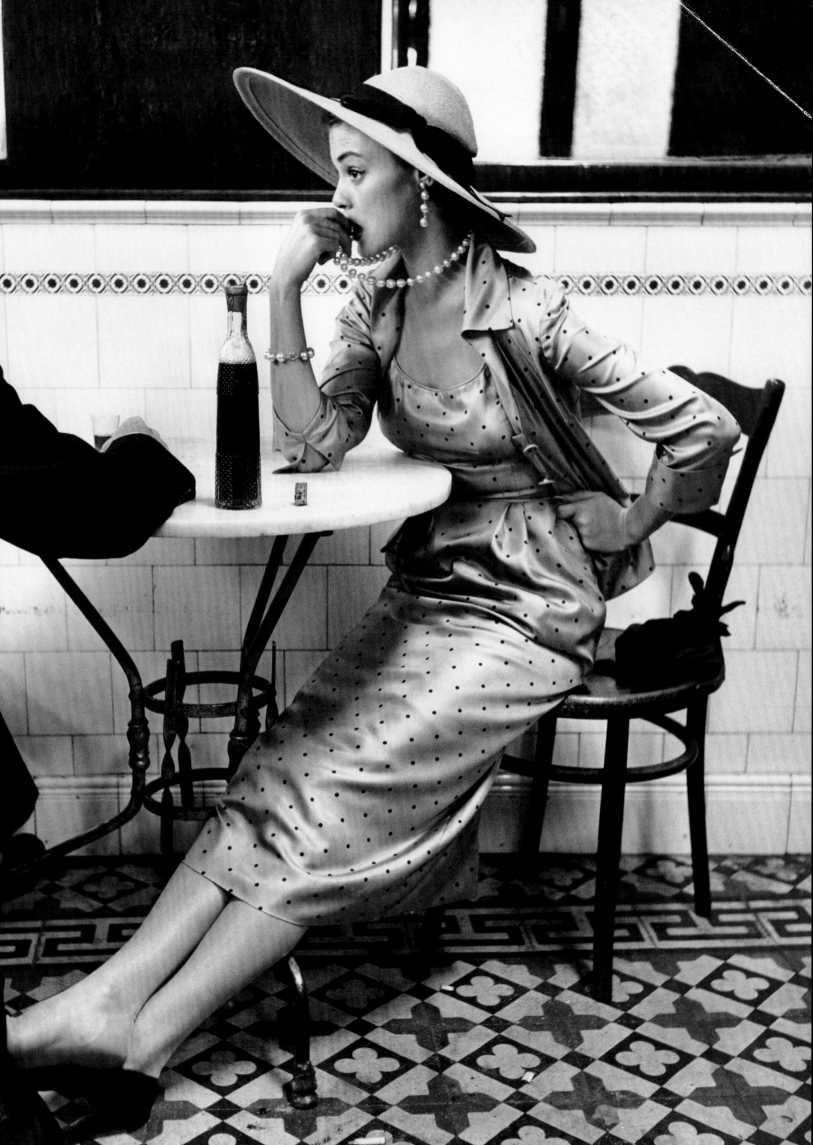

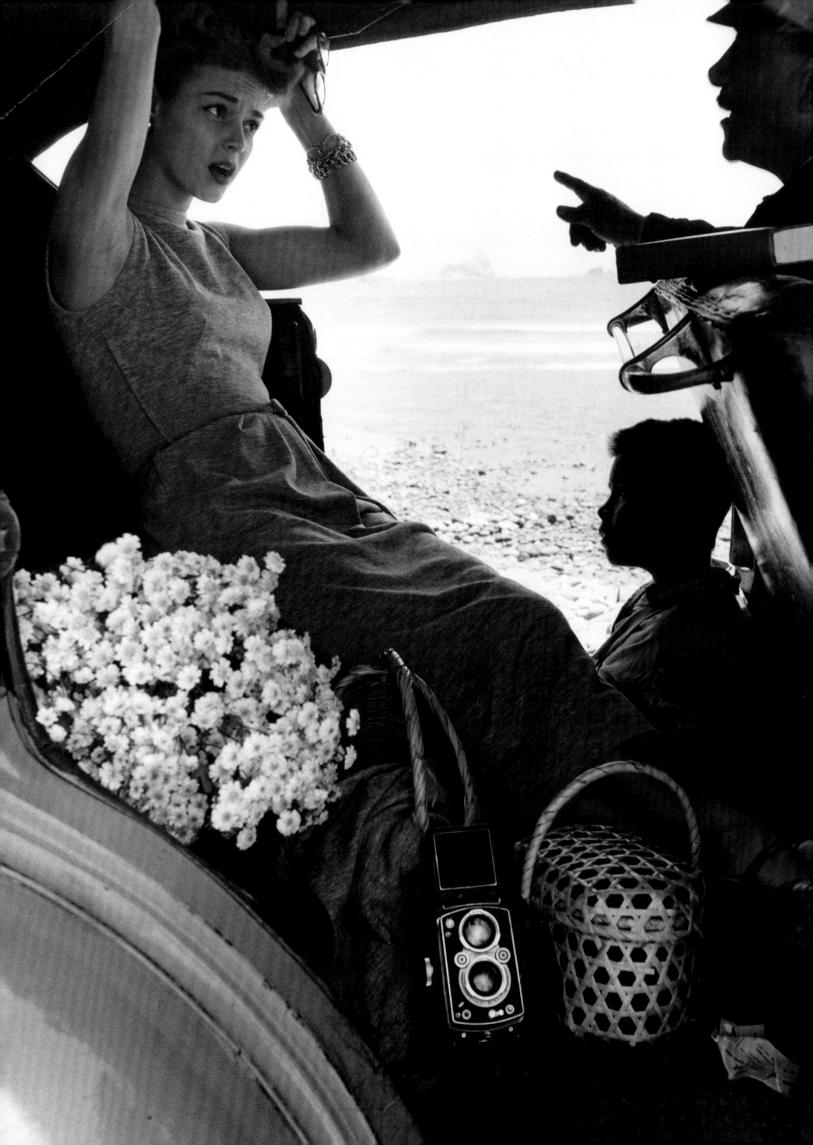

THIS PAGE: Jean Patchett keeps company in a shoeshine stall plastered with photos of movie stars and saints. OPPOSITE PAGE: Leaving the beach, Patchett loads a cab with flowers.

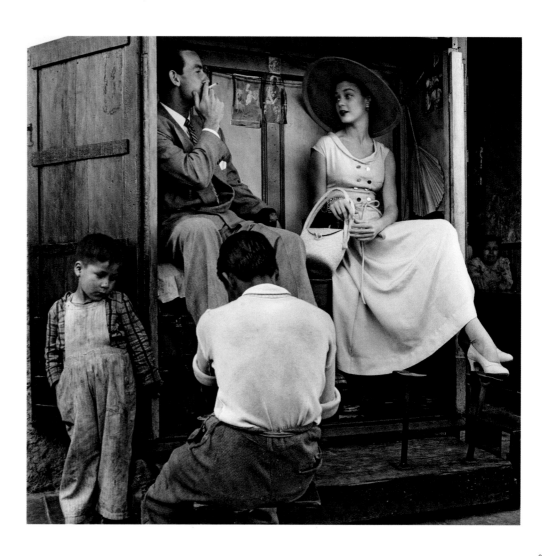

1948

The Russian-born, newly American photographer Serge Balkin set out cross-country to photograph the majestic landscapes of the United States, whose postwar preeminence loomed over the rehabilitating Old World. Here, Kentucky's portion of the Cumberland Gap, a sliver of Daniel Boone country between the Cumberland and Appalachian Mountains.

THIS PAGE AND FOLLOWING PAGES: *Photographed by Serge Balkin, February 1, 1948*

Sunlight streams into Utah's Zion National Park.

Thirty-five miles east of the Grand Canyon near Tuba City, Arizona, endless vistas are carpeted with weathered earth.

The Pacific Ocean as seen from a rock-laden beach 30 miles north of Los Angeles.

1947

A figure boards a ship docked amid the rock formations along Capri's famous coast.

Photographed by Clifford Coffin,
September 1, 1947

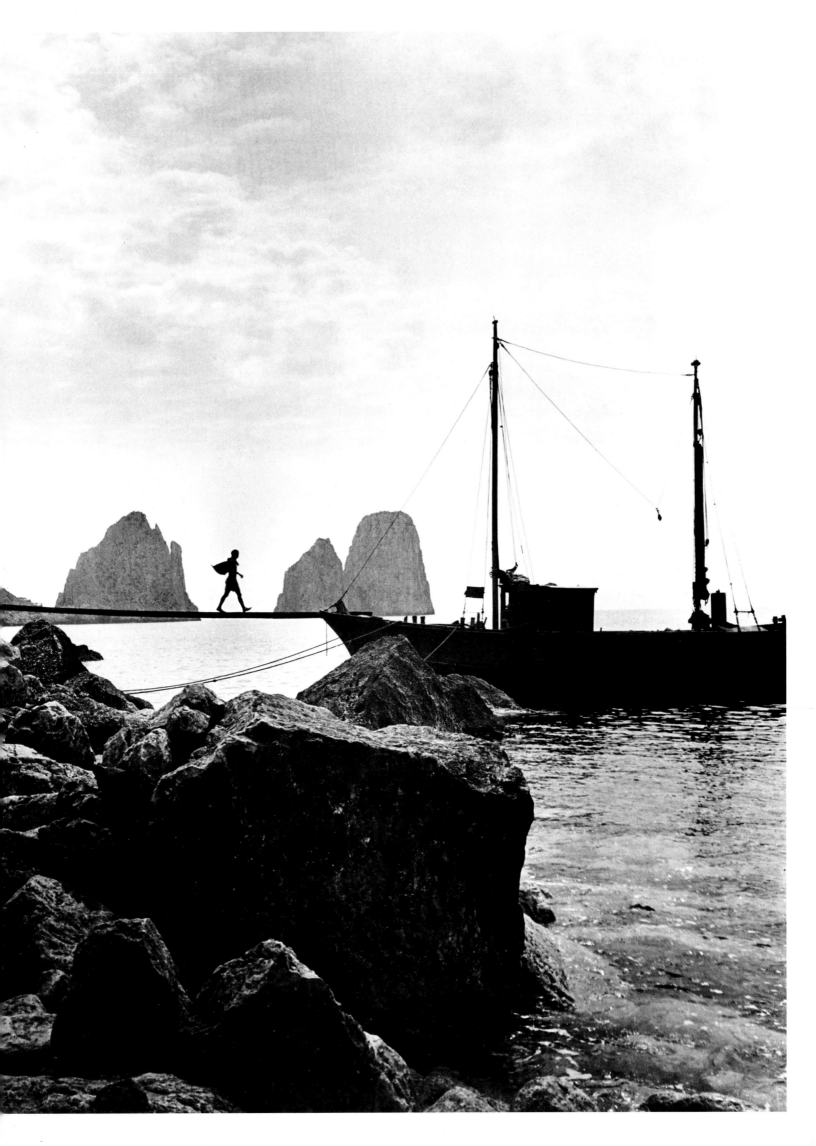

2

1960 — 1969

At the dawn of the 1960s, the Jet Age had definitively begun, with Boeing 707s and Douglas DC-8s shrinking the world at speeds of up to 600 miles an hour. Now it was not only possible but easy for travelers of more moderate means to jet off to many of the places they had only dreamed about: Monte Carlo, Mallorca, Mykonos, Acapulco, St. Tropez, Marrakesh, Beirut, or perhaps just London or Paris. Indeed, by the end of the decade, the number of passenger miles flown had more than tripled, from 40 billion to about 130 billion per year.

V

Vogue reflected these new realities in stories that offered cutting commentary on far-flung destinations in the guise of travel advice. Tel Aviv was "beige and restless, impatient as a deadline," wrote *Vogue*'s travel editor Despina "Depy" Messinesi. The Portuguese island of Madeira shot "out of the Atlantic like a cornucopia spilling with flowers." In Depy's descriptions, even mundane scenes were sprinkled with magic: "In the thick blackness of a midtown Melbourne park, schoolgirls leaping like ballerinas on a lighted stage were playing night basketball."

Commercial jet travel also enabled *Vogue* to send teams of photographers, fashion editors, hair and makeup artists, and models across the globe. A trip to Australia or Asia on even the fastest of propeller planes—which had to make numerous stops for refueling and flew at slower speeds—could take days. Now, jets could take you from shore to distant shore in the course of a day.

1966

For a 26-page story, photographer Henry Clarke, *Vogue* editor Susan Train, and a team of models set out on a three-week odyssey to the Euphrates in eastern Turkey. THIS PAGE: Among the stops was the wind-carved Valley of Göreme, where yellow-and-black striped djellaba dresses were photographed on Antonia Boeckesteyn and Editha Dussler. FOLLOWING PAGES: A model poses next to the giant head of Apollo-Mithra. A model stands tall in a hollowed-out cliff.

Photographed by Henry Clarke, December 1, 1966

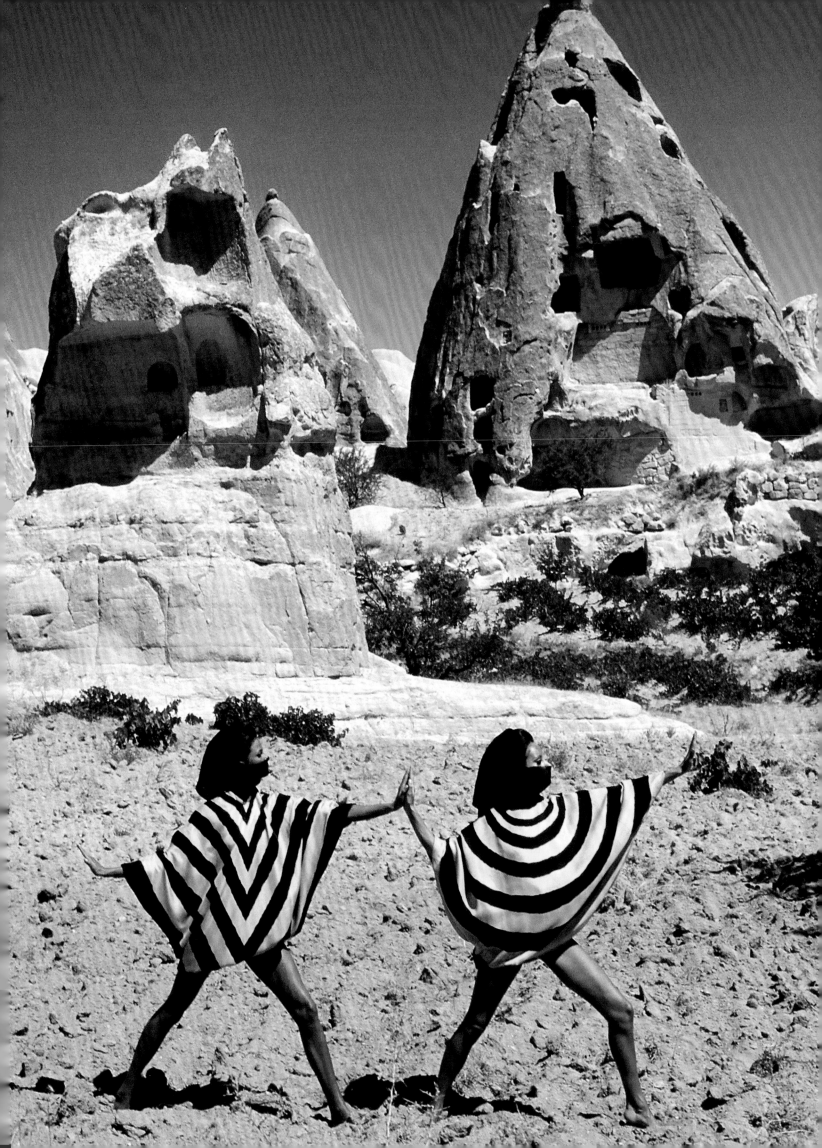

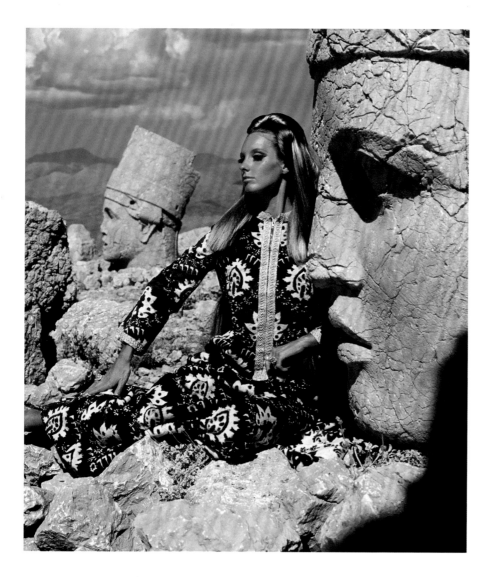

issue trip became a regular feature—despite the expensive and elaborate arrangements it required: multipart itineraries, visas, and inventories from the fashion editors of every item they were taking with them.

Vreeland paid little heed to these logistical challenges. If she wanted a particular hat at the top of the Himalayas, then that hat made its way there, "by car and by Jeep and by camel and by donkey," as Grace Mirabella, who would eventually become the editor-in-chief, wrote in her book *In and Out of Vogue*. For one memorable 1965 shoot, Vreeland dispatched photographer Norman Parkinson with two models and 200 pounds of fake hair. The idea was to find "the finest Arab stallion that you can find in Tahiti—check with some veterinarian," she dictated, and braid the horse's mane to the ground with plastic hair. This was characteristic of Vreeland's approach, Parkinson later wrote: She was always "punching for the impossible and the unattainable." There were, it turned out, few horses on Tahiti, but the crew knew, as Vreeland put it, that "they couldn't come home to me without a picture of a white horse, and, sure enough, they came home with a horse and he was white."

No photographer was better matched to the peripatetic-spirited Vreeland than Henry Clarke. With the Los Angeles–born, Paris-based Clarke, Vreeland pulled off shoots in India, Syria, Turkey, and Iran, often resulting in 20-plus-page stories that injected a worldliness into the pages

Perhaps no one in the fashion world greeted this revolution with greater enthusiasm than Diana Vreeland, the iconic editor-in-chief who was at the helm of *Vogue* for most of the 1960s. For Vreeland, style was no longer merely a function of refinement and symmetrical features; it had also to do with confidence and bearing, and the energy with which one moved through the world. "You held your head high, and you were a beauty," she said. "You knew how to water-ski, and how to take a jet plane fast in the morning, arrive anywhere, and be anyone when you got off." That spirit led her to dispatch photographers to the far reaches of the globe: Egypt, India, Greenland, Libya, Mexico, Peru. And under Vreeland, the Christmas

YOU MUST GO ALONE at twilight, must walk very slowly across the vast approach, listen as the traffic on the Reforma recedes into some profound stillness. On a knoll among the pepper and eucalyptus trees, among the pines, blowing, closing in, rests a giant stone Olmec head, the long grass grown around it as if it had been there always.

JOAN DIDION, 1965 NEW MUSEUM IN MEXICO

of the magazine. The exotic locations provided striking backgrounds for the bold new fashions of the decade as well: the vivid colors and wild prints, tunics and robes, turbans, or, more frequently, huge hair that was often a work of art in itself.

Some shoots became inadvertent chronicles of historic moments. For Clarke's trip to Thailand, depicted in the February 1965 issue, he gained access to Bangkok's Grand Palace, a "square mile of walled enchantment," as it was then described. Here, in a shimmering gold pavilion, seven-year-old royal princess Chulabhorn posed with her toys and her jewels: golden anklets, diamond bracelets, a ruby and diamond necklace. In other photos, Clarke captured Queen Sirikit and King Bhumibol Adulyadej, who, when he died in 2016 at the age of 88, was the world's longest-reigning monarch. In 1969, Vreeland sent Clarke to Iran to photograph models Lauren Hutton and Marisa Berenson amid the ancient ruins at Persepolis. "Fashion in the Persian-Blue Gardens of the Sun," the piece was called, and Hutton and Berenson strode through tiled courtyards and palaces in skin-baring outfits that would seem inconceivable just ten years later, when the Islamic revolution made it practically impossible for women to walk through the streets without wearing the hijab.

At other times, Vreeland and Clarke pushed into places that were previously unknown to most of her readers, such as "the sunny secret reaches of Turkey." Roads and flights were opening up previously inaccessible stretches of the country, the magazine reported: "Across miles and millennia, the remote country as well as the art of Turkey is coming within reach." It was not a journey for the meek, however. It took Clarke and company "three stalwart weeks of Jeeps, mule-trains, and sleeping bags" to reach the strange and majestic Valley of Göreme (here and page 45), with its weird rocky spires and rock-hewn dwellings and chapels.

A perfectionist whose greatest gift, according to Susan Train, longtime Paris editor of American *Vogue*, was "doing his homework," Clarke would issue highly specific requests when he landed at the location of the shoot. "He was able to tell the official guides assigned to us, 'No, I want this and this,'" Train told *The New York Times* in 1996. "And we would race around the country with two models, a hairdresser and a fleet of cars."

The sixties was also the decade when Richard Avedon, who had migrated with Vreeland from her previous perch at *Harper's Bazaar*, became a regular feature in the pages of *Vogue*. Among his more memorable odysseys was "The Shrimp at Sea," which followed British model Jean Shrimpton and her photographer pal Jeanloup Sieff as they sailed between the Greek islands aboard millionaire shipowner Stavros Niarchos's "yacht of yachts," the *Creole*.

Avedon's most notable work abroad for the magazine, however, was probably "The Great Fur Caravan," which took the legendary German model Veruschka along with three limousine loads of furs to Japan's snow country, Hokkaido, the country's northernmost island. Along the way, they picked up a sumo wrestler, and shot against a surreal landscape of volcanoes, hot springs, and endless snow, where, as *Vogue* put it, "the earth looks as it must have at the dawn of creation—restless, tormented, seething." The magazine had traveled so far that it seemed to have gone back in time.

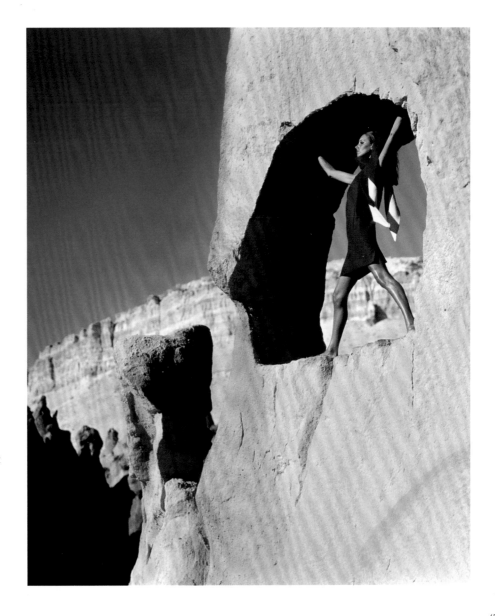

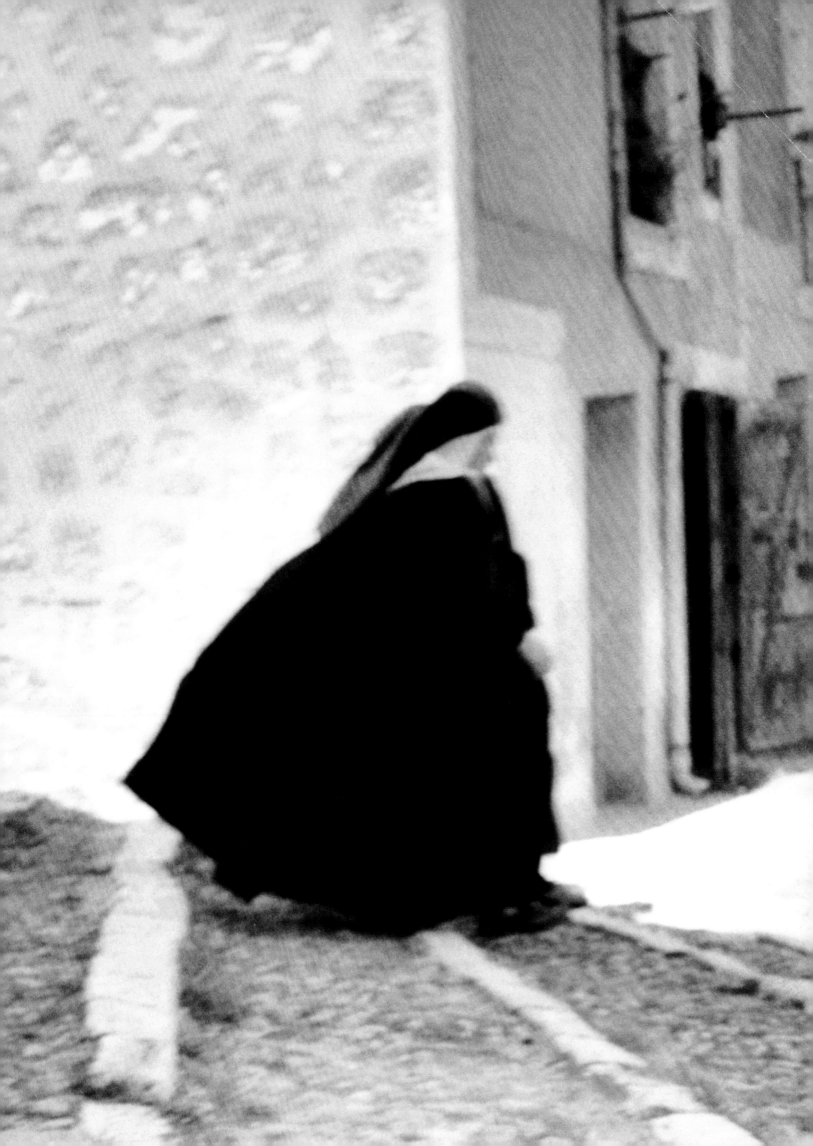

AT SPANISH *FIESTAS*, there is always time, *siempre hay tiempo*, and as people had yet to dine, everyone proceeded to the restaurant, El Bosque. Acres of tables were set in an outdoor pavilion, under lighted orange trees. A zealous orchestra played, half-bottles of *fino* nested in shaved ice, and a regiment of white-coated waiters were in no apparent rush to serve dinner. After a few dances, and more than a few *finos*, dinner started at two; delicious, long, and leisurely. Coffee and cognac arrived around four, and at five-thirty in the morning came the farewells: *adiós, adiós, mucho gusto...hasta mañana*, although it was already *mañana*.

PEGGY DONOVAN, 1962 SHERRY MERRY IN SPAIN

1964

Master of candid photography Henri Cartier-Bresson traveled to Spain on assignment for *Vogue*, and the result was a surreal snapshot of mid-century Spanish life.
OPPOSITE PAGE, FROM TOP: Men mill outside the fortified city of Ávila. A dog roams the streets of La Mancha. PREVIOUS PAGES: A scene near Burgos's Gothic cathedral. FOLLOWING PAGES: A bullfighter just moments before he enters the ring. Orphans and their nun caretakers in Toledo.
Photographed by Henri Cartier-Bresson, June 1, 1964

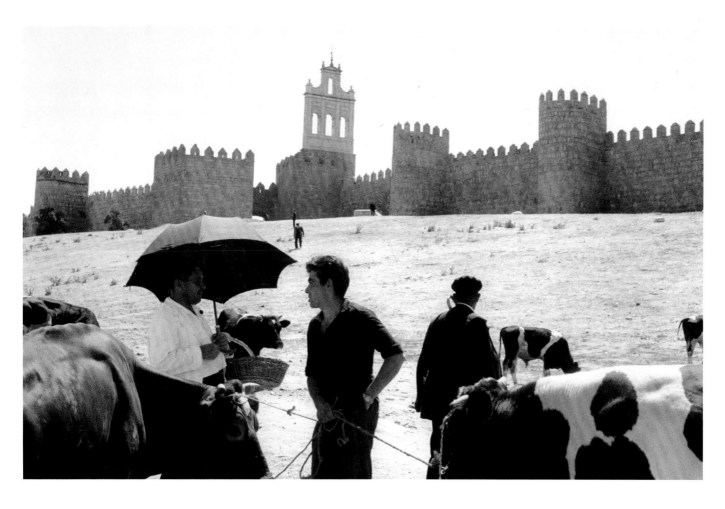

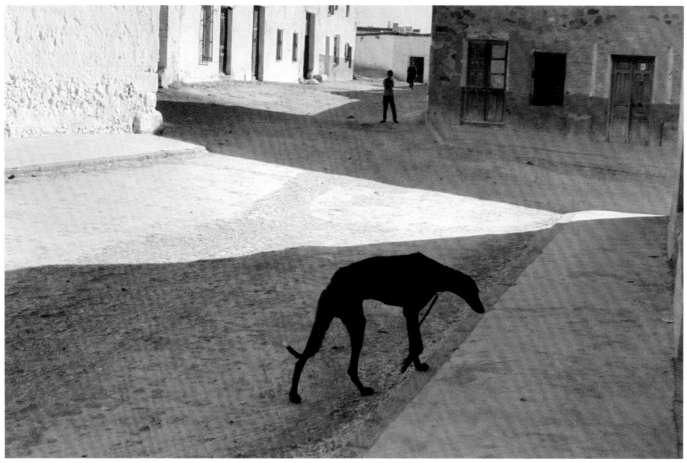

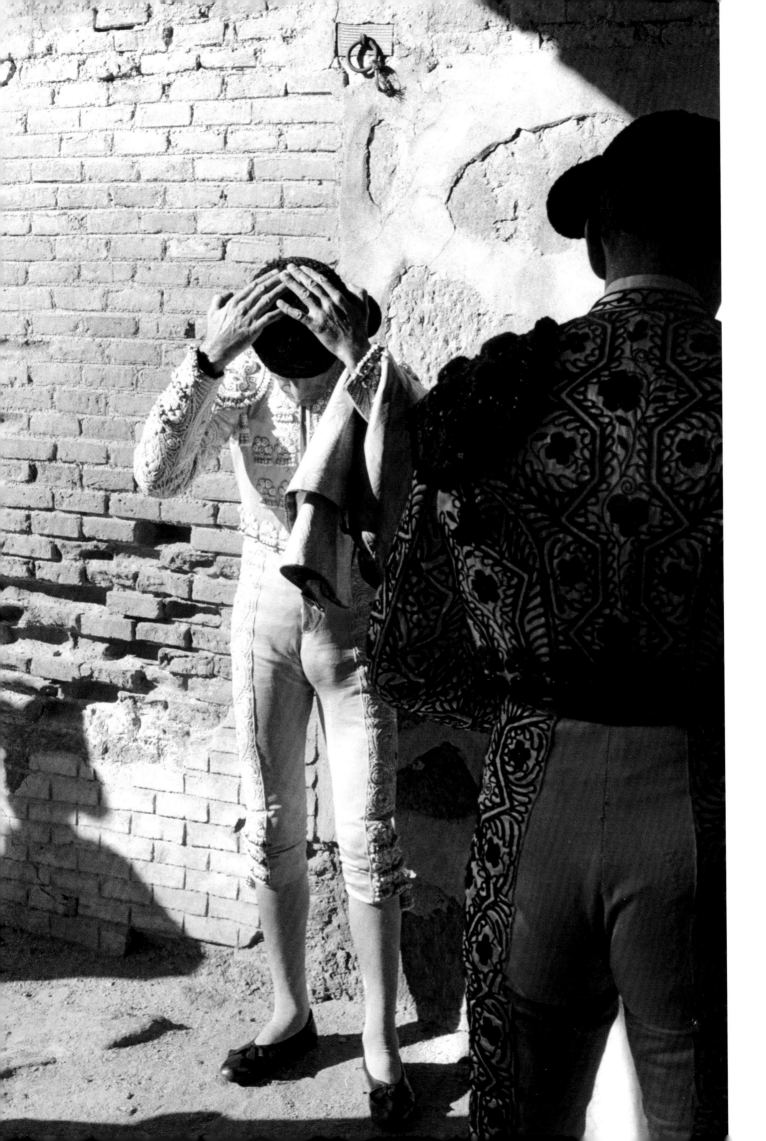

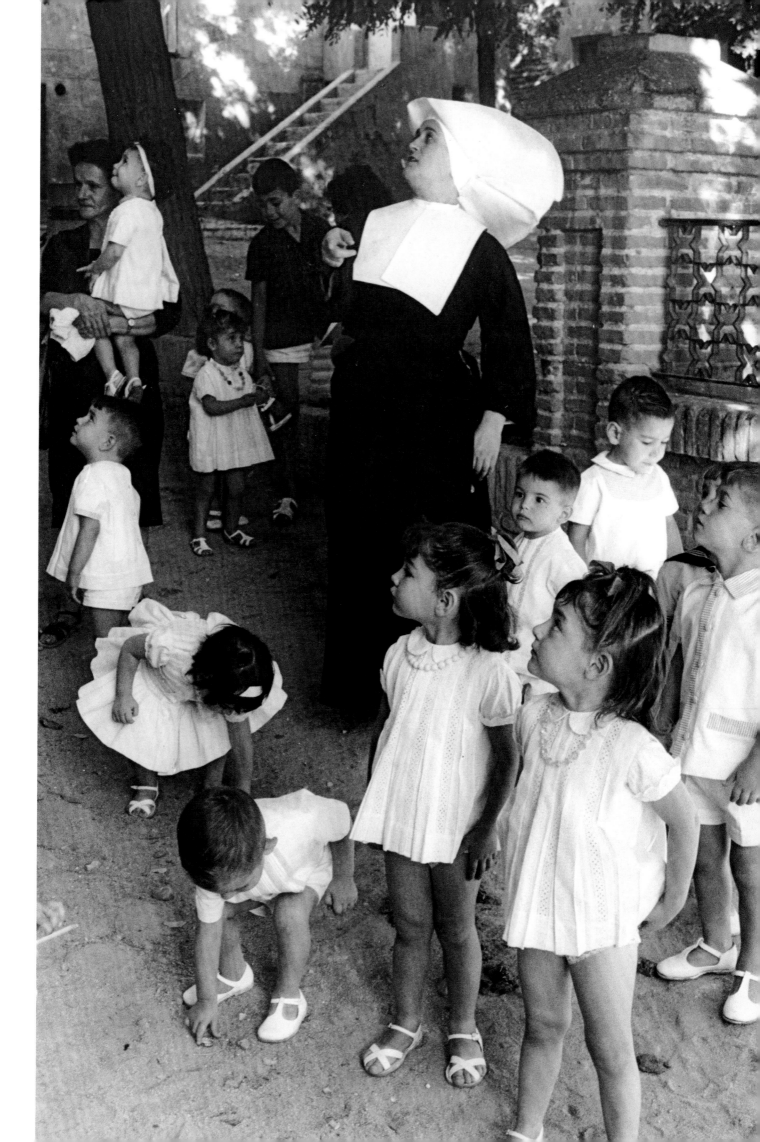

1966

Richard Avedon captured
his frequent subject,
Jean Shrimpton, and the
photographer Jeanloup
Sieff island-hopping in
Greece. "I'd never seen
anywhere more beautiful
than Greece," said
Shrimpton of their eight-
day adventure. OPPOSITE PAGE:
The ruins of Delos. FOLLOWING
PAGE: The Paraportiani
church on Mykonos.

Photographed by Richard Avedon,
October 1966

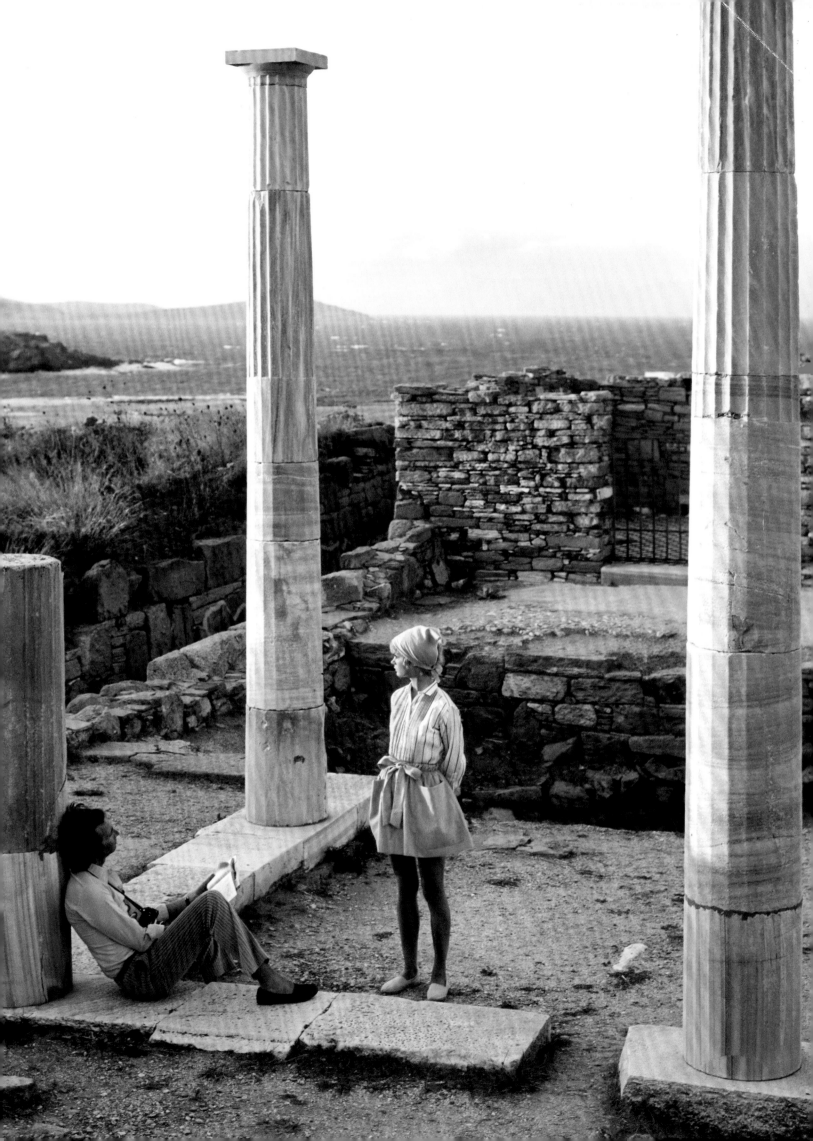

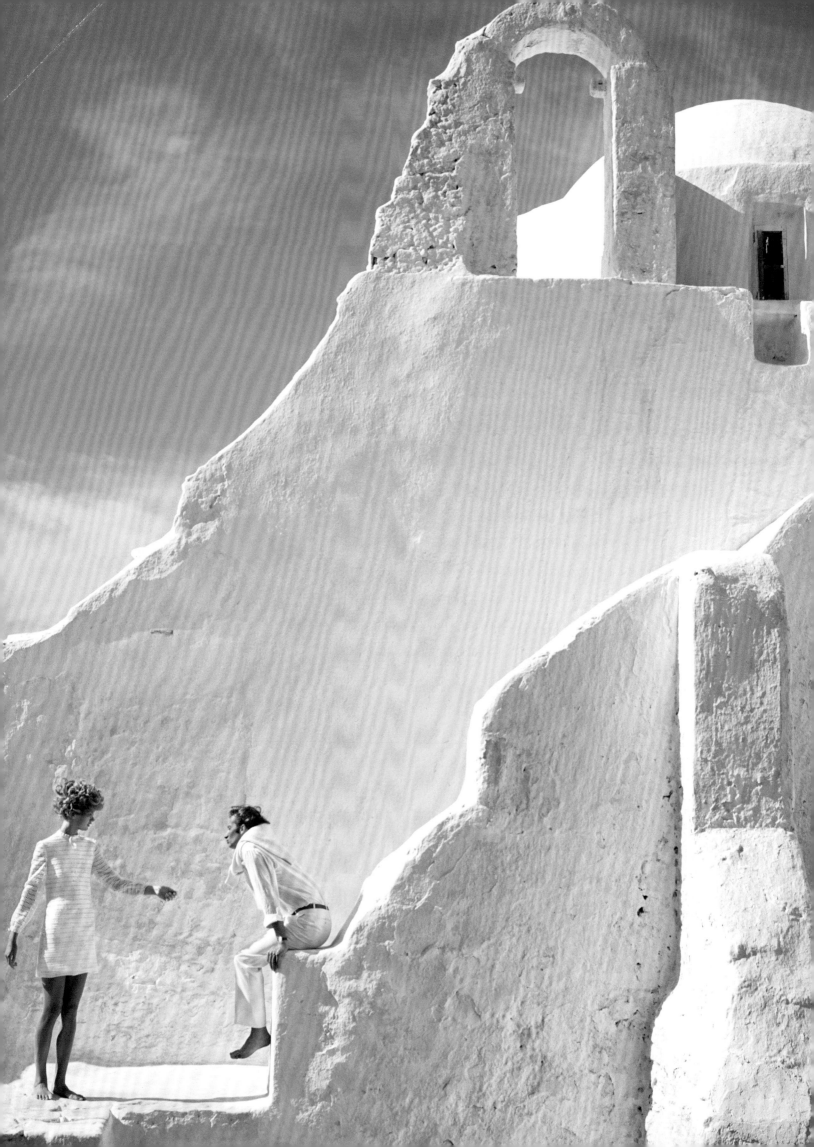

NO MATTER WHERE YOU GO on Crete, you can never really forget you're on an island. Even in a gorge where vertical stone cliffs rising a thousand feet above your head threaten to converge, the sensation is more comparable to moving in the bowels of a ship than in the innards of the fixed earth. Only on certain stretches of the northern coast do you get a distinct taste of the unknowable, of an affective continent beyond the background of mountains where snow turns pink during the spring sirocco....Partly it is the climate which declares the island: the atmosphere has that inventive instability peculiar to places surrounded by water. The sky seldom jells into the thick invariable blue of the tropics; neither does it grow white and self-consuming like the air over deserts. It moves, as if the island were under way. At night it accedes (but coolly) to oversized stars; clouds, real El Greco clouds (no one else's—you will recognize all at once that sky over "Toledo") flow from an erupting moon. Then the whole of Crete seems, sensually, to be floating under a tangible heaven over an endless sea.

CHARLES HALDEMAN, 1965
INDEPENDENCE, HONOUR,
AND ECSTASY, IN CRETE

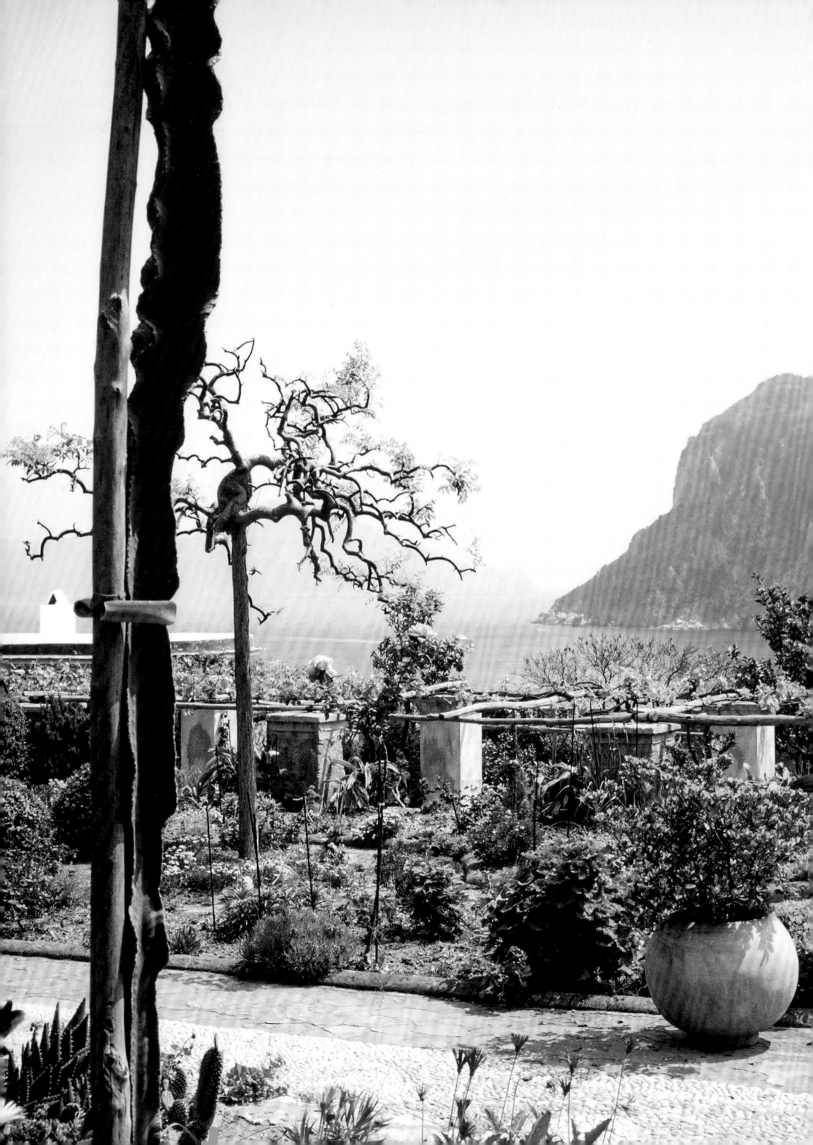

1967

"The garden of Fortino, Count and Countess Edward Bismarck's surpassingly beautiful property on the north coast of Capri, is one of the most famous of all the gardens on the shores of the Mediterranean," wrote Valentine Lawford. THIS PAGE: The Countess grew and harvested her own roses, which she later arranged in her home's flower pavilion. OPPOSITE PAGE: A view of the nearby cliffs.

Photographed by Horst P. Horst, April 1, 1967

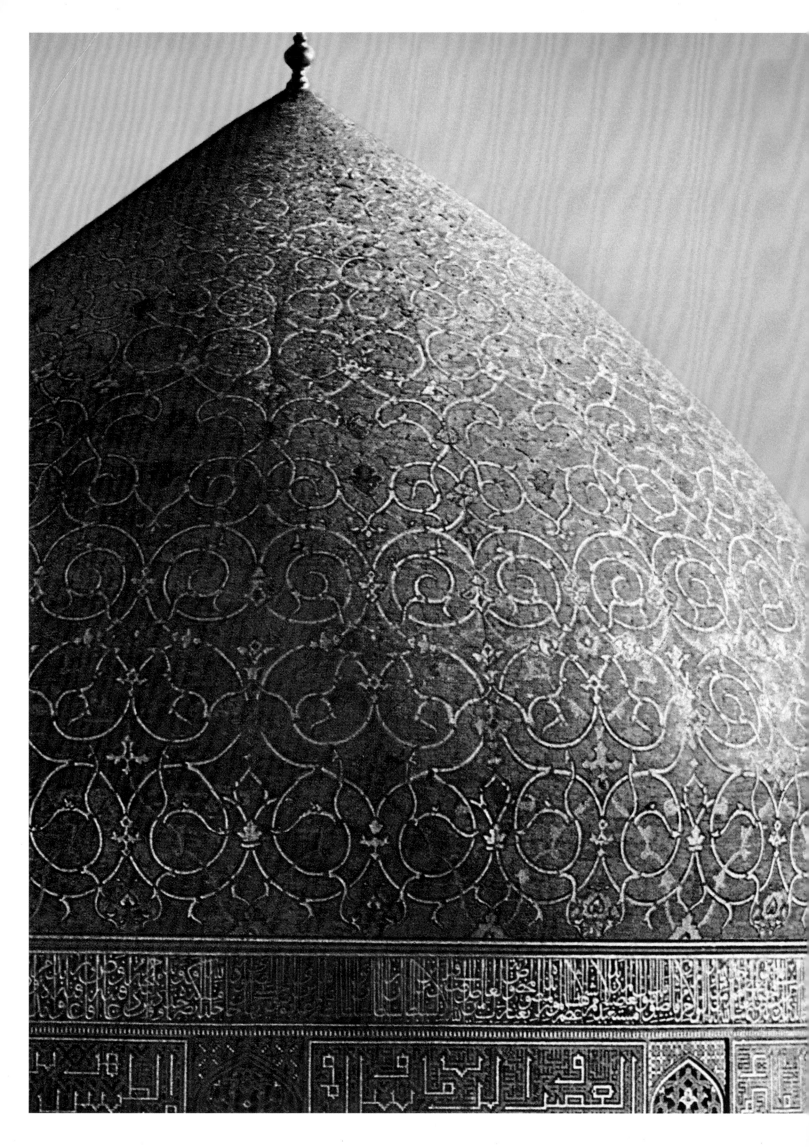

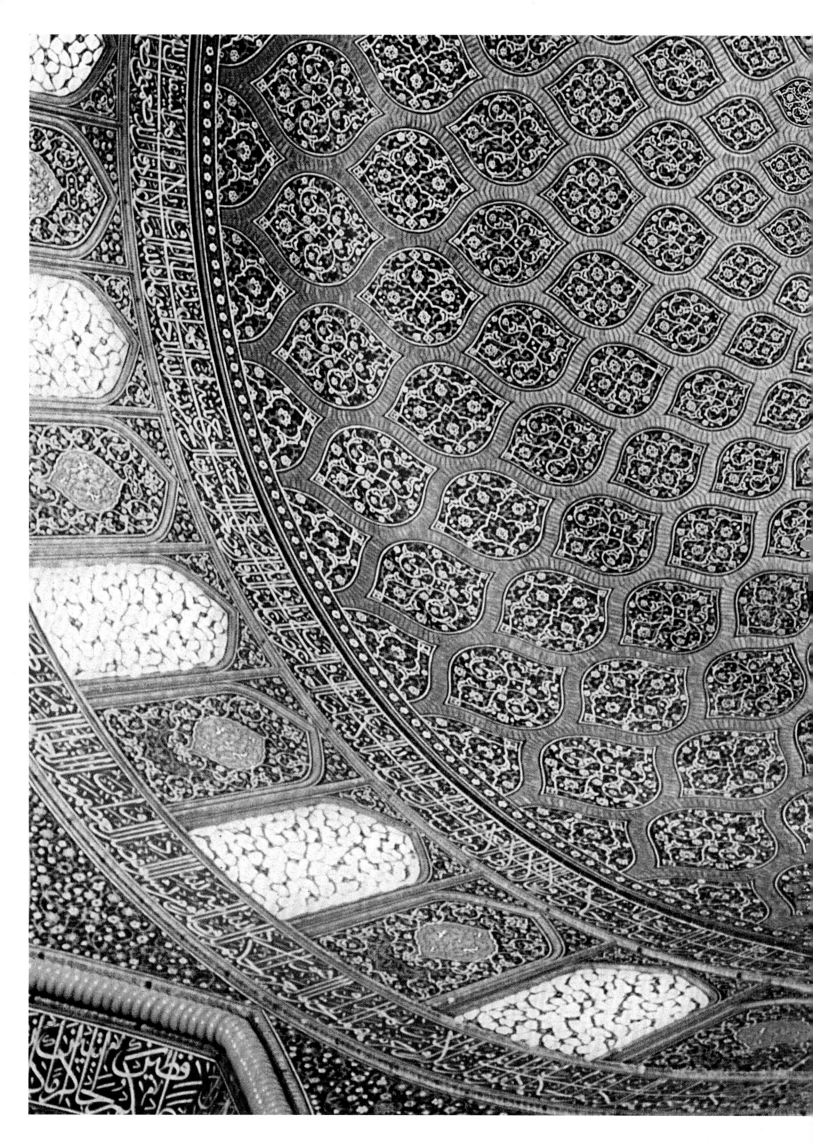

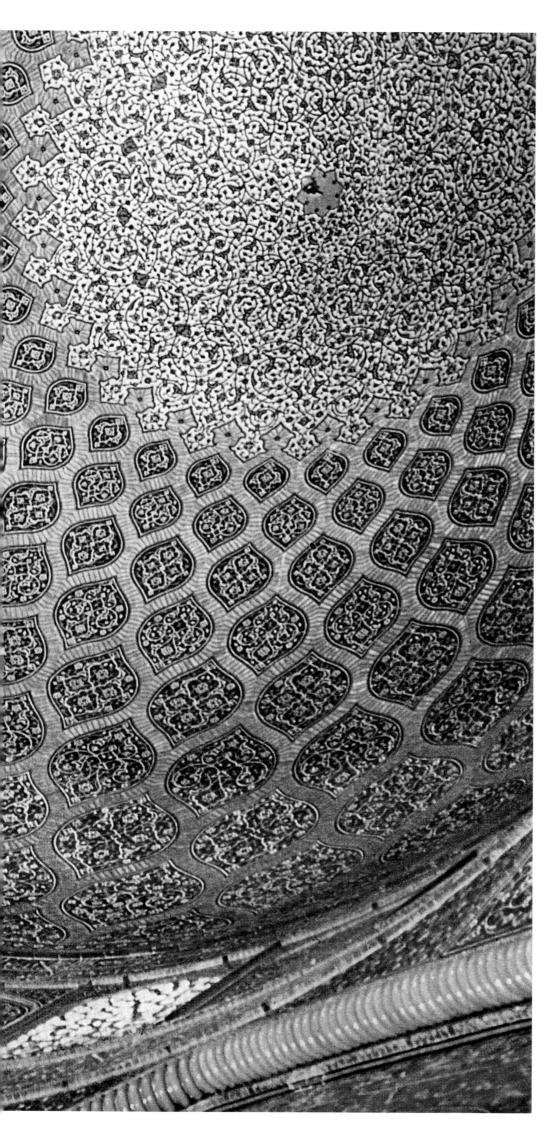

THE VILLAGE was a cluster of balconies, gardens, mud walls, and poplars, with a blue-coned shrine in an orchard, a derelict fort, the four-square compound of a caravanserai, and presiding over it all on the slope of the hills, the very dream of a mosque—a dome of turquoise and yellow, four turquoise-and-yellow minarets, and seven small polychromatic spikes poised in attendance all about.

Nothing moved in the village, as I sat in the car contemplating this celestial scene. The people, I suppose, were all at work, or food, or prayer, or very likely love. A scented hush lay over the scene, and everything shone. Just over the ridge lay the desert, and presently I drove on and entered the brown hangdog streets of Kashan, where a garage man told me that the village was probably Jooshagan, once famous for its carpets. But I did not care what its name was. It really had seemed, as the Persian planners would have wished it, a passing suggestion of Paradise.

JAMES MORRIS, 1969
IRAN BORN PERSIA:
"A PASSING SUGGESTION
OF PARADISE"

1965

"Even at night, colour does not desert Isfahan, and its great mosques gleam like veiled peacocks," wrote Lesley Blanch in a profile of Iran's imperial family that accompanied these photographs. THIS PAGE AND PREVIOUS PAGES: The turquoise and lapis lazuli dome of the Masjid-i-Shah mosque in Isfahan, Iran.

Photographed by H.C. Seherr-Thoss, August 15, 1965

1968

Photographer John Cowan followed model Françoise Rubartelli through Peru. Here, Rubartelli finds the light on the steps of Machu Picchu.

Photographed by John Cowan, October 15, 1968

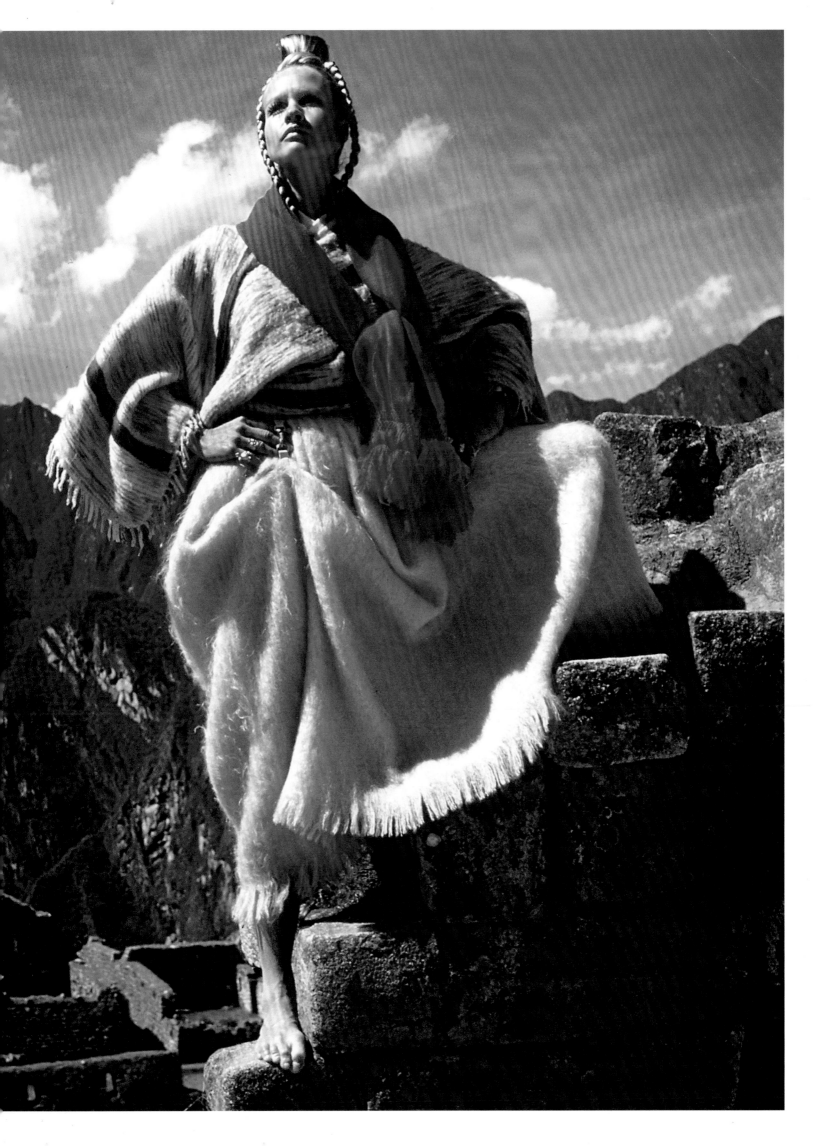

1968

THIS PAGE AND FOLLOWING PAGES: Veruschka, styled by fashion designer Giorgio di Sant'Angelo, poses in a variety of fantastical creations in Arizona's Painted Desert.

Photographed by Franco Rubartelli, July 1, 1968

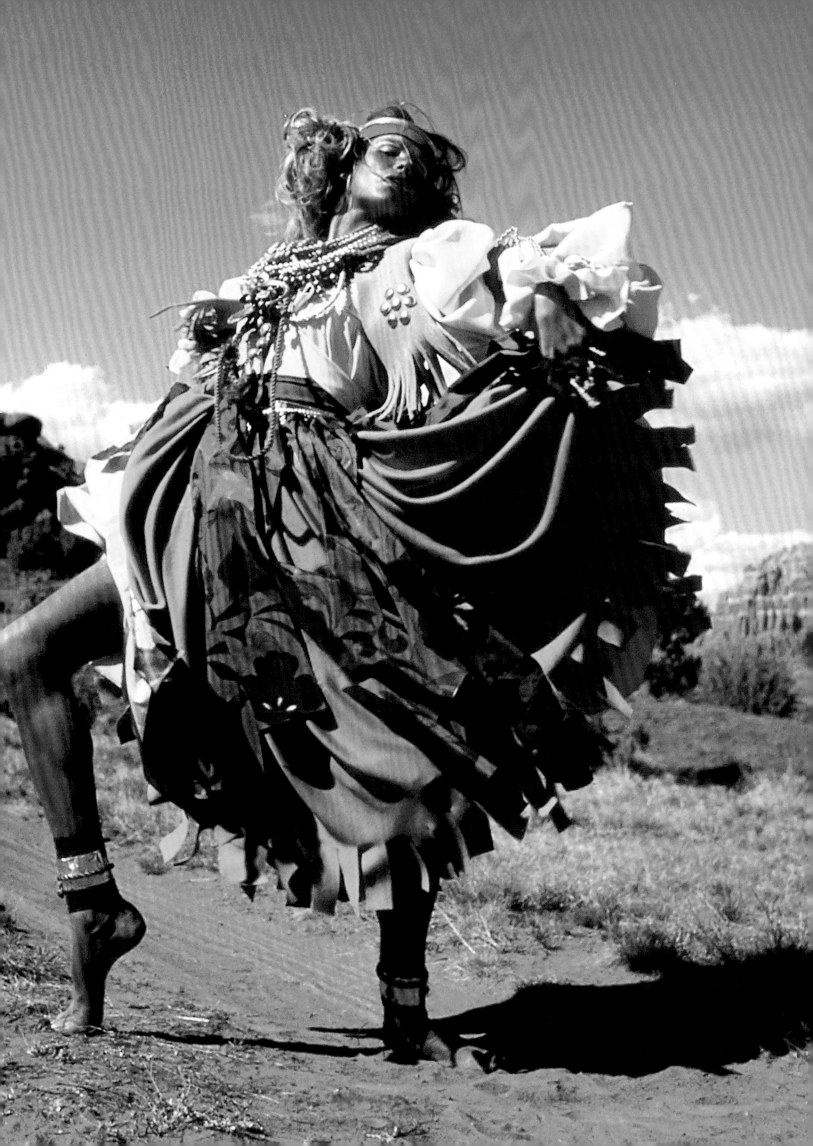

1964

THIS PAGE: The grand estate of La Grange Mortefontaine, near Paris. Once owned by Napoleon's sister Pauline Borghese, by the 1960s it was the property of Baronne Geoffroy de Waldner. FOLLOWING PAGES: Baronne de Waldner was a keen horticulturist, and for parties, would create life-size animals out of flowers. Scenes from her interiors.

Photographed by Horst P. Horst, December 1, 1964

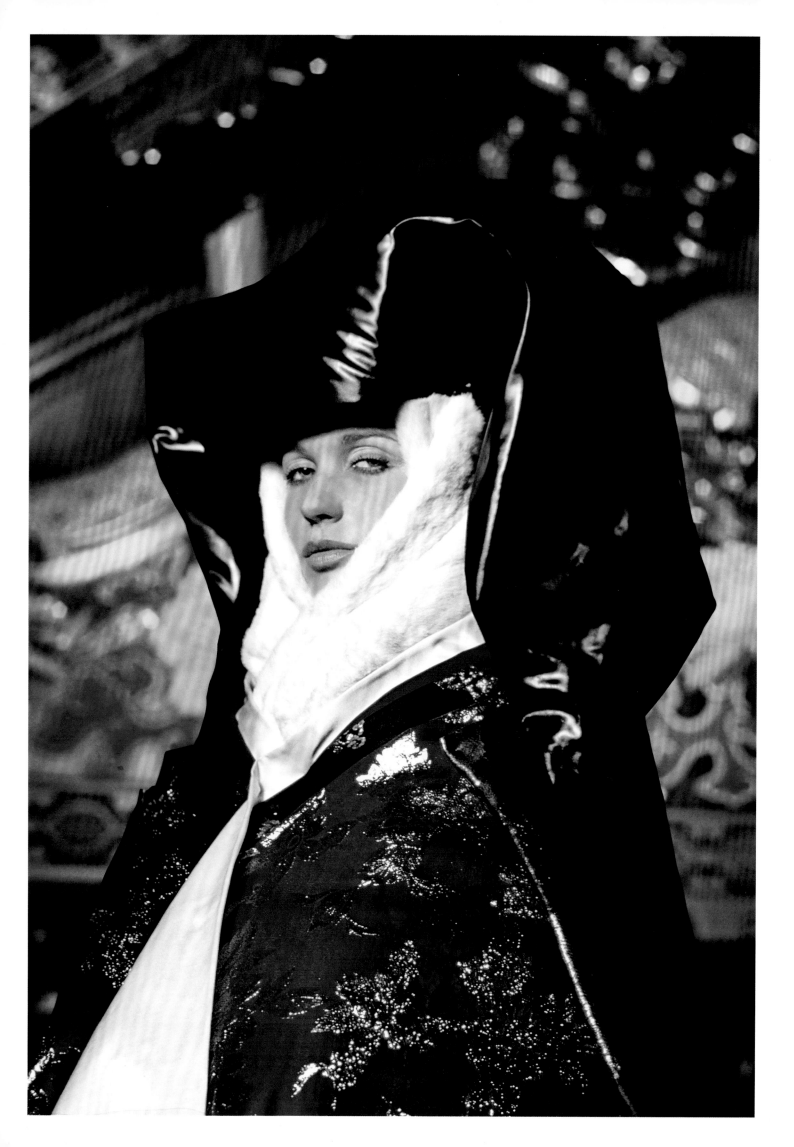

1966

For the "The Great Fur Caravan," Richard Avedon and Veruschka traversed Northern Japan—from the mysterious hot springs of Hokkaido to the snowdrifts of Yuzawa to a 17th-century shogun shrine. Here, Veruschka in a ciré and white ermine headdress inside a shrine in Nikko, Japan.

Photographed by Richard Avedon, February 1966

THIS PAGE: Veruschka at
Japan's Jigokudani, a
geothermal crater.
FOLLOWING PAGES: Veruschka
and a sumo wrestler.
*Photographed by Richard Avedon,
February 1966*

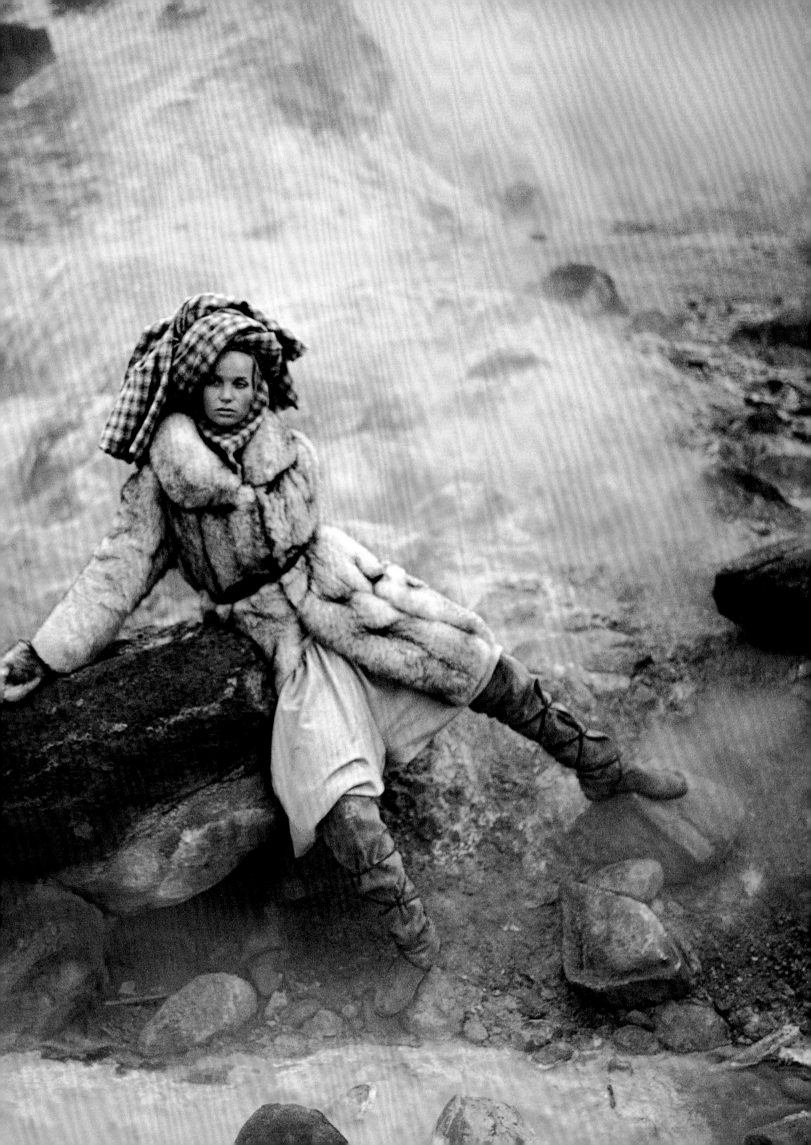

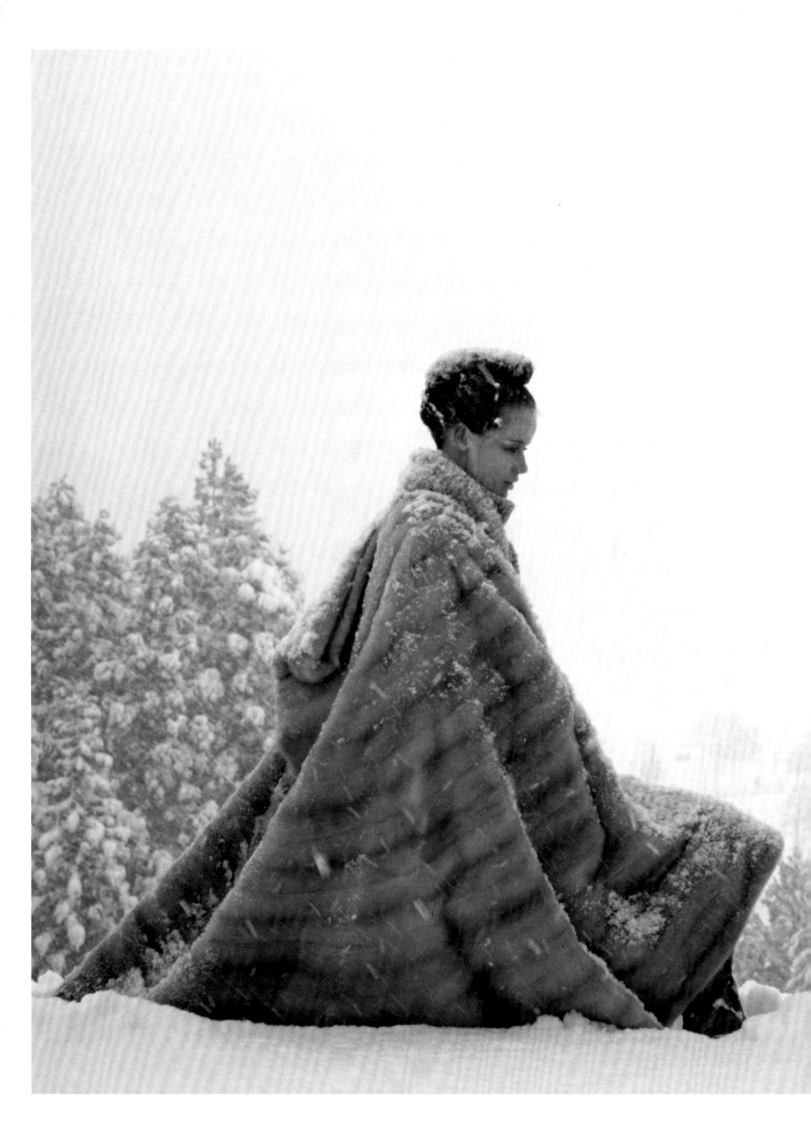

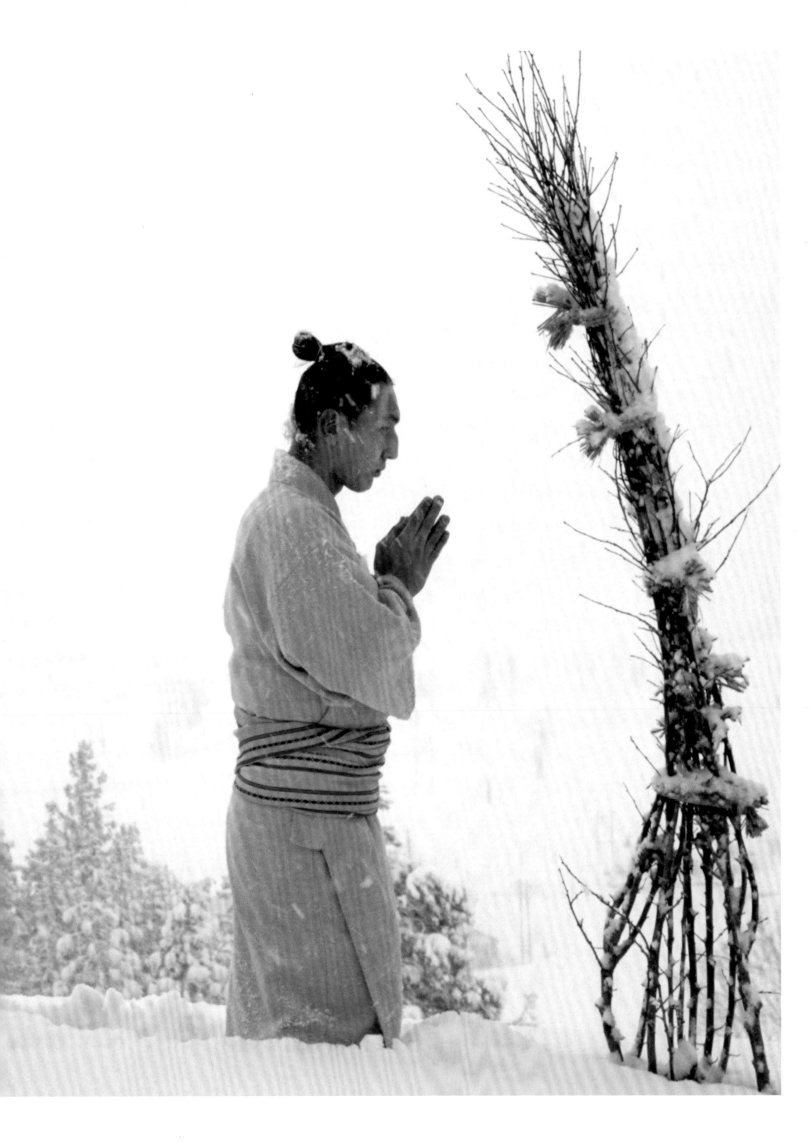

DIVINE CLICHÉS—that's the real thrill in Kyoto, and it's not even fair to call them clichés. Except there you are with those "cherry flowers." With the strange low gong of temple bells to wake you in the morning. Great weathered temples seen through young greenery, wild plum, pine, and bamboo; far more moving than the bright new red and gold affairs in Tokyo—more temples than you can possibly manage though the fascination grows, and the appetite of the Western eye and ear rapidly become insatiable. Though I had often felt a slight Occidental impatience when the Japanese explained over and over how much importance they attach to the changing seasons, I found myself turning into a tiger-butter of sudden rapport when I went a second time to see the four-seasons ink paintings of Sô-ami at Daisen-in—misted, unreal, unattainable landscapes, a yearned-for celestial Japan painted on sliding screens.

ROSEMARY BLACKMON, 1964
NEW JAPAN: "PILLOW-BOOK" NOTES FROM
AN HONOURABLE PICNIC WITH NO SPECIAL PLANS

Veruschka in a white mink coat, with the elaborately carved Karamon Gate of the 17th-century Nikko Toshogu Shrine as a backdrop.
Photographed by Richard Avedon, February 1966

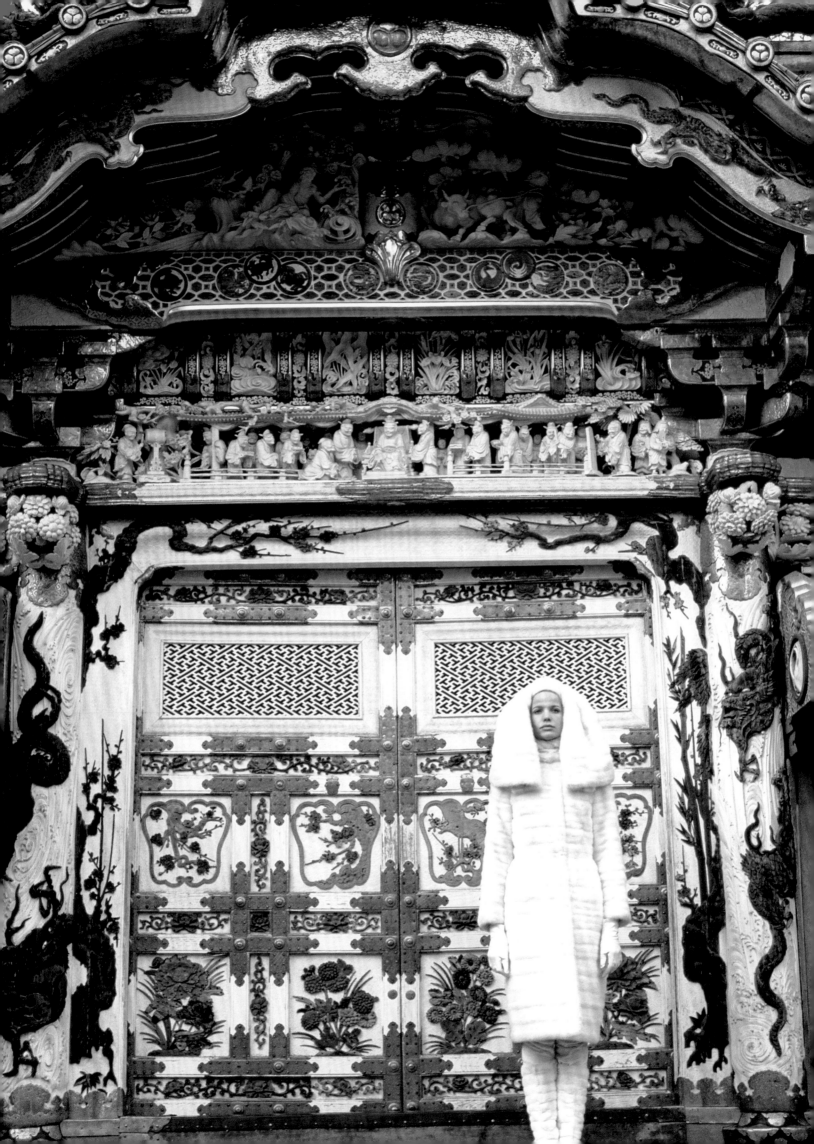

3

1970 — 1989

Things seemed to calm down in the 1970s. Fashion was less outrageous, more down-to-earth, not unlike *Vogue*'s new editor-in-chief Grace Mirabella, who succeeded Diana Vreeland in 1971. Mirabella had been Vreeland's assistant for nine years and was considered a marked contrast to her predecessor. A straight-shooting daughter of Italian immigrants, she was not, as most *Vogue* editors at the time were, from society. Under Mirabella, the fantasy shoots of the Vreeland era—showcasing extreme fashion that most readers would never wear, in exotic locales that few would ever visit—came to an end.

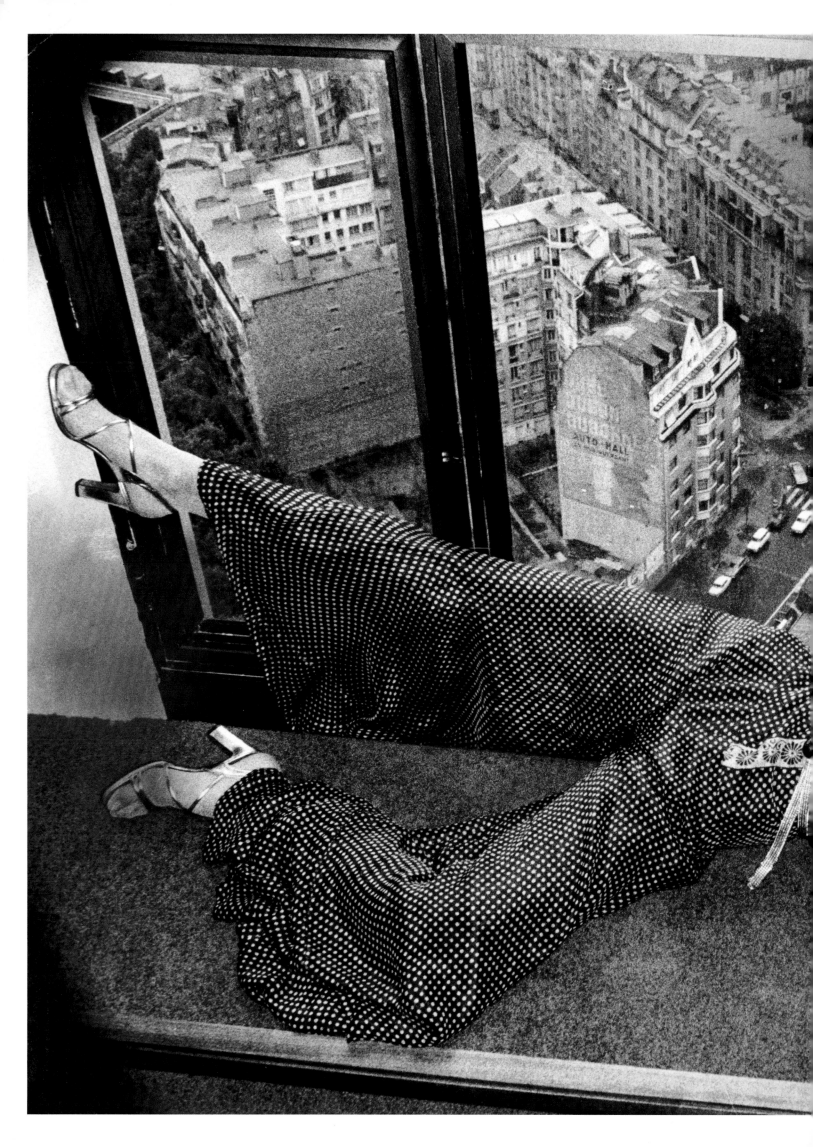

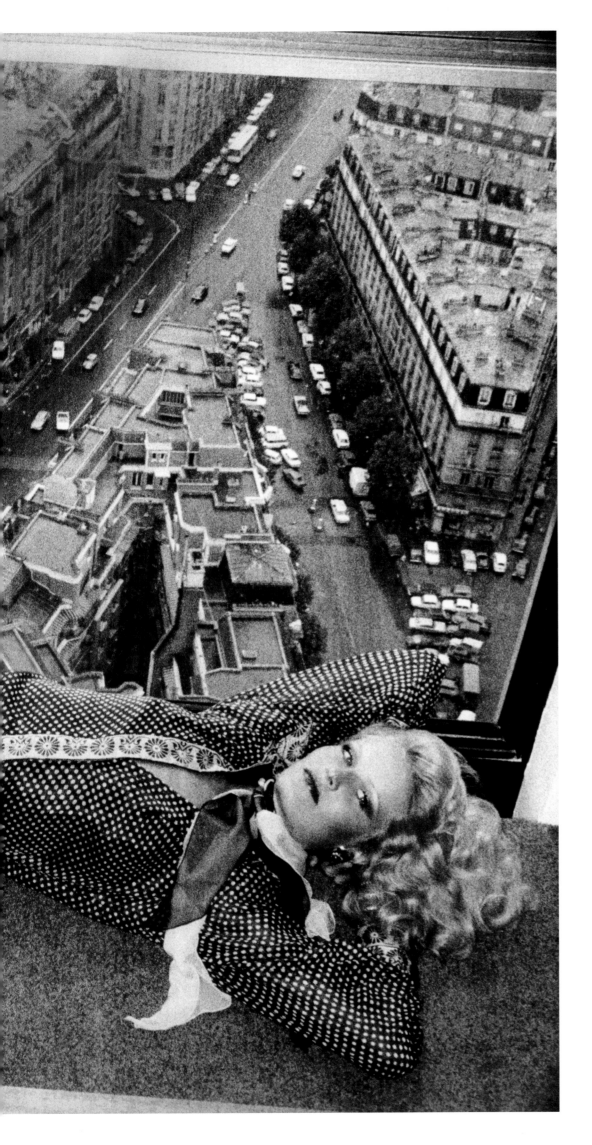

1974

A photo shoot at Bar Panoramique, on an upper floor of Paris's Hotel Concorde-Lafayette, one of the city's tallest buildings. A model lounges while overlooking the City of Lights.

Photographed by Helmut Newton, October 1974

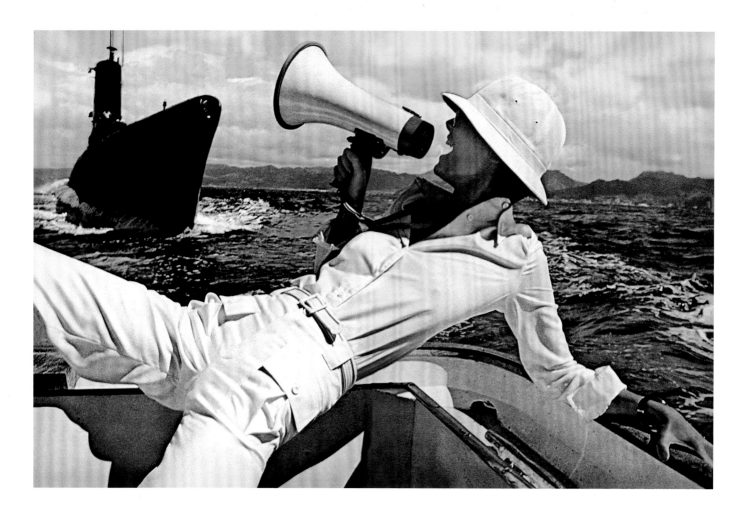

N

Now, ambitions were a bit more restrained, both in terms of the clothes and the locations where they were shown. These were often cities and resorts well-known to many of *Vogue*'s frequent-flyer readers. Whereas the spectacular ruins of ancient Persia or the snowbound landscapes of northern Japan provided the drama for a shoot in the sixties, the excitement in the seventies and eighties sprang less from the location than from the story that played out against it.

The photographer whose work most reflected this new commitment to photographic narrative was Helmut Newton. He laced his work with a sense of danger, domination, and violence. His aesthetic celebrated women in suspenders, tuxedo pants, and stilettos, smoking cigarettes and sipping champagne—Weimar Berlin by way of the 1970s. "The point of my photography," said the so-called King of Kink in 1996, "has always been to challenge myself, to go a little further than my Germanic discipline and Teutonic nature would permit me to." His shoots for *Vogue* took him far beyond his Berlin birthplace to Brazil, Hawaii, Monaco, and elsewhere. In return, a Newton shoot took readers along on Hitchcockian journeys that ventured into the far reaches of his unique imagination.

In 1974, for a story innocently titled "Adventures in Sundressing," models Cheryl Tiegs and Rene Russo (before her movie star days) traveled to the Hawaiian island of Maui. Newton cast them both as women on holiday,

and the shoot was imbued with fun, cocktails, and sex—not just with the handsome young man they picked up along the way but, it was implied, with each other (a twist that prompted strong and scandalized reactions among some readers). But the Hawaiian sojourn was positively tame compared to Newton's 1979 "To Catch a Diamond..." extravaganza, set in that most decadent of locales, Monte Carlo. Here, models Rosemary McGrotha and Eva Wallen lounged on the beach, clad in maillots, diamonds, and little else. The Monte Carlo story garnered not only letters, but also canceled subscriptions.

1973

Model Cheryl Tiegs just off the Hawaiian shore.

Photographed by Helmut Newton, January 1, 1973

Newton's photography has elicited a mixed response over the years, with some dismissing it as "porno-chic" and others—like the feminist film critic Molly Haskell—claiming (in the pages of *Vogue*) that its explicitness not only demeaned women, it sapped the seductive power from sex. "The constant compulsion to expose the clinical foundations of eroticism ends up by killing eroticism itself," Haskell wrote. Others have come to Newton's defense, citing the complex dynamics his photography conveyed and its technical precision. "If Newton's work was controversial, I believe it's because he expressed the contradictions within all of us," wrote Wallis Annenberg of the Annenberg Space for Photography in 2013.

Perhaps even more than Mirabella, it was Alexander Liberman whose vision for *Vogue* guided Newton and many others involved in the artistic direction of the magazine. Although, as Condé Nast's editorial director, he looked after the entire stable of Condé magazines, *Vogue* was Liberman's baby, and his imprint remained strong throughout most of his career. Indeed, it was he who was responsible for wooing back Newton, who had stopped working with American *Vogue* in the sixties owing to differences with Diana Vreeland. Liberman was also behind some of *Vogue*'s history-making overseas shoots, such as the magazine's groundbreaking visit to China in 1979 with Nancy Kissinger and photographer Arthur Elgort. Liberman—a noted artist in his own right—was profoundly invested in the arts as well: When the Pompidou Center opened in 1977, he guided the magazine's extensive coverage of the "radical inside-outside building" that constituted "France's bold art coup."

In this era, the magazine also glamorized the practicalities of travel, seeking advice from unlikely experts. In the April 1971 issue, an Avedon portfolio of "The Clothes That Get You Where You're Going" sat next to an essay by Richard Burton on traveling with his wife, Elizabeth Taylor ("I love Elizabeth to the point of idolatry but—let's repeat that 'but'—she will unquestionably be...late for the last bloody judgment"). In another issue, Sophia Loren revealed her packing plan ("plotted to the last detail"); a few pages later, Vladimir Nabokov discussed his butterfly-hunting trips to Wyoming and Colorado, as well as other parts of the U.S. and Canada. Food was often part of the conversation. "Buenos Aires is a city of two conflicting passions: food and fashion," wrote Luisa Valenzuela in "The New Argentina" (1987). "You cannot know what meat means if you haven't tasted a steak at a Buenos Aires grill." And politics remained a conscious backdrop to many of the stories *Vogue* published. "Franco is dead," wrote Alan Jolis in his report on a newly animated Madrid in 1989, "and something *is* happening here— Madrileños are happy and free and dancing until all hours, spending their monthly paychecks right down to the last peseta."

If there was a trend embraced by the magazine in the seventies and eighties, it was the turn to "adventure travel," trips designed for type-A tourists who wanted to experience their destinations by Land Rover, bicycle, river raft, and horseback. In the early sixties, travelers were pretty much left to their own devices when it came to planning a high-energy holiday. But by the end of the decade, two pricey luxury travel companies, Abercrombie & Kent (which specialized in safaris) and Butterfield & Robinson (bike trips), had established themselves within this market, with more moderately priced companies following suit. *Vogue* played its part in the adventure travel revolution with stories like accessories editor Jade Hobson's 1976 survivalist week on the Colorado River in Utah. Hobson's adventure involved face climbing, rafting down the Colorado rapids, and spending 24 hours alone on a mountain: "This was one of the few times that there was absolutely nothing that I had to do," she reported. "I was just there. I felt part of the place—it was so magnificent and so impressive." At a fashion shoot at Wyoming's Breteche Creek Ranch, model Tatjana Patitz was photographed not with the horses but on them, tearing across the plains.

The grandest adventure—the "adventure of a lifetime," as *Vogue* called it—took place in 1988 when the magazine sent Kim Basinger on safari in Kenya. There she befriended cheetahs, handled falcons, sang with Masai warriors, and was awed by the beauty of the bush. "You start to feel rather small there," wrote journalist Stephen Drucker, who accompanied the team, "and that can be exhilarating, the sort of sensation that could compel you to travel around the world."

IN THE BEST OF ALL POSSIBLE WORLDS, to quote a Frenchman, life would be long enough to visit the Louvre at least seventy-five times.

JAY McINERNEY, 1986 · WHY, OH WHY DO I LOVE PARIS?

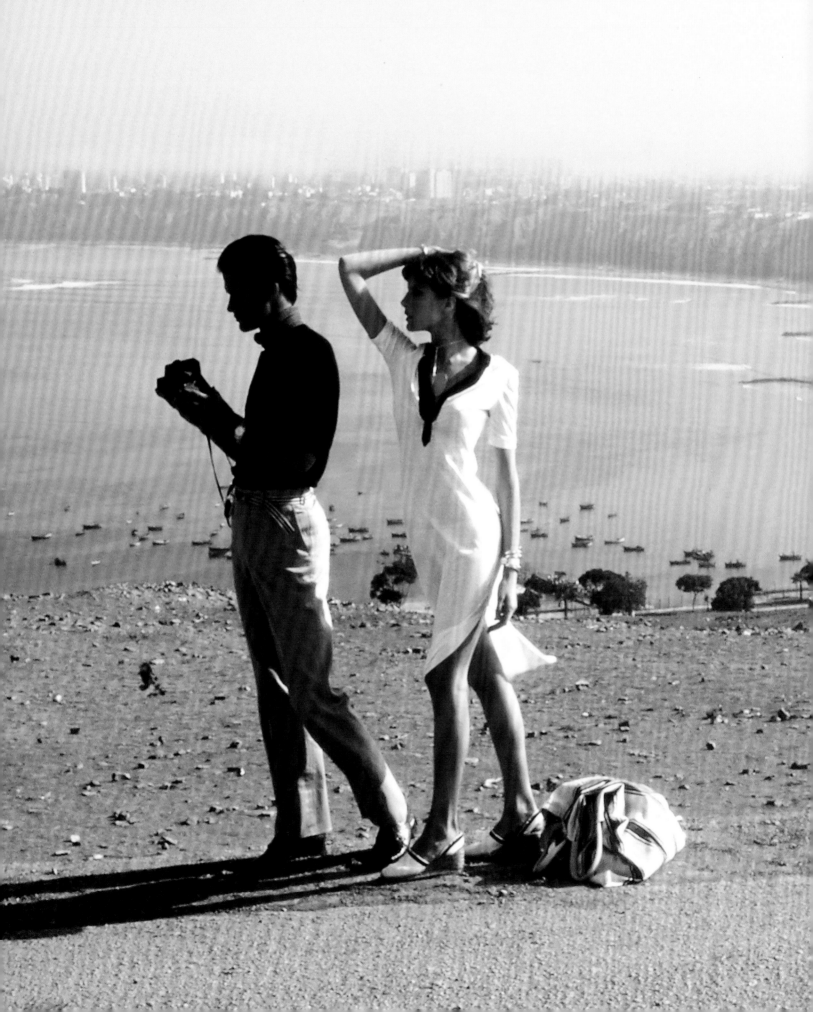

1976

Rene Russo and
a companion
in Lima, Peru.
*Photographed by Francesco
Scavullo, May 1976*

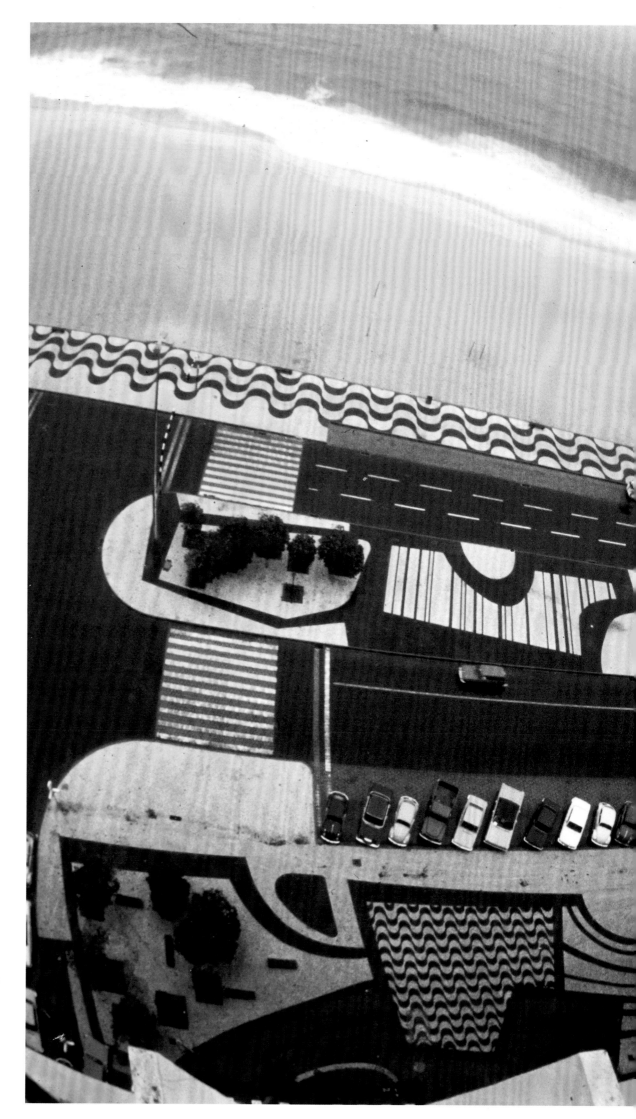

1973

Model Beverly Johnson overlooks the Roberto Burle Marx–designed promenade, a serpentine mosaic along Rio de Janeiro's Copacabana Beach.

Photographed by Kourken Pakchanian, December 1, 1973

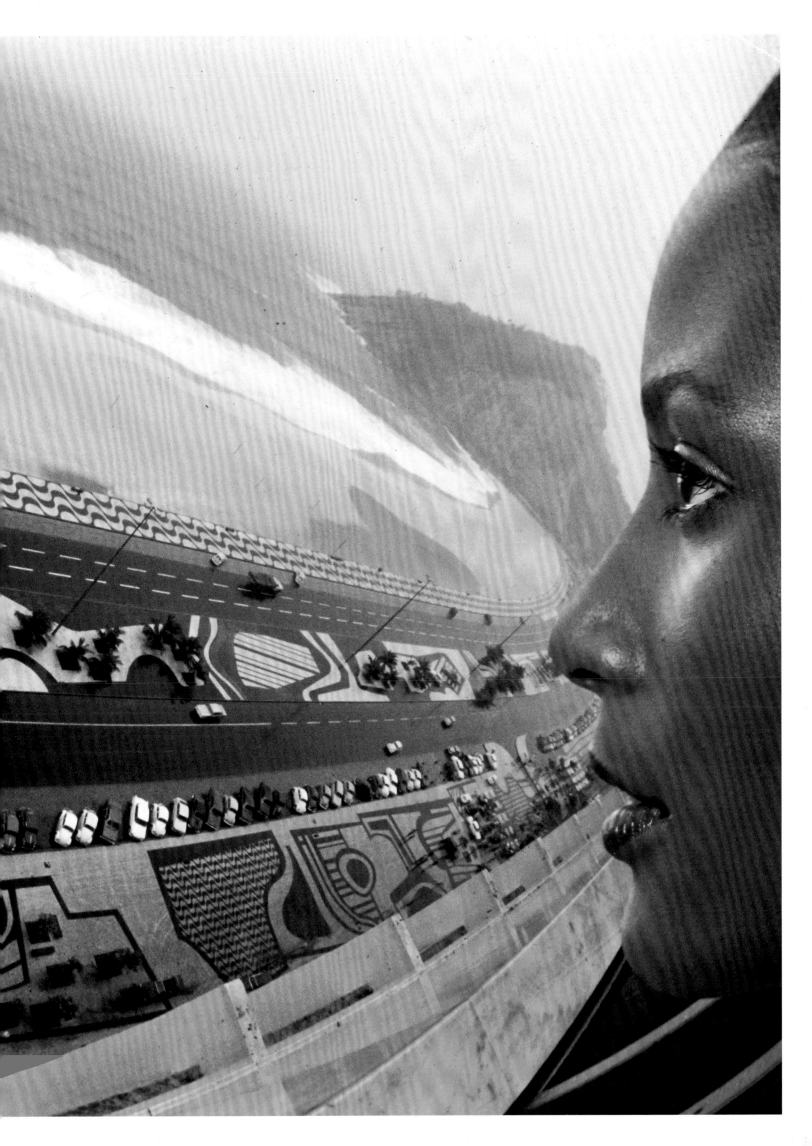

1971

For the living room of Wenda and Norman Parkinson's Tobago home, the couple asked artist Kenneth Partridge to create a sliding wall of multicolored plastic to filter the harsh afternoon sun, a popular—and playful—design tactic in the West Indies.

Photographed by Norman Parkinson, January 1971

1974

Near the town of La Romana,
an hour's drive from Santo
Domingo in the Dominican
Republic, Oscar de la Renta
sets a table for an alfresco
lunch at his island home.

*Photographed by Horst P. Horst,
January 1974*

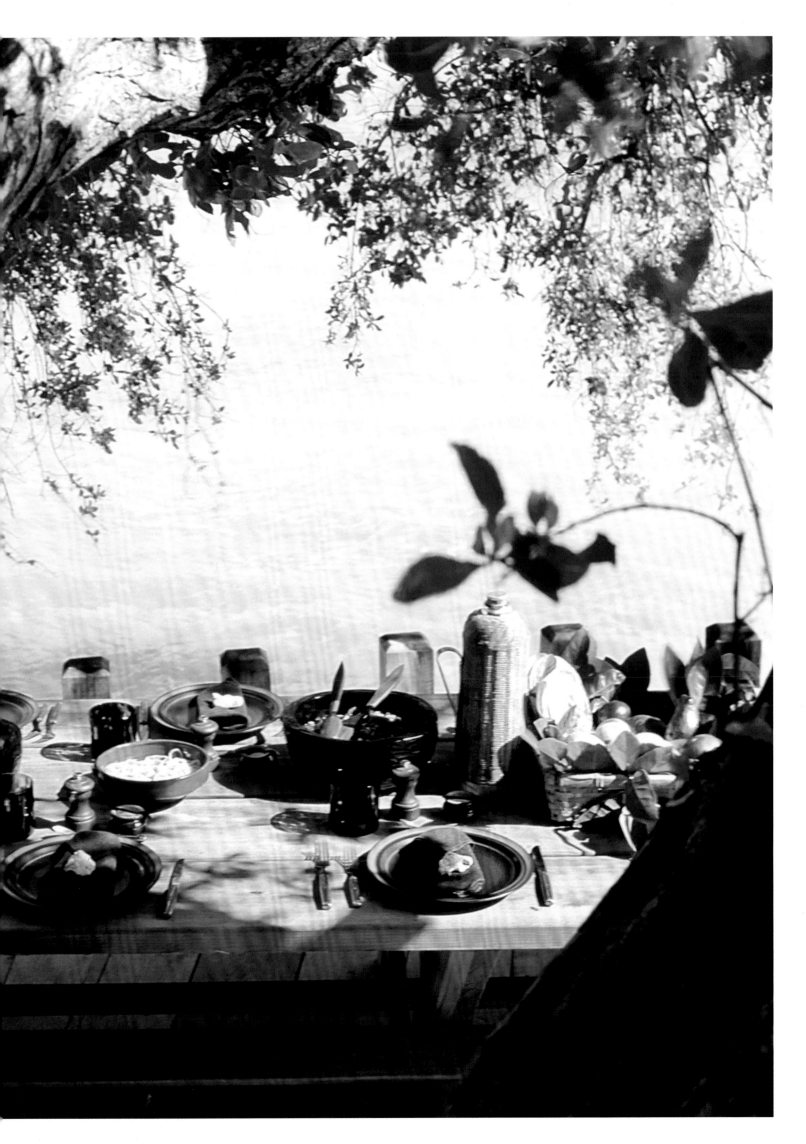

1974

Vogue's famous "Hawaii: Adventures in Sundressing" shoot, set on Maui. OPPOSITE PAGE: Cheryl Tiegs cools off on Kaanapali Beach. FOLLOWING PAGES: Rene Russo and a male model splash around on Fleming Beach. Tiegs swoons over the sunset and dances on the edge of Haleakalā Crater.

Photographed by Helmut Newton, December 1974

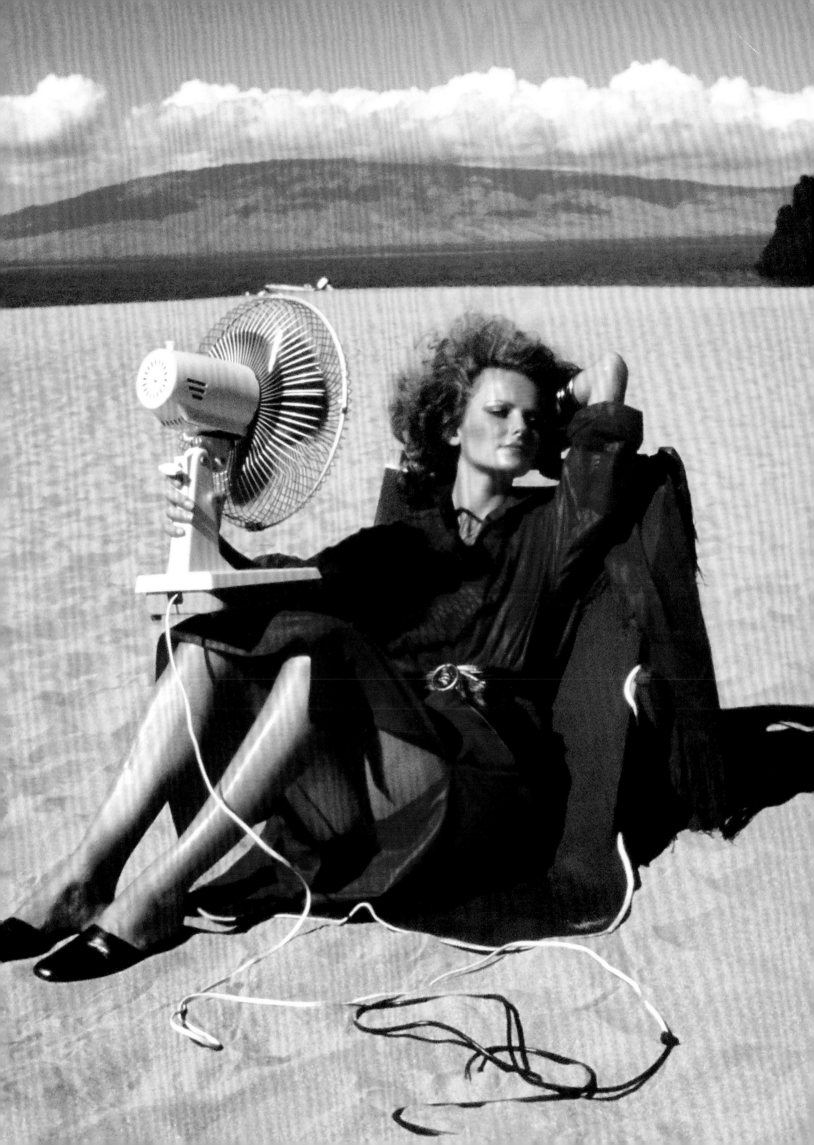

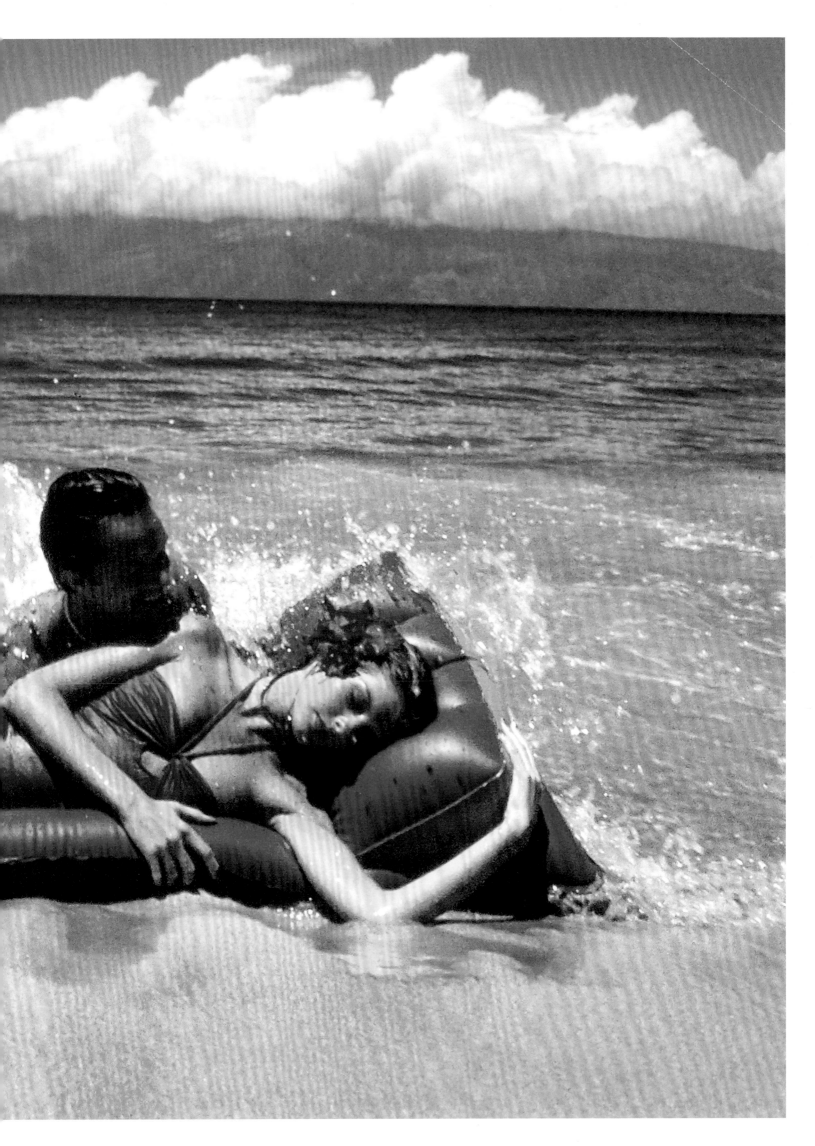

THE MAGIC OF HAWAII is so potent, it probably should be rationed. First-time visitors as well as repeaters and returning islanders succumb the moment they step off the plane to the first brush of delicious air. It's an instant shift to low speed; it unravels tangled nerves. Hawaii's effect takes hold as the plane circles over Diamond Head, Honolulu's green, sphinx-shaped landmark in the Pacific; flies over the green volcanic crater Punchbowl; banks over Hawaii's striking new state capitol; cruises along Waikiki's span of beach, marinas, hotels; and, before touching down, skims over Pearl Harbor, that historied Pacific shelter.

"It's like an airborne solarium," said one passenger about his United Air Lines flight from New York to Honolulu. On this ten-hour nonstop stretch flying in sunshine, the light grows stronger as the plane heads west. Sunbeams bounce off china, silver, glasses. (Sunglasses, of course.)

South Pacific food and drink go on these long hauls—New York to the West Coast and on to Hawaii: drinks made with tropical fruit juices; Hawaiian abalone and salmon; pineapple boats piled with other fresh fruits; Macadamia-nut sauces; coconut puddings. Bacon and eggs with an orchid, a habit to Hawaiians, startles the neophytes, especially the French.

DESPINA MESSINESI, 1972
ABOARD AN AIRBORNE SOLARIUM TO HAWAII

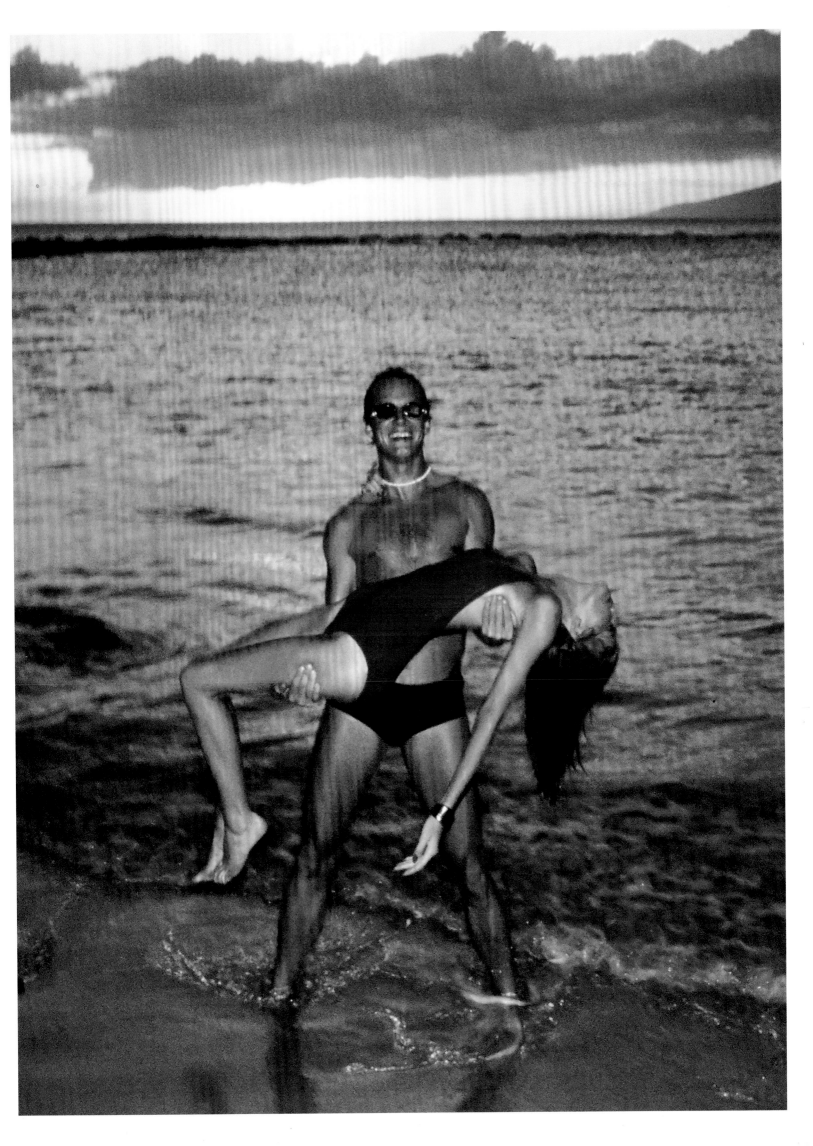

1987

"I garden out of enthusiasm," Maryll Lanvin told *Vogue*. "The passion takes hold of me, I work and work, and suddenly it's done, as if all at once." THIS PAGE: An 18th-century sphinx in the allée of Lanvin's Île de France garden. FOLLOWING PAGES: A pavilion surrounded by flowers in bloom.

Photographed by Jacques Dirand, December 1987

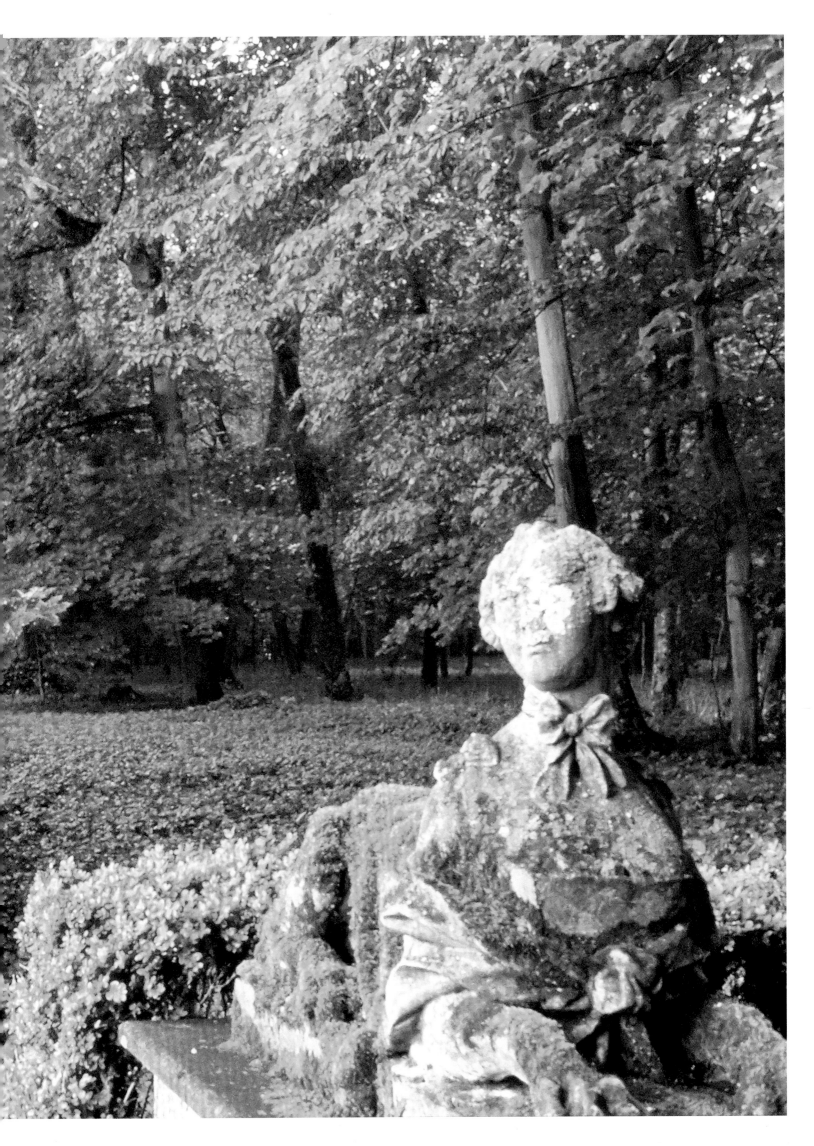

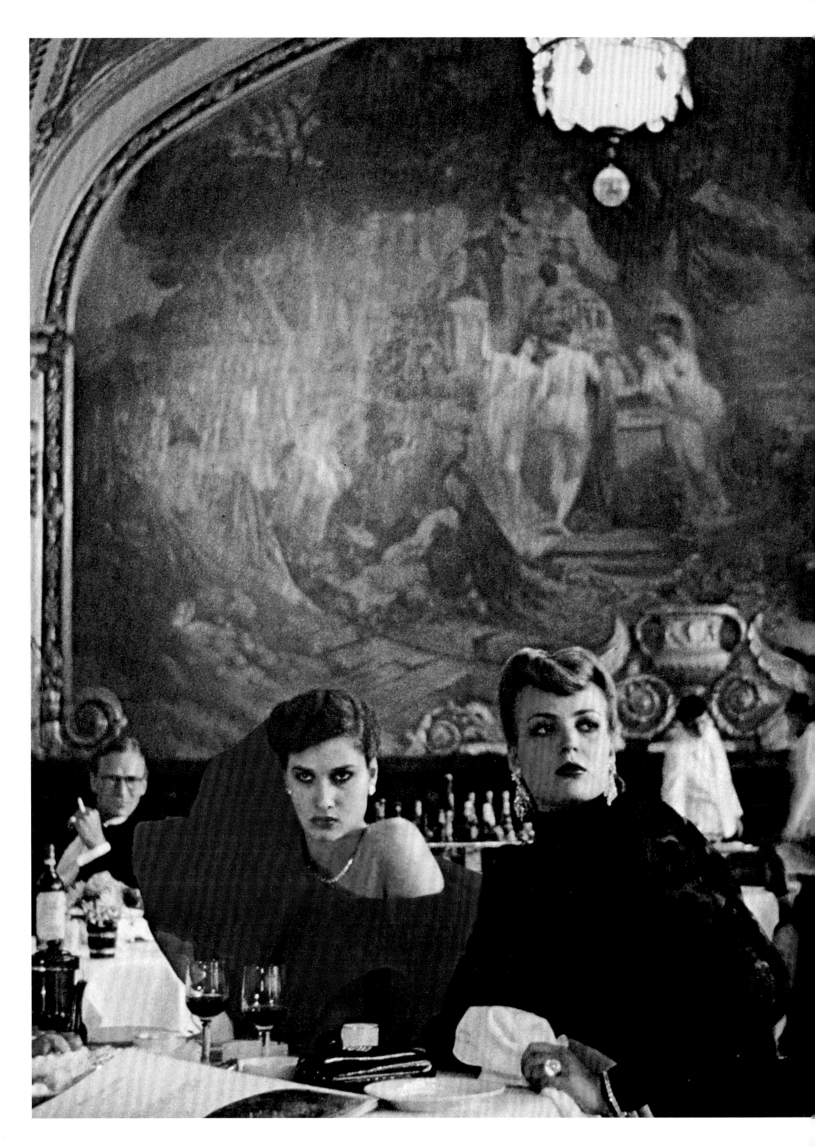

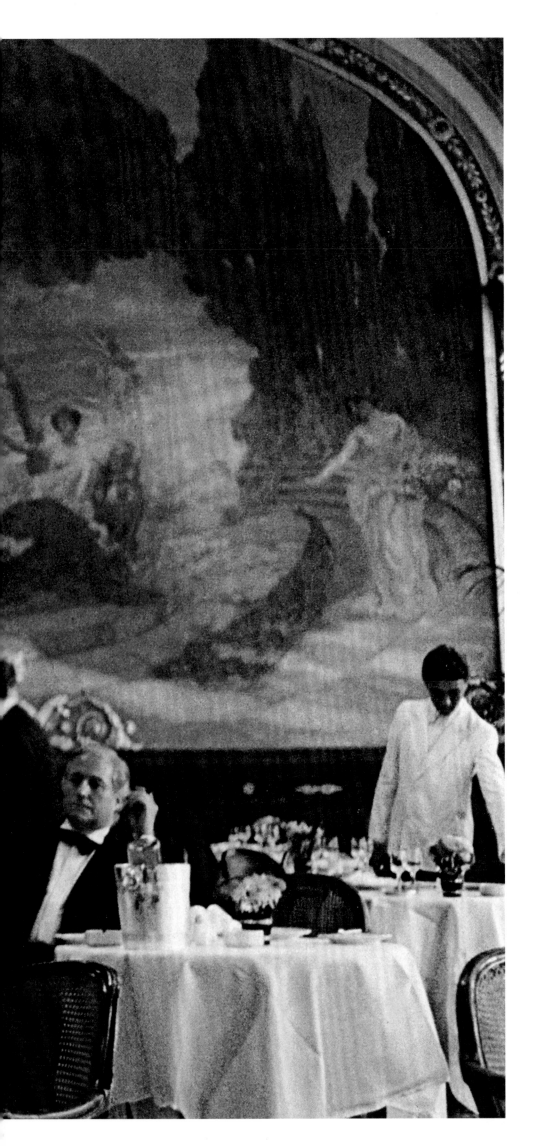

1979

"The Empress Eugénie visited," wrote Joan Juliet Buck of Monte Carlo, "the Prince of Wales couldn't keep away, Emperor Franz Josef kept his mistress there while staying at Cap Martin with his wife. Karl Marx came for his lungs and made snide remarks." THIS PAGE: Models Rosemary McGrotha and Eva Wallen dine at the Hôtel de Paris Monte-Carlo. FOLLOWING PAGES: The pair recline on the beach. McGrotha keeps company with scantily clad sun worshippers.

Photographed by Helmut Newton, December 1979

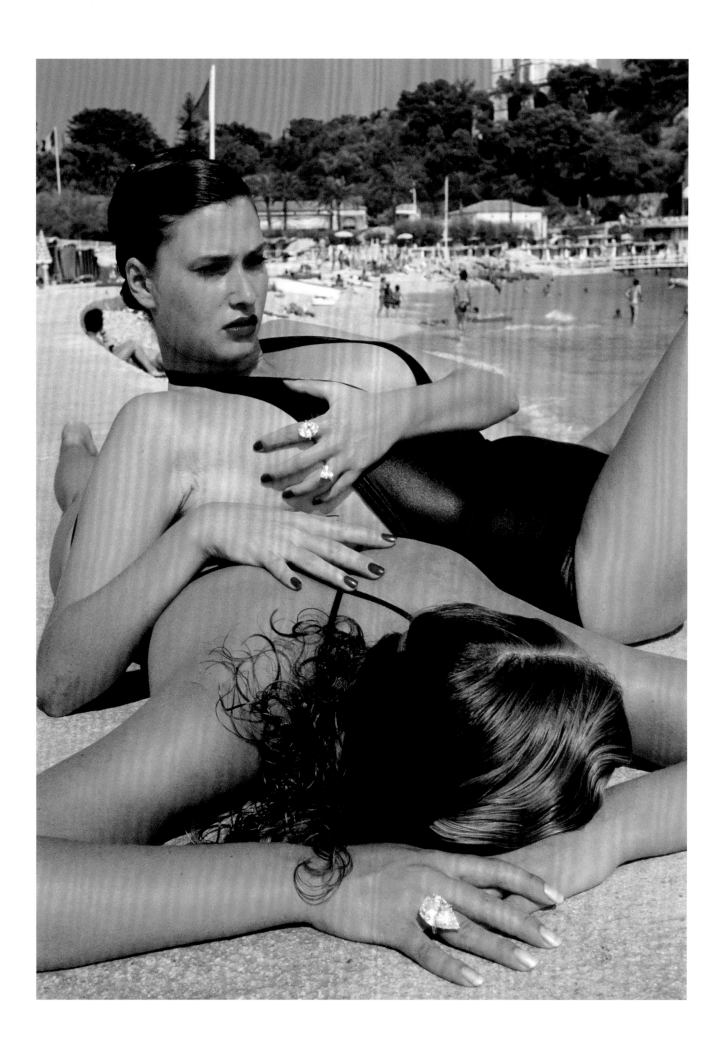

MONTE CARLO IS A ROCK. The skyline is rocky with crags, granite jutting up behind the glass and concrete skyscrapers, a phalanx of prisms shooting up like hurried crystals. Even the beach is rocky: made up of smooth grey pebbles, silky to the touch, but unyielding to bare feet....It's a fortress, where money and those who have it are guarded by a huge force of policemen, both uniformed and disguised. It is a Rock of Gibraltar in these unsure times for people whose holdings include not only land and real estate, but the fruits of geological time: metals, gold, and the substance transmuted by time into oil from the flesh and bones of dead dinosaurs. There are dangers at the gates: taxes to the north and west, violent death at the hands of the Red Brigades to the south, Communism to the east. But nothing can touch Monte Carlo, for it is devoted not to the changing forms of society, but to the one constant, the core of all serious activity: money. There is a certain *gravitas* in this vocation, a necessity to keep oneself above reproach; a sternness in dealing with imposters, con men, lightweights. Monte Carlo has existed a little over a hundred years; it could continue for thousands of years, like the Christian church. Like a rock of ages.

JOAN JULIET BUCK, 1979 TO CATCH A DIAMOND...

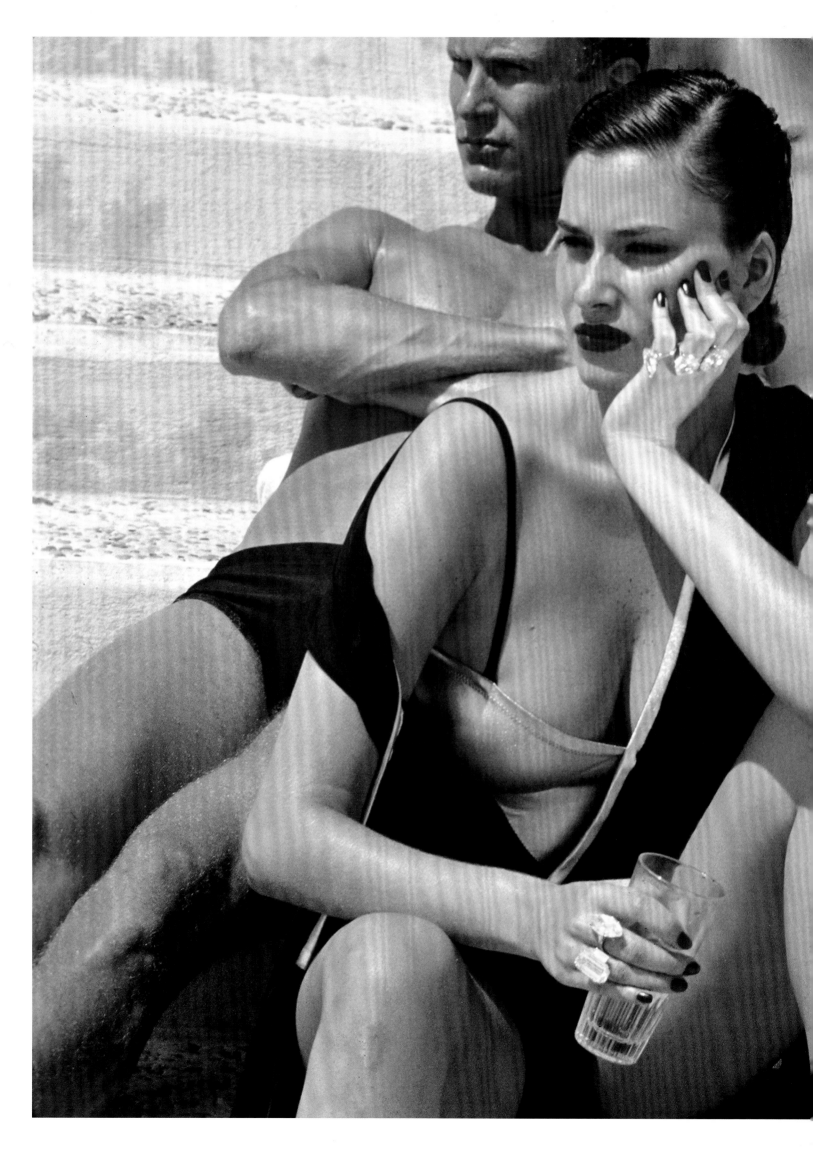

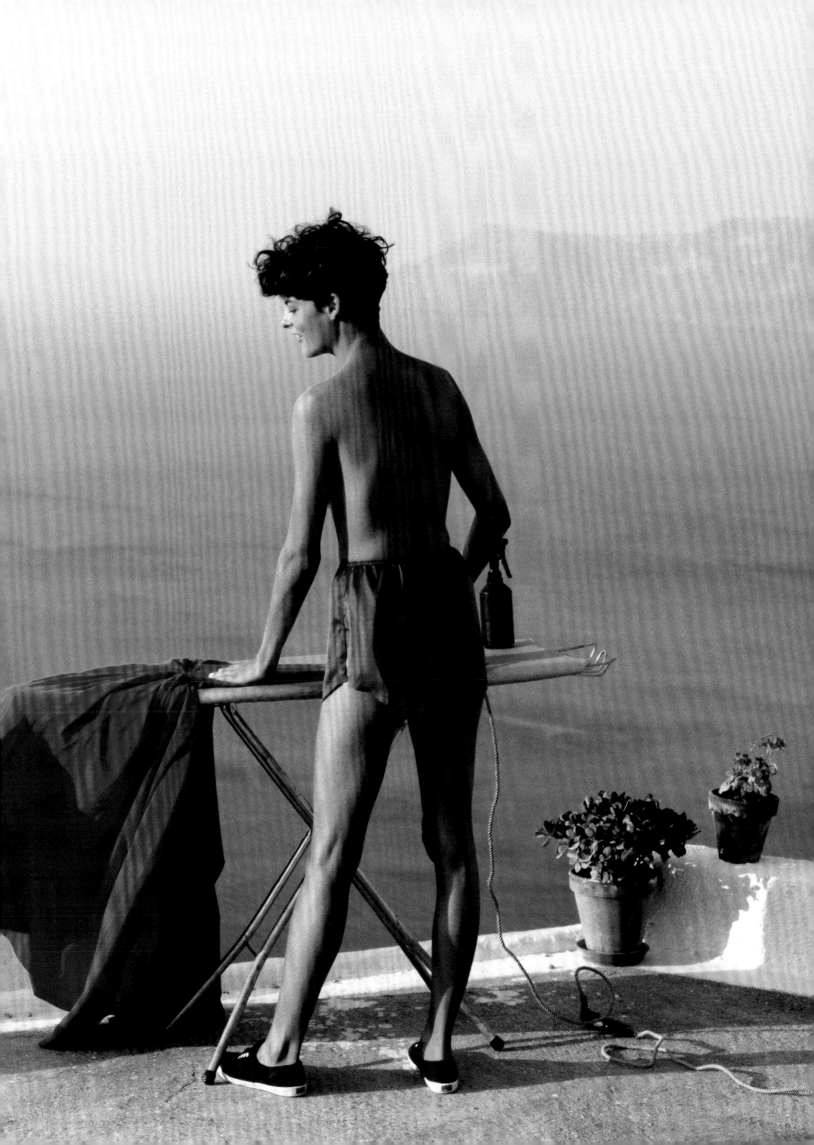

1988

For this Santorini-set shoot, Linda Evangelista and Carré Otis cavorted through whitewashed alleys. THIS PAGE: Otis with a local woman. PREVIOUS PAGES: Evangelista irons in front of the Atlantis Villas. FOLLOWING PAGE: Evangelista converses on cobblestone streets.

Photographed by Peter Lindbergh, December 1988

YOU COME FOR THE SUN—white, strong but somehow forgiving, for limitless blue sky and sea. For history and culture and human thought because, should you happen to care, those things pretty much began here, survived here, and have been fought for still in our lifetime. Because once gods here were close enough (and human enough) to be called by name.

KATHLEEN MADDEN, 1983
SAILING THE GREEK ISLES—THE FEELING IS FREEDOM

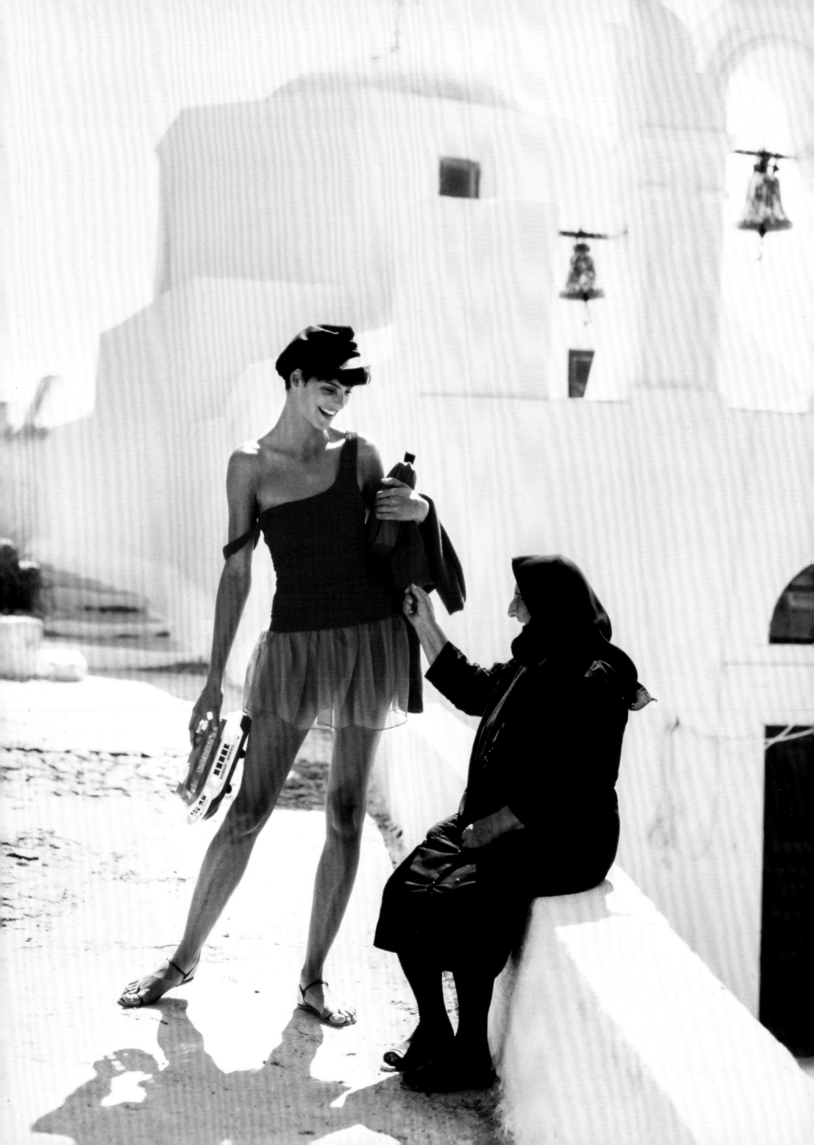

1980

Behind a walled garden
in Marrakesh, Yves Saint
Laurent's retreat, Dar Es
Saada, is a Moroccan oasis.
THIS PAGE: The designer relaxes
in his alfresco living space.
FOLLOWING PAGES: The home's
limestone and stucco exterior.
A covered terrace overlooks
a water-lily pond.

Photographed by Horst P. Horst,
August 1980

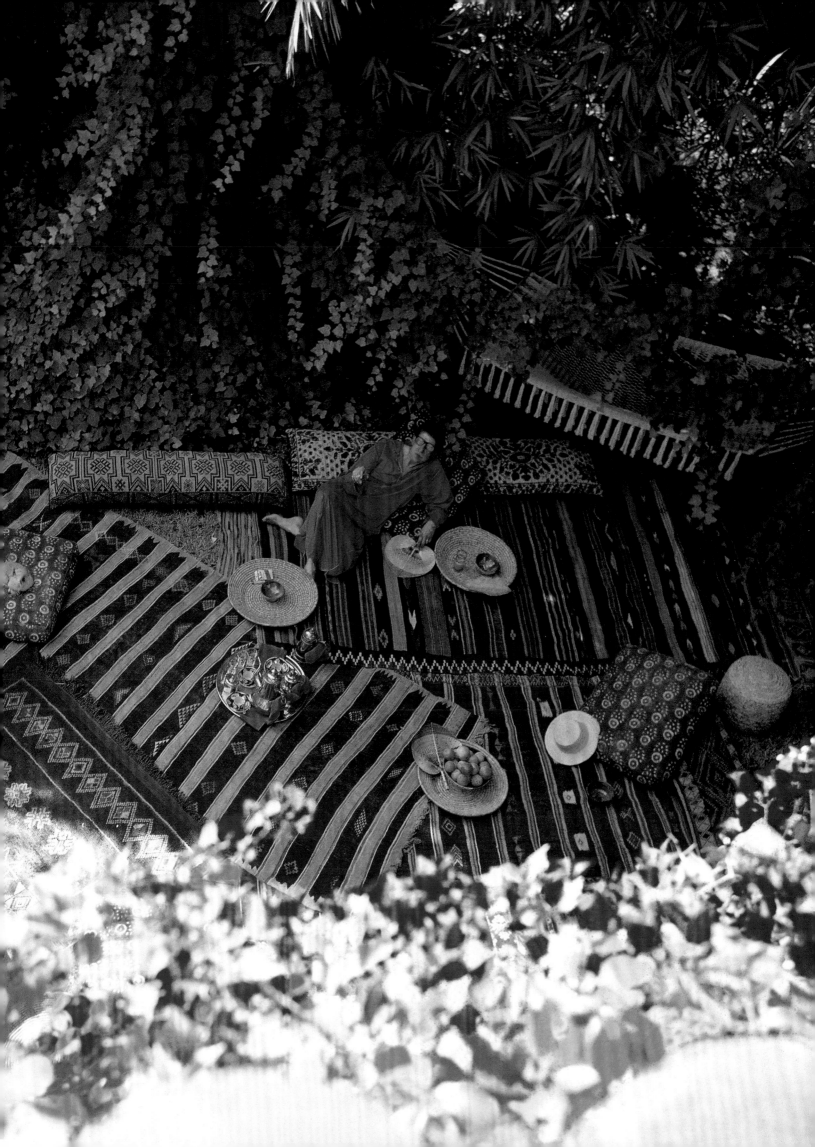

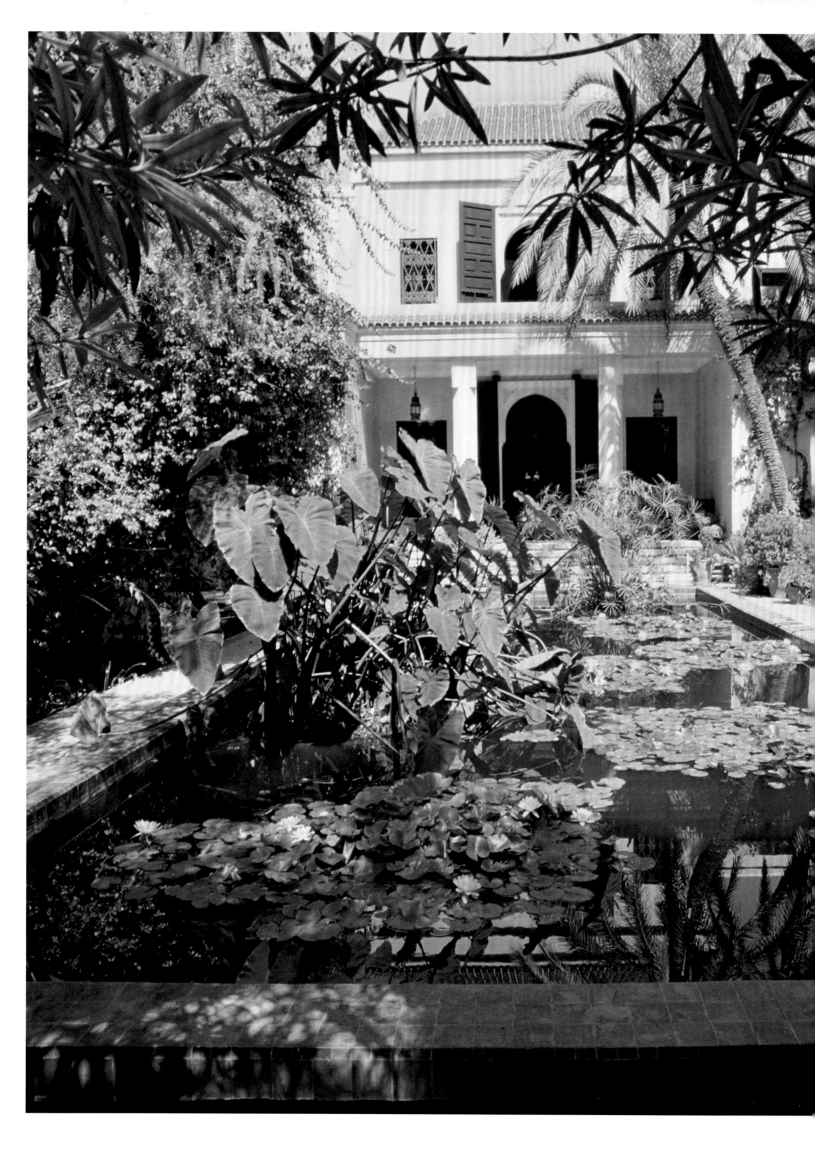

TO VISIT YVES SAINT LAURENT in the pink city of Marrakesh, you ask your driver to take you to "the house of happiness," in the quarter called "Serenity." (Dar Es Saada and La Zahia in Arabic.) Behind a high wall are a house and gardens laid out with a gentle order.

It's also very French, Cartesian, this geometry of vistas—of mini-vistas: in the way rooms of Saint Laurent's house give on to other rooms, and the garden path, for example, that leads to a vine-covered kiosk where Saint Laurent and Pierre Bergé, his partner in life and business, take mint tea on Oriental rugs, waited on by boys in harem pants. But there's nothing like a poor-man's Versailles here, just a spine of order; and the hedonism, if luxurious, is without pomp. Dar Es Saada is neither a French palace nor a local, Arab one. "The last thing I wanted was a palace," Saint Laurent said, "I'm against ultra-splendor."...

In the evening, Saint Laurent likes to lie on the upstairs terrace counting the shooting stars. By day, the upstairs salon and the library below, where he has a desk of his own design for sketching, are his favorite rooms. If it's not too hot, he and Bergé sit out on the downstairs terrace, facing the garden with its water-lily pond. "On five-dollar chairs," Bergé insists, proudly.

The place, then, is a witty invention, as eclectic as an Yves Saint Laurent collection of clothes, with no pedigree of place and time outside the imagination of Saint Laurent....

"The city is magic," he says, "like Venice, but much more joyful. It's a place of infinite peace, glowing mauve, pink, or violet with the season, and wrapped in blue light."

G.Y. DRYANSKY, 1980
A QUIET SPLENDOR: YSL'S MARRAKESH HOUSE

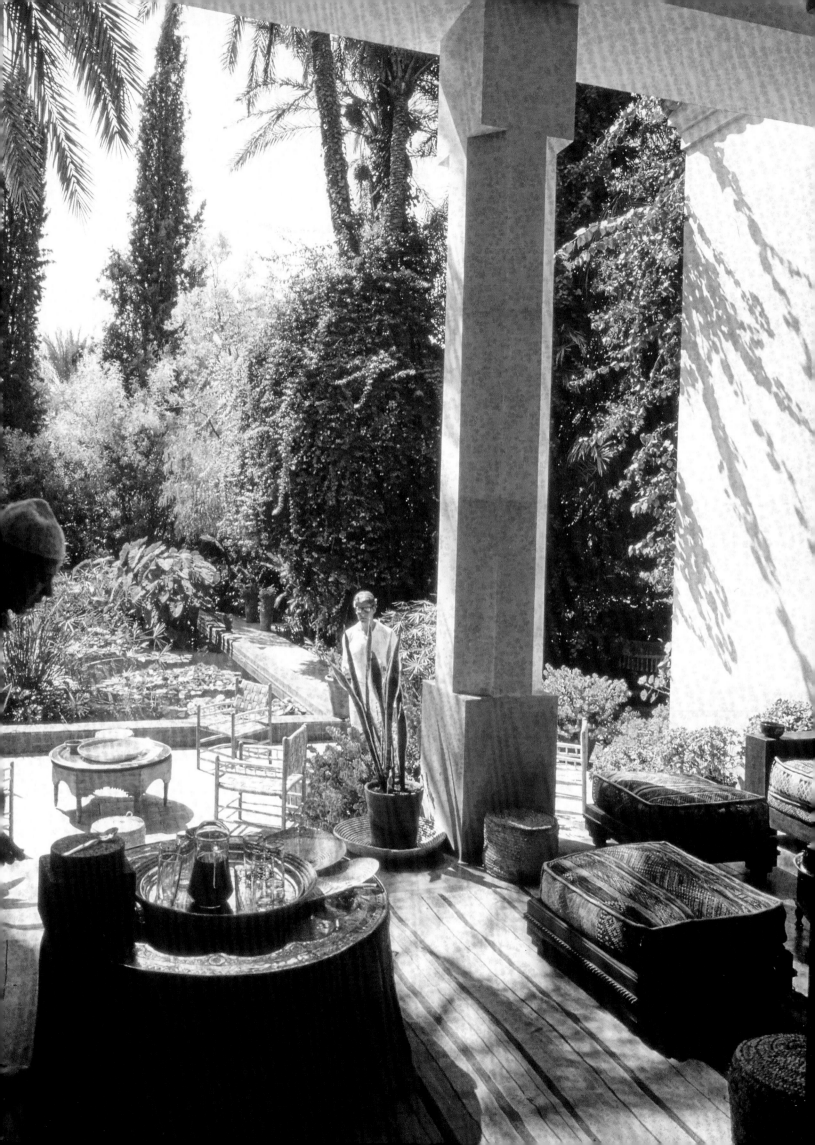

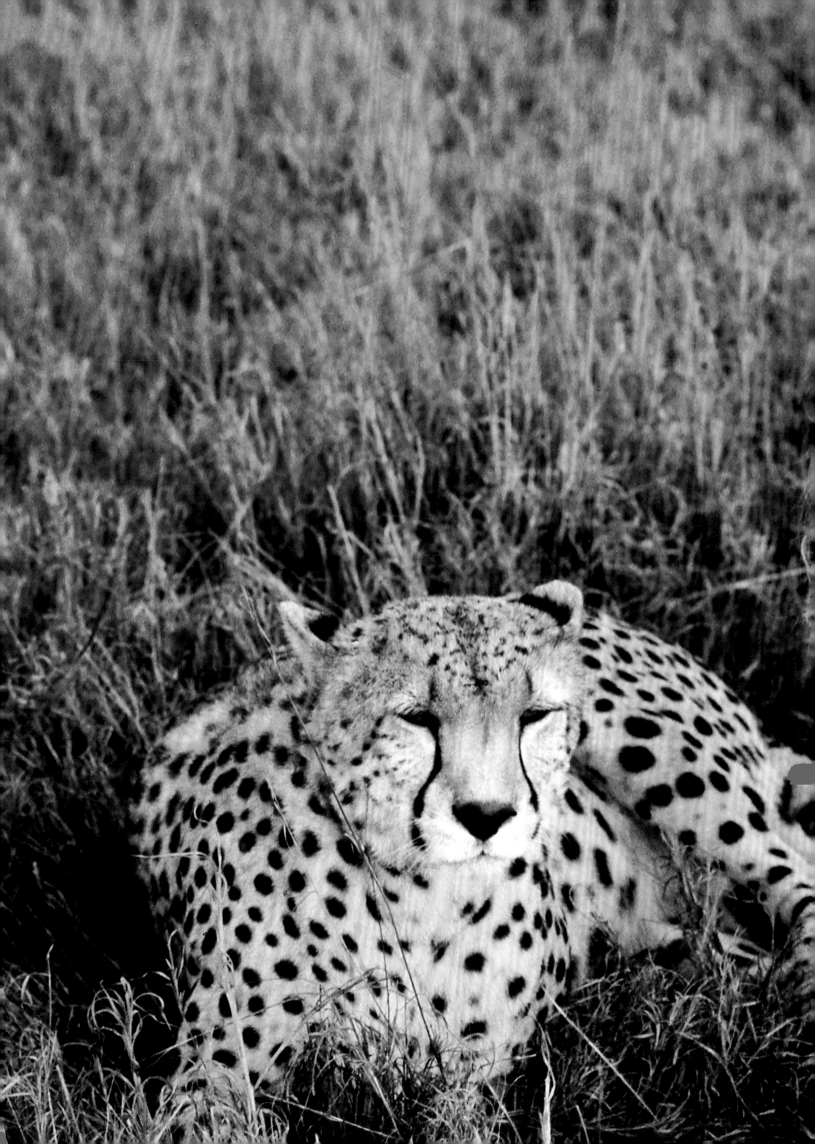

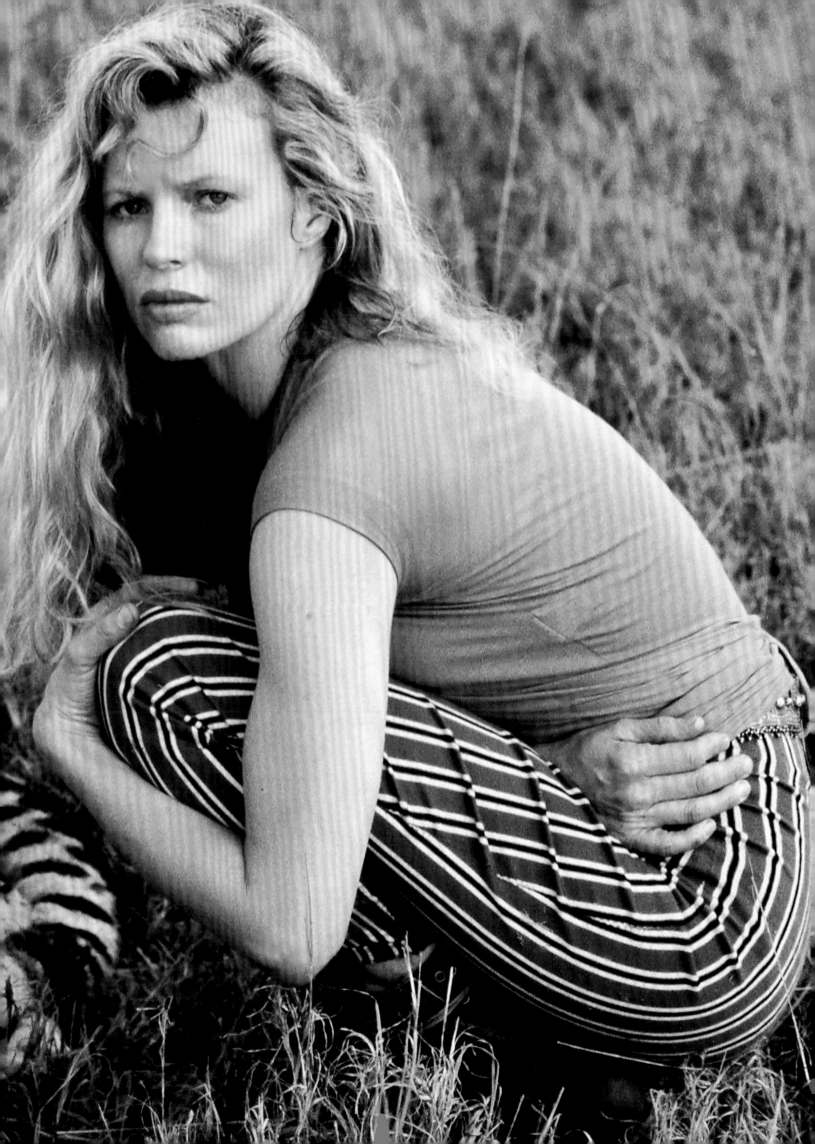

OPPOSITE PAGE: Kim Basinger with a trained peregrine falcon. "The creature is like some precious *objet*; we handle him like a Tiffany lamp," recalled journalist Stephen Drucker, along for the trip. PREVIOUS PAGES: Basinger in the plains of Kenya, posing with a cheetah named Dooms.

Photographed by Sheila Metzner, April 1988

WE'VE COME FROM A DINOSAUR LANDSCAPE to a Rousseau painting, green and fertile and home to huge herds of game. They're strangely peaceful, like animals in a fable, almost on the verge of speaking. Day and night, with great finesse, the animals watch us—from hills and treetops, from bushes and the sky. They seem strong, healthy, and remarkably purposeful: there is nothing quite like the sound of hundreds of animals single-mindedly pulling grass out of the earth.

STEPHEN DRUCKER, 1988 **SOMETHING WILD**

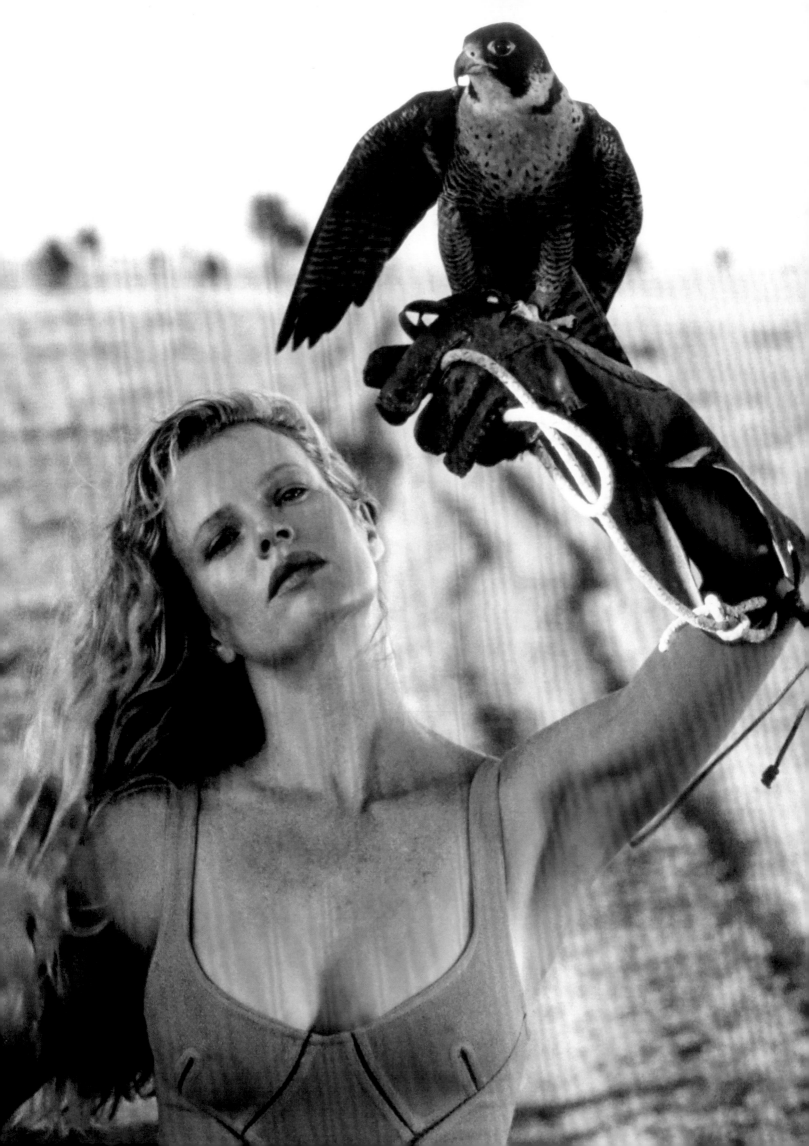

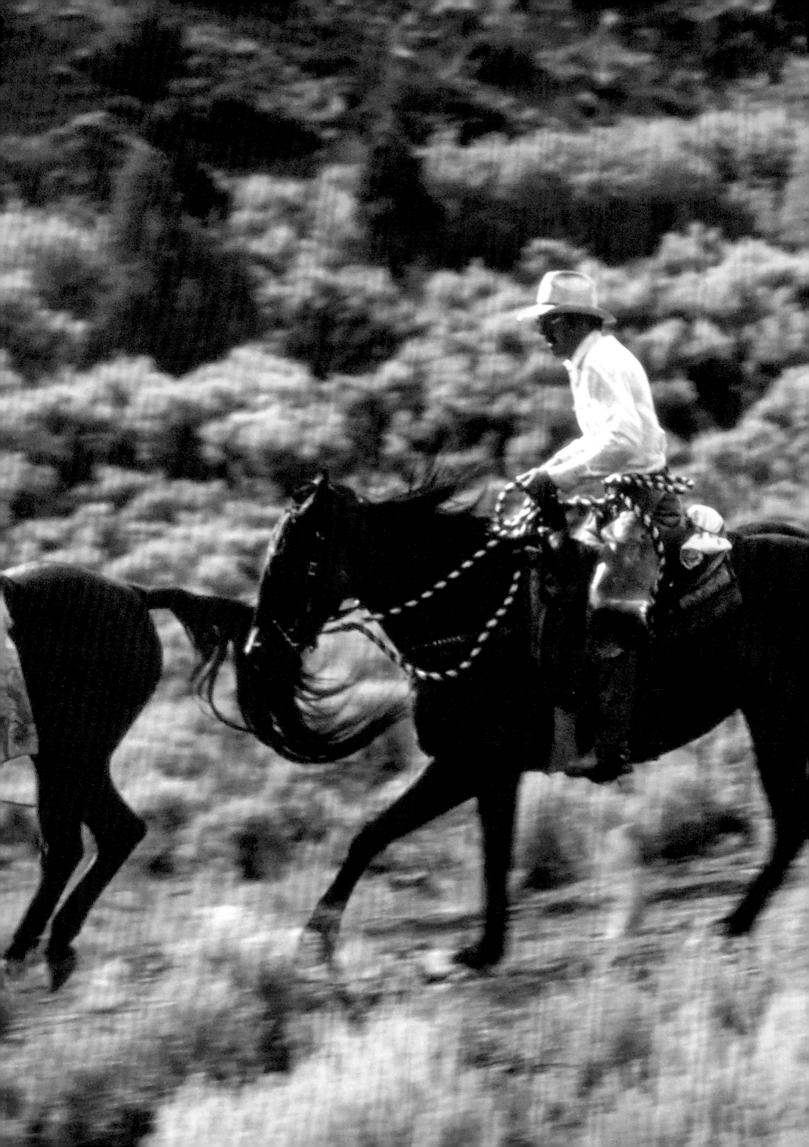

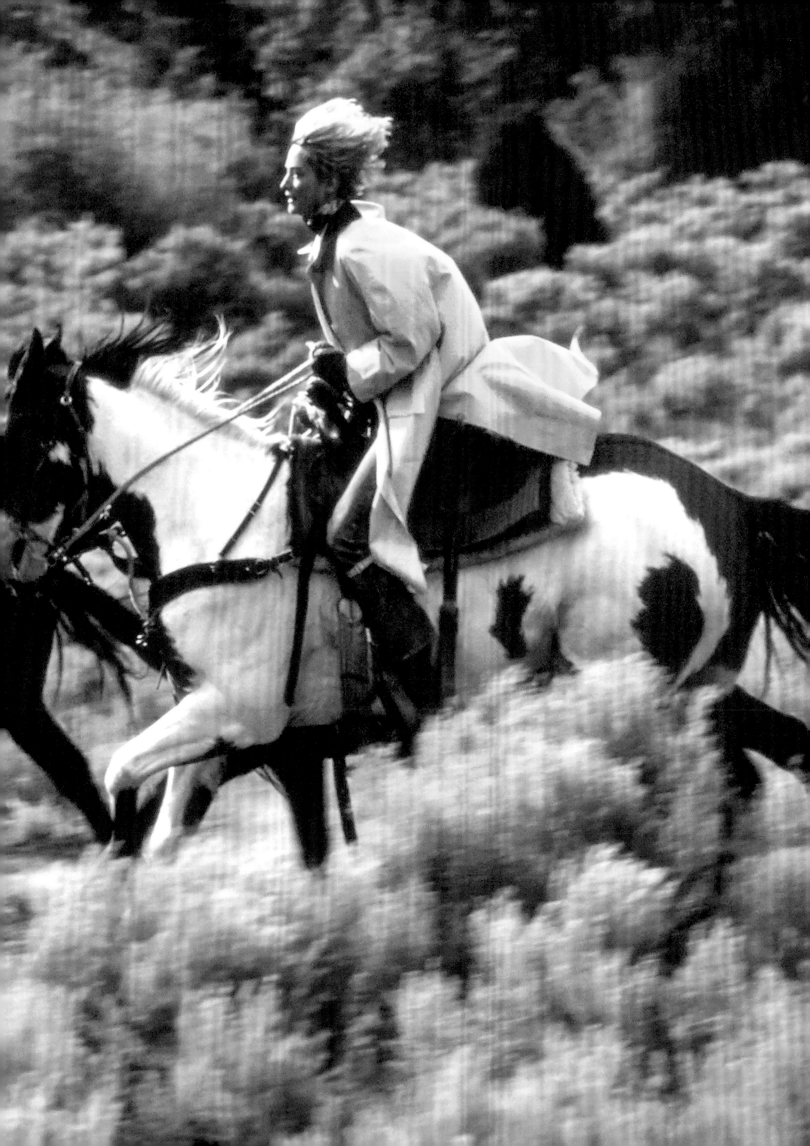

1989

Model Tatjana Patitz went to Wyoming for this showcase of Western design. THIS PAGE: Patitz beside the campfire in a Navajo-print jacket. PREVIOUS PAGES: She gallops through the brush at the Breteche Creek Ranch.

Photographed by Arthur Elgort, October 1989

4

1990 – 1999

The 1990s was a decade of great social change worldwide—from the opening of Vietnam to the aftermath of the fall of the Berlin Wall to the end of apartheid in South Africa. And *Vogue,* now guided by Anna Wintour, who published her first issue as editor-in-chief in November of 1988, was there—documenting these monumental changes not just with correspondents, but also, when politics allowed, with photo shoots that combined fashion and reportage. "I very much like photographs that involve environment and place," Wintour has said. "I like to situate the image, to make thematic shoots and tell stories through a narrative."

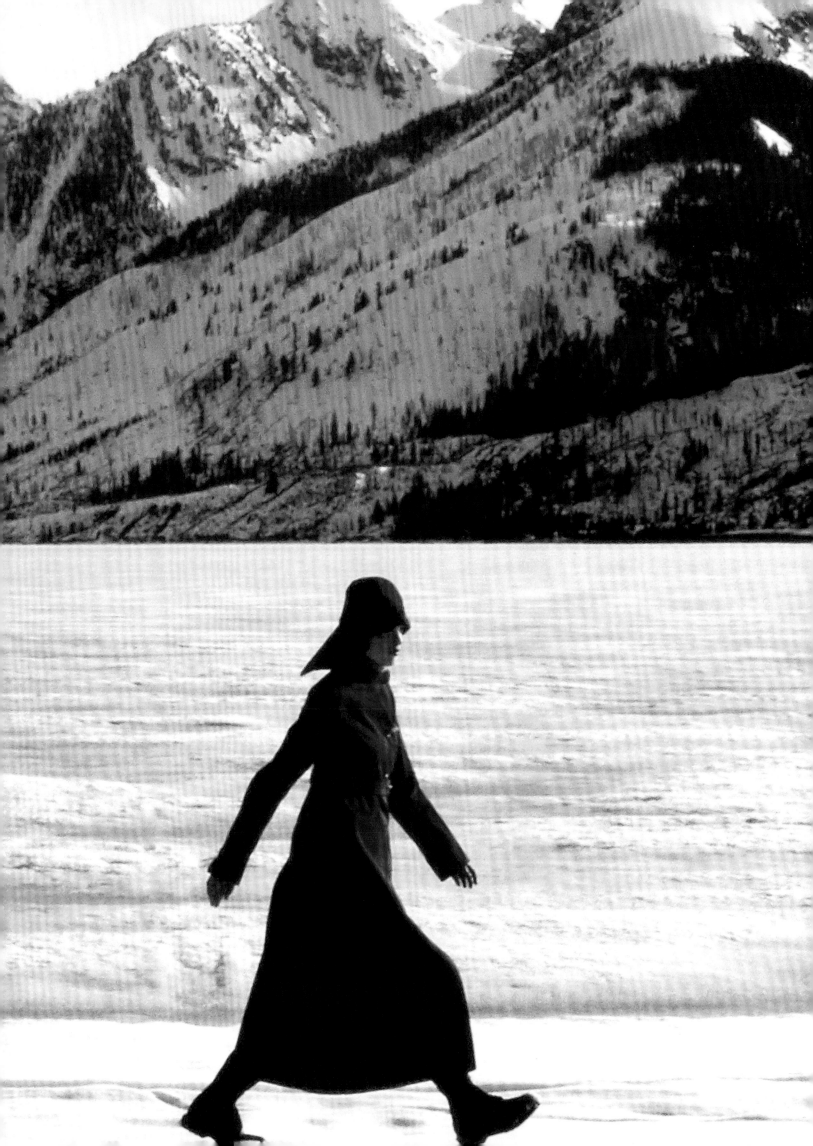

Alongside Wintour, Grace Coddington, who became creative director in 1995, had a profound effect on these narratives—particularly when they were set in far-off places. "A location gives you something to work from," she said. "It gives you a scene. It carries fashion to a place beyond just fashion. It inspires you to try things you might not do at home." Many of Coddington's most memorable shoots were shaped by her collaboration with photographer Arthur Elgort, whom she deemed "bar none, the best photographer to travel with—he keeps his eyes open." His photographs may have a fantastical quality of escape, but they are rooted in the spot in which they're taken: "He's fantastic at showing the reality of a place," she said.

For "Reds" (1990), Coddington and Elgort captured the waning Soviet Union, formulating a plan for Christy Turlington, dressed exclusively in tones that evoked the hammer and sickle, to meet leading journalists, actors, athletes, fashion designers, and dancers. The team stayed at one of the first Moscow properties to be modernized to Western standards: the Savoy Hotel, which despite its upgrade, offered little in the way of culinary variety. The tiny Russian dumplings known as pelmeni—along with plenty of champagne and vodka—provided the primary sustenance for the crew. (Huge tins of clandestine caviar purchased from furtive street vendors as souvenirs never got beyond the airport, seized by knowing customs officials.)

Seismic changes were taking place in China as well, and *Vogue* sent Coddington and Elgort along with Linda Evangelista to take stock of a country that seemed to be making up for the lost time of the Maoist era. The team shot in Shanghai and traveled to the city of Guilin, noted for its proximity to the Li River, backed by China's famed limestone mountains. "We wanted to shoot Linda standing on one of the long, narrow bamboo boats that the fishermen use on the river," Elgort recalled in 2015. "But our guide said absolutely not—it would be too hard for Linda to keep her balance, and the boat might tip over. I remember Linda saying to me, 'May I ask you a question? Will it be a single- or a double-page spread in the magazine?' I said it would be a double, and she said, 'If it's a double, I can stand on that boat.'"

Perhaps because of the reshuffling that was taking place in the world and the optimism that accompanied much of it, there was a palpable sense of joy that permeated many of *Vogue*'s on-location shoots in this era. In 1995, for example, Iman and her rock-star husband David Bowie visited South Africa barely a year after the country's first fully democratic elections. Within the three-minute window he'd been allotted, photographer Bruce Weber was even able to capture an image of Iman with the newly elected Nelson Mandela. "I said a prayer and took the photos," Weber recalled in 2016. "There were people pushing me around, but I held my ground like a rugby player and didn't move, and took the pictures." Elsewhere, Iman, Bowie, and Weber found a nation celebrating freedom—in the jazz clubs, on the beaches, and on the township streets. A similar exuberance came through in "Good Morning, Vietnam,"

1999

Model Karen Elson in the photogenic valley of Jackson, Wyoming. PREVIOUS PAGES, OPPOSITE PAGE, AND FOLLOWING PAGES: Elson traverses the snow-blanketed foothills, totes a sled, keeps company with cowboys, and stays dry on a craggy rock.
Photographed by Arthur Elgort, October 1999

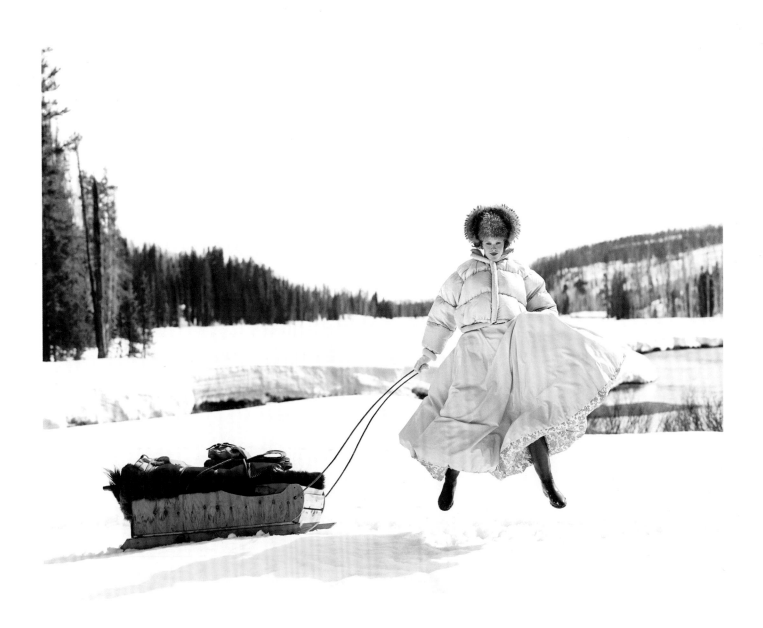

shot by Weber in 1996, just months after the reestablishment of diplomatic relations between the U.S. and its former adversary. This time, Kate Moss was *Vogue*'s goodwill ambassador to the "land of intensely lush landscapes and unexpectedly open people," as the magazine put it, visiting schools, pool halls, and historic French colonial houses. Not just joy, but often humor characterized many of the decade's most famous shoots. "All the Raj" (1999), for instance, featured model Maggie Rizer and Indian actor Rahul Khanna as a fictional couple bouncing across India, from Mumbai (then Bombay) to the Pink City of Jaipur, where they "wed" in a spectacular tribute to Bollywood-style excess.

Sometimes the whimsy came from injecting an unpredictable element into an otherwise familiar location—such as Paris, where Ellen von Unwerth photographed the 1991 couture collections. "Ellen wanted a dog in every picture," Coddington recalled of "Paris Lightens Up" (1991), a portfolio of gorgeously overdressed models, chatting in sidewalk cafés or walking classy pooches through elegant topiary gardens. "We pointed out how difficult it would be to hire so many dogs," Coddington said, "but she said we could just get them off the streets, so we merely grabbed them as they went by." The City of Lights, of course, is arguably *Vogue*'s most frequently used location. "Sit down anywhere and it's a picture," Coddington said. "In Paris, every doorway, every café is a picture." And yet here, as elsewhere in the world, *Vogue* made even the most recognizable scenes appear new.

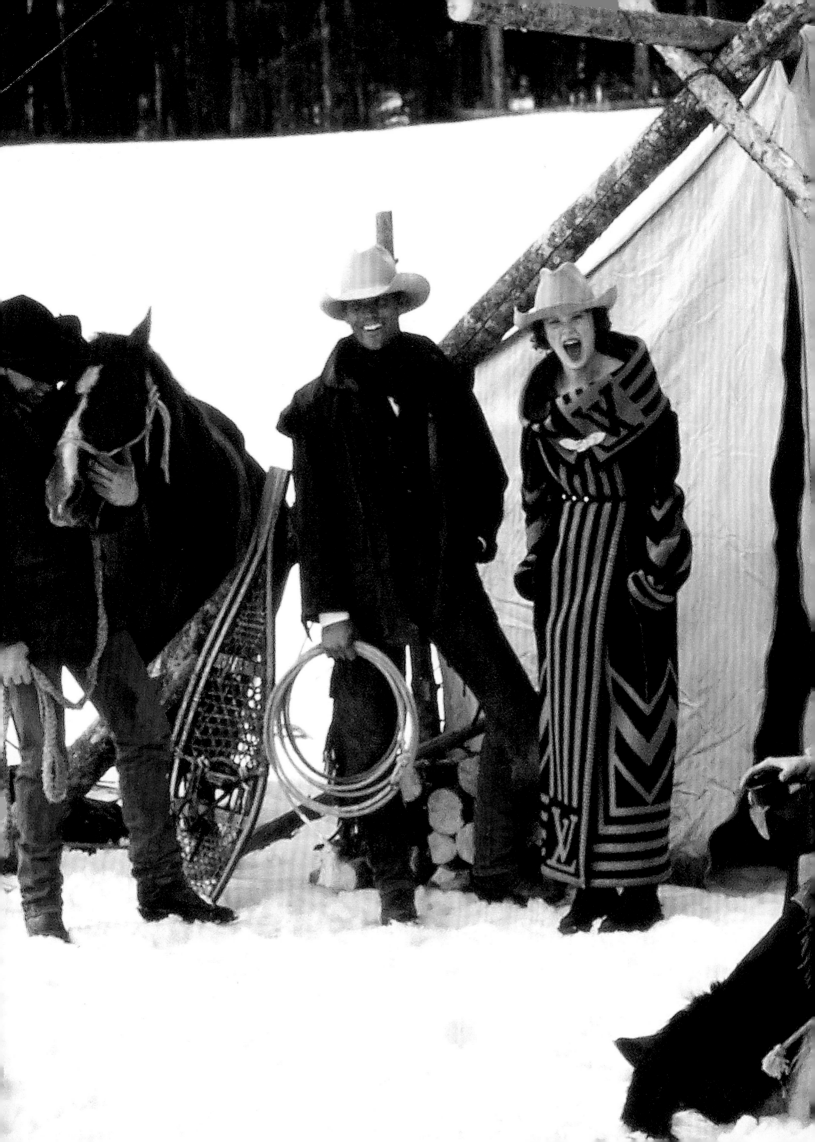

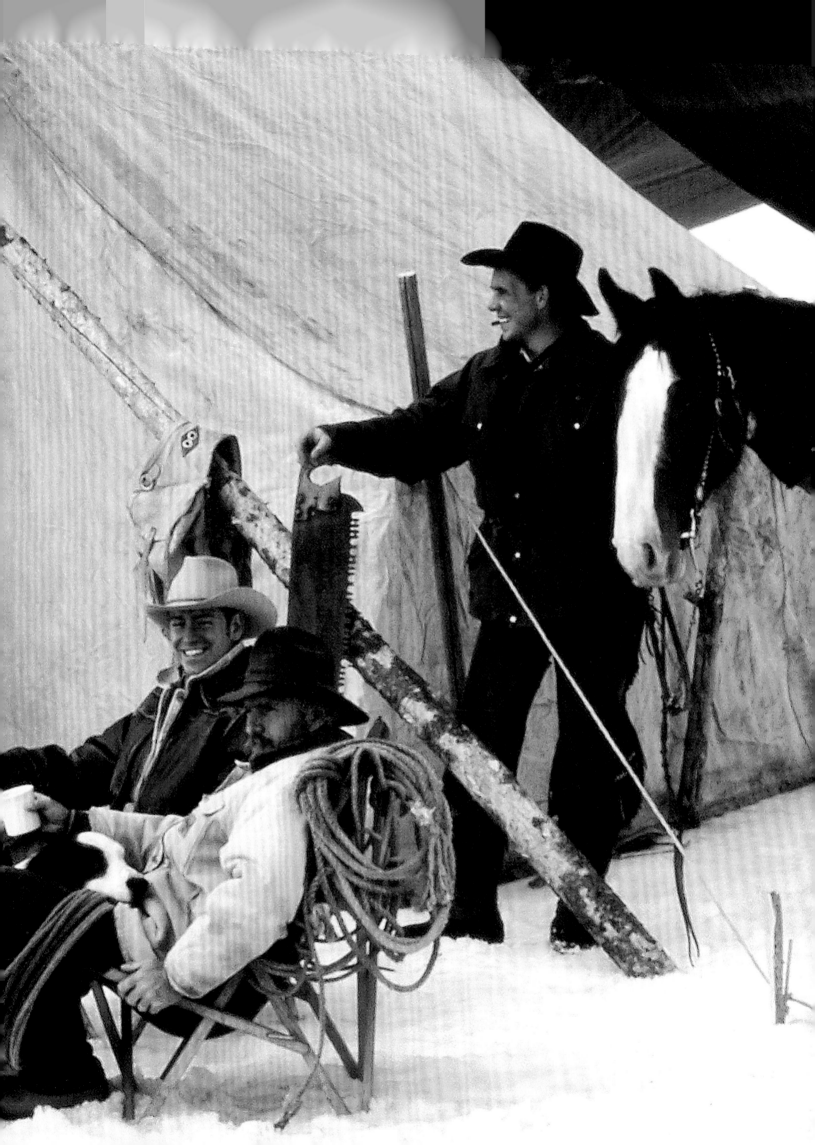

LATE ONE SUNNY AFTERNOON, skiing the steep glades of Evan's Heaven under a dark and juicy blue sky, with Glacier Park a surge of wrinkled granite across the valley before me, I looked west and caught the alpenglow, the sunset that bruises the land orange, bewitching the snow into chaste desert sand. Shadows from the fir trees lapped into the dusk.

TAD FRIEND, 1991 TRAVEL: BIG MOUNTAIN, MONTANA

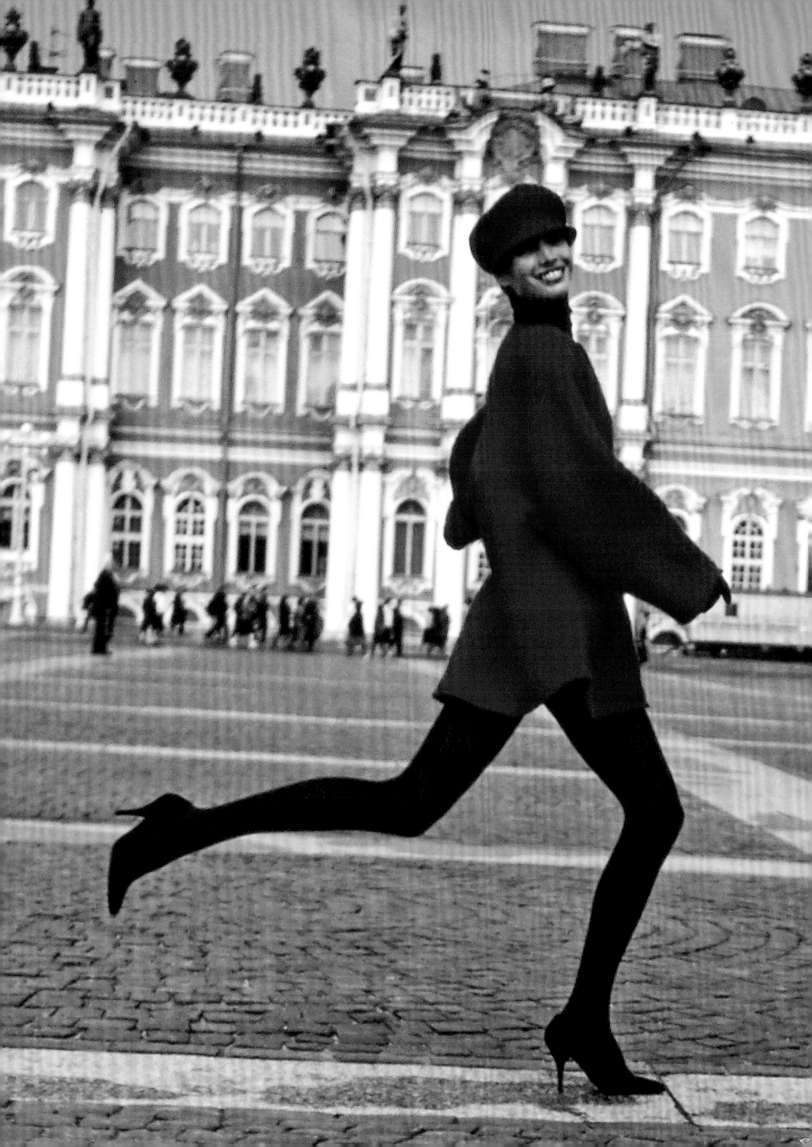

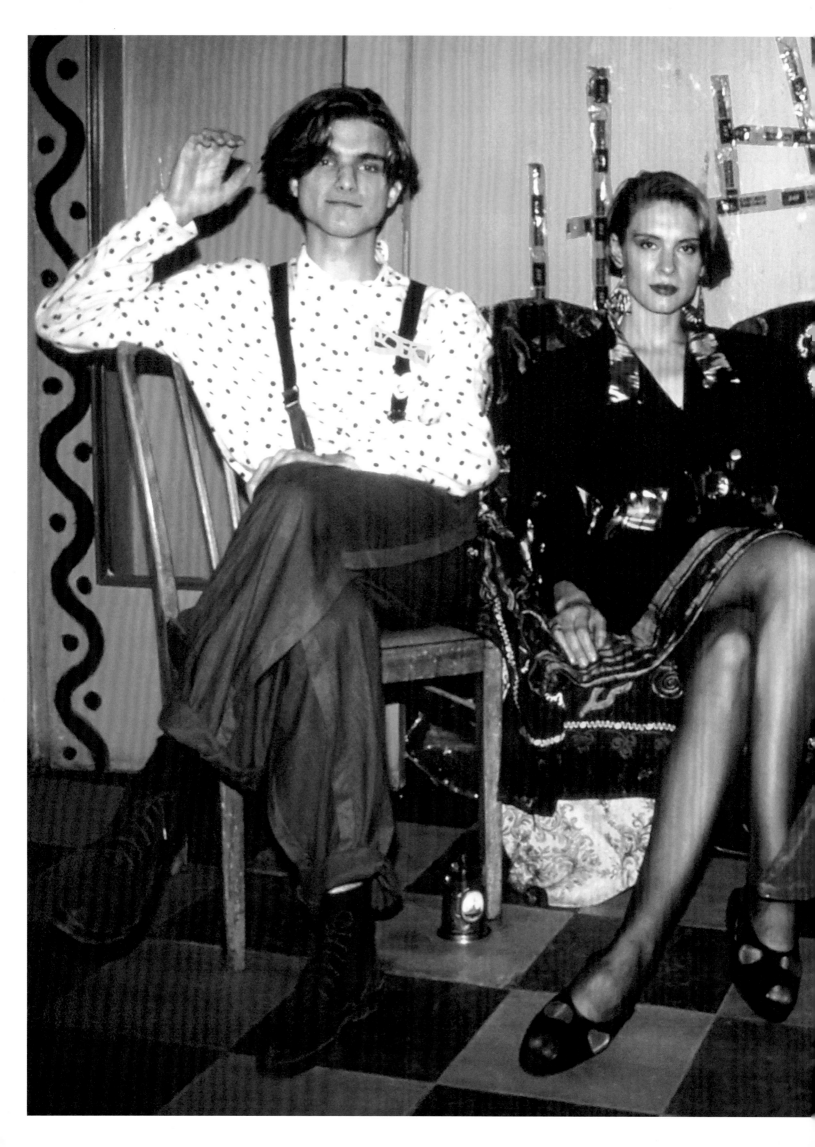

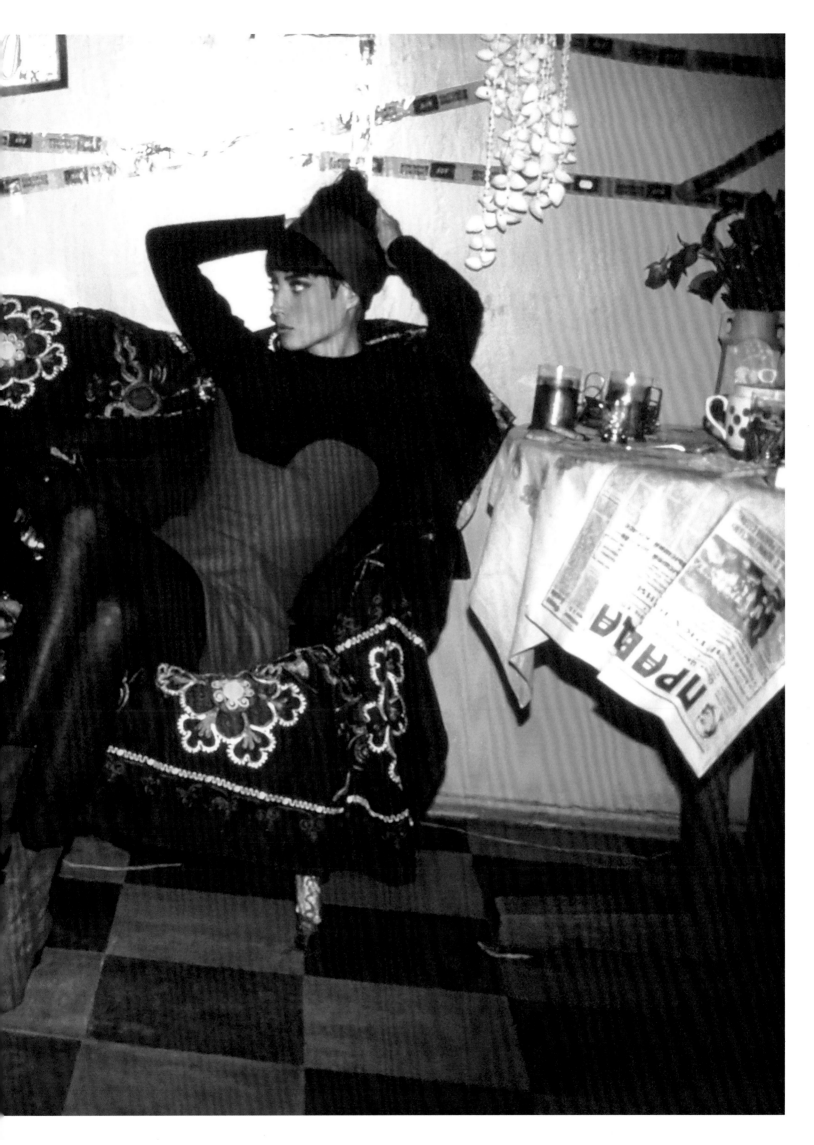

1990

Nearly a year after the fall of the Berlin Wall, *Vogue* set out for Moscow and the city then known as Leningrad. THIS PAGE: Christy Turlington (temporarily) joins the ranks of the Torpedos soccer team. PREVIOUS PAGES: Turlington kicks up her heels in front of the Winter Palace and poses in a bohemian apartment with local artists.

Photographed by Arthur Elgort, September 1990

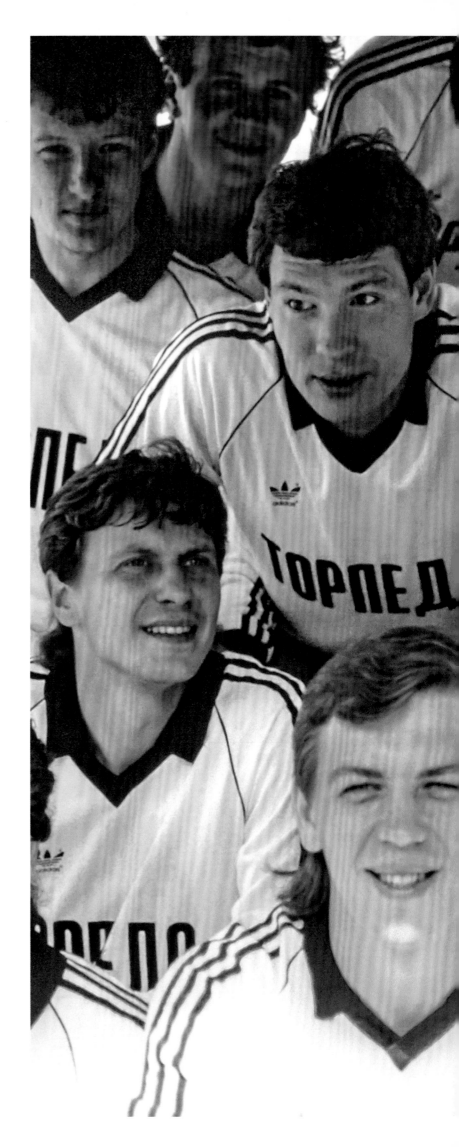

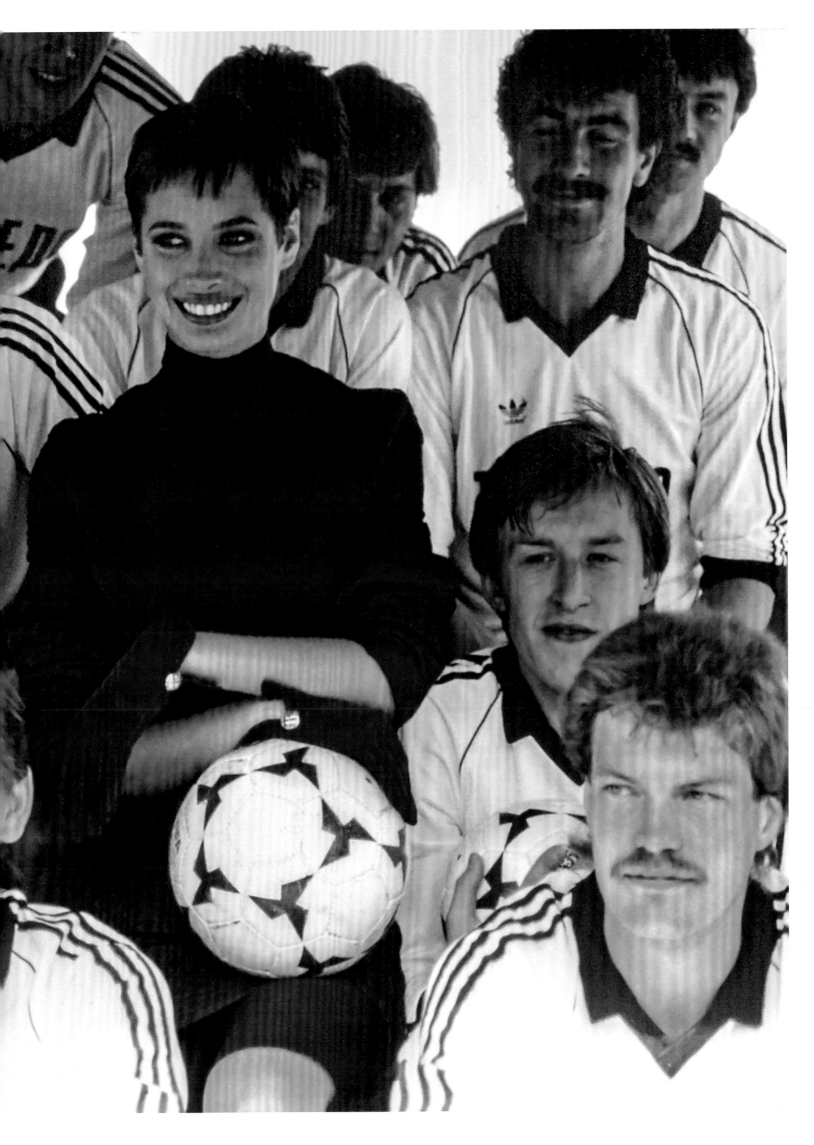

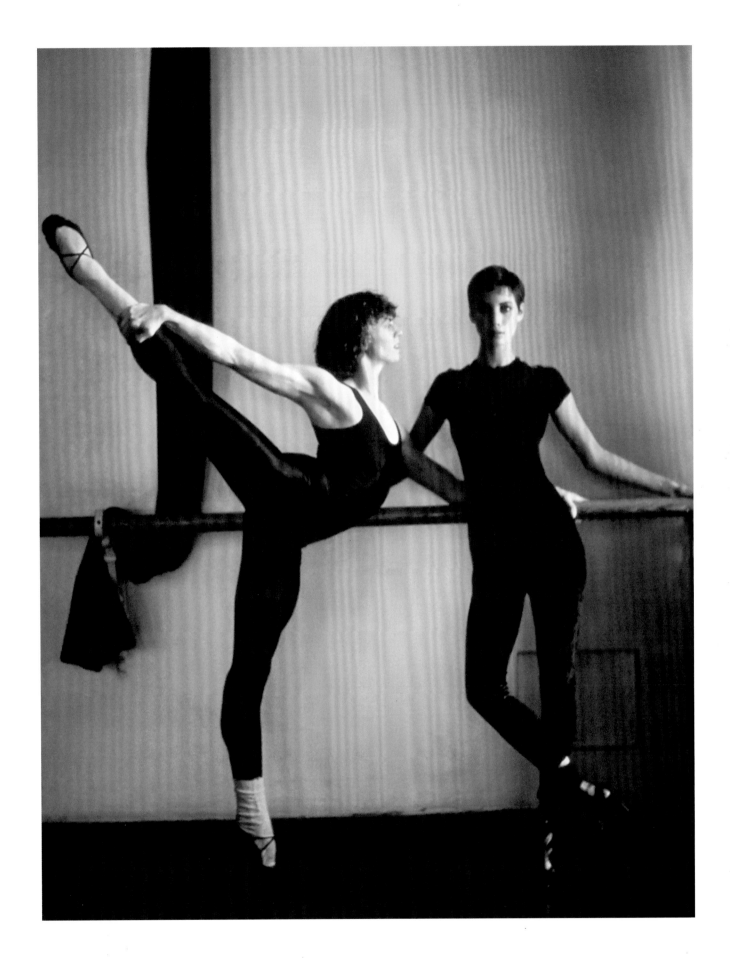

THIS PAGE: Christy Turlington at the barre with Vladimir Malakhov, then a principal wunderkind at the Moscow Classical Ballet.
OPPOSITE PAGE: Turlington with the tiny dancers of the Vaganova Ballet Academy, which gave the world Nijinsky, Nureyev, and Baryshnikov. FOLLOWING PAGE: A couple of colossi at the Little Hermitage Palace in St. Petersburg (then Leningrad).

Photographed by Arthur Elgort, September 1990

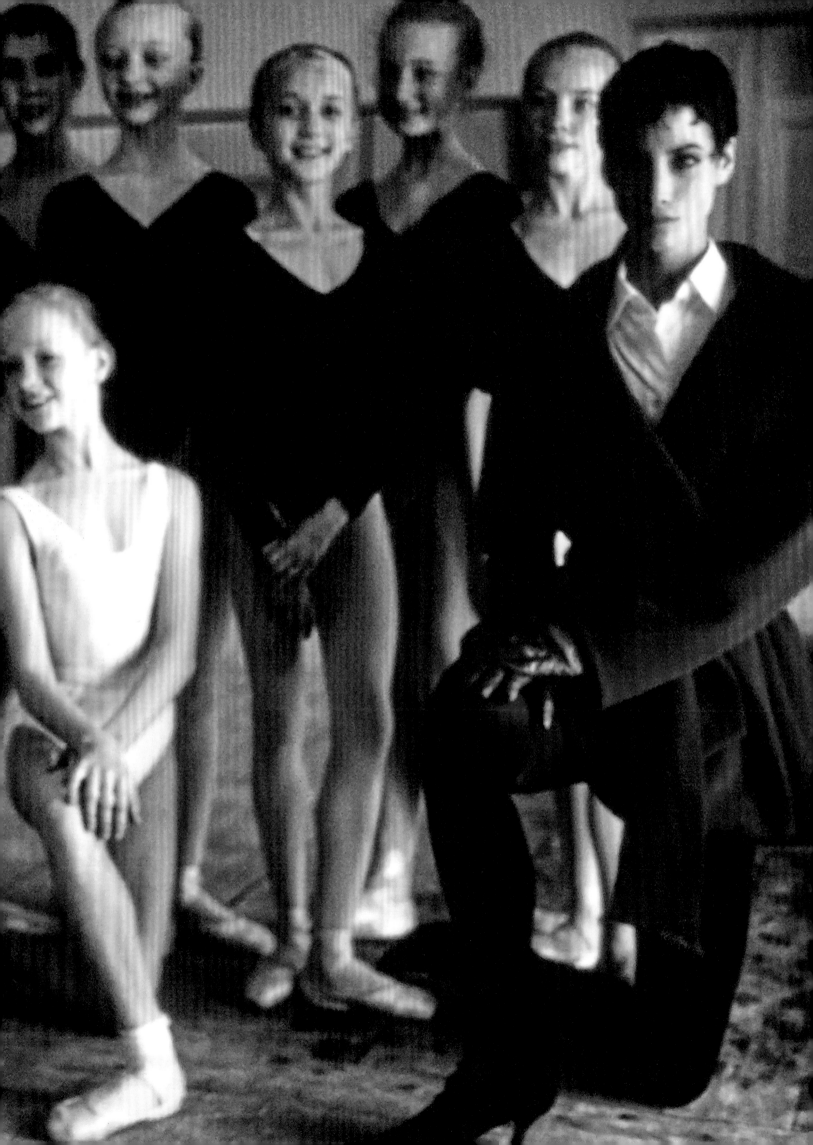

YOU'VE BEEN TOLD TO take chewing gum, Marlboros, dollars, blue jeans, even condoms—to use as currency, tips, bribes. You've been told to take peanut butter, tuna fish, toilet paper, sink stoppers, towels—to survive the hotels, the restaurants. You've been told to expect drab from Moscow, splendor from Leningrad, and the Party line from your Intourist guide. You have visions of the KGB in every corridor, a bug in every wall, because you grew up in the USA in the 1960s and you remember the Berlin Wall going *up*, the Cuban Missile Crisis, *The Spy Who Came in from the Cold*, Prague, Afghanistan. It's hard to shake all that. Glasnost or no, going to the USSR for the first time is still a bit like going behind enemy lines.

So when you arrive at Moscow's Sheremetyevo International Airport, it's somewhat anticlimactic. You breeze through customs, get into your hotel's waiting Volvo, and find that instead of drab, Moscow in late May is lush, green, and blooming with pink, purple, and white lilacs. You're not ready for the architecture either. Granted, there are the massive apartment projects on the outskirts of the city, but as you reach the center of town, Moscow becomes a pastel hodgepodge of Greek-temple palaces, exotic Russian imperial-style fortresses, and wonderfully eclectic Art Nouveau....And by the time you come up on Red Square and get that first flash of St. Basil's, with its intense polychrome onion domes, you think you've died and gone to Disneyland.

RICHARD ALLEMAN, 1990 **REDS**

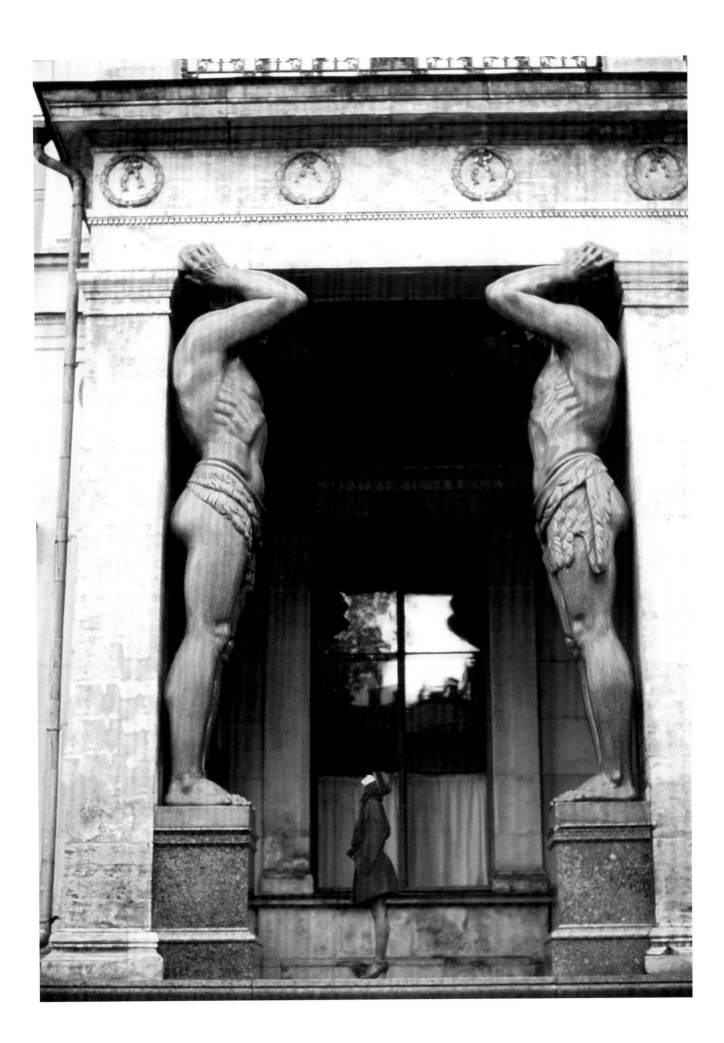

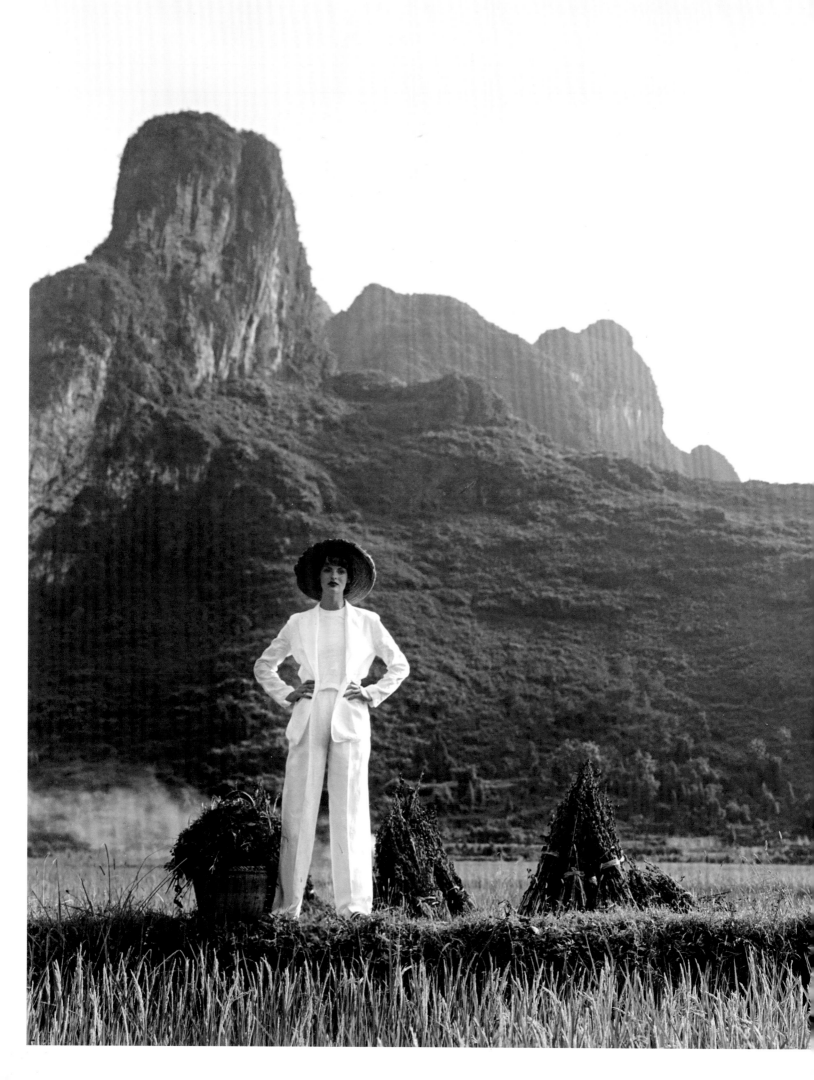

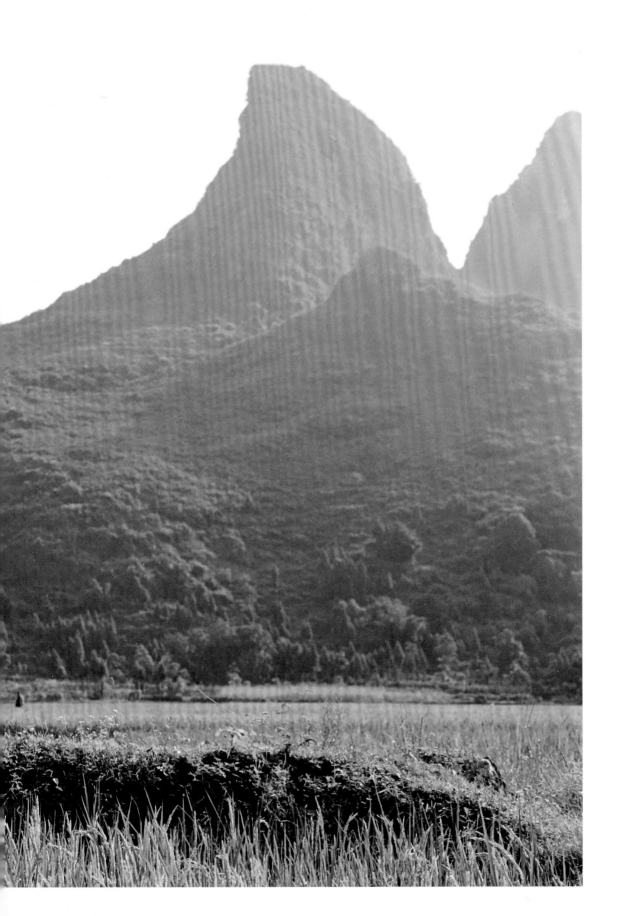

1993

On a tour of China, Linda Evangelista journeyed to Shanghai and the southern province of Guangxi. THIS PAGE: Evangelista surveys the mountainous terrain. FOLLOWING PAGES: She joins a tai chi group alongside Shanghai locals.

Photographed by Arthur Elgort, December 1993

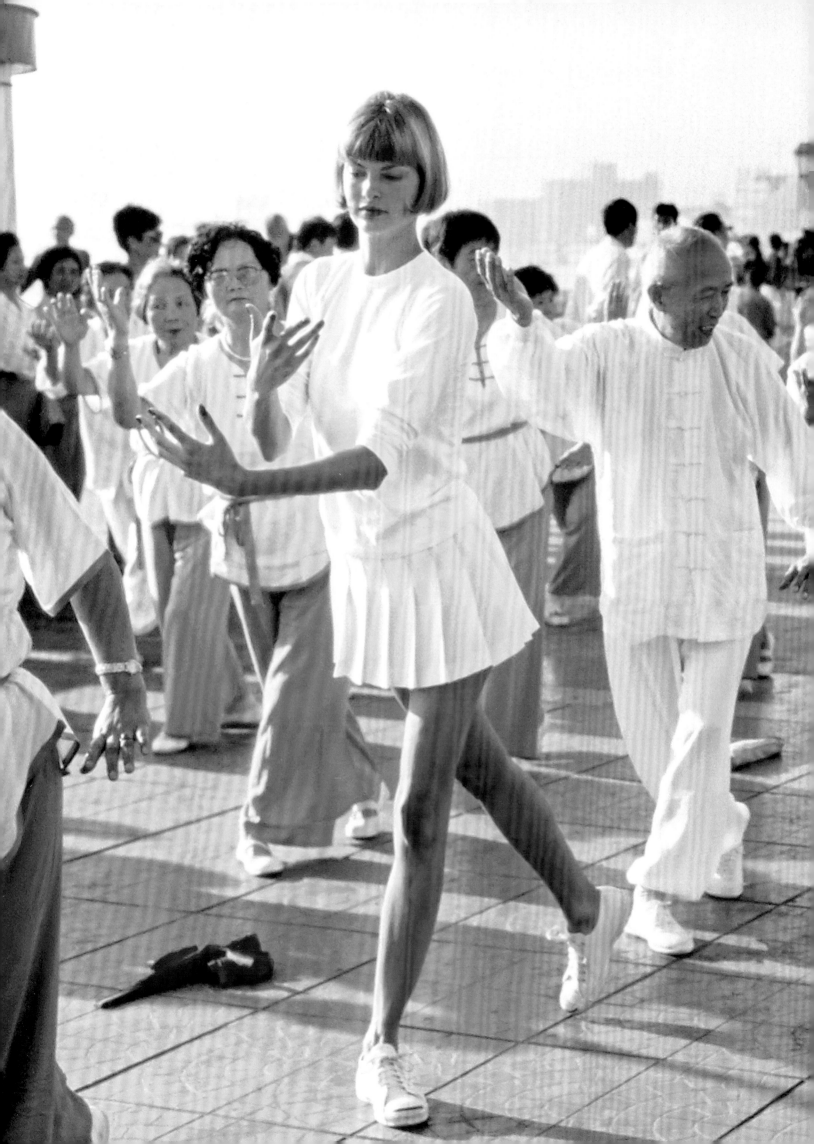

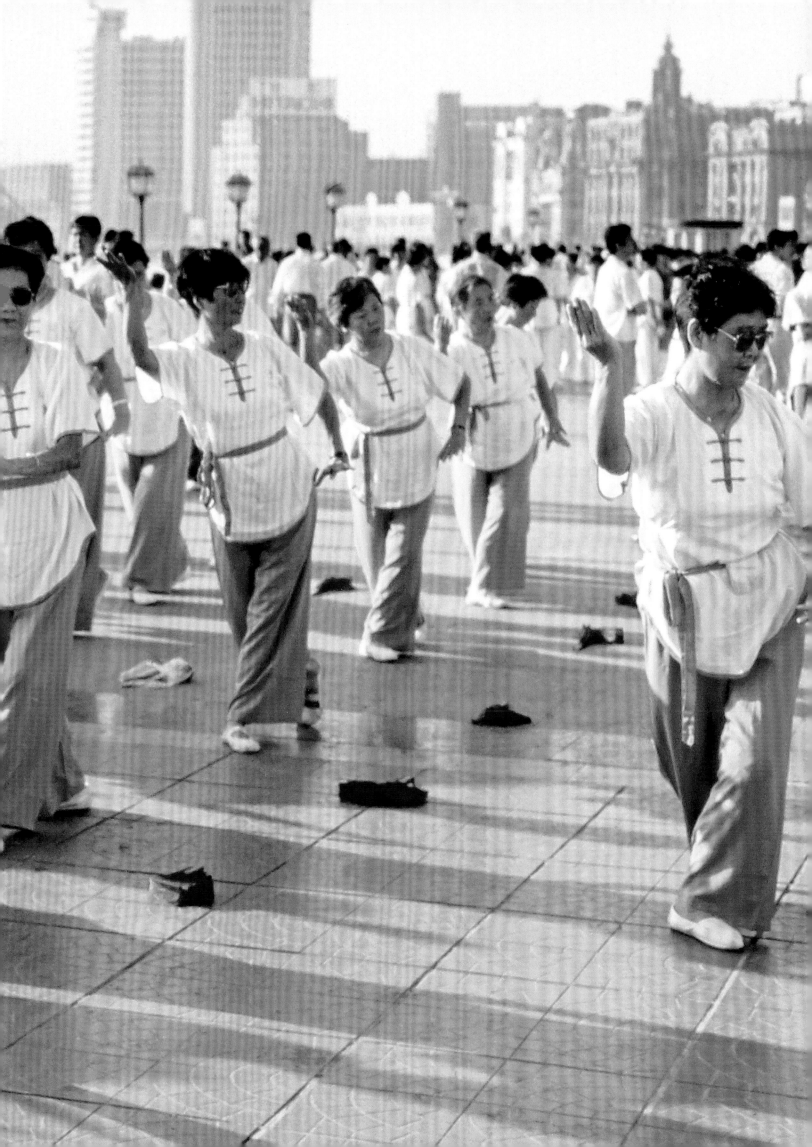

A TWO-HOUR FLIGHT south of Beijing, in the province of Guangxi, there is some of the most extraordinary scenery on earth. Here, rising like giant green gumdrops for miles and miles in all directions, are the limestone mountains that have inspired Chinese painters and poets for centuries. To see them in their full glory, most travelers...take a daylong cruise down the Li River. Floating through this Tolkienesque landscape, you pass sultry water buffalo, thatched villages, waterfalls, men poling skinny rafts, giant bursts of bamboo that look like topiary camels, horses, unicorns. You forget politics, you stop speculating on China's future; you are simply very happy to be here.

RICHARD ALLEMAN, 1993 SHANGHAI AND OTHER SURPRISES

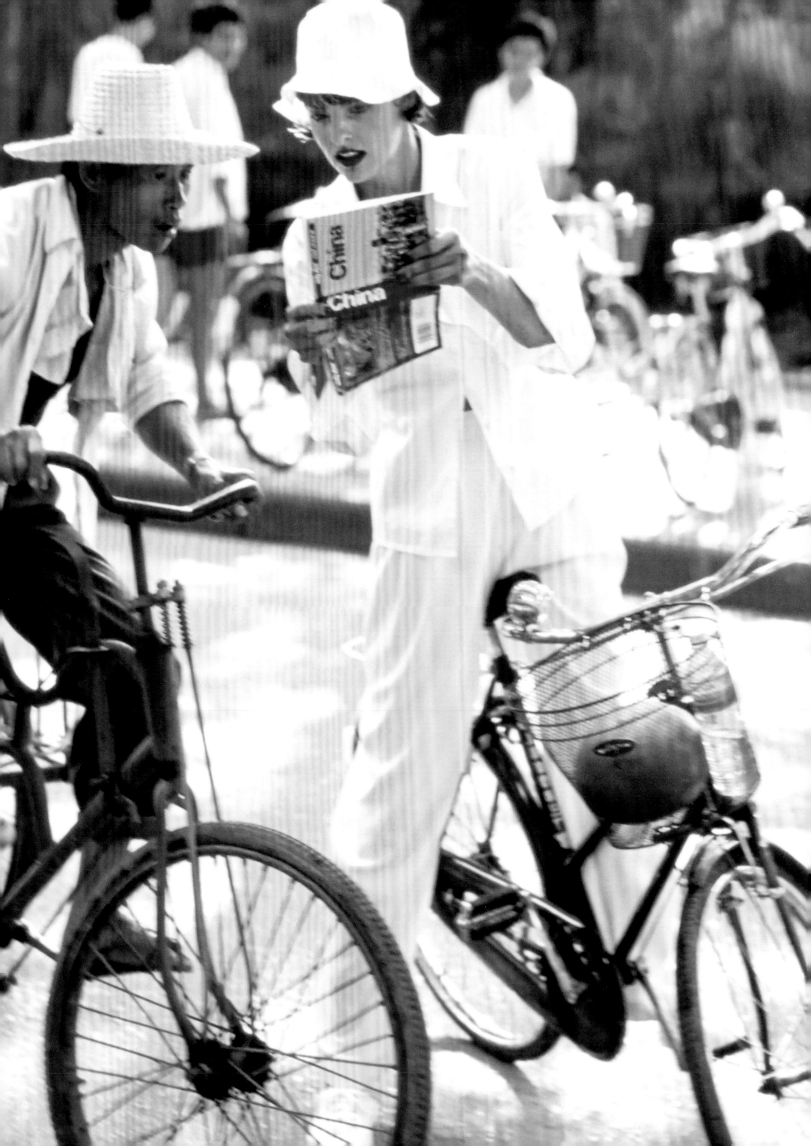

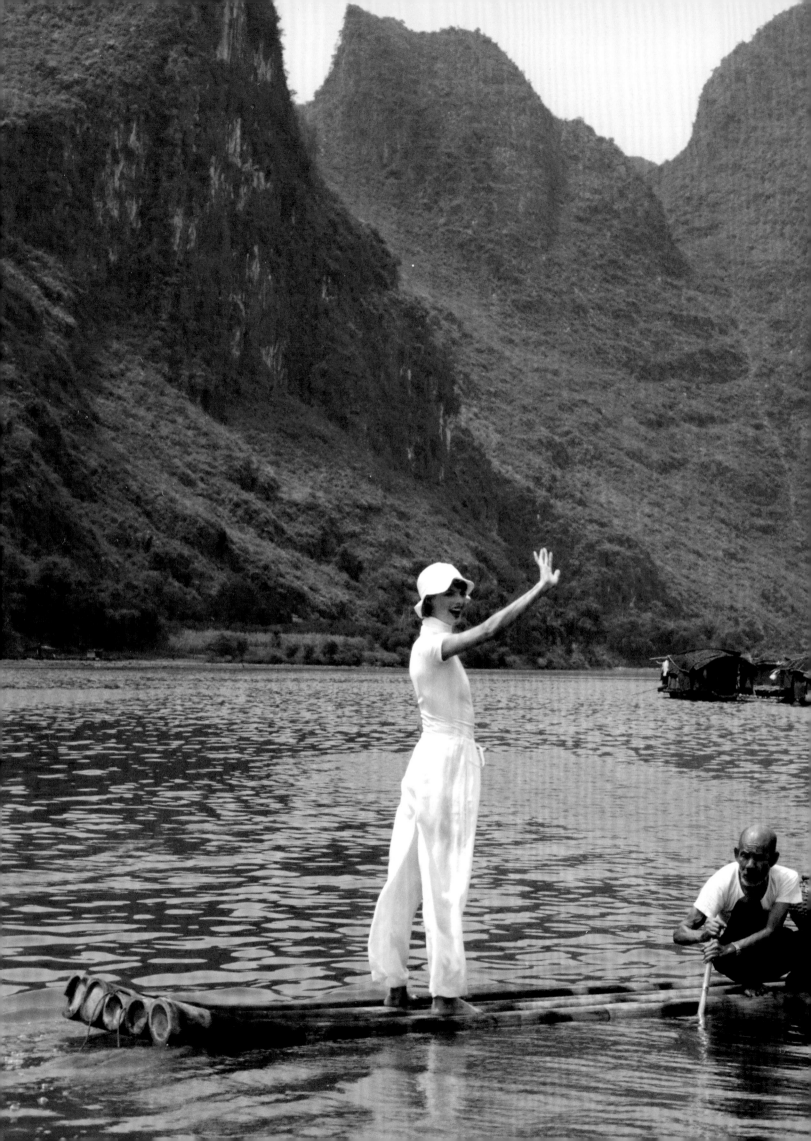

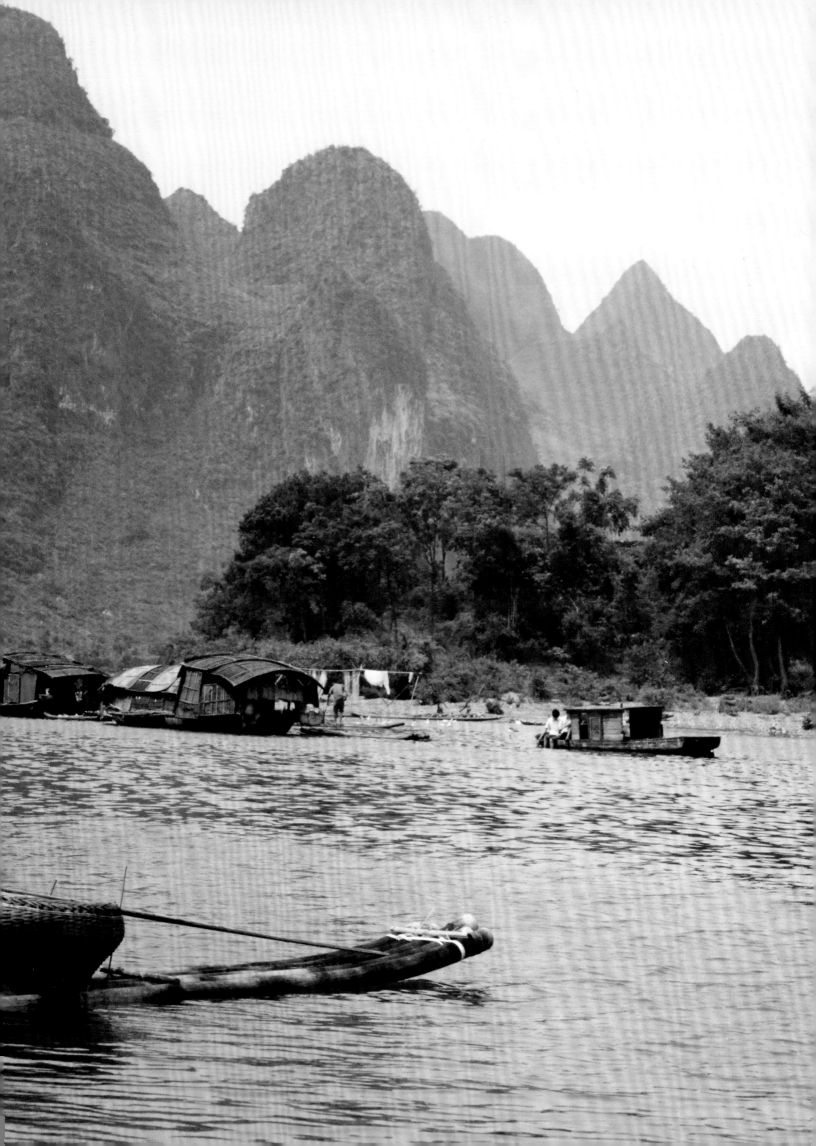

ON MY WAY TO the Mekong Delta, I'm hoping to float downstream through rivulets teeming with indigenous folklore. Instead, I'm ferried across Southeast Asia's grandest river in a cushiony, mint-condition Citroën, then delivered to the care of a French-speaking, straw-hatted lady guide for a private lesson in tropical horticulture. Maybe what really matters in other countries, as with other people, isn't what you want to see but what they deem important to show you.

JOHN KRICH, 1992 AT PEACE IN VIETNAM

1996

OPPOSITE PAGE: A sunset over the fishing village of Phan Thiet in Vietnam. FOLLOWING PAGES: Dancers on the streets of Ho Chi Minh City (then Saigon).
Photographed by Bruce Weber, June 1996

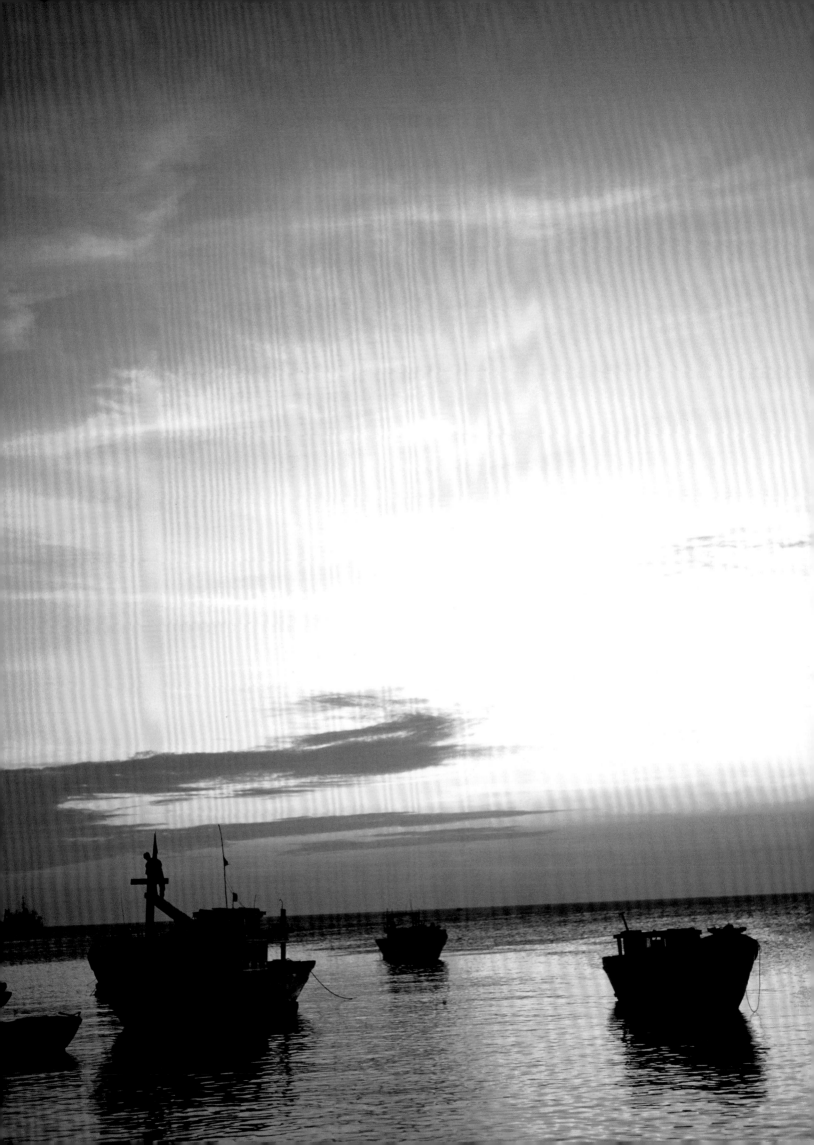

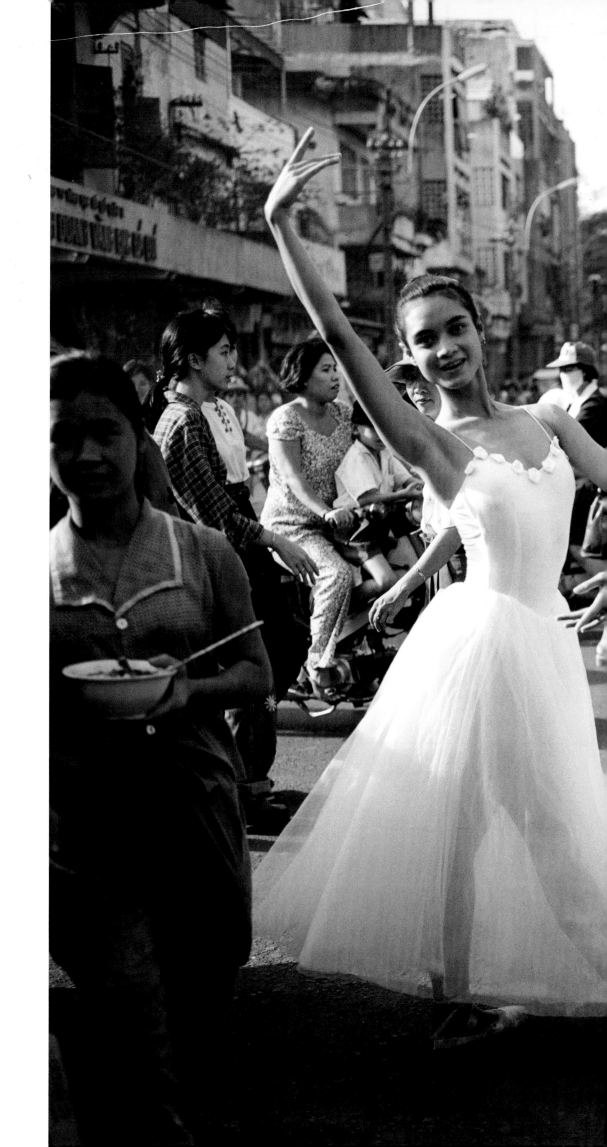

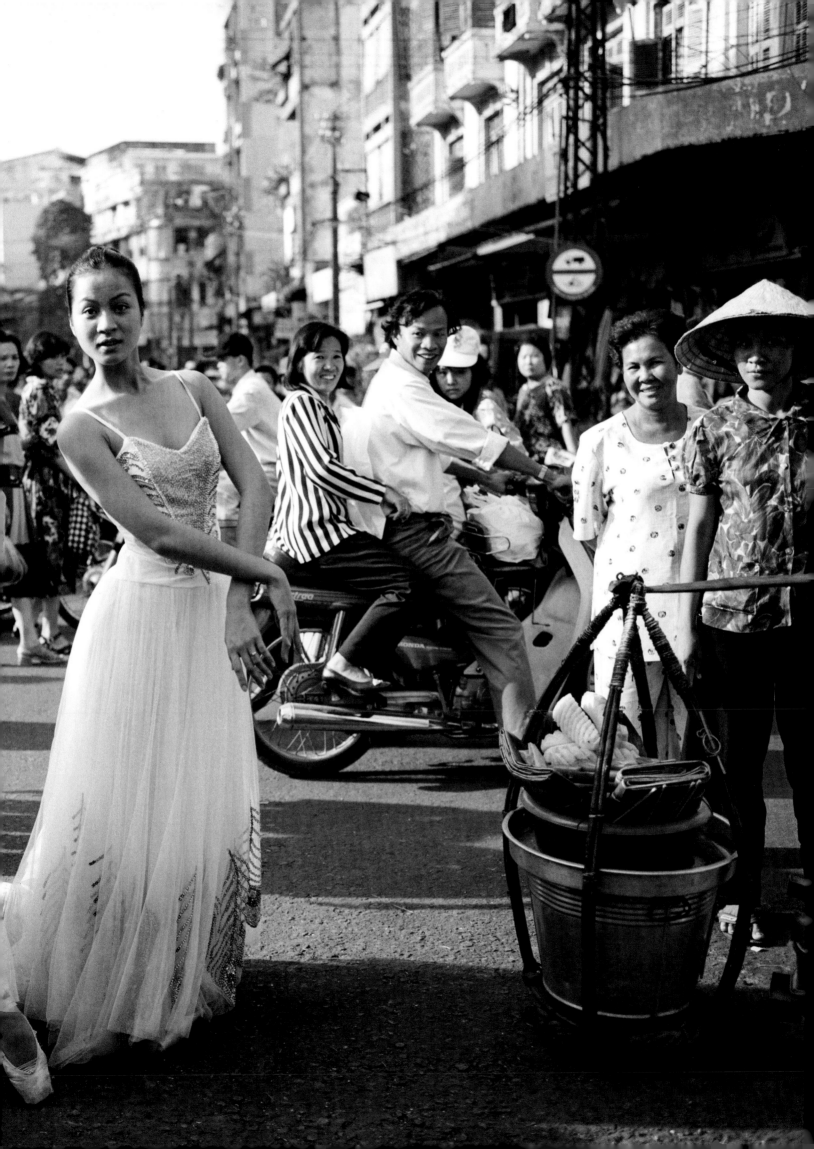

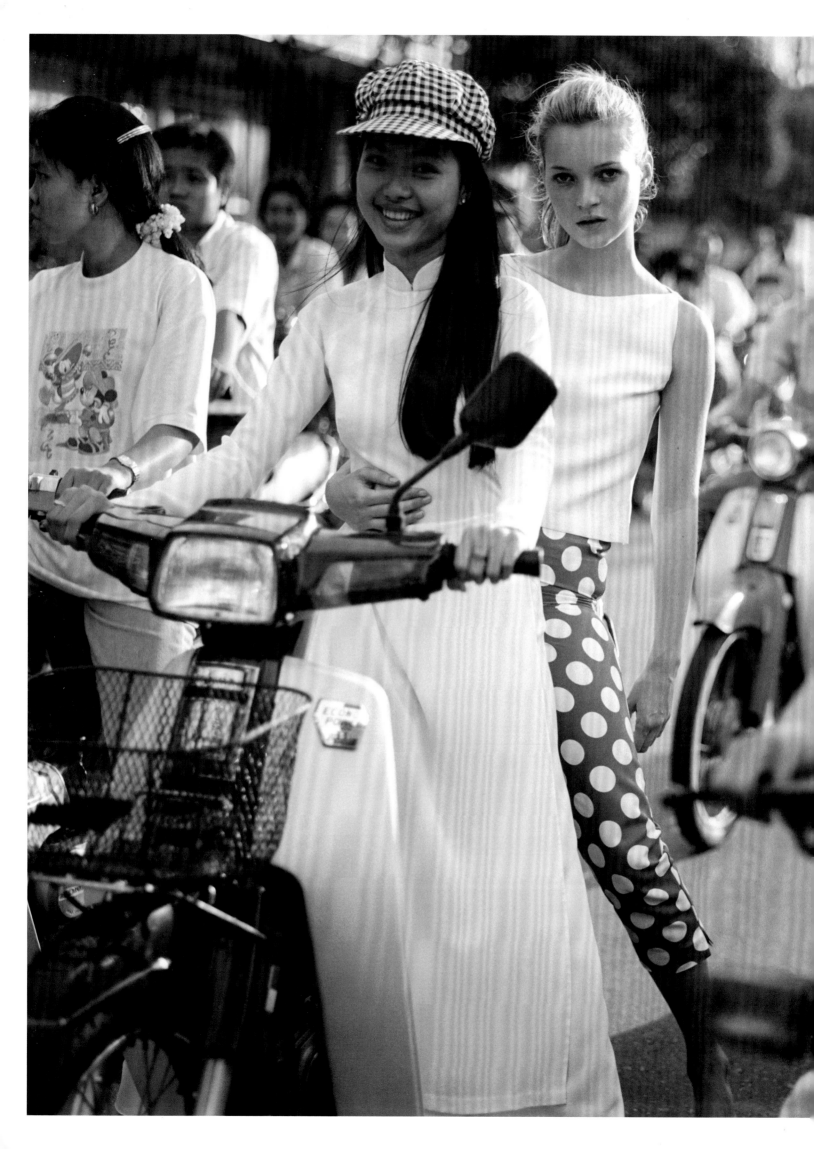

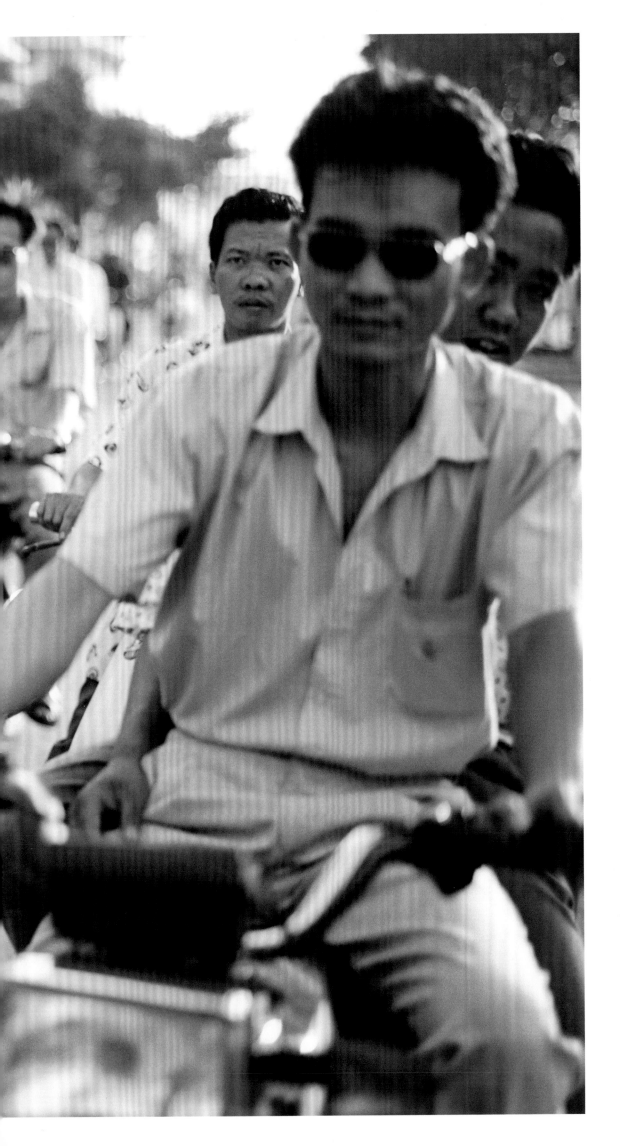

THIS PAGE: Kate Moss catches a ride with a student in Ho Chi Minh City (then Saigon).
FOLLOWING PAGES: An overdressed Moss stands beside a local landowner.

Photographed by Bruce Weber, June 1996

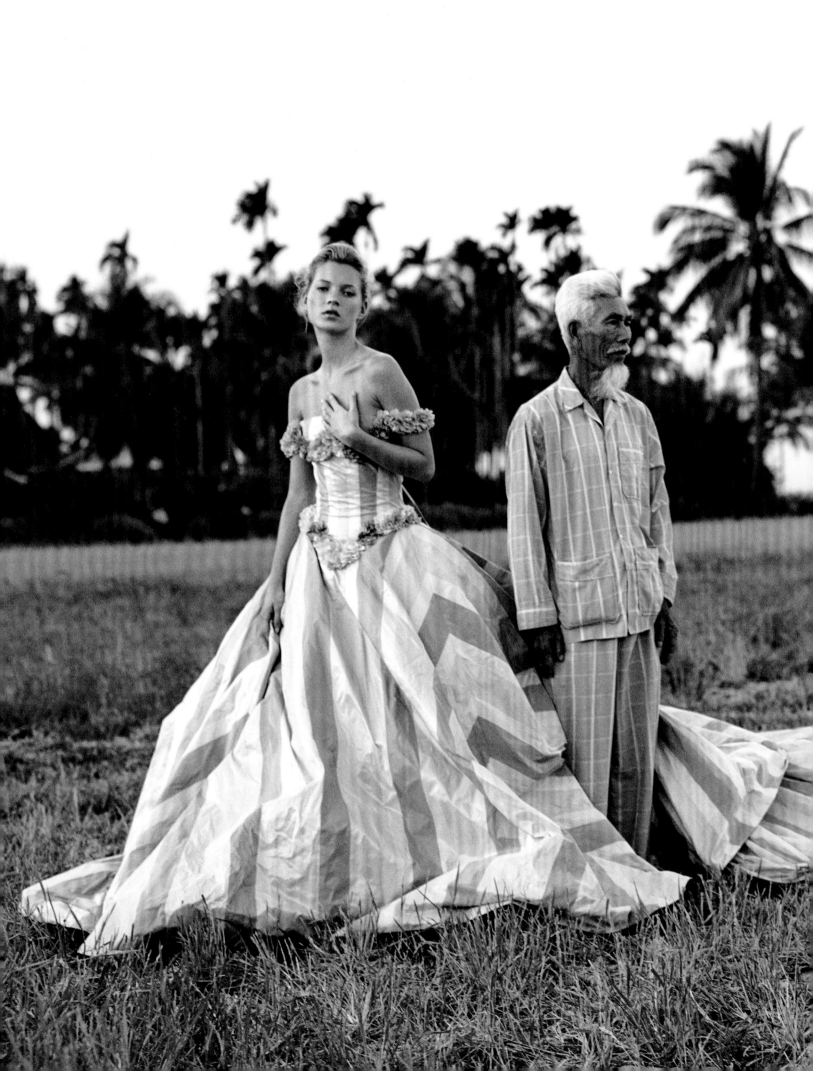

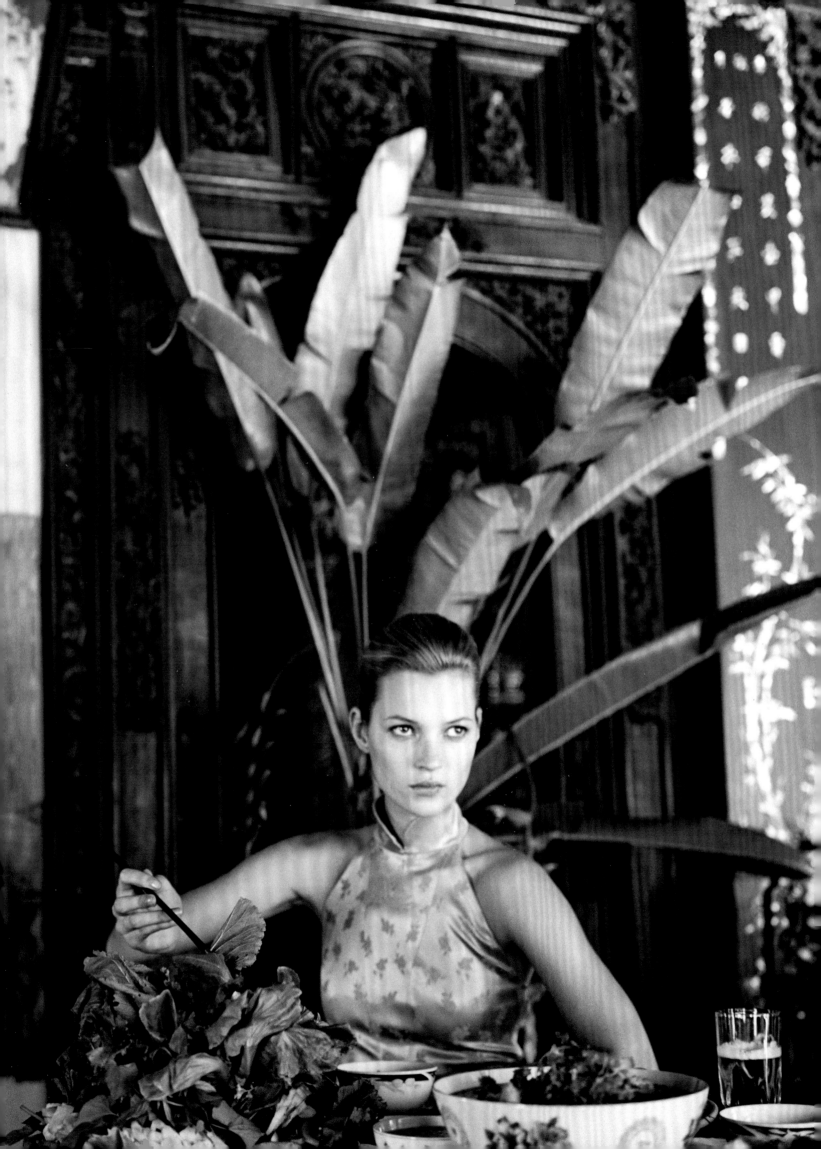

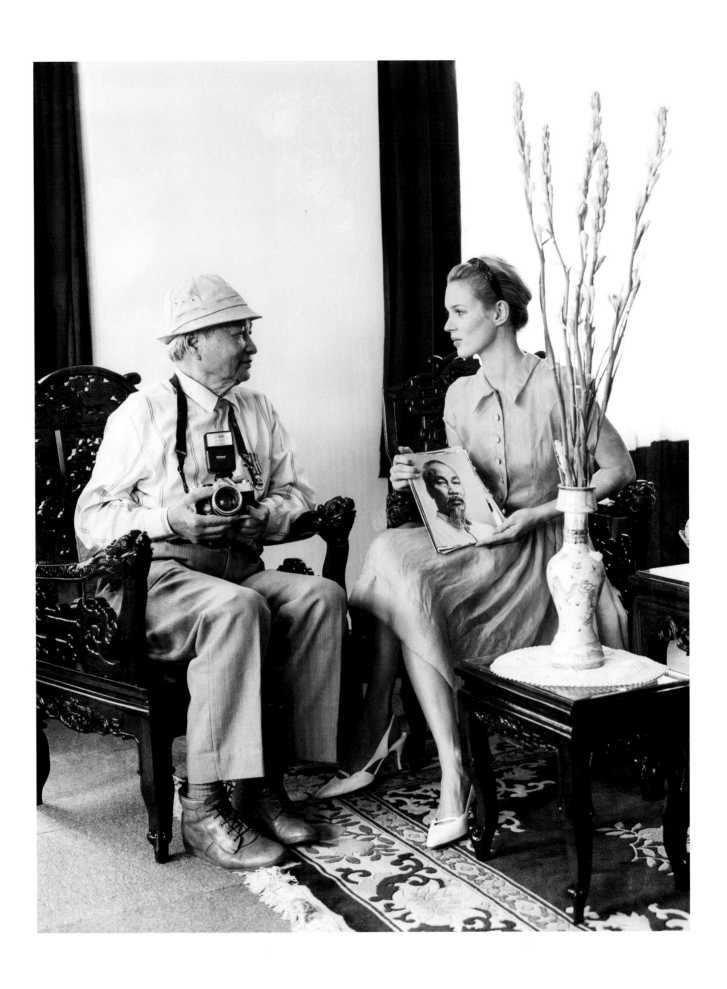

THIS PAGE: Kate Moss, holding a portrait of Ho Chi Minh, sits with the photographer. OPPOSITE PAGE: Chopsticks in hand, Moss samples the local cuisine.
Photographed by Bruce Weber, June 1996

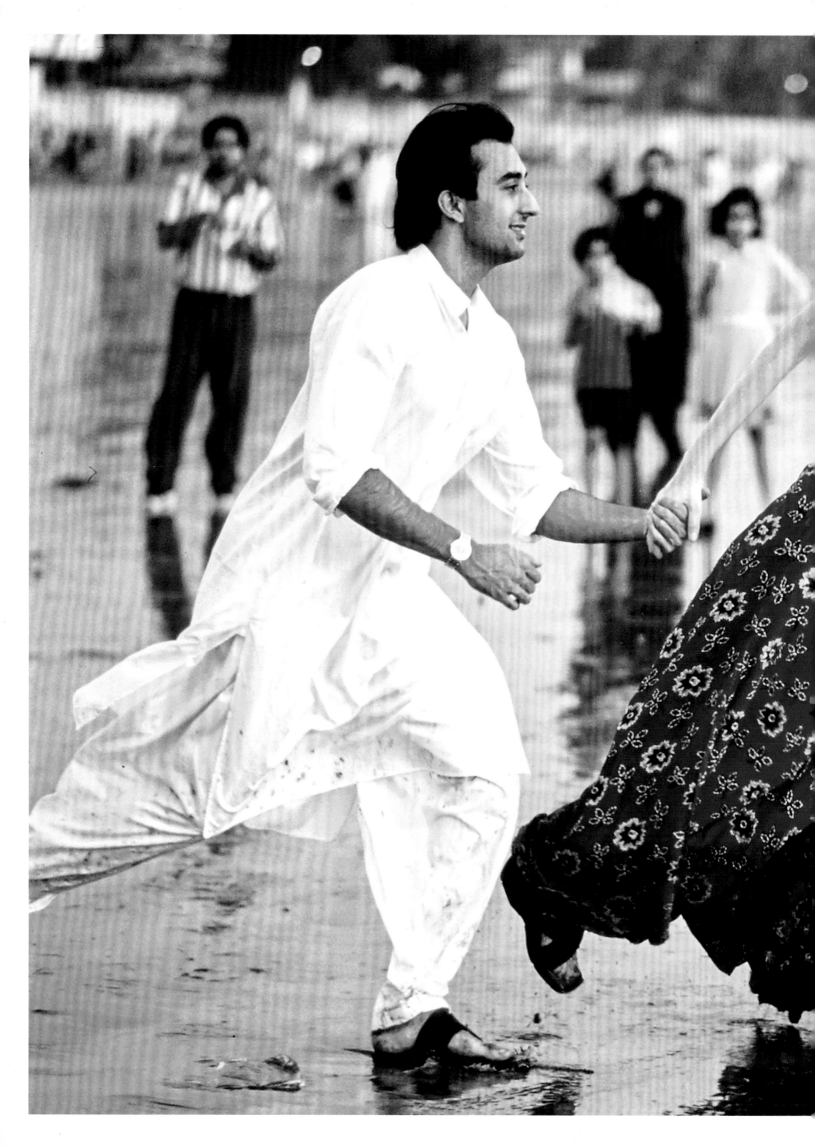

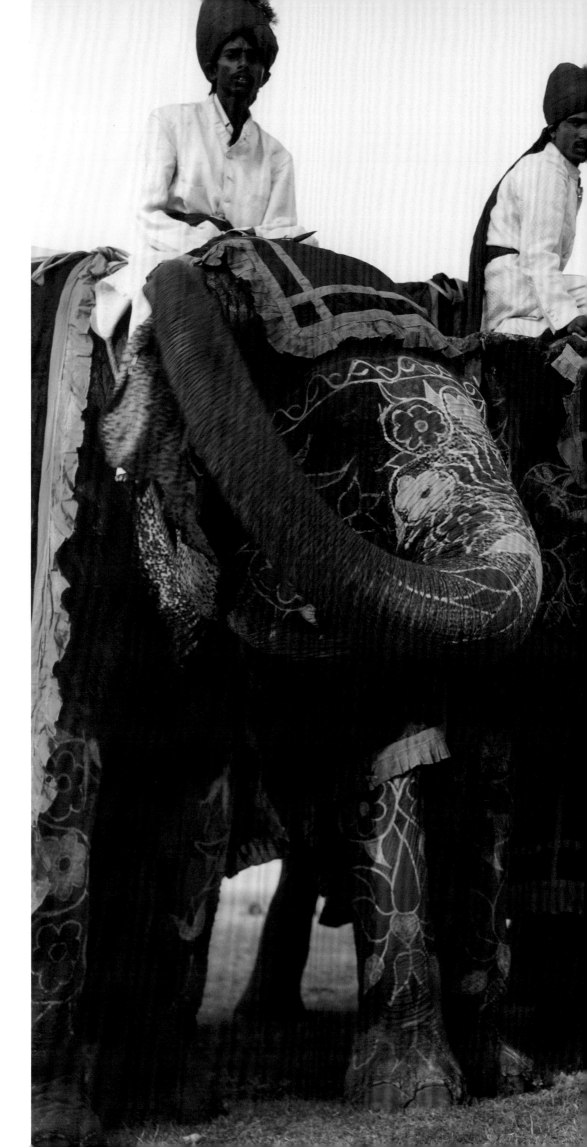

1999

THIS PAGE: Model Maggie Rizer stands with elephants covered in elaborate paint, denoting their exalted status in Rajasthan.
PREVIOUS PAGES: Rizer and Indian actor Rahul Khanna, hand in hand on Mumbai's (then Bombay's) Juhu Beach.
Photographed by Arthur Elgort, June 1999

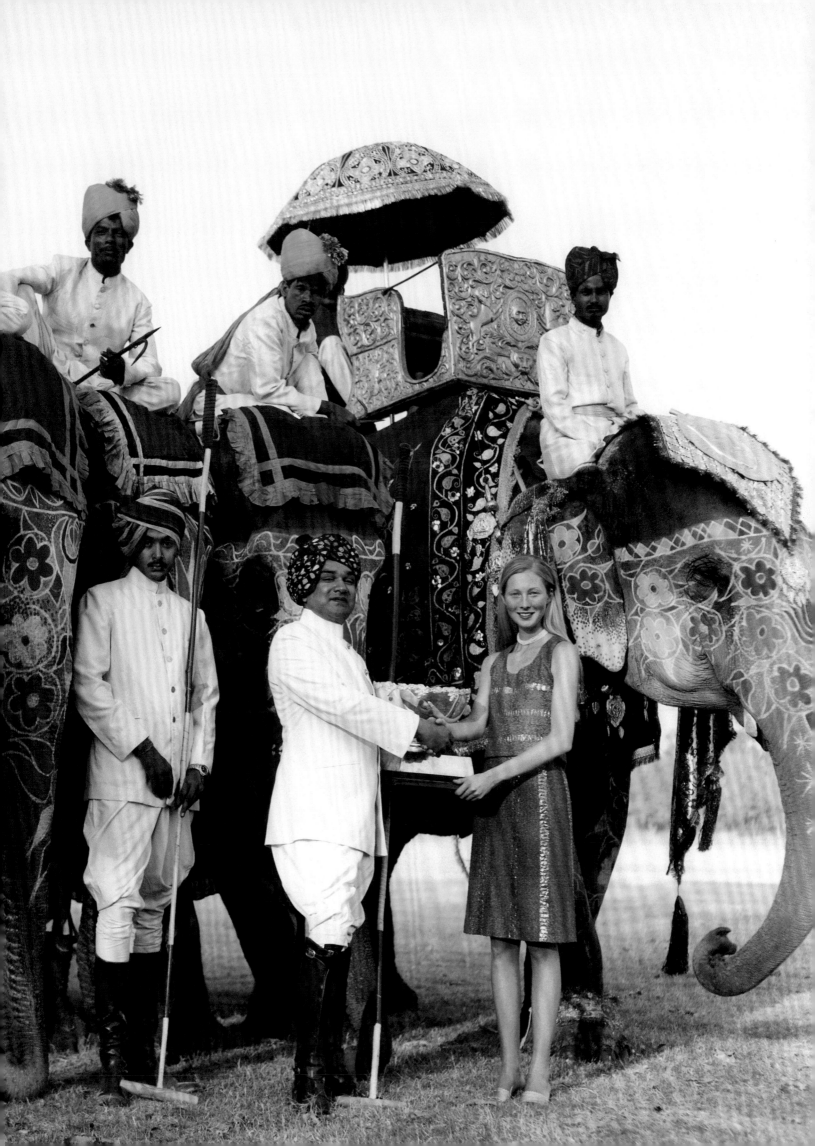

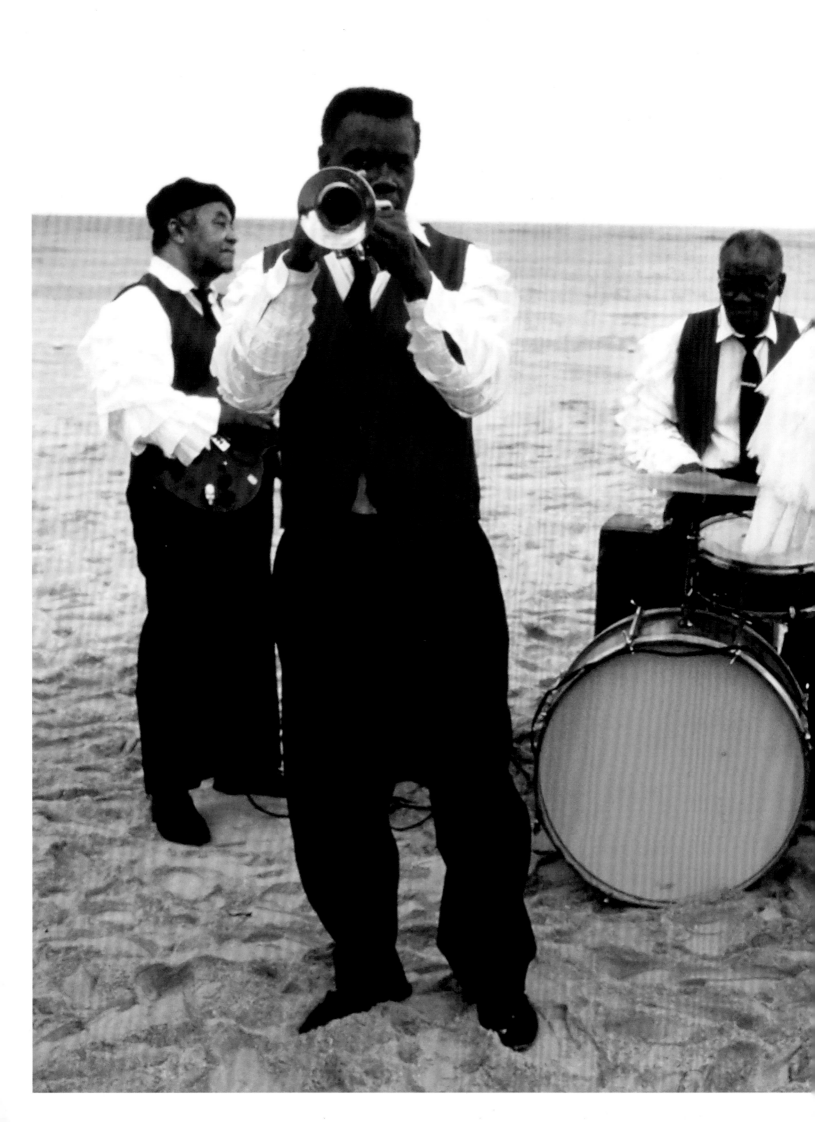

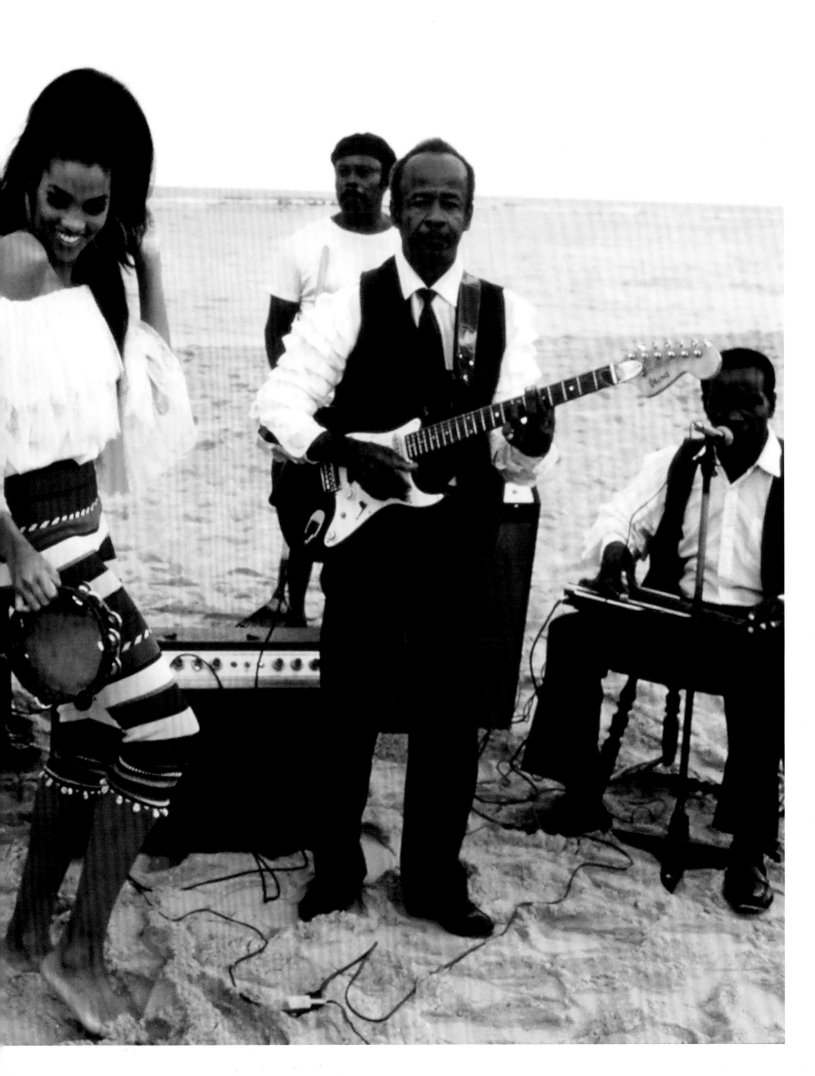

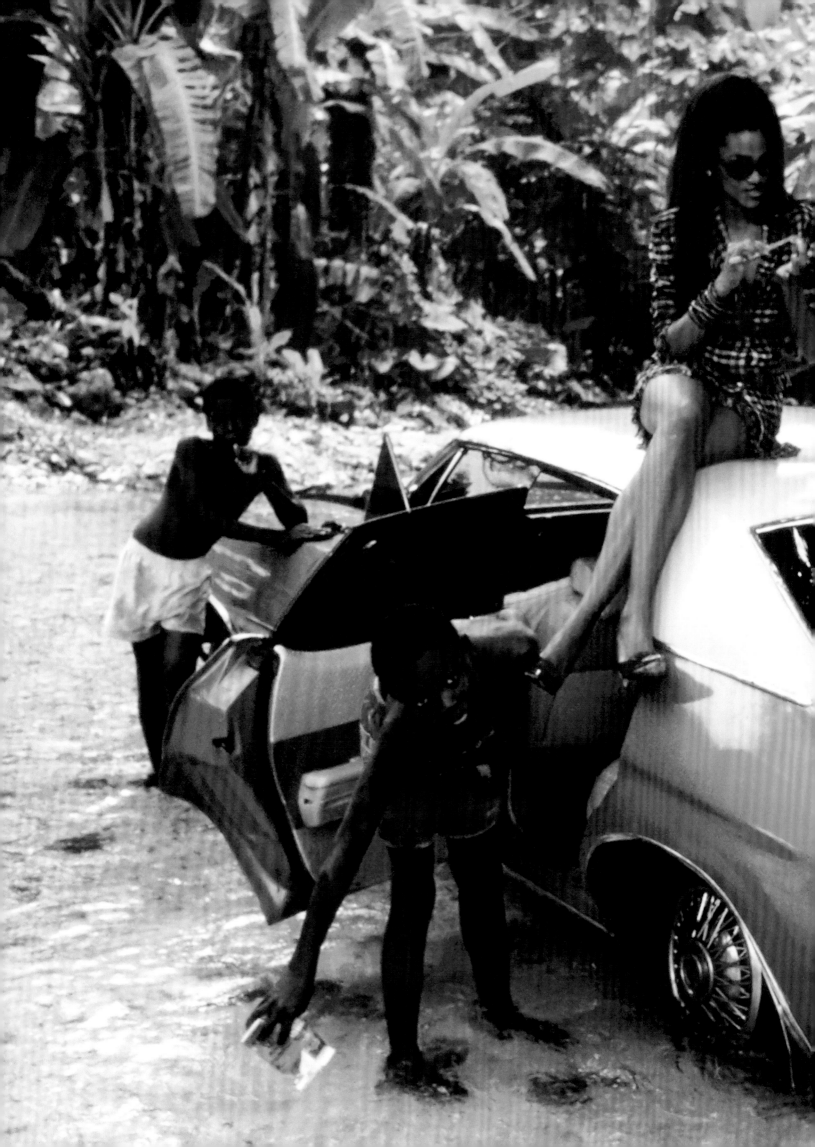

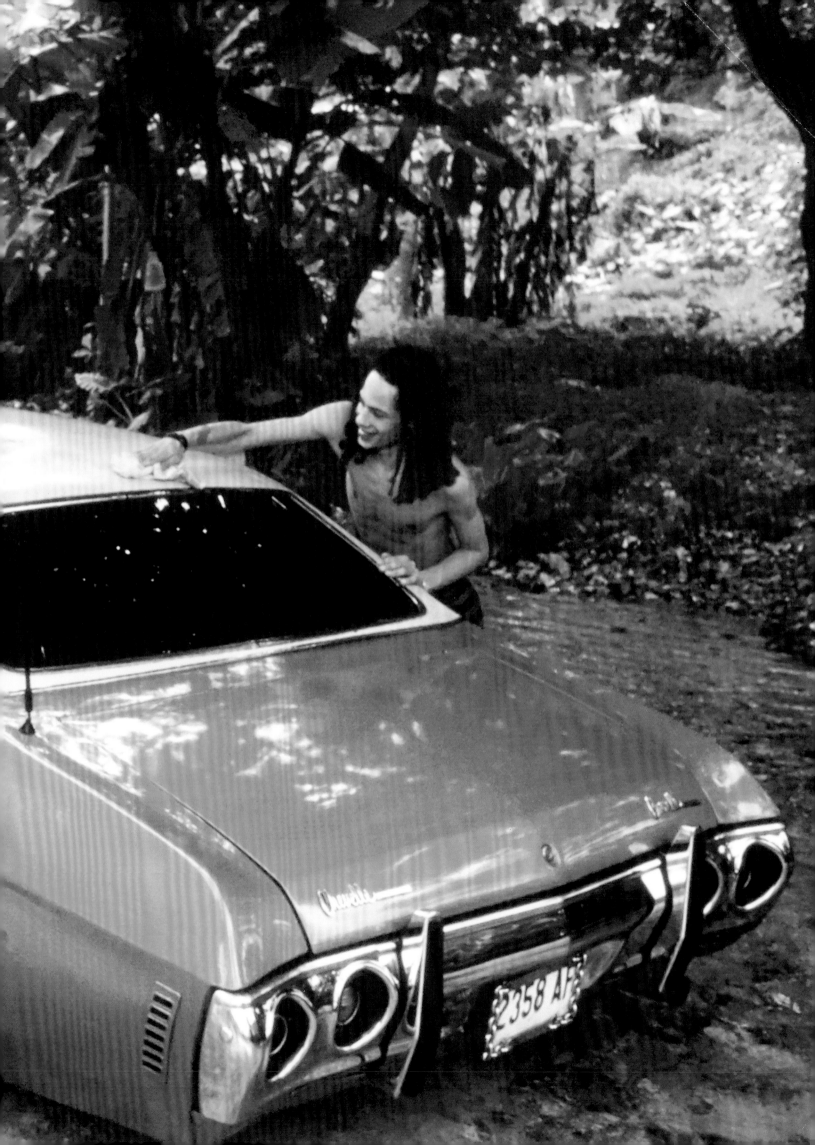

1991

OPPOSITE PAGE: Model
Stephanie Roberts
embraces a friend.
PREVIOUS PAGES: Roberts
jams on a Jamaican
beach with the
Georgie Wilson
Band and makes a
pit stop in the jungle
for some automotive
grooming.

*Photographed by Ellen von
Unwerth, April 1991*

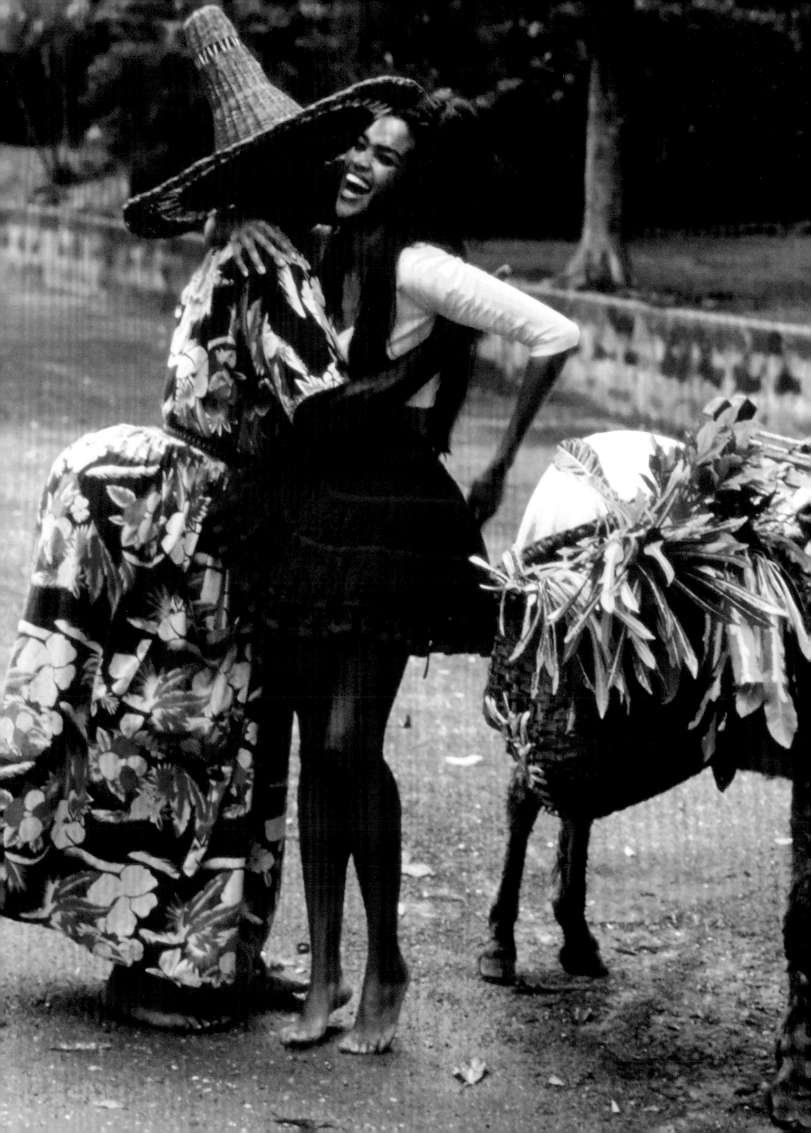

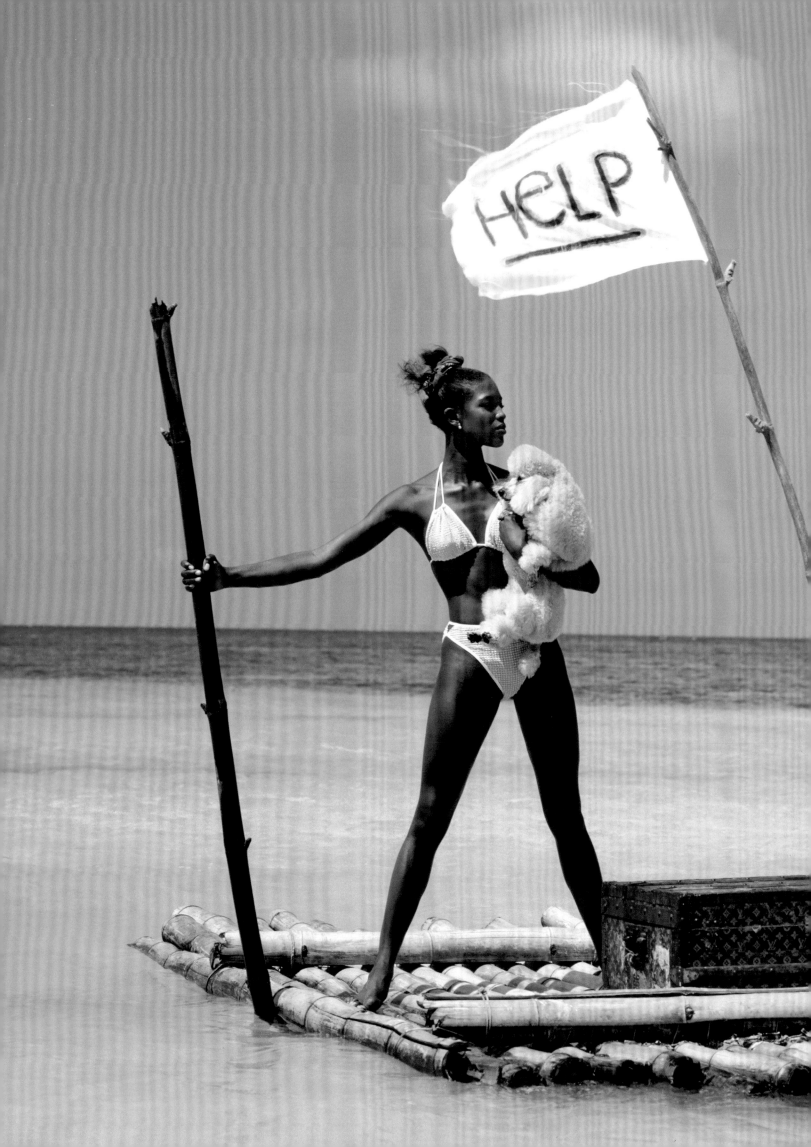

1996

THIS PAGE: Naomi Campbell cries SOS off the Jamaican shore with a power pose and a pink poodle. FOLLOWING PAGES: Campbell and a parrot friend take shelter in a beach hut. She runs down the boardwalk with leopard-like speed. Campbell stands atop a jumble of driftwood.

Photographed by Herb Ritts, May 1996

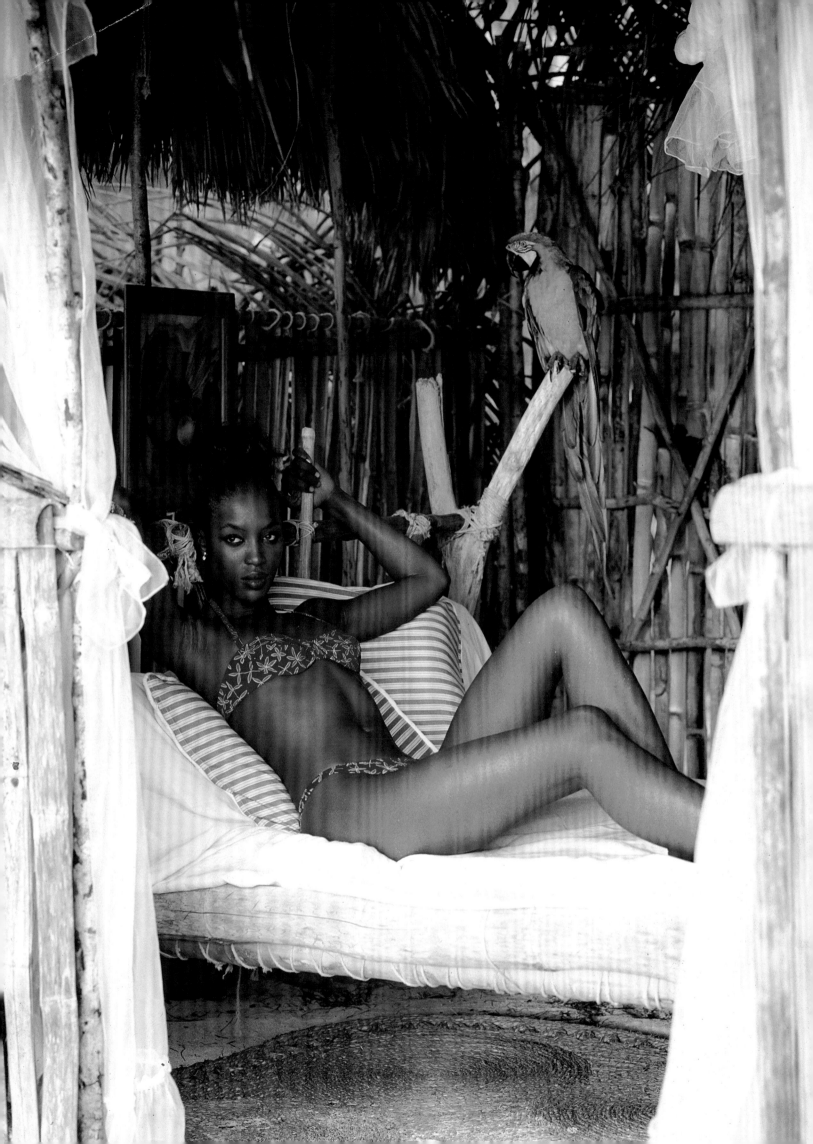

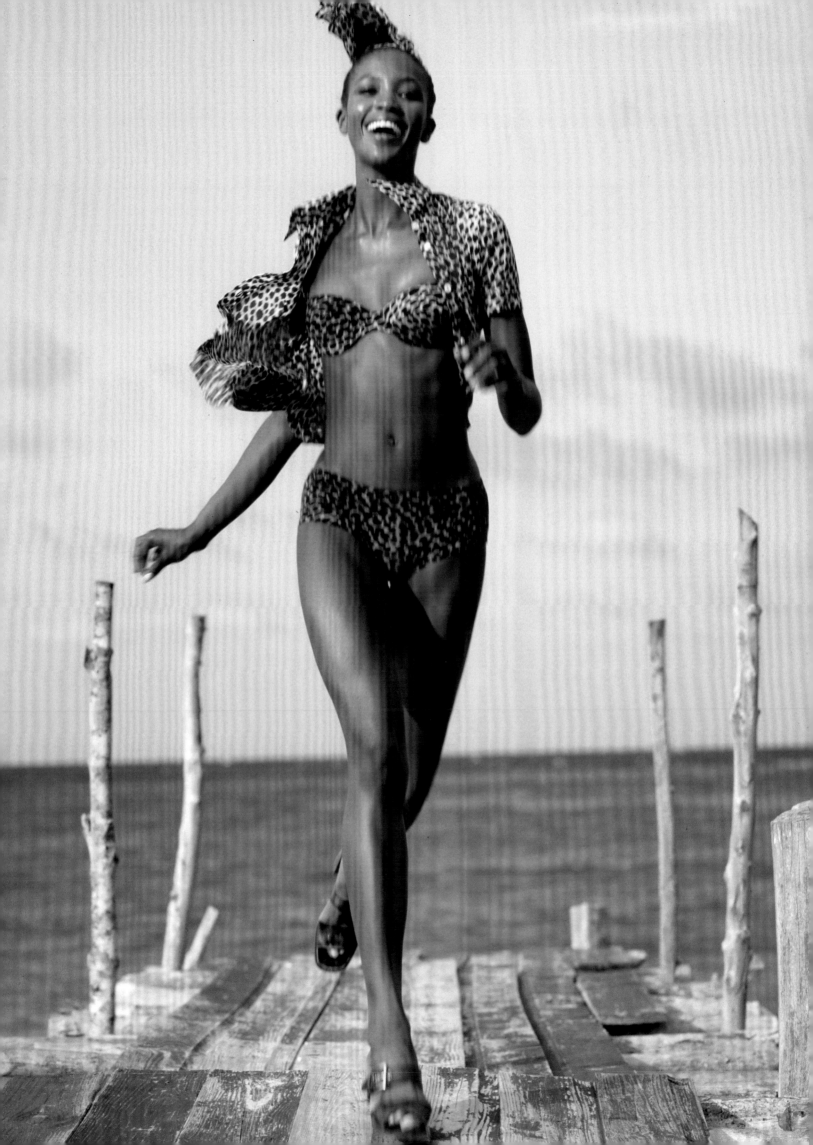

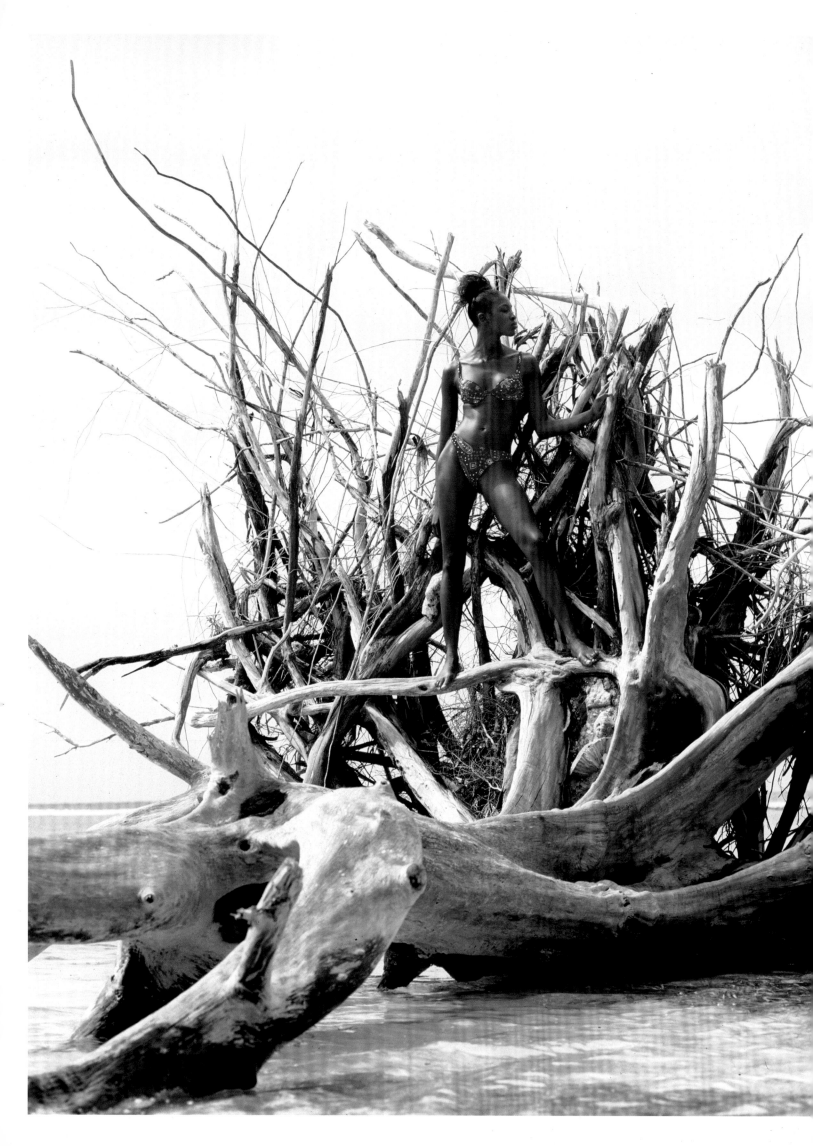

¹995

To celebrate the election of
Nelson Mandela in South
Africa, *Vogue* sent Somalian-
born Iman along with her
rock-star husband, David
Bowie, to Cape Town. THIS PAGE:
The couple at Manenberg's
Jazz Cafe. FOLLOWING PAGES:
Iman and the South African
national treasure, singer
Miriam Makeba, walk along
the beach. Iman is dwarfed by
a giant aged palm tree.

Photographed by Bruce Weber, June 1995

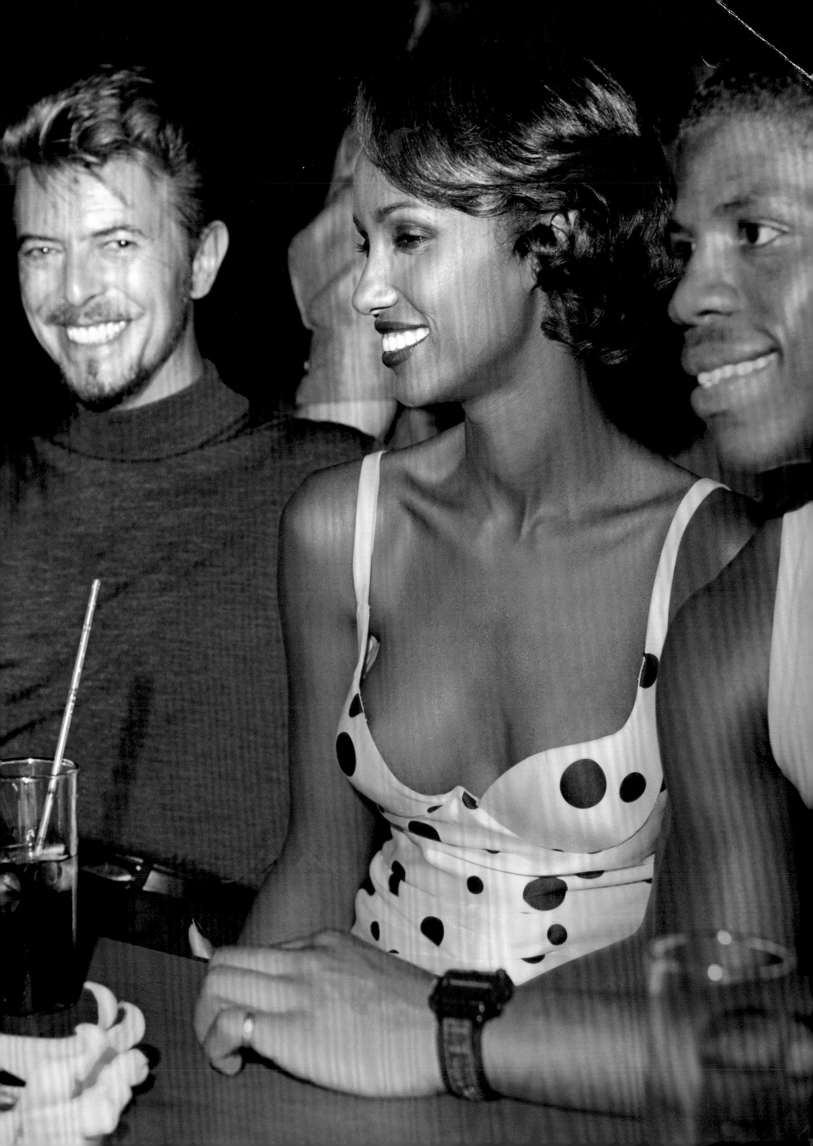

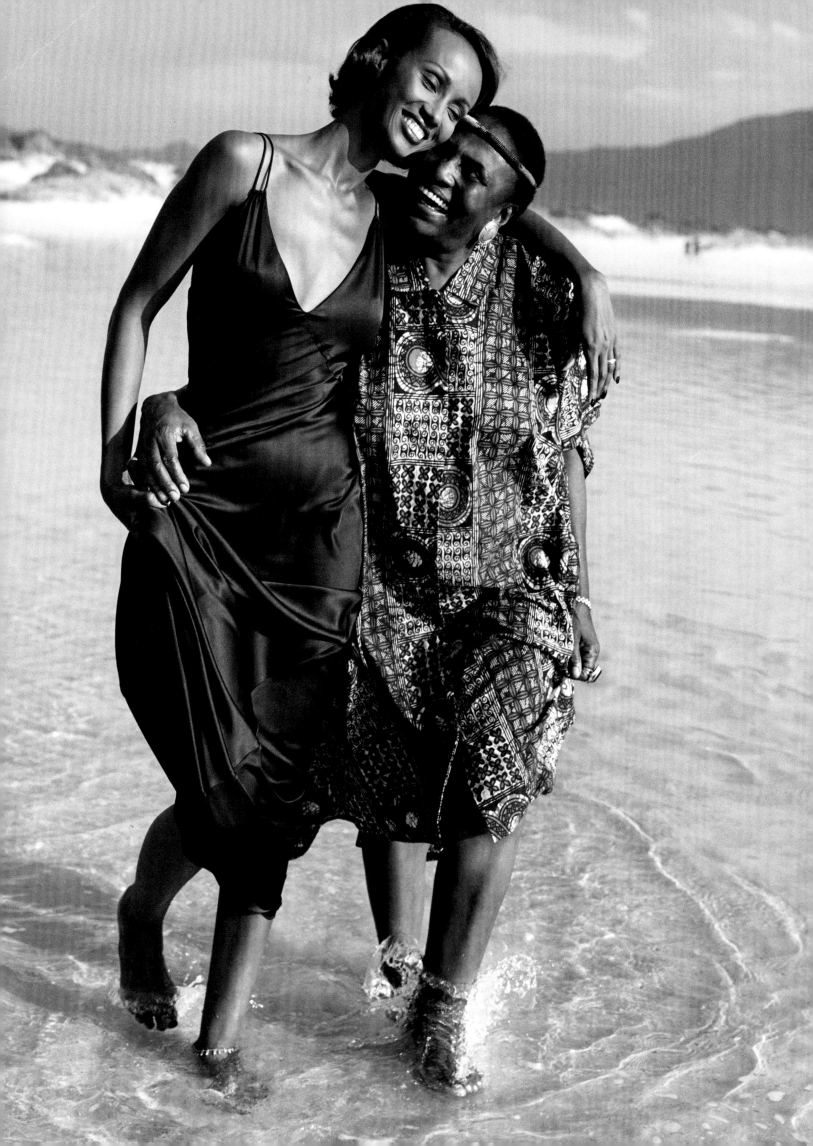

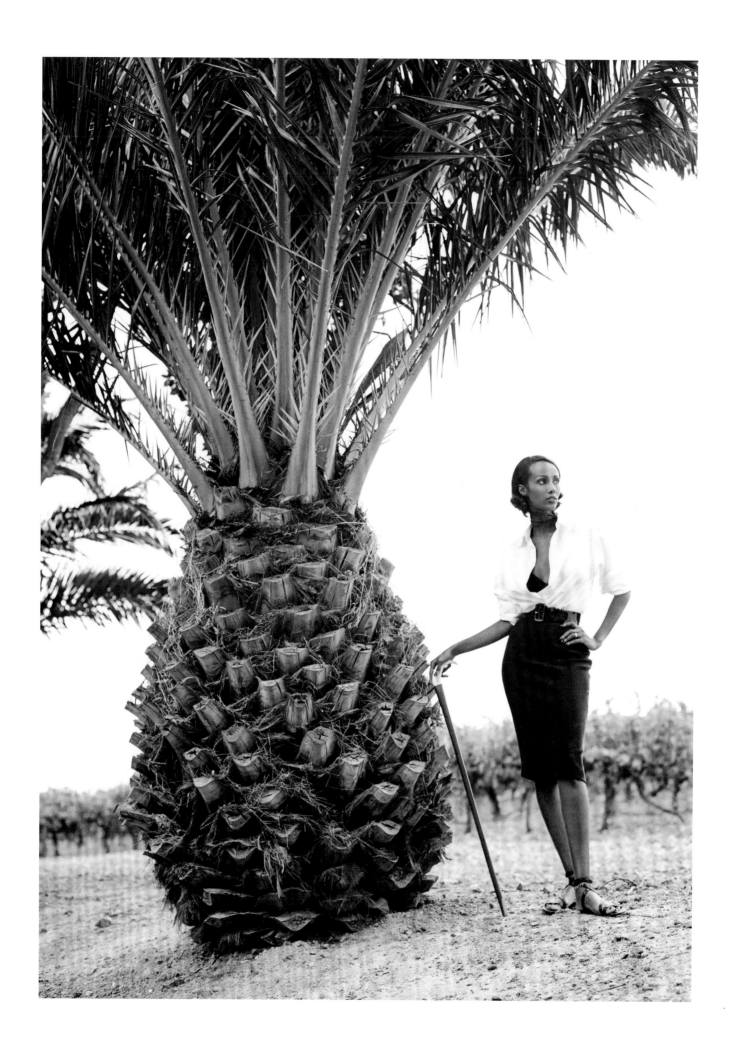

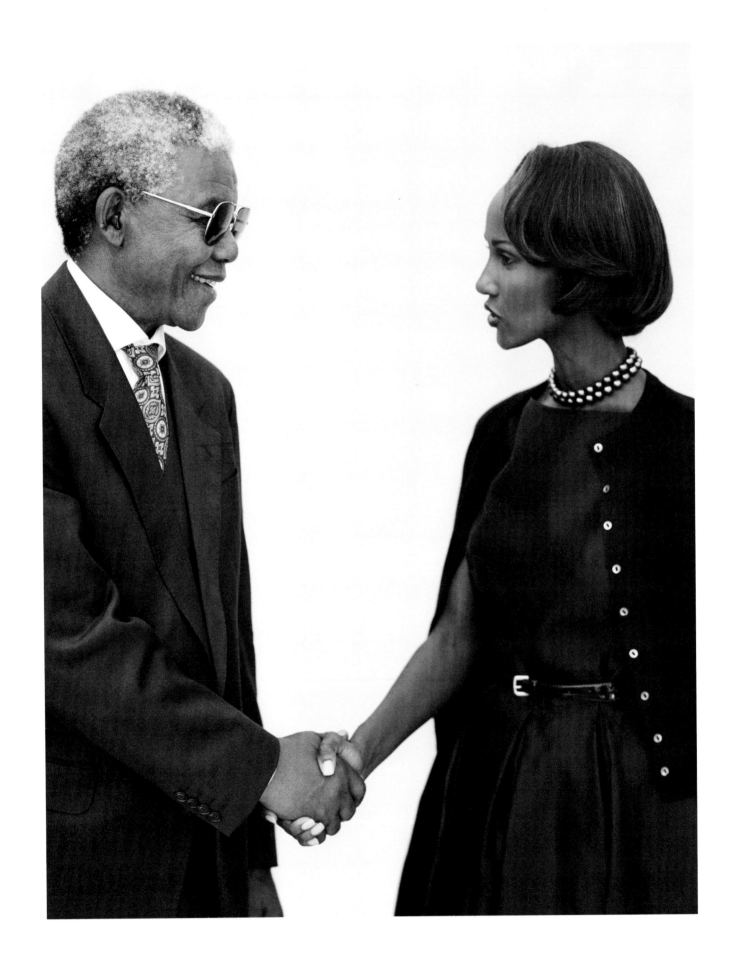

THIS PAGE: Iman meets Nelson Mandela. OPPOSITE PAGE: The model hangs out with students at a Cape Town high school.

FOLLOWING PAGE: Bowie steals a kiss on the beach.

Photographed by Bruce Weber, June 1995

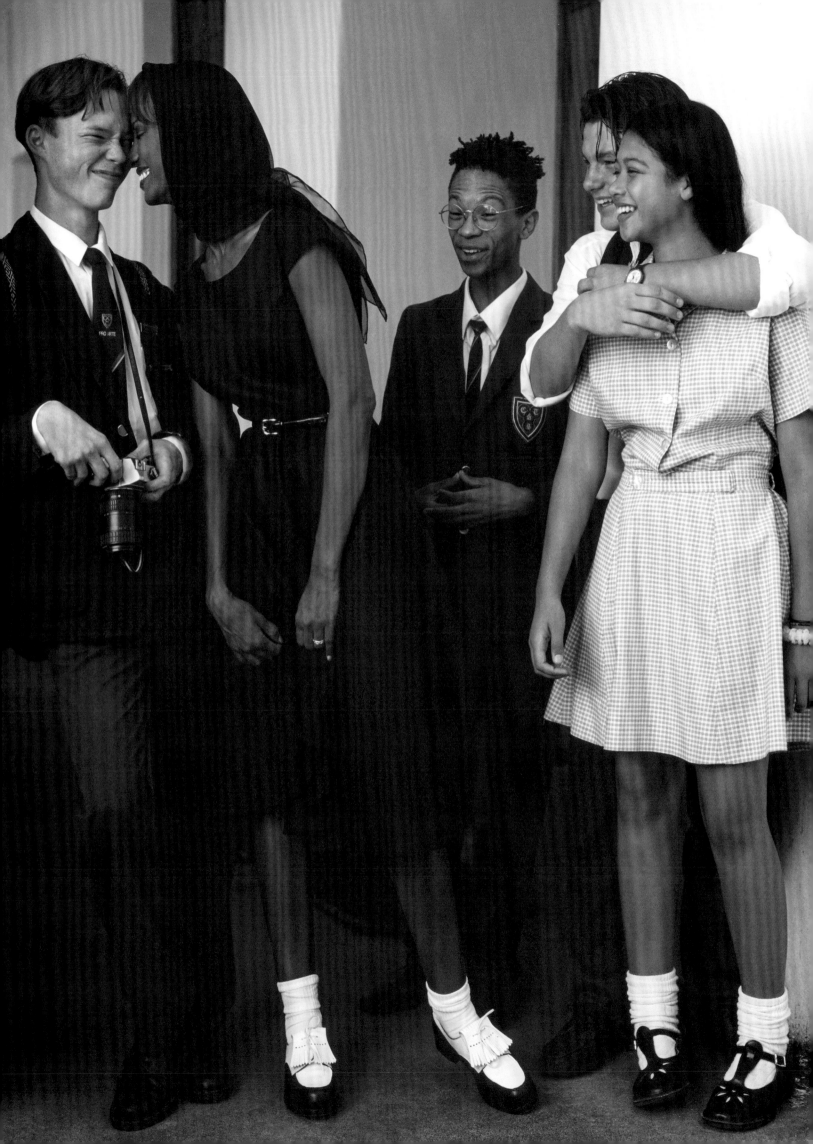

I HAD COME TO SOUTH AFRICA hoping to attach memories to alluring words like *veld* and *fever tree*, as well as to foreboding words like *township* and *apartheid*, and to try to understand how both could coexist in such a God-given landscape.

Certainly the flora and fauna are by any name enchanting. The fever tree hallucinates greenly out of the veld, thick dark pine groves line the Indian Ocean's Garden Route, and in October and November purple jacarandas blaze on all the streets of Pretoria. From the Cape of Good Hope's heathery cliffs I watched screaming cormorants wheel in the windy blue confluence where the Atlantic and Indian Oceans meet. The breeze carried the scent of Bartholomeu Dias, of 500 years of frigates beating around—and often into—the treacherous cape, the powerful scent of history....

One sunny afternoon in Cape Town itself, the country displayed its velvety underside as I strolled beneath Government Avenue's oak canopy, past the Dutch East India Company garden, into the outdoor market....Table Mountain, which presides over the city, was lapped with ermine clouds— the Tablecloth—and eight black men dressed in wild pink-and-blue suits swaggered by, blowing an infectious brass lick that attracted dozens of dancing children. Five young boys arrayed beside carved Zulu giraffes and elephants began slapping their gum boots. The wet, hollow sound punctuated their grave *mbaqanga* chants as a multiracial crowd dipped and swayed. Closing a global loop, the chorus even sang a version of Paul Simon's *mbaqanga*-derived "Graceland."

TAD FRIEND, 1993 **SOUTH AFRICAN SOJOURN**

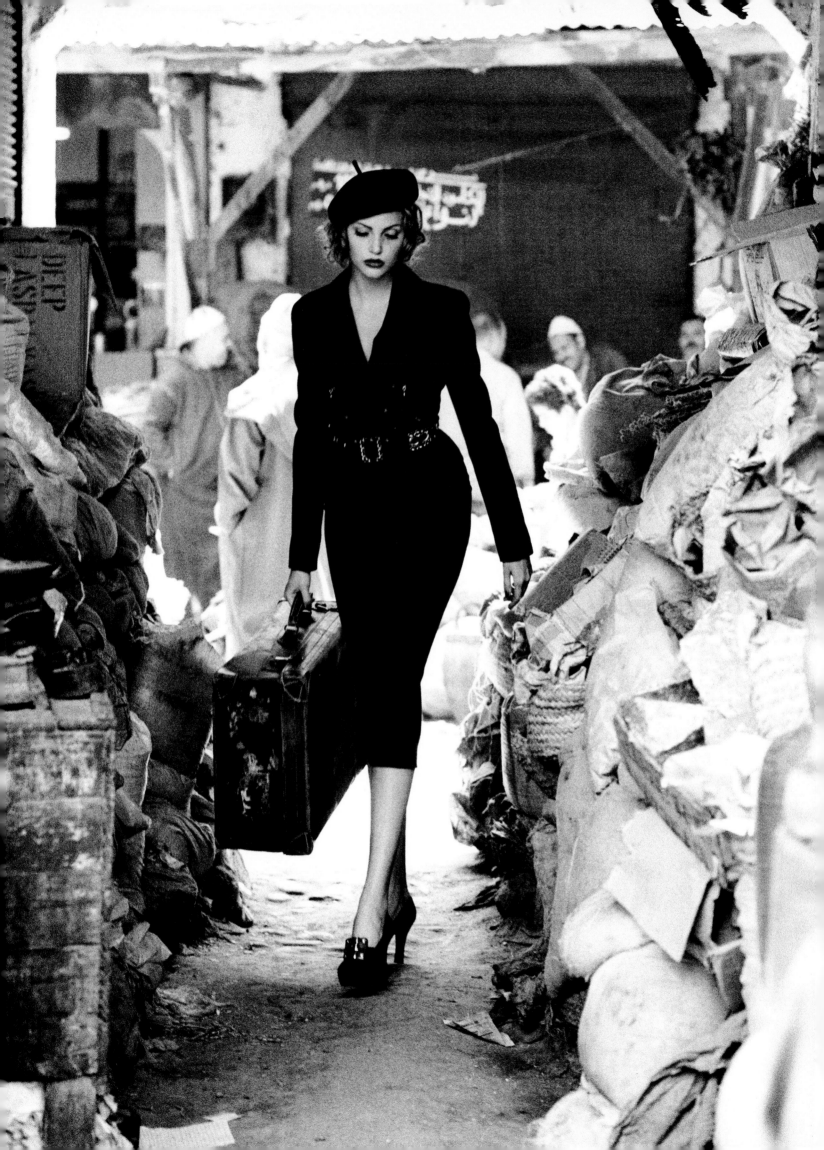

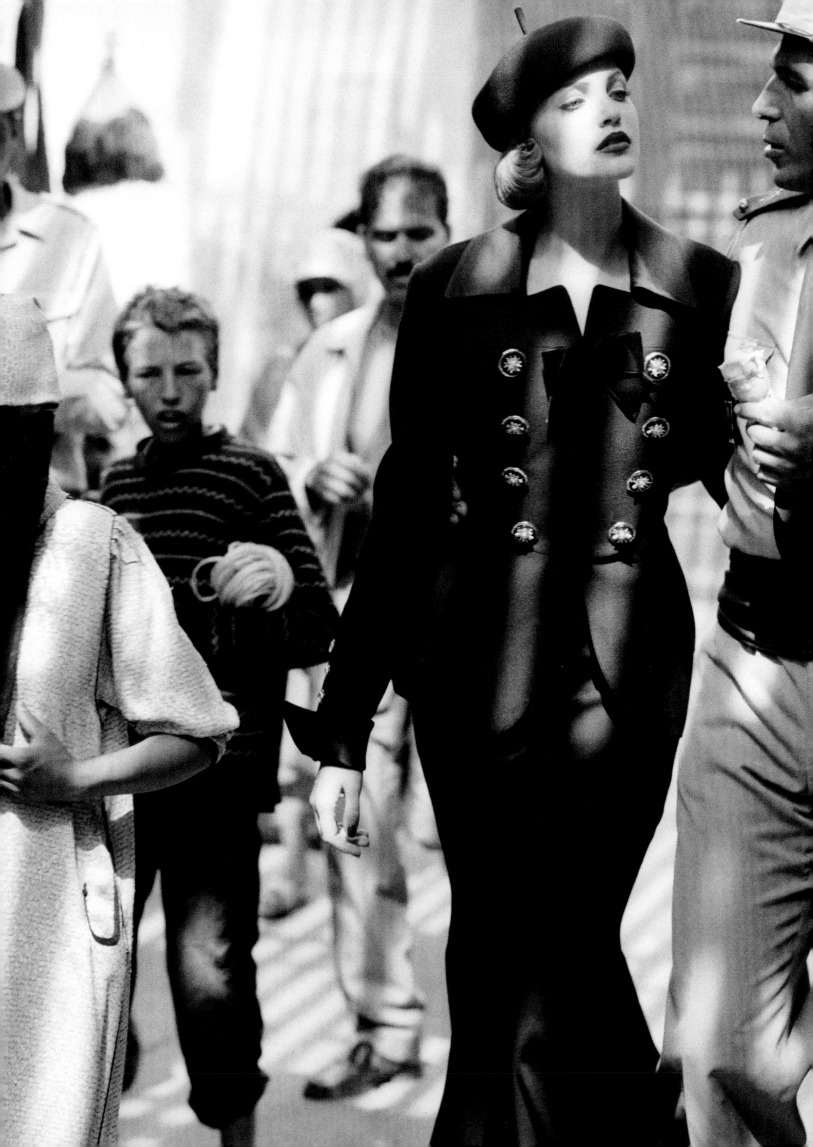

JUST WHAT WERE the qualities of Tangier that I found so irresistible when I first arrived here?...It takes a moment of intense effort for me to exist again in midsummer 1931, intoxicated by the sun-heated odor of fig trees, kelp, and gorse, or hypnotized by the chanting of peasant women on the road, backed by the soft sounds of wind in the cypresses and waves breaking on Merkala beach below. Such details, acting like a drug, furnished the constant sensation of excitement that I found so satisfying.

PAUL BOWLES, 1990 TANGIER DREAM

1992

German-born model Nadja Auermann bears a striking resemblance to Marlene Dietrich. To celebrate the star's distinctive style, *Vogue* sent Auermann to Marrakesh to re-create the aesthetic of Dietrich's first Hollywood film, *Morocco*. OPPOSITE PAGE: Auermann practices her poker face with a local. PREVIOUS PAGES: Auermann walks the ancient medina streets. FOLLOWING PAGES: She snaps a photo of a limber street performer.

Photographed by Ellen von Unwerth, September 1992

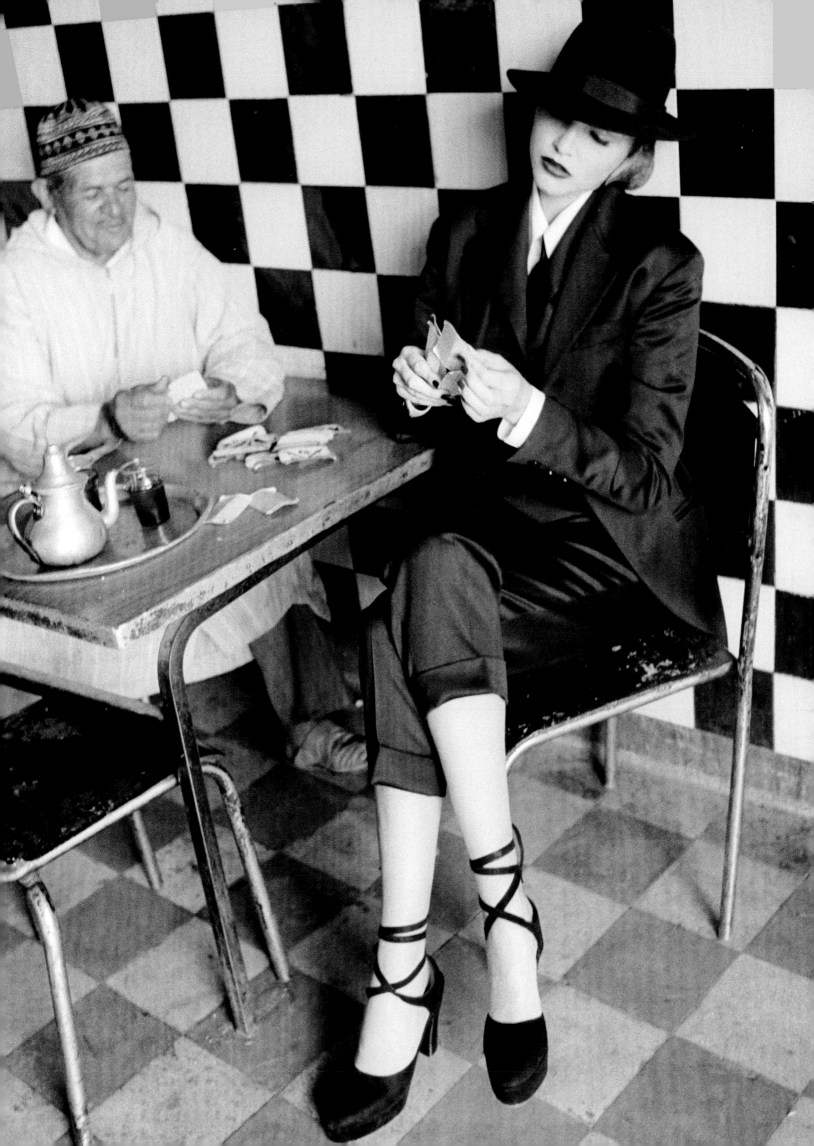

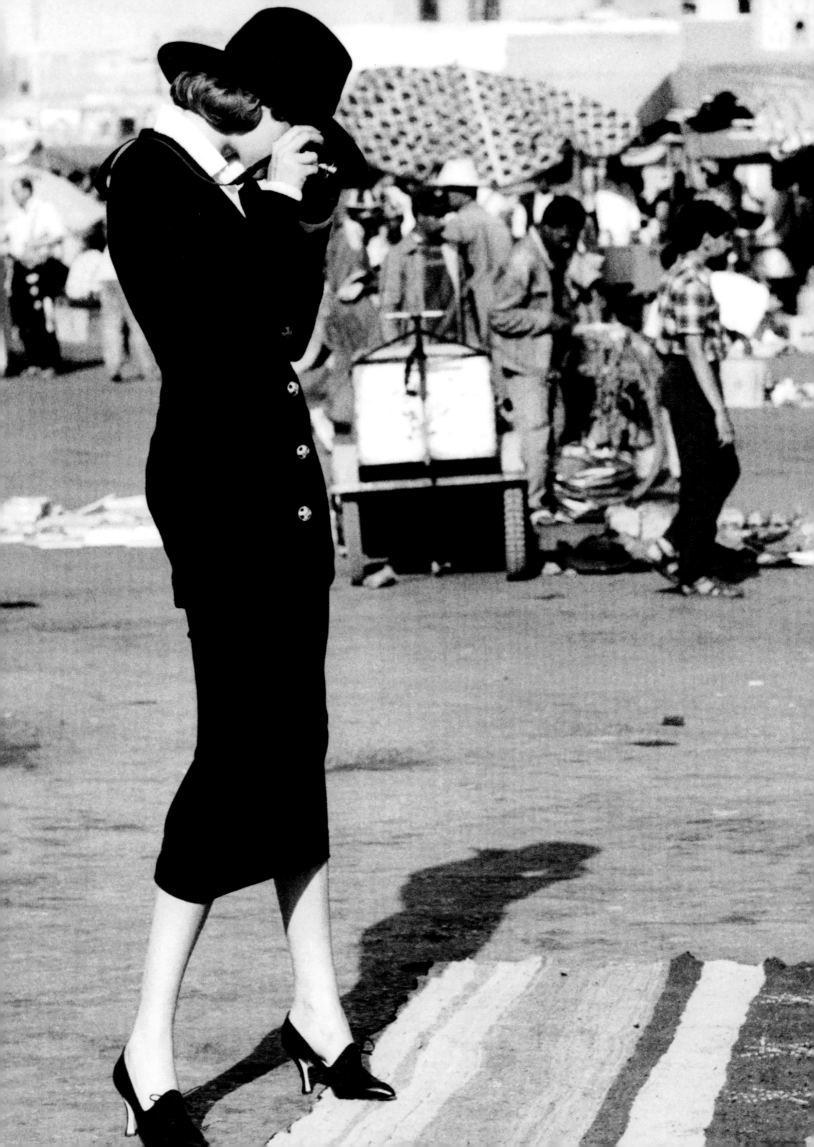

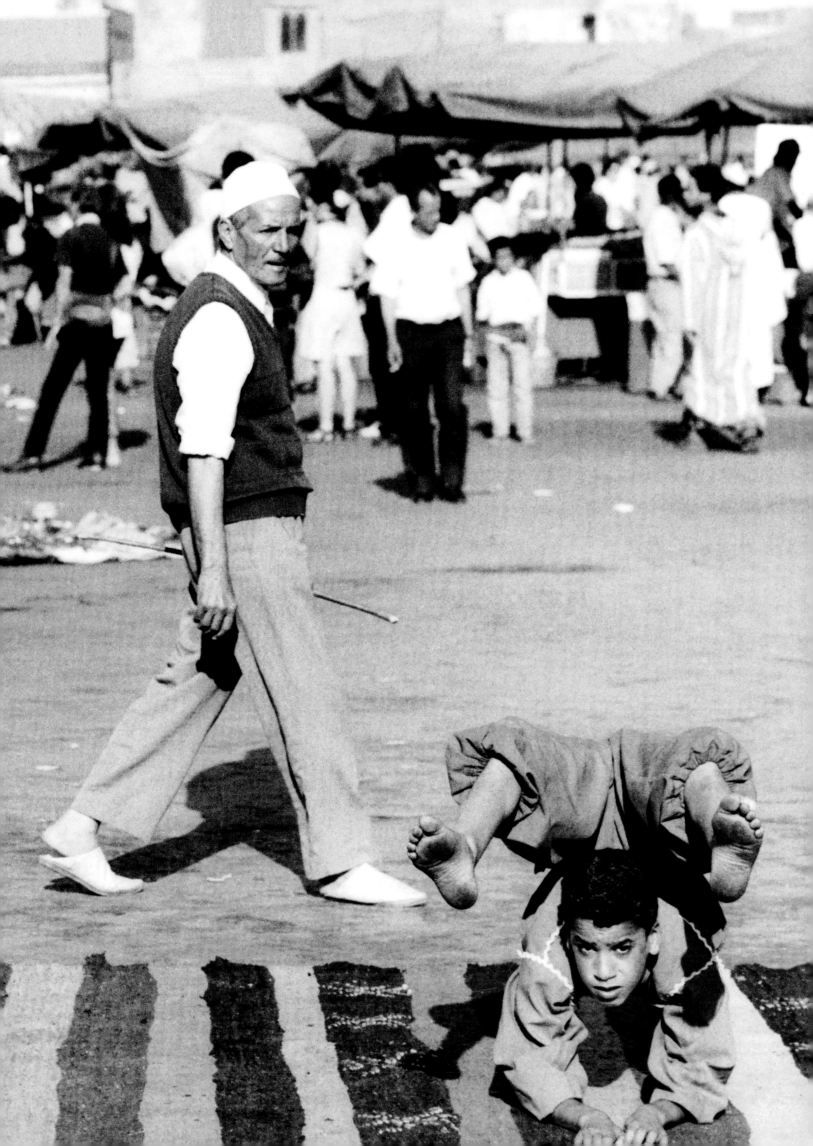

1991

Parisian haute couture
confections appear
on the streets of the city
where they were born.
OPPOSITE PAGE: Models
Deon Bray and Karen
Mulder promenade in,
respectively, Chanel
and Christian Lacroix.
FOLLOWING PAGES: Mulder
and Bray sip coffee in
tweedy Chanel suits.
Bray takes tea at the
Hôtel Raphael.

*Photographed by Ellen von
Unwerth, October 1991*

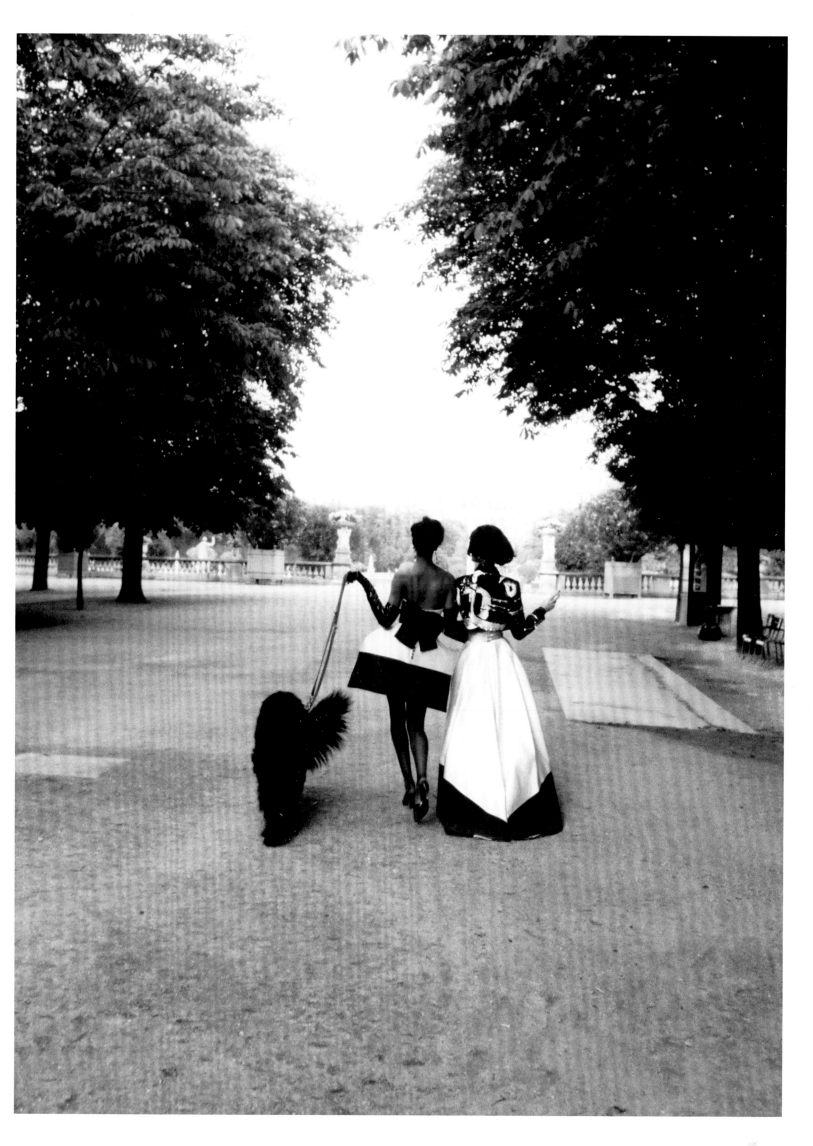

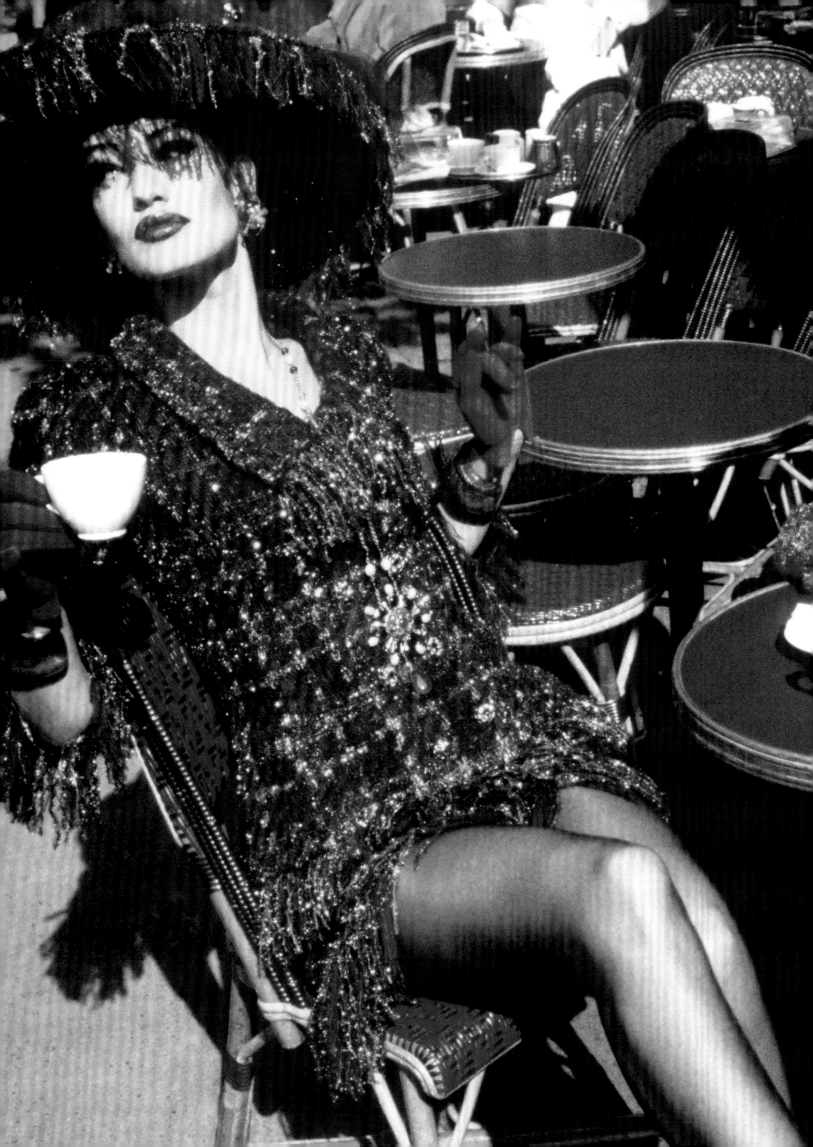

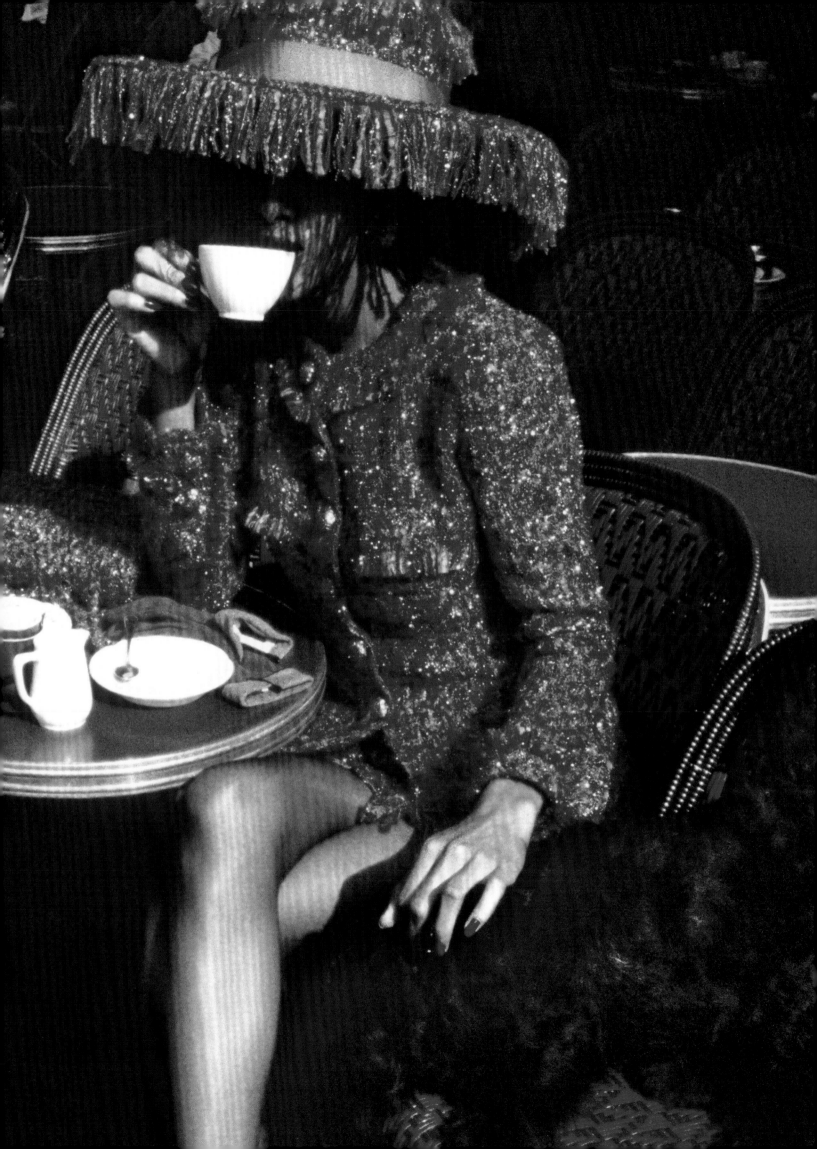

IN THE GATHERING DUSK, I stood on the sidewalk at 27, rue de Fleurus, near the Luxembourg Gardens, and peered up at the apartment where Gertrude Stein lived between the wars with Alice B. Toklas and where she welcomed Hemingway when he was twenty-two. I wondered whether his *cervelas* and potatoes were as good as they sounded, and how he could write so vividly about food without adjectives, adverbs, or commas....Seventy years have passed since Hemingway walked down to Brasserie Lipp, but his picture of life in the bars and bistros of Paris still has amazing power....I am convinced that the great two- and three-star restaurants of France, when they are at the top of their form, represent a pinnacle of human artistic achievement that makes the contents of the Louvre look pretty silly by comparison.

JEFFREY STEINGARTEN, 1990 **FOOD**

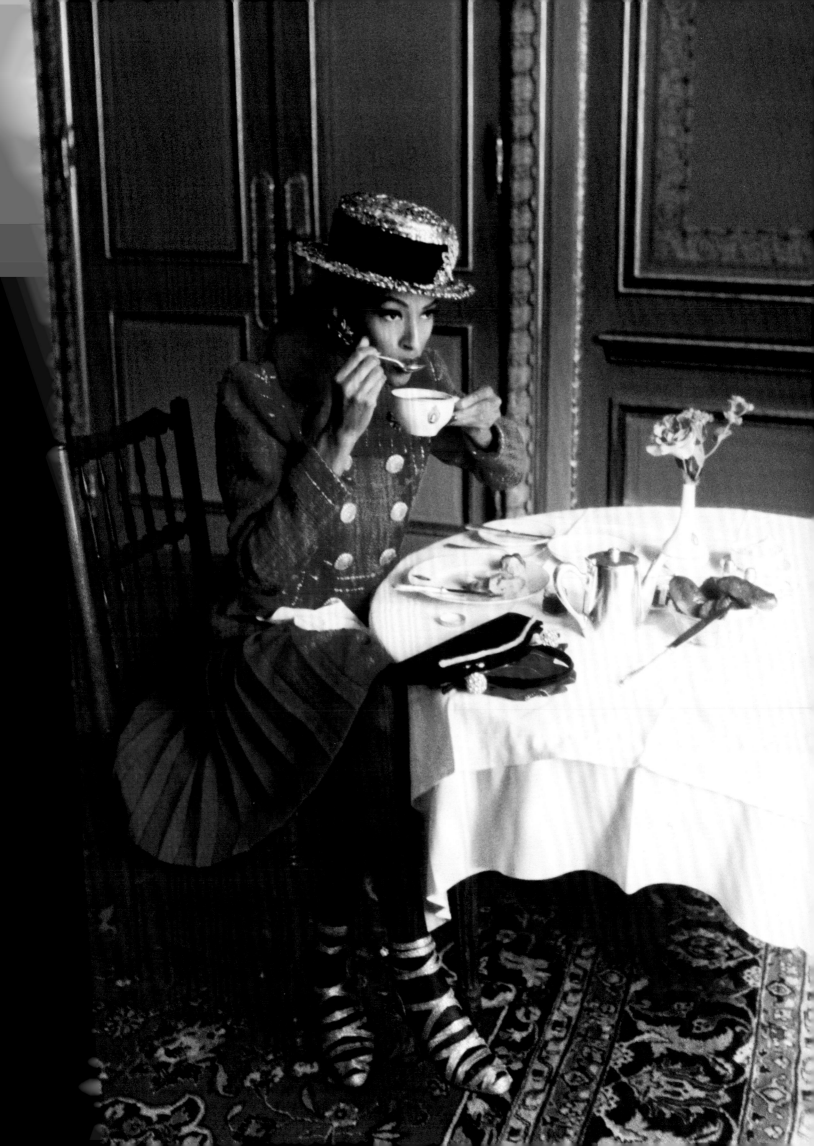

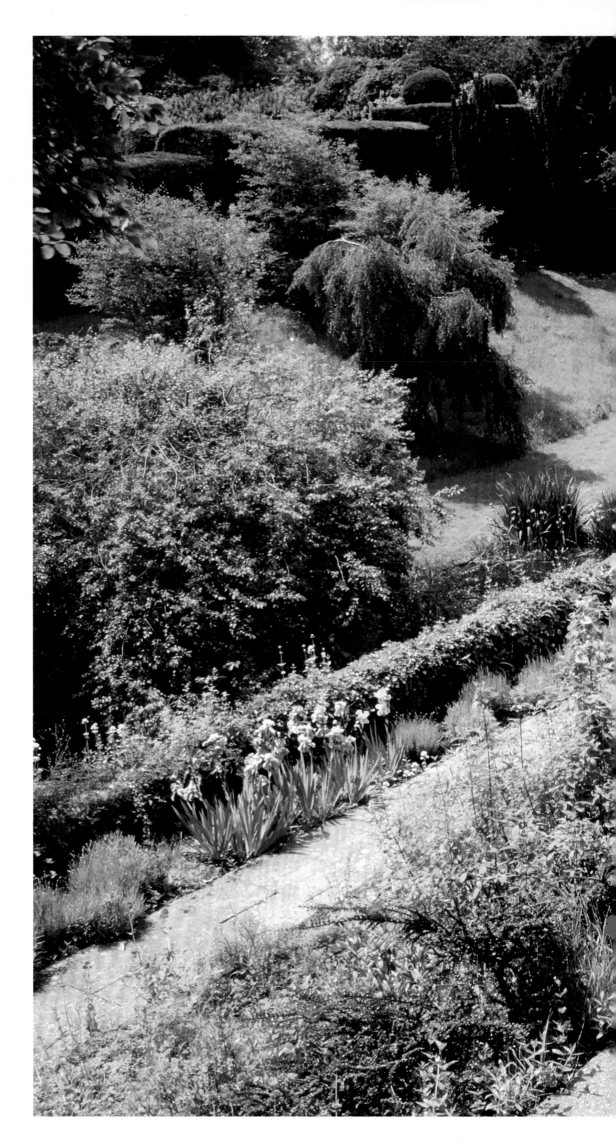

1991

A brook runs through
the grounds of Bryan
and Lucy Ferry's Sussex,
England, estate; the
gardens were originally
designed by celebrated
British architect Clough
Williams-Ellis in 1919.

Photographed by Eric Boman,
September 1991

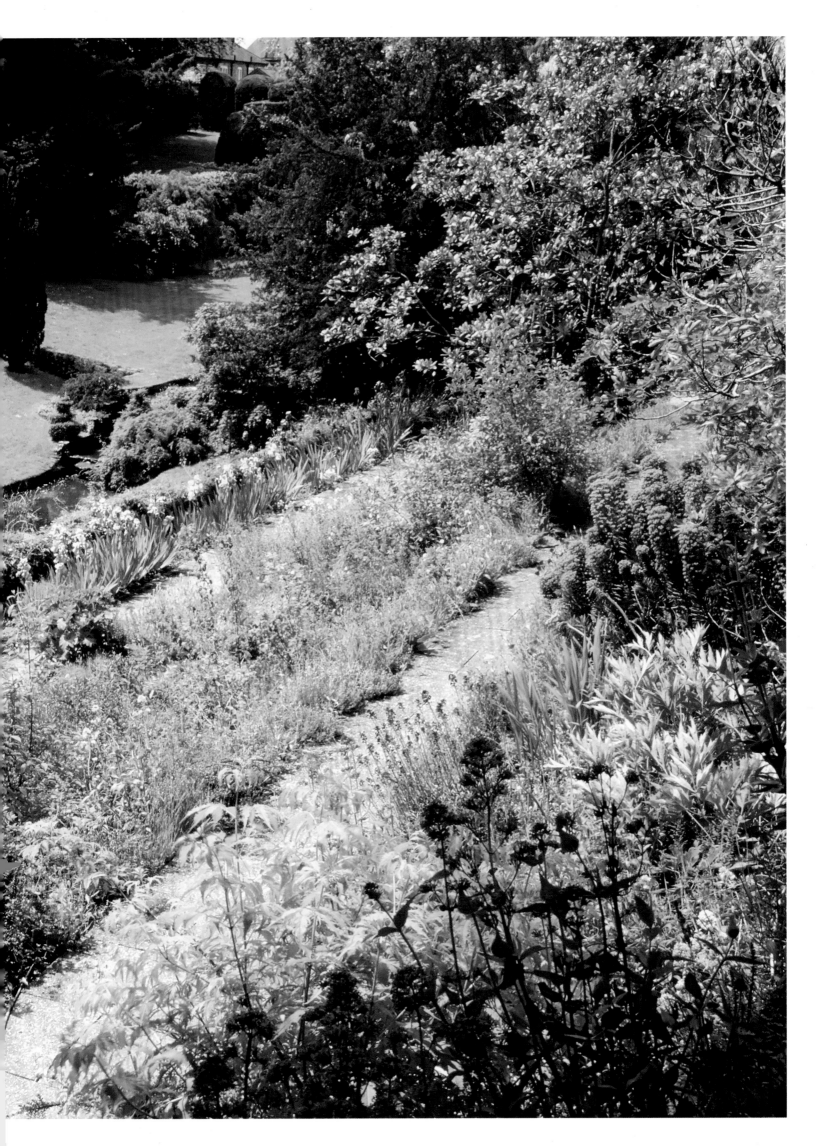

1991

Linda Evangelista hops through the Scottish Highlands from Cawdor Castle, the fabled home of the Macbeth clan, to Eilean Aigas, a private 60-acre island on the River Beauly. THIS PAGE: Evangelista scales the wrought-iron gate at Beaufort Castle. PREVIOUS PAGES: The model keeps in step. FOLLOWING PAGES: She teases a remarkably composed bagpipe player.

Photographed by Arthur Elgort, September 1991

5

2000 – 2019

The new millennium began with a tragedy that made the world seem a frightening and inaccessible place. Not only were many people afraid to fly in the wake of September 11, some were fearful of traveling, period. Ever-evolving security measures—multiple metal detectors, stringent on-flight liquid restrictions, shoe-removal requirements—made flying a complicated rather than an exhilarating experience. But despite the inconvenience that these precautions brought about, travelers still flew. In fact, they did so in record numbers, as U.S. airports saw the number of passenger boardings rise from some 700 million in 2003 to over a billion in 2018.

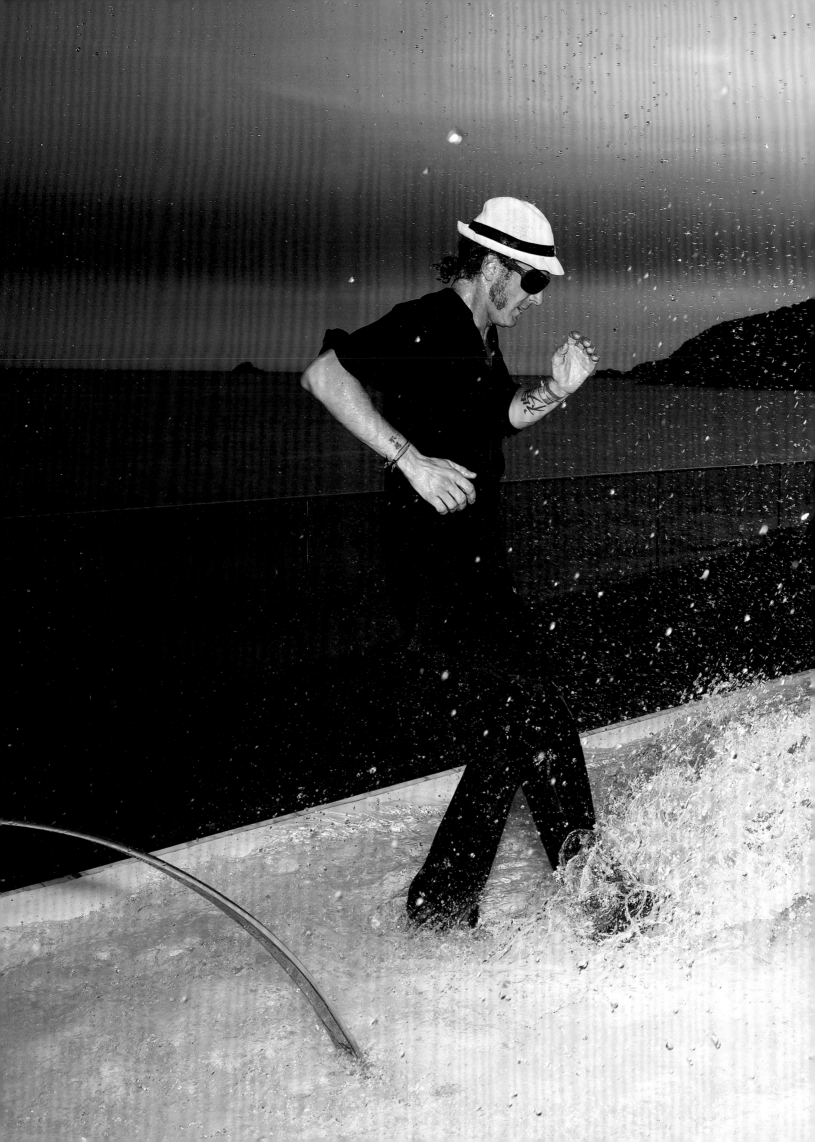

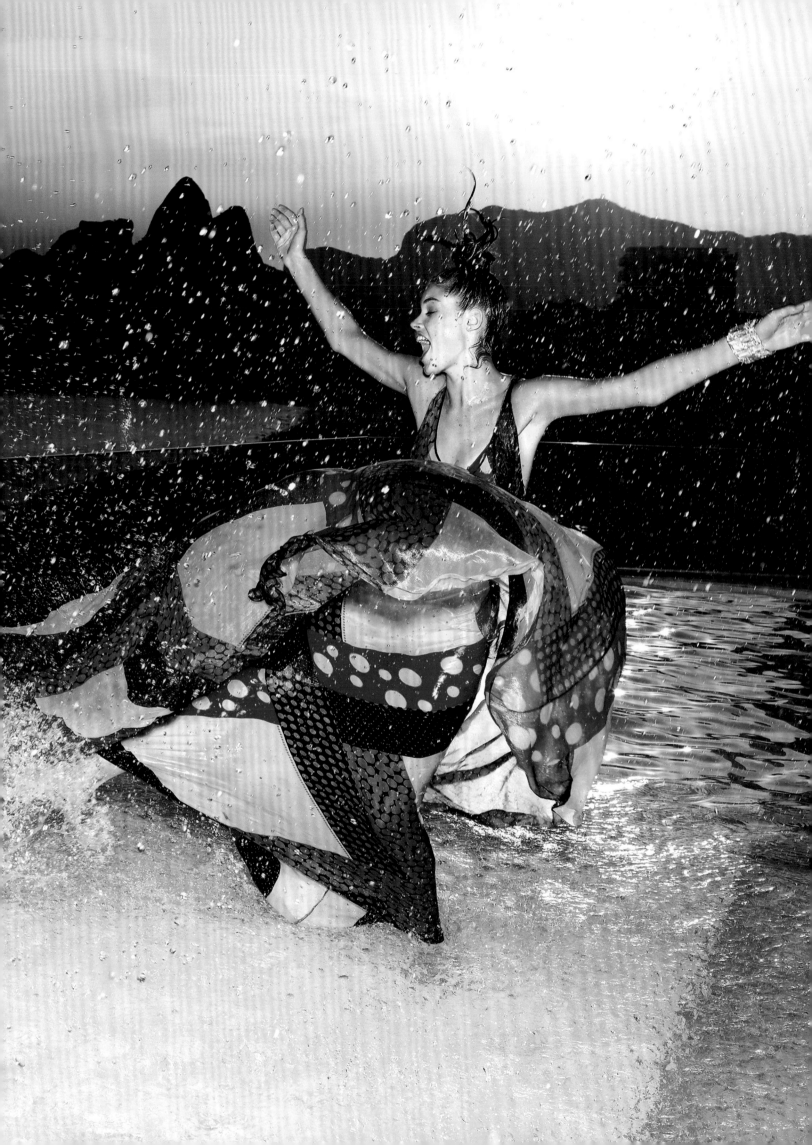

And *Vogue* continued to take readers to the places that, as fashion editor Tonne Goodman put it, "you don't know yet, but you know you *want* to know." As early as December 2001, *Vogue* transported its readers to Italy with "Roman Holiday," Mario Testino's quirky look at the Eternal City. In January 2002, writer and editor Hamish Bowles and photographer François Halard tracked an American family's move from New York to Oaxaca; March took Bowles and Arthur Elgort to Julio Iglesias's Balinese-style compound in the Dominican Republic; and April featured Karl Lagerfeld's own photos of his glamorous villa in Biarritz.

The Lagerfeld villa was one of many lifestyle stories that invited readers in the early part of the century to some of the world's most exquisite private homes and estates. Of course, the magazine had been doing this for decades, but a new energy was brought to these projects by Halard, a young French architectural and

2007

PREVIOUS PAGES: Lapo Elkann and model Doutzen Kroes splash around at the Hotel Fasano Rio de Janeiro. For this shoot, Elkann brought his own wardrobe— including vintage pieces from his grandfather, Italian industrialist and Fiat mogul Gianni Agnelli—to Brazil.

Photographed by Mario Testino, June 2007

interiors photographer who had been a protégé of Condé Nast's editorial director Alexander Liberman. ("The only advice [Liberman] ever gave me was to always try to surprise him," he said in 2013.) Halard's pictures often depicted stunningly grand estates, but he had a way of making them seem intimate and comfortable as well. This was a mode of photography that presented the humble wooden chair as prominently as the Gothic cathedral, the perfectly composed tablescape as carefully as Moroccan mosaics. If much of *Vogue's* on-location work had been about a kind of fleeting fantasy—the magical weekend jaunt, the whirlwind safari— Halard's photos offered perhaps the most captivating dream of all: that one might someday put down roots in one of the spectacular landscapes and cities and villages that the magazine was depicting, and make the place one's own.

Of course, the magazine still brought its readers to the realm of fantasy. Over the subsequent decade, *Vogue* photographers and editors would venture to Bahia and Bora Bora, Mali and Patagonia. "You never forget your first iceberg," wrote Rebecca Johnson on her 2008 trip to the glacial waters of Argentina. "Mine was the size of a Volkswagen Beetle but shaped like a regal swan with flying buttresses shooting out of her head."

The Peruvian-born photographer Mario Testino is probably most responsible for leading the way when it came to this type of expedition. Testino arrived at the magazine via the U.K., where he was known in the early 1990s for his fashion photography for British *Vogue*, but at American *Vogue*, he became famous for his location work. Fluent in five languages, with homes in London, Los Angeles, and Lima, he was always traveling. "They used to say that Mario 'follows the sun,'" said Ivan Shaw, who worked at the magazine between 1996 and 2016, ending his tenure as photography director. Testino's comfort in the

world was echoed by Goodman, a frequent collaborator: "I have seen Mario barter in the souk in Morocco, going back five times before he's willing to accept the deal." In a Testino photo, tired tourist scenes, like feeding the pigeons in Venice's Piazza San Marco, became elegant works of art, often enigmatic and sometimes slightly spooky. In another Venice image, masked men escort a model in a mink coat along a shadowy back canal. "I think he is better on location than in his studio," Grace Coddington has said of Testino. "The studio stifled him."

Another relative newcomer to *Vogue*, although hardly to the world of photography, was the legendary Annie Leibovitz. While she was perhaps best known for her portraits, at *Vogue* in the early twenty-first century she branched out with a new narrative style, which resulted in some remarkable productions. For the magazine's October 2001 issue, she proposed a re-creation of iconic images—using Ben Stiller, fresh from *Zoolander,* as a model. "I wasn't sure what she meant by this," wrote Anna Wintour in her editor's letter for the issue, "but in accordance with our tradition of letting creative genius have its head, I went along with the scheme." Among the images in Leibovitz's story: Stiller leaping in front of the Eiffel Tower just as Lauren Hutton did for Richard Avedon, Stiller floating above the Seine inside a giant plastic bubble in a composition reminiscent of photographer Melvin Sokolsky's indelible 1963 image.

For pure romance, it's hard to imagine a shoot more dreamy than Leibovitz's 2013 "Wild Irish Rose," which paired model Daria Werbowy with actor Adam Driver in a reinterpretation of the unrequited love between Irish poet W.B. Yeats and Irish patriot Maud Gonne amid the boulder-strewn lakefronts, dramatic cliffs, and impossibly green meadows of County Kerry in southwestern Ireland. The shoot was the idea of

Coddington, who was enchanted by the area when she visited Werbowy: The model lived part of the year in nearby West Cork with her carpenter partner. "We asked Daria whom she would like to be photographed with, and the answer was not her boyfriend, but Adam Driver, at the time a star of *Girls*," said Coddington. To fit in with, rather than detract from, the epic natural landscape, Coddington and Leibovitz agreed to forgo hair and makeup. "We wanted to strip things down to bare essentials," Coddington said. "It was supposed to be very real."

But perhaps Leibovitz's most spectacular on-location outing was "Teen Queen" (2006), which she shot at one of the world's most lavish and historic locations: Louis XIV's royal palace at Versailles, just outside Paris—the first fashion shoot authorized by the Château de Versailles in 25 years. For her story, Leibovitz recruited Kirsten Dunst, Jason Schwartzman, and Jamie Dornan, the stars of Sofia Coppola's film *Marie Antoinette*, and re-created the divinely decadent world of eighteenth-century France with its gossip, its games, its treachery. The costumes, however, were updated, with some of the world's top designers offering custom creations for the shoot. "Whether we're shooting models or actors, working with Annie Leibovitz is like making a major movie," commented Coddington. "And she is very much that movie's director." The Versailles shoot may be the ultimate case in point. Marie Antoinette no doubt would have approved.

From the royal court of eighteenth-century France to the family village in Kenya of actress Lupita Nyong'o to a secret sculpture garden in a jungle in the middle of Mexico—these are just a few of the places that have lured *Vogue*'s editors and photographers in recent decades. What is it that continues to propel the magazine to the far corners of the world? Call it restlessness, call it wanderlust, or simply call it curiosity—the same spirit of adventure that seduced the great explorers of centuries past. Or, as Goodman put it, "It's the insatiable quest for something that is new and inspirational. It's not really what you can put your hands on, it's what you would love to put your hands on." *Vogue* has been doing just that for a century, tantalizing readers with a vicarious experience of beauty and adventure, often no less—and sometimes more—potent than the real thing.

Over the decades, *Vogue* has empowered women to go beyond the dream and to actually take off to many of the locations it has covered. And while not every woman is an Amelia Earhart, there's a bit of Amelia Earhart in the *Vogue* woman: pioneering, strong, and ready for adventure. When the magazine wrote of the famous female pilot in the 1930s, it cautioned against clothing that would not suit the practicalities of flying an airplane and warned that airplane controls were designed for men. Today, as the more recent chapters of this book attest, no such limits exist.

2009

On designer Gela Nash-Taylor's estate, South Wraxall Manor in Wiltshire, England, a peacock perches in an acacia tree.

Photographed by François Halard, September 2009

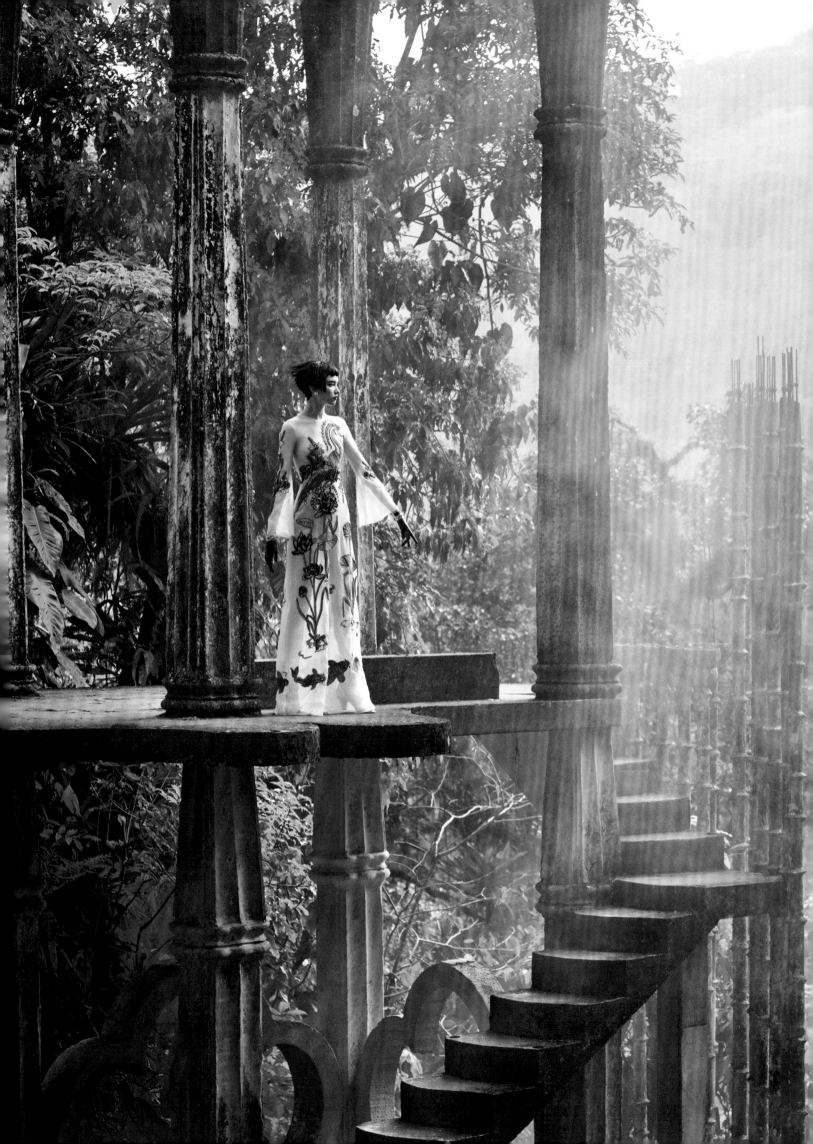

2016

In the mountains of central Mexico lies Las Pozas, a preserve of Surrealist sculptures by poet Edward James, which he conceived in the late '40s. OPPOSITE PAGE: Model Grace Hartzel walks with parrots. PREVIOUS PAGES: She poses atop a staircase to nowhere. FOLLOWING PAGES: Hartzel explores the jungle.

Photographed by Mikael Jansson, April 2016

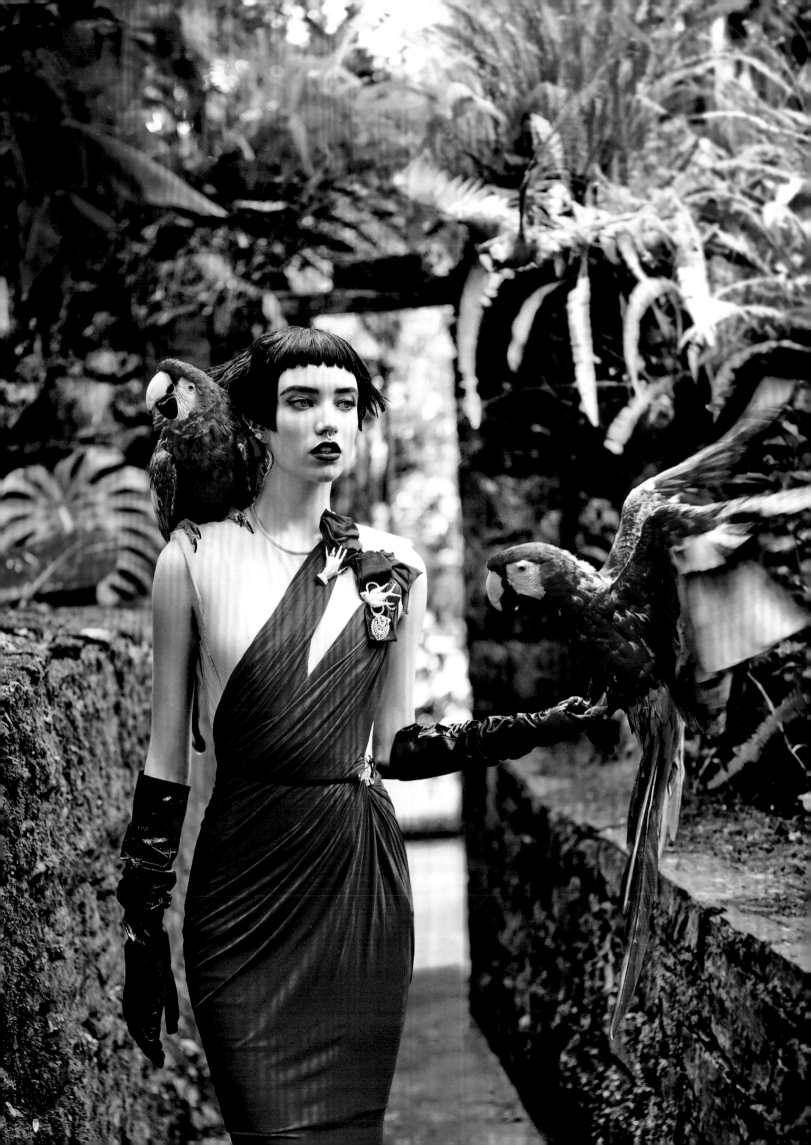

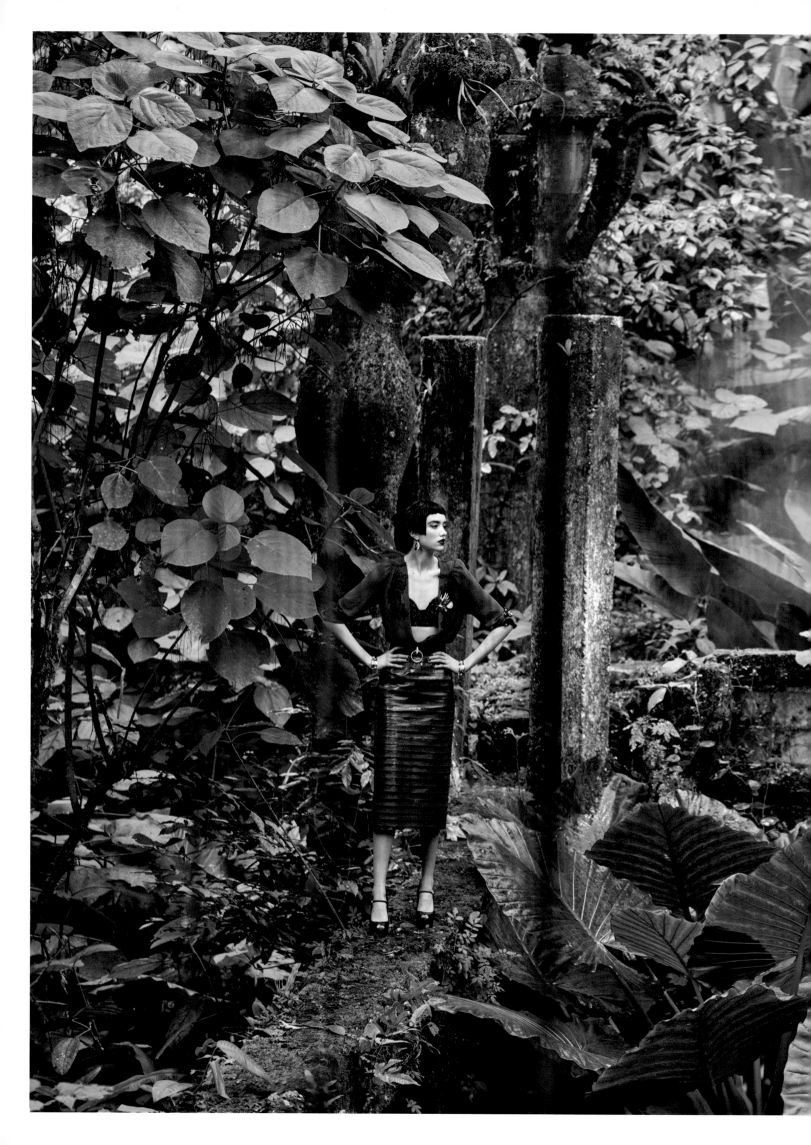

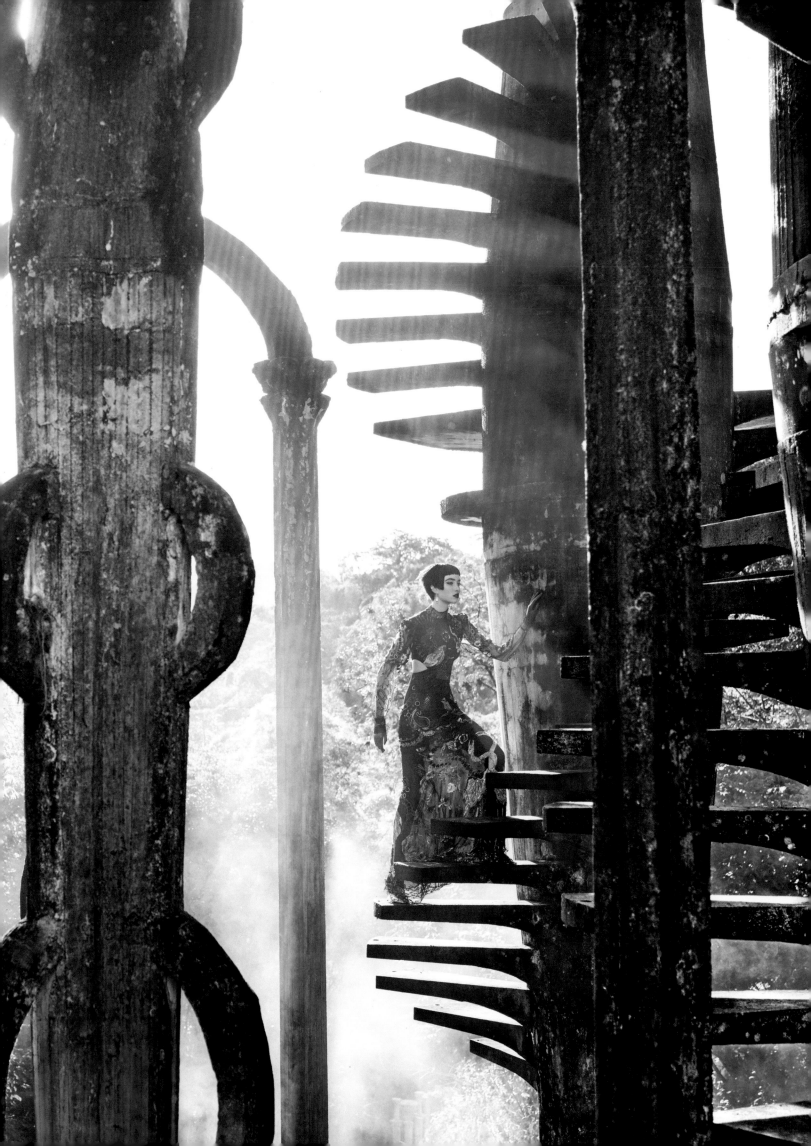

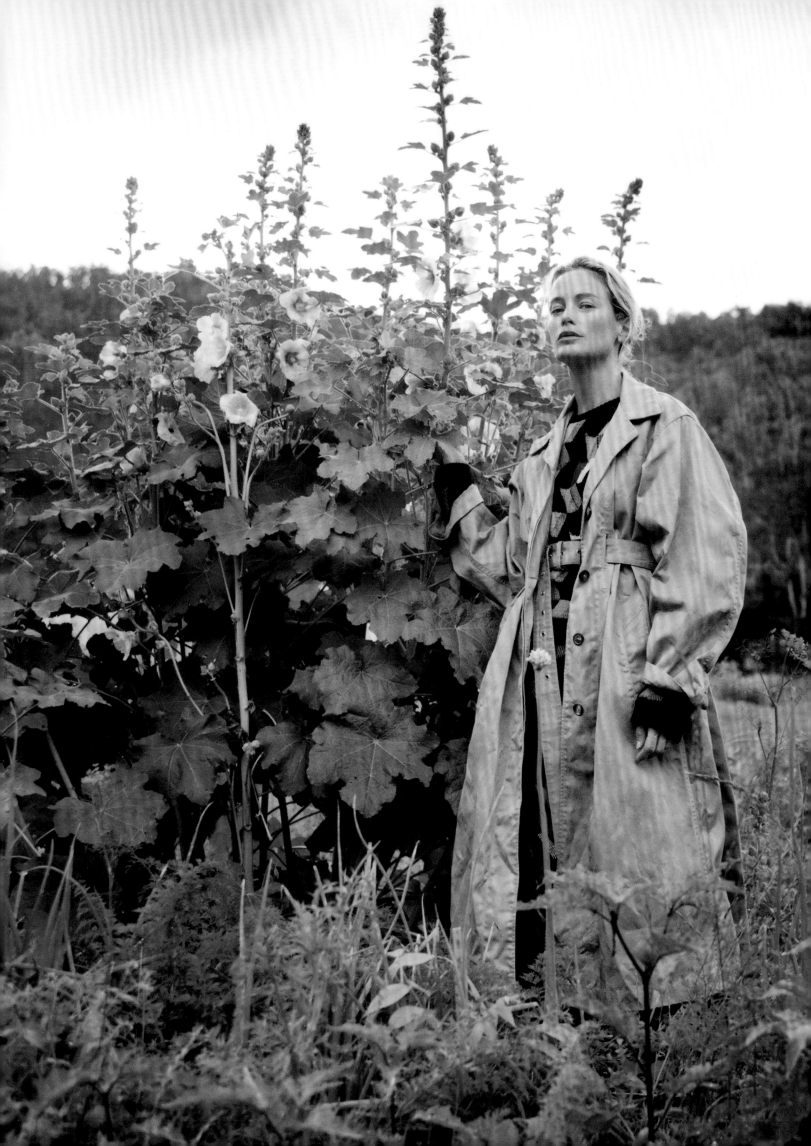

2017

For "The Road Home," *Vogue* shot American models against the varied landscapes of the U.S. THIS PAGE: Amber Valletta in the open fields of Oklahoma. PREVIOUS PAGES: Carolyn Murphy amid lush greenery in Tennessee. FOLLOWING PAGES: Selena Forrest in the Louisiana bayou.

Photographed by Zoe Ghertner, September 2017

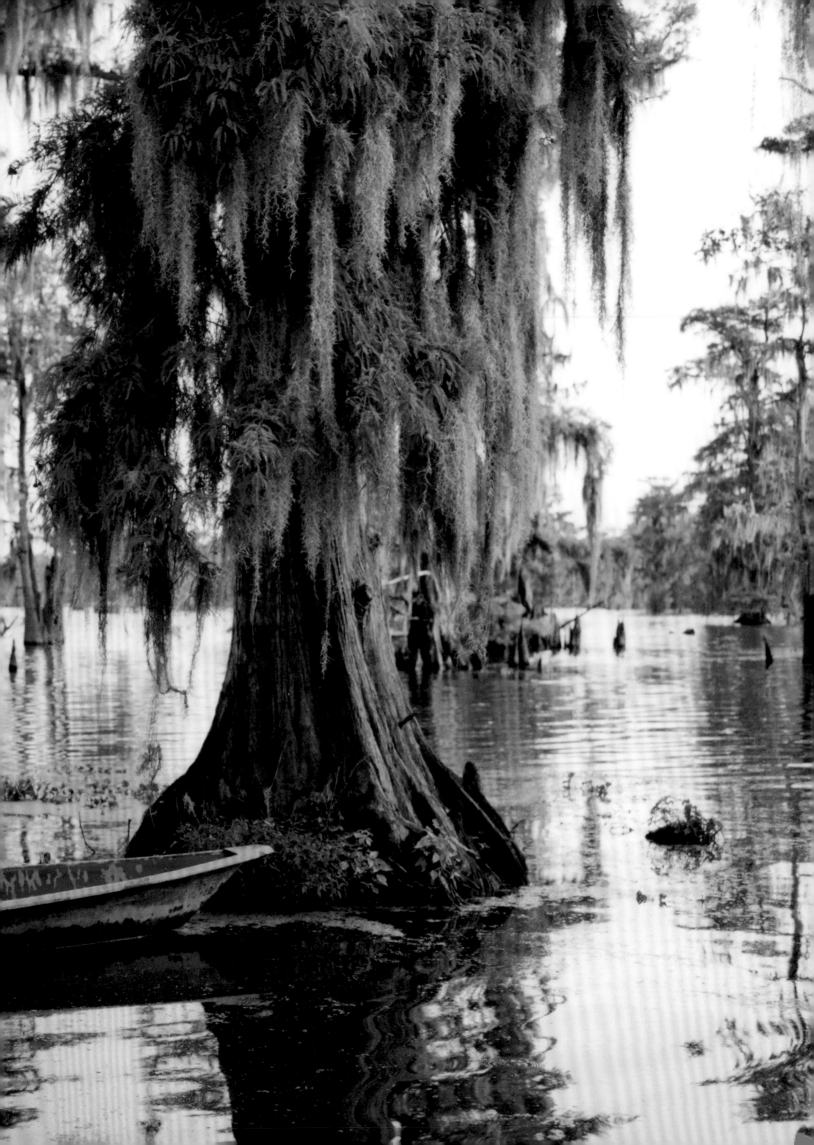

IN MAINE, NIGHT SKIES ARE INKY BLACK and shot with stars. My four-year-old can find the Milky Way, and she talks about the time we freed a bat from a bell jar and coaxed him out of the house. In Manhattan, lettuce comes in a bag, flowers come from the deli. We don't have a car, so we don't listen to the radio. In Maine, I drive and the girls hear country and classic rock. Recently, in a Manhattan taxicab, Caroline heard "Thunder Road," looked at me, and said, "Bruce?"

MARINA RUST, 2006 MAINE ATTRACTION

2006

"My husband calls the island a matriarchy," Marina Rust writes of her family property in Penobscot Bay, Maine, which has seen five generations of female caretakers. THIS PAGE: The local harbor. PREVIOUS PAGES: Rust's daughter steps out of the house, Bird Cottage, built in 1899.
Photographed by François Halard, June 2006

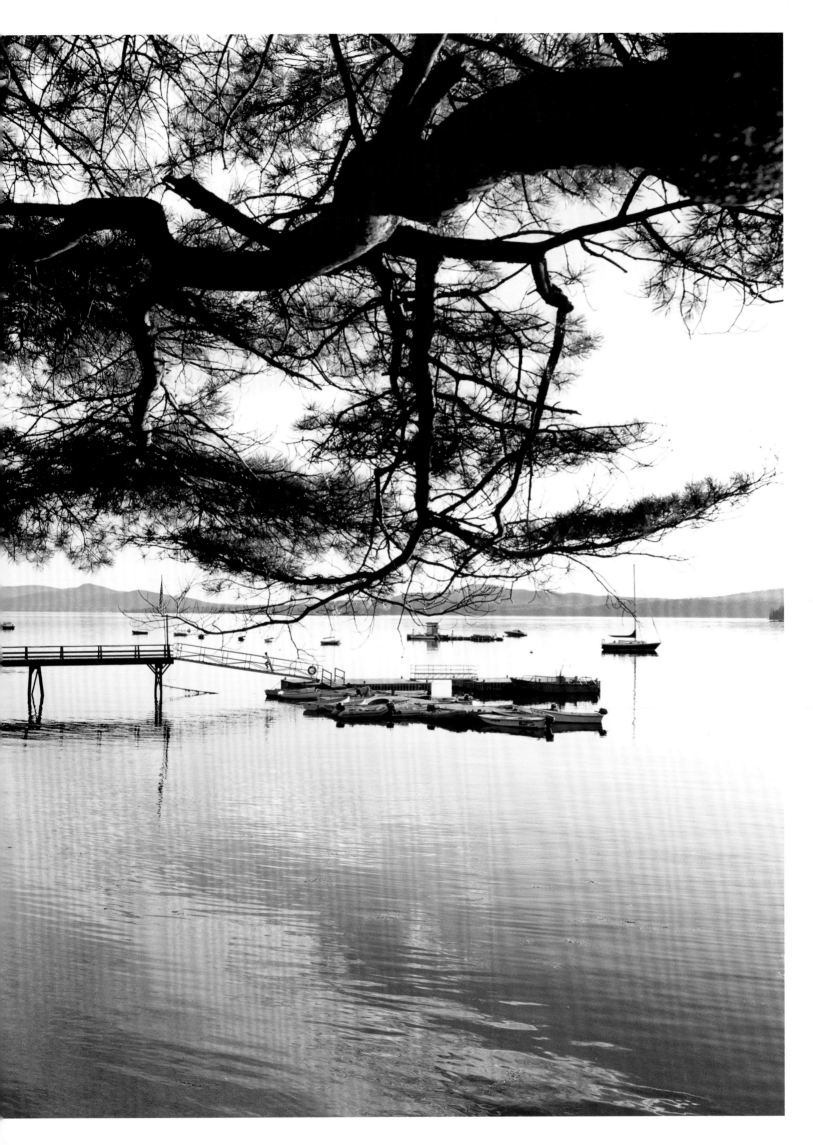

2014

Environmentally minded landscape designer Edwina von Gal let nature run wild in this verbena-and-lily-filled garden in East Hampton, New York.

Photographed by Allan Pollok-Morris, December 2014

2018

"This is not one garden; it is multiple gardens, moods, and scenes," Plum Sykes writes of Viscountess Rothermere's grand English estate. THIS PAGE: Claudia Rothermere (CENTER) poses on horseback with daughters (FROM LEFT) Theodora, Iris, and Eleanor. FOLLOWING PAGES: A loggia overlooks a trout pound.

Photographed by Simon Upton, December 2018

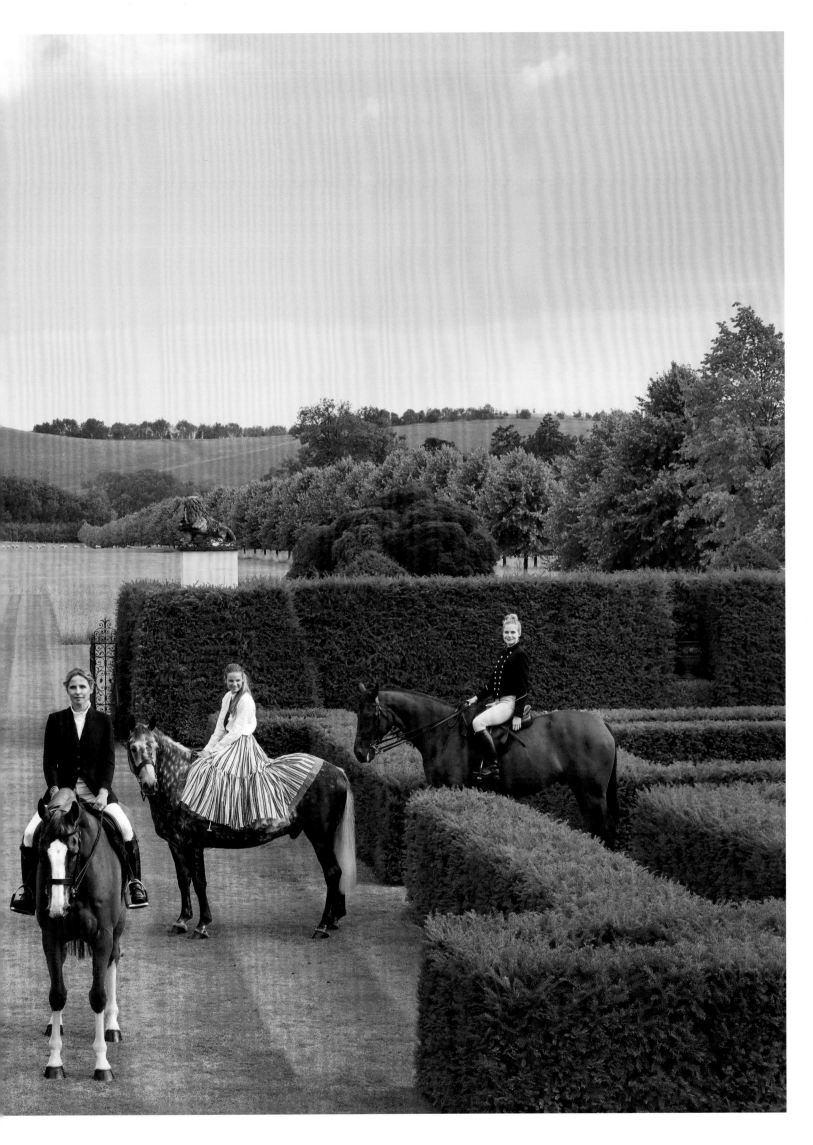

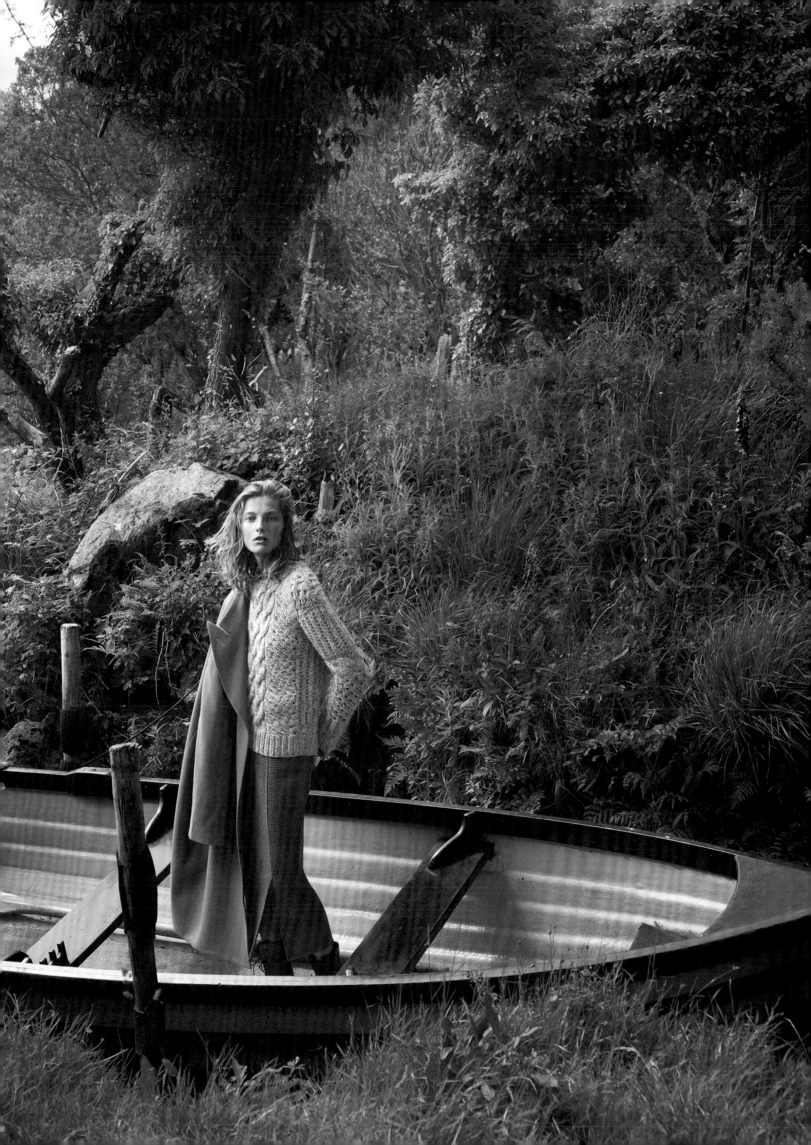

2013

THIS PAGE AND PREVIOUS PAGES:
Inspired by the verse of
W.B. Yeats, actor Adam
Driver and model Daria
Werbowy re-create the
epic unrequited romance
between the great Irish
poet and the Irish patriot
Maud Gonne against
the dramatic backdrop of
County Kerry, Ireland.

*Photographed by Annie Leibovitz,
September 2013*

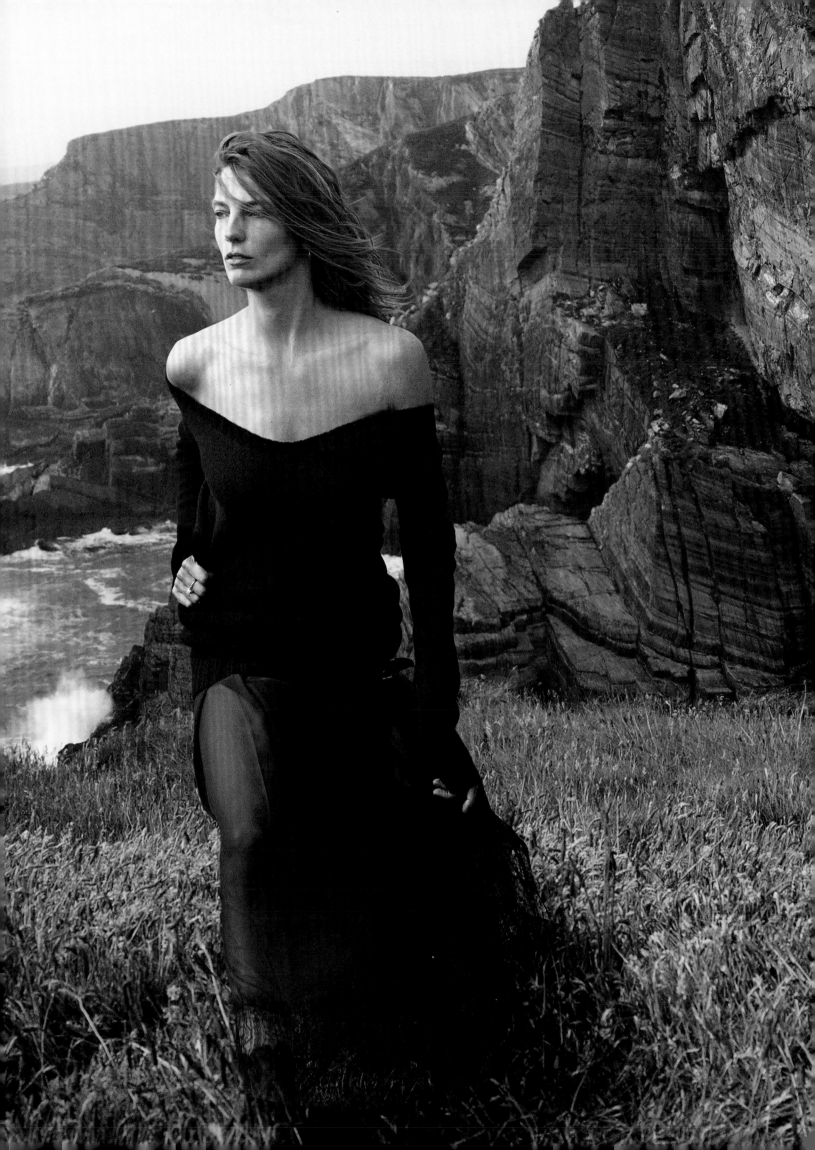

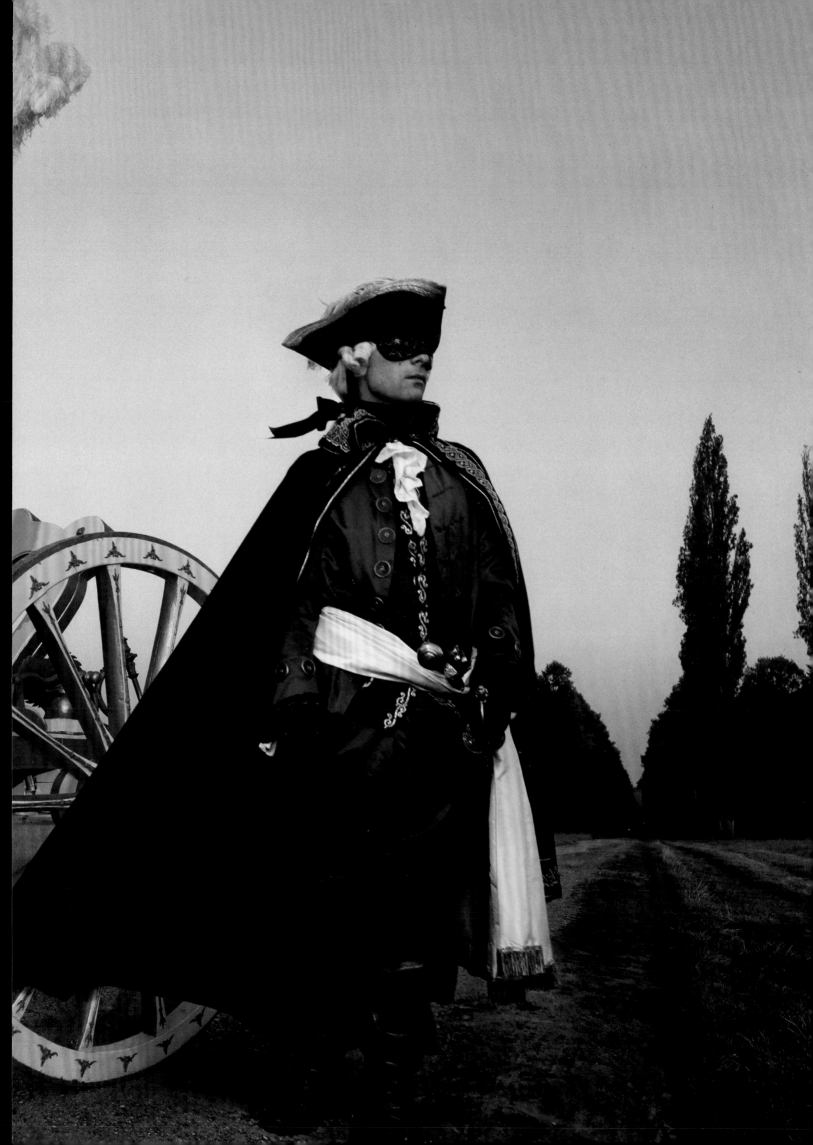

NOTHING COULD PREPARE an outsider for living with the rigid etiquette of Versailles. In a strictly hierarchical system of absolute monarchy, all power derived from the king, who was next in line to God. Everything at the palace was designed to awe. The facade with its huge balconied windows was a quarter-mile long, and its famous mirrored gallery was more like a stage or a street for deities than an ordinary room. An emasculated nobility had to hang out, cap in hand, in hopes of catching the king's attention (or that of his official mistress) and begging for favors and pensions. Power was reflected in the smallest ritual and gesture. The presence at the humblest human activities of the monarch—dressing, undressing for bed, eating a meal, using a candle or the chamber pot—was an honor for the courtiers and a chance for them to be rewarded for their subservience. Young Marie Antoinette found herself shivering in the cold while princesses of the blood fought over the right to pass her the royal undergarments. Like box hedges on the move, the ladies squeezed into her apartments in panniered skirts to watch circles of quite unnecessary rouge applied to her pink-and-white cheeks.

KENNEDY FRASER, 2006 **TEEN QUEEN**

2006

In Sofia Coppola's *Marie Antoinette*, Kirsten Dunst starred as the monarch. Here, she revisits the role. OPPOSITE PAGE: The actress at the peristyle of the Palace's Grand Trianon. PREVIOUS PAGES: She steps out of a gilded carriage with Louis XVI, played by Jason Schwartzman. FOLLOWING PAGES: Dunst poses in front of the Grand Canal.

Photographed by Annie Leibovitz, September 2006

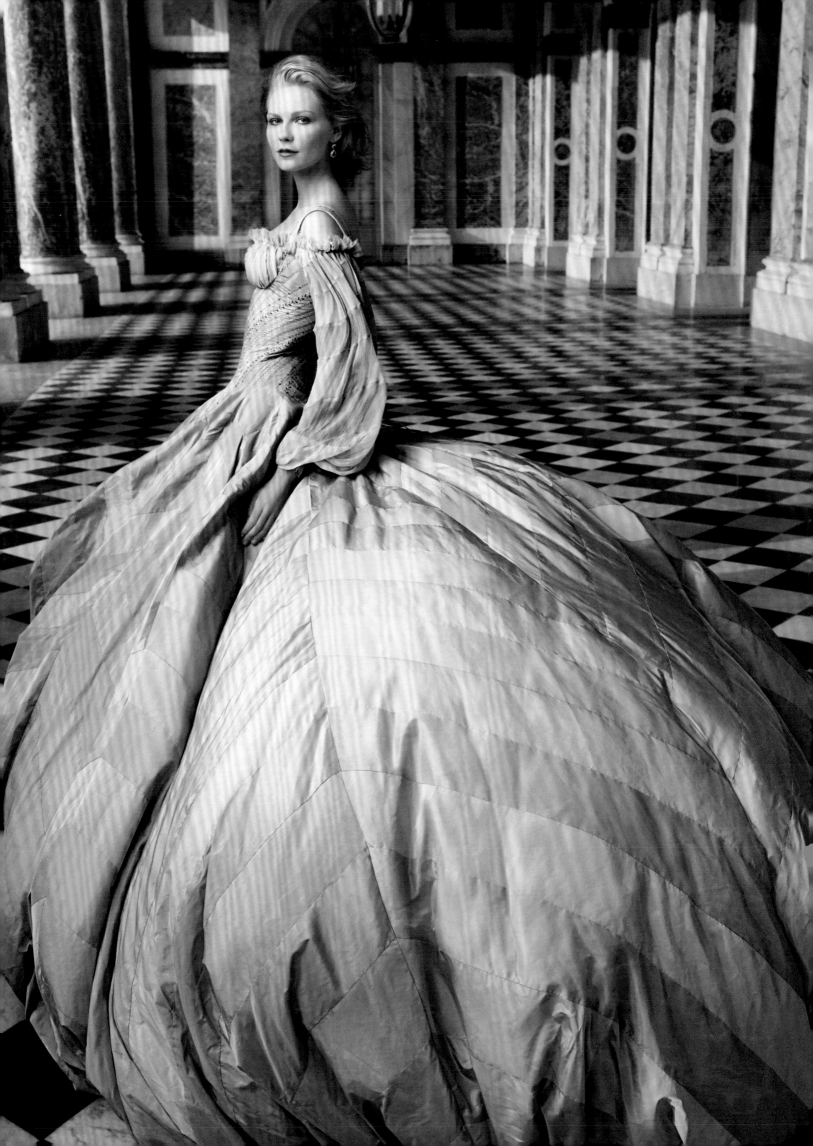

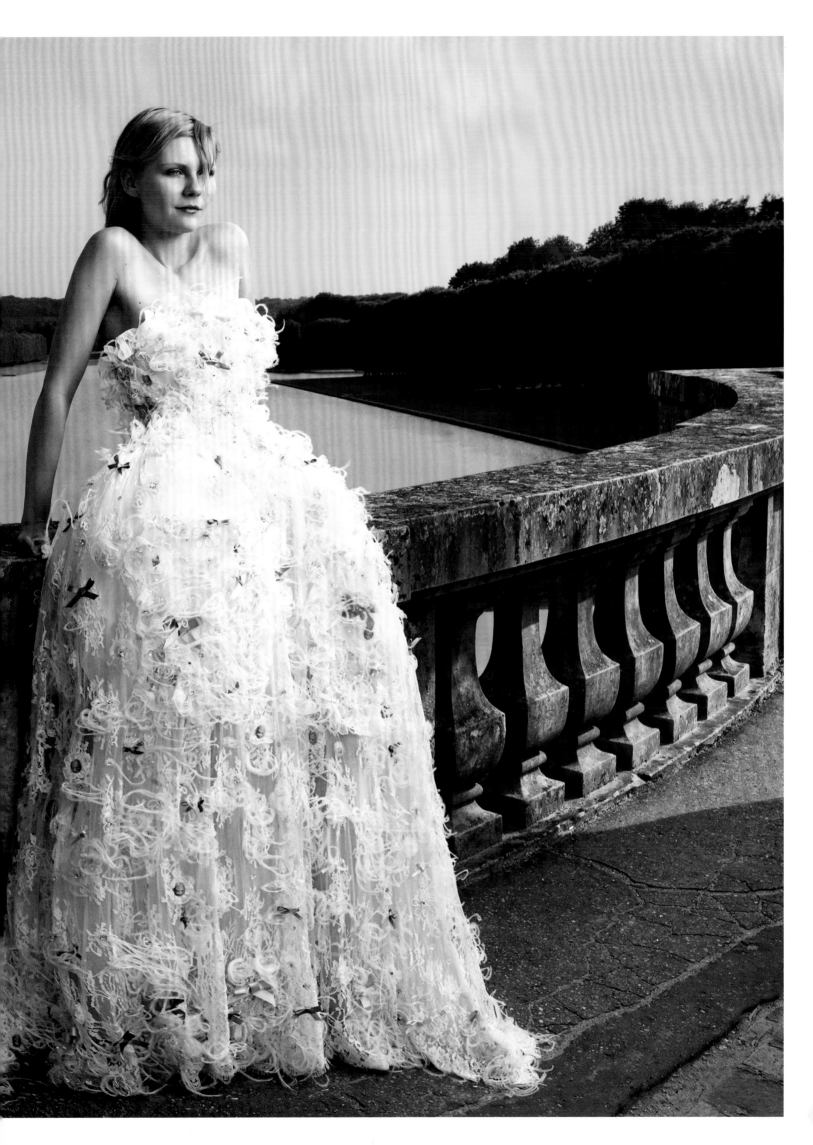

THE RITZ PARIS HAS ALWAYS been a symbol of comfort and celebrity and that special hard-diamond glitter that only chandeliers (rigorously rinsed of dust and thumbprints) can radiate. It was always a hotel where Americans could break into English with the staff without hesitation. The bar in the winter and the adjoining terrace in the summer even felt geographically as if they were mid-Atlantic—as casual as a posh American country club and as elegant as an Yves Saint Laurent showroom....

Proust often dined alone at the Ritz, though he also hosted large dinners there. Several of his friends, unable to heat their huge town houses during World War I, moved into the hotel full time. As Ghislain de Diesbach wrote, "In this gray Paris during the third year of the hostilities, the Ritz was like a great ocean liner de luxe in the midst of the fog of the North Atlantic."

EDMUND WHITE, 2012 CHECKING OUT: A PLACE IN HISTORY

2012

Before the Ritz Paris closed for a four-year renovation, *Vogue* shot its storied interiors one last time with Kate Moss. OPPOSITE PAGE AND FOLLOWING PAGES: Moss poses in the gilded rooms.

Photographed by Tim Walker, April 2012

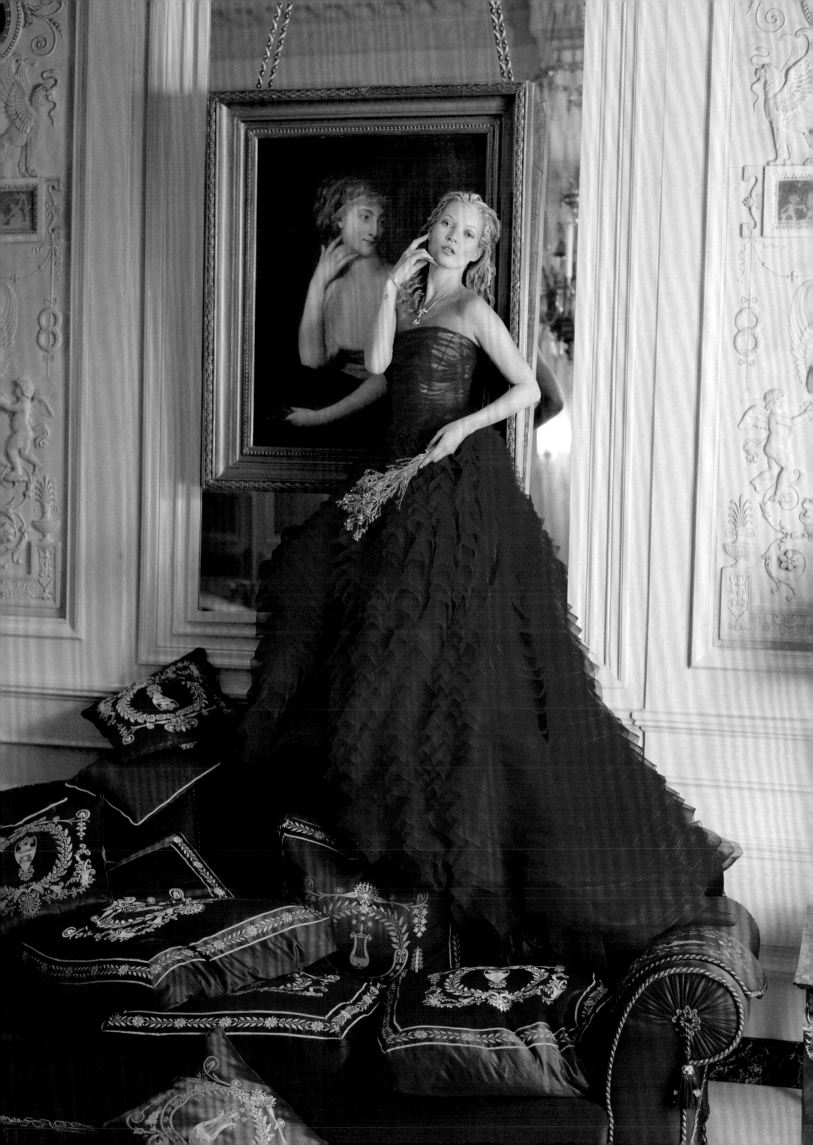

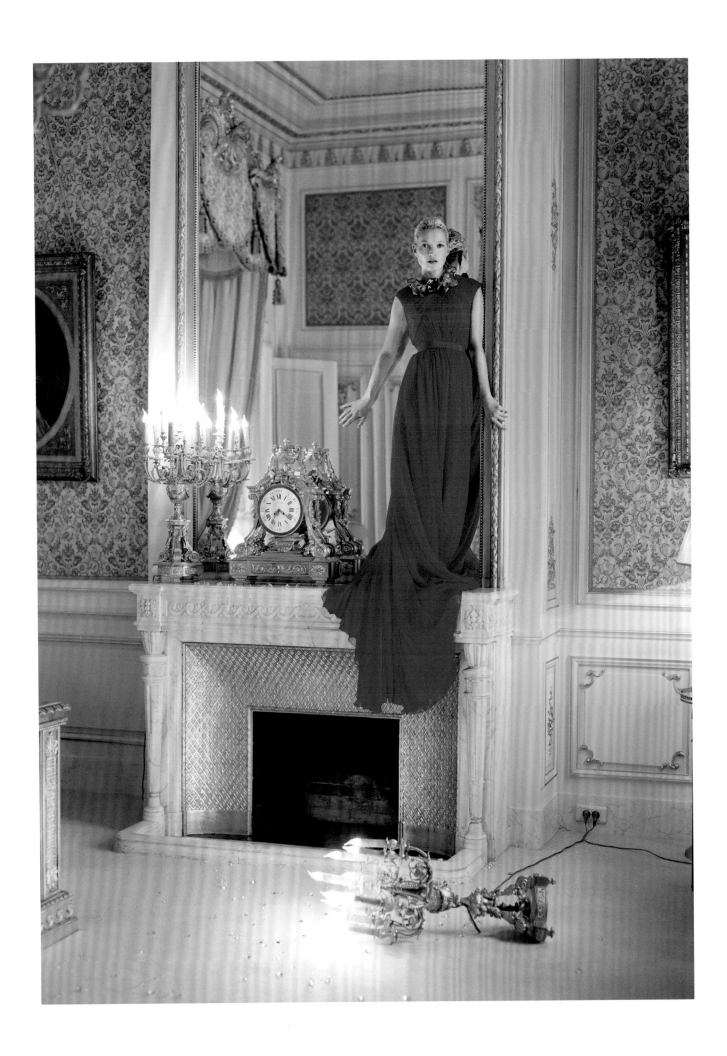

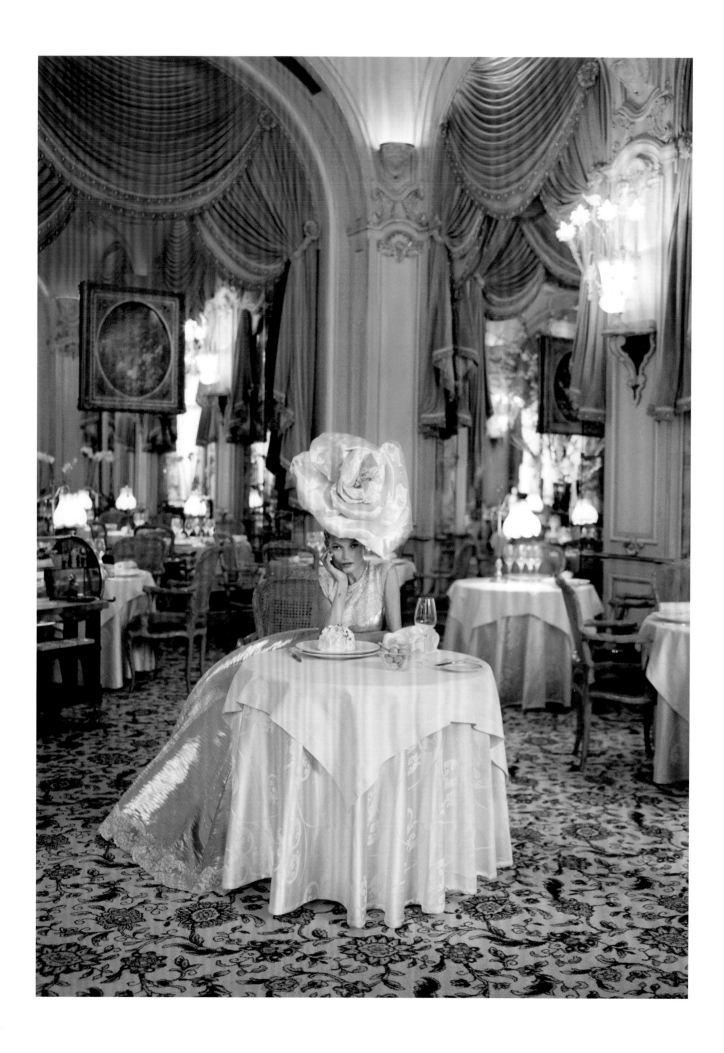

Ritz Paris housekeeper
Khadidja Fakri helps Kate
Moss with her Dior Haute
Couture dress while Lollie
Bacete looks on.

Photographed by
Tim Walker, April 2012

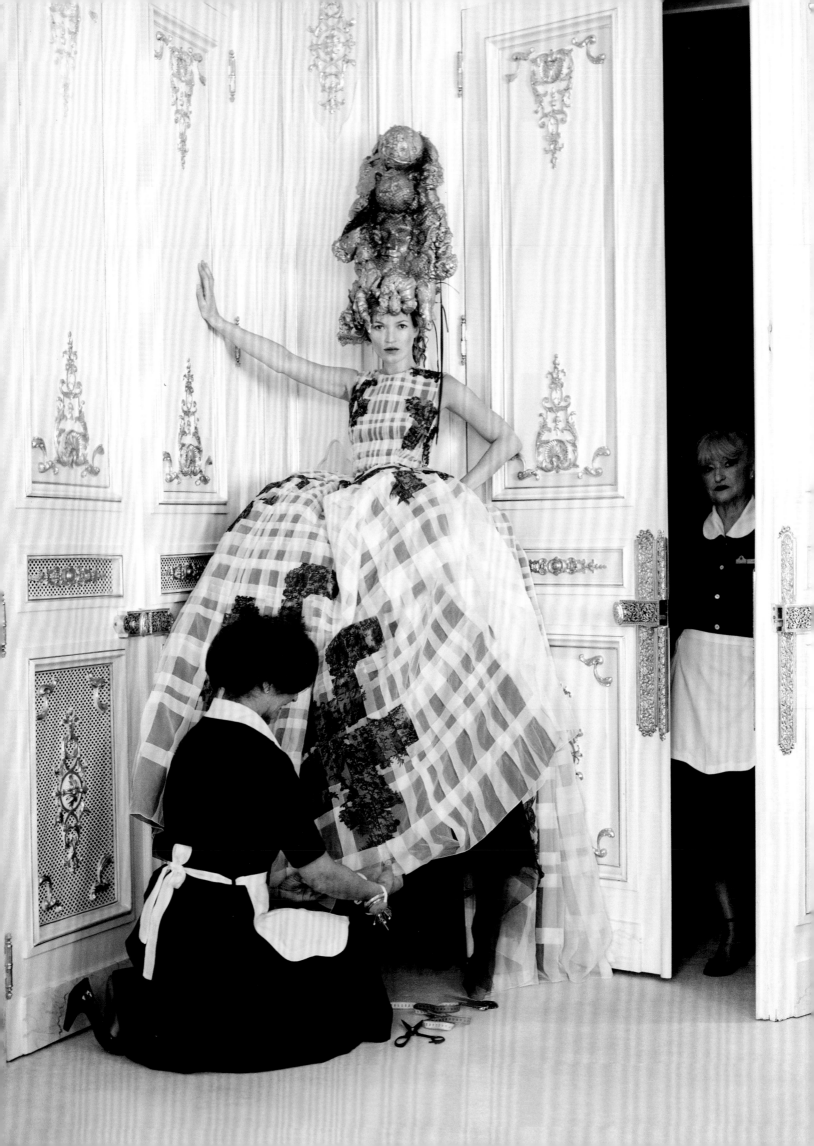

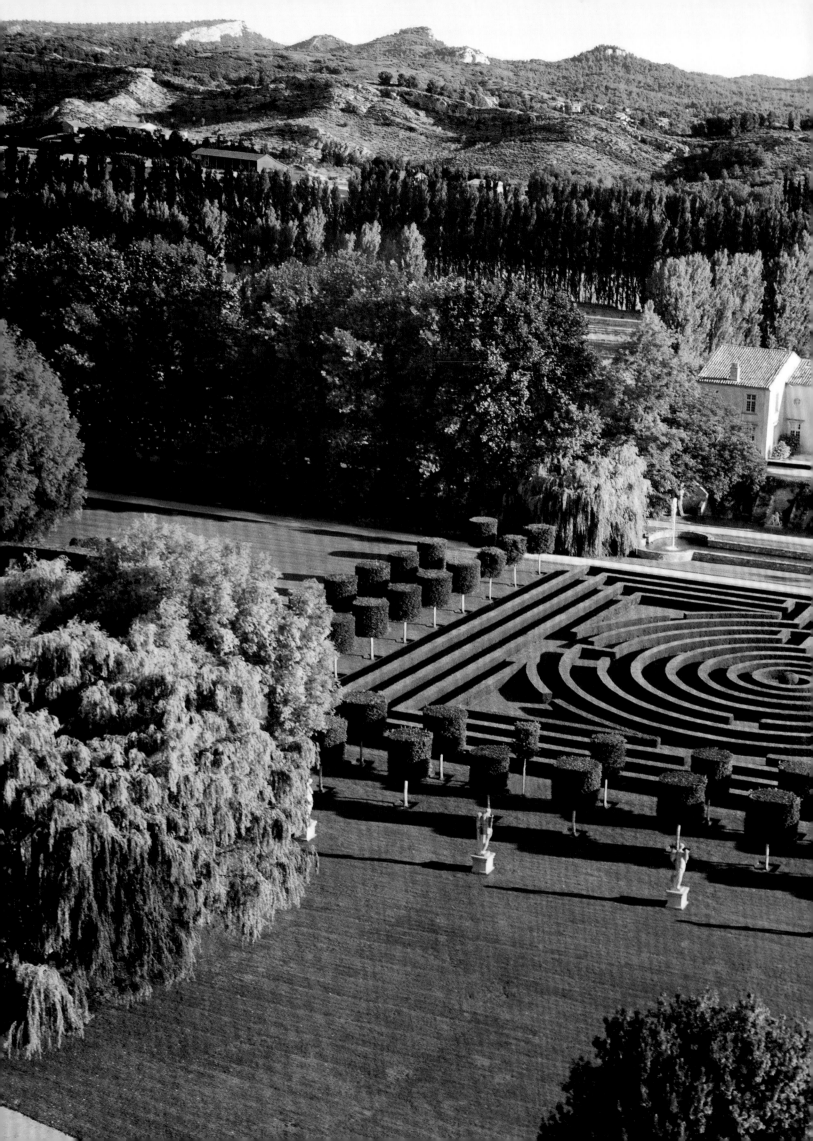

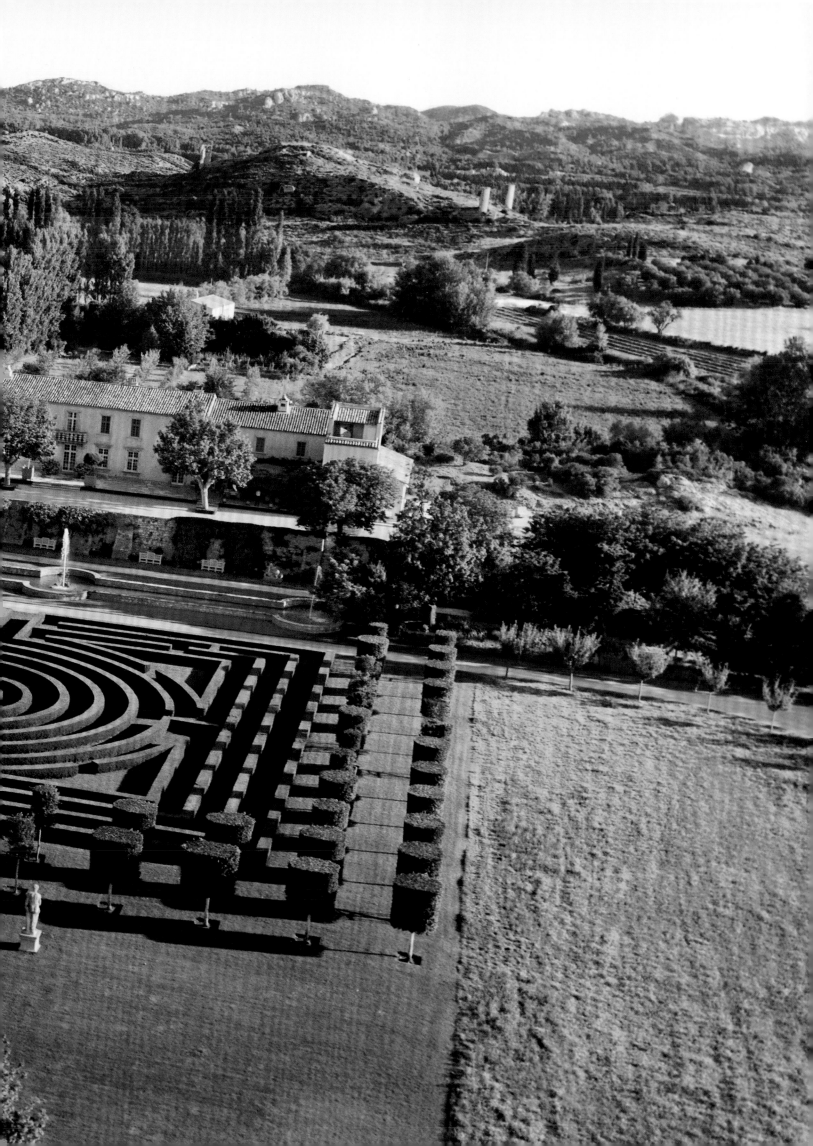

2004

At Janet de Botton's grand estate in the South of France, the Englishwoman hosts an eclectic assortment of luminaries. THIS PAGE: An arbor frame of Adélaïde d'Orléans roses. PREVIOUS PAGES: A maze inspired by the legend of the Minotaur. FOLLOWING PAGES: A shaded terrace.

Photographed by François Halard, September 2004

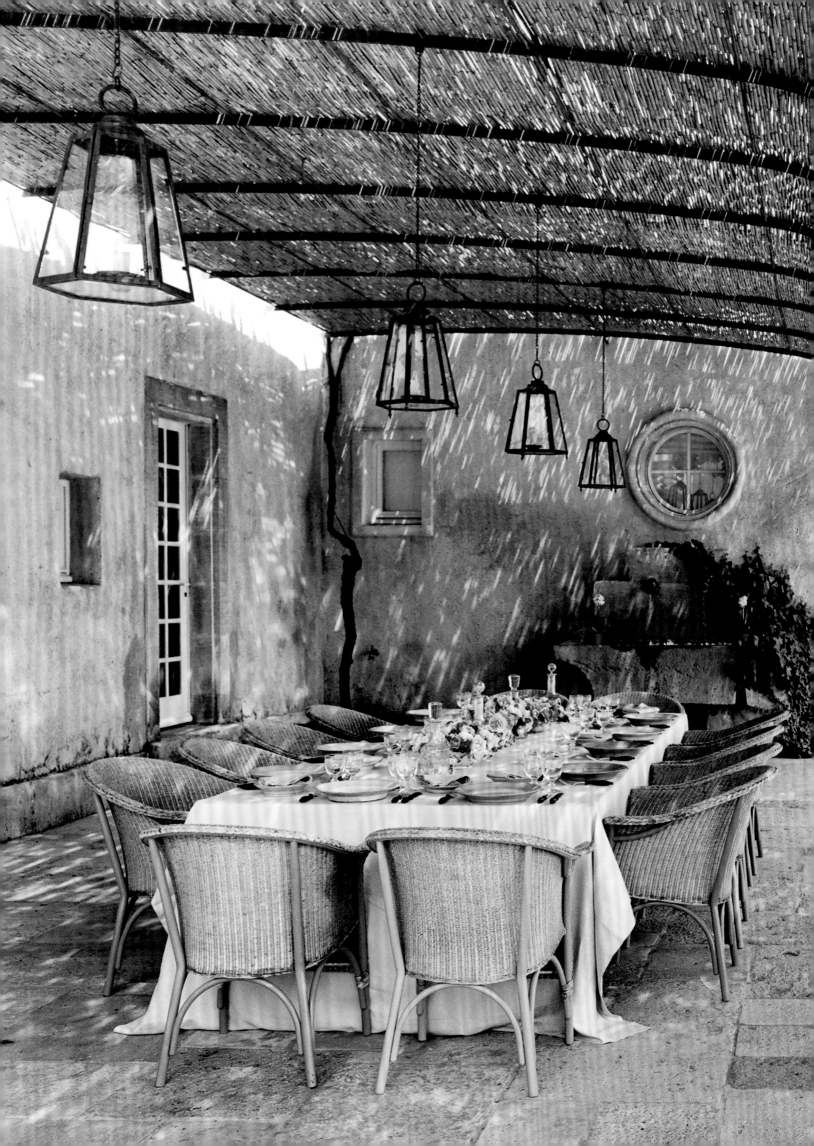

2005

THIS PAGE: Natalia
Vodianova perches
above the canals of
Venice. FOLLOWING PAGES:
Vodianova takes a
gondola ride.

Photographed by Mario Testino,
July 2005

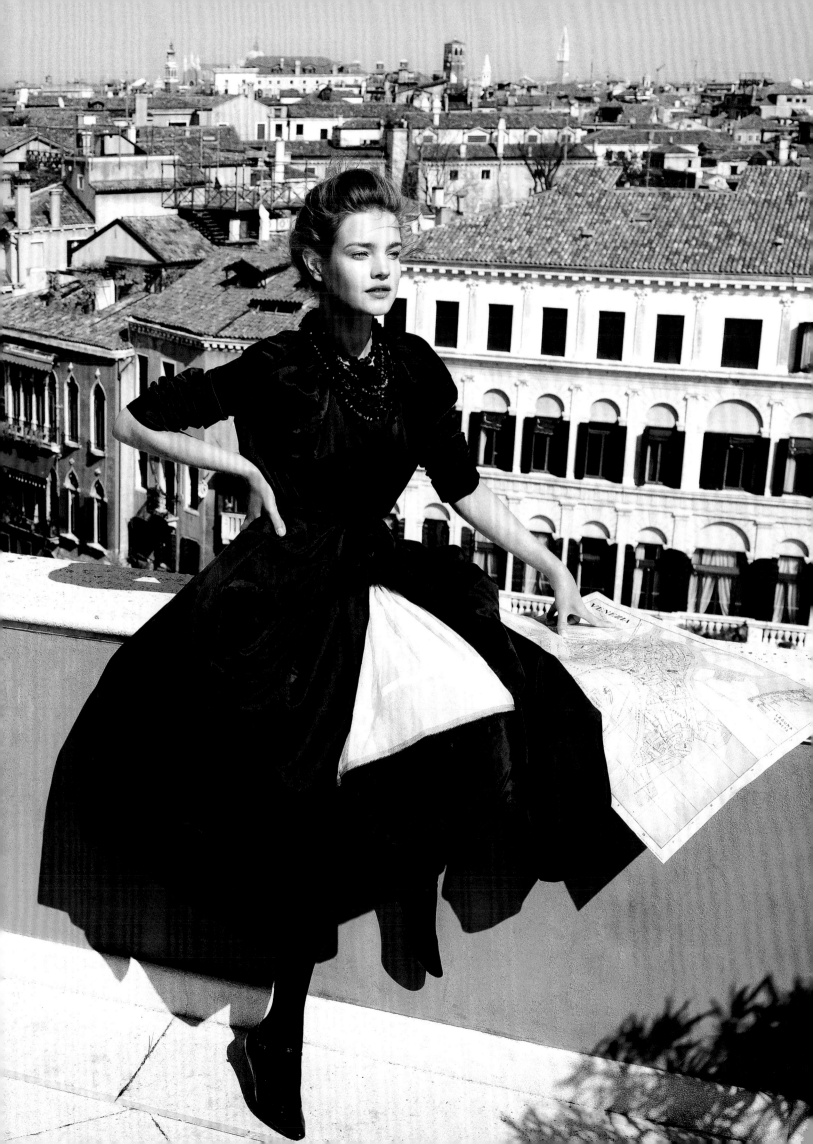

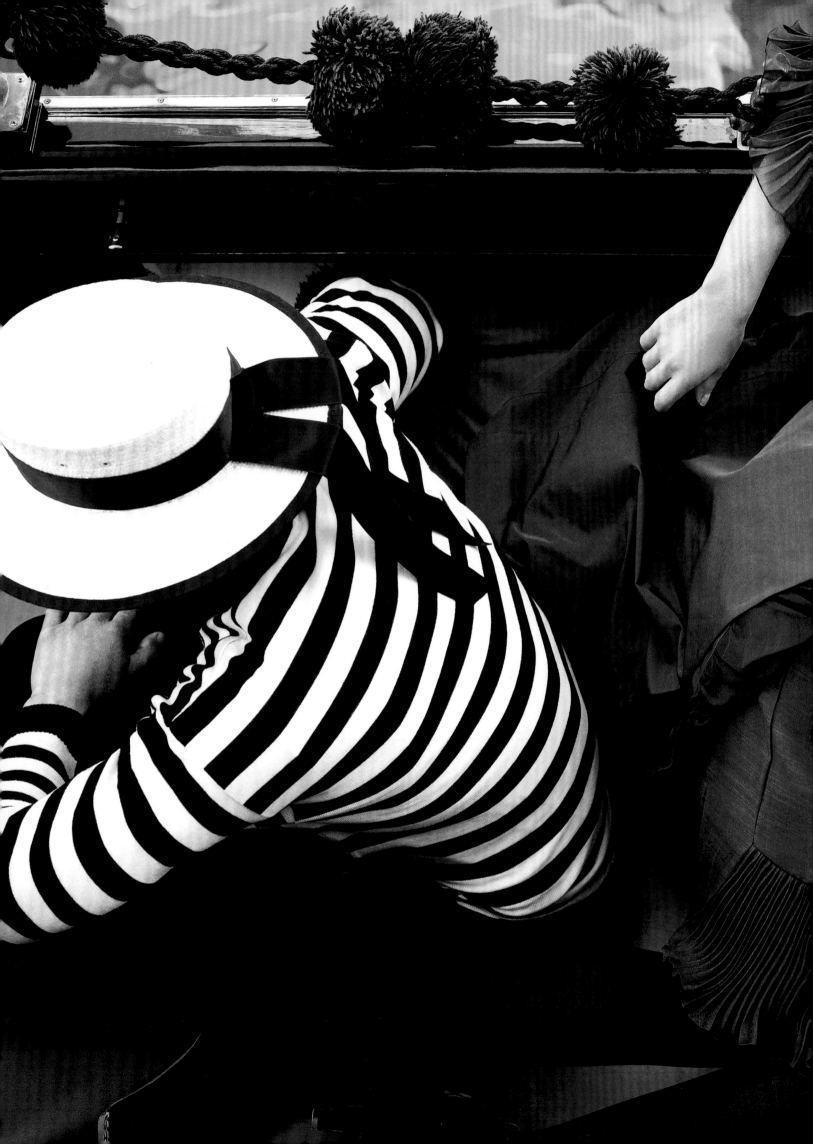

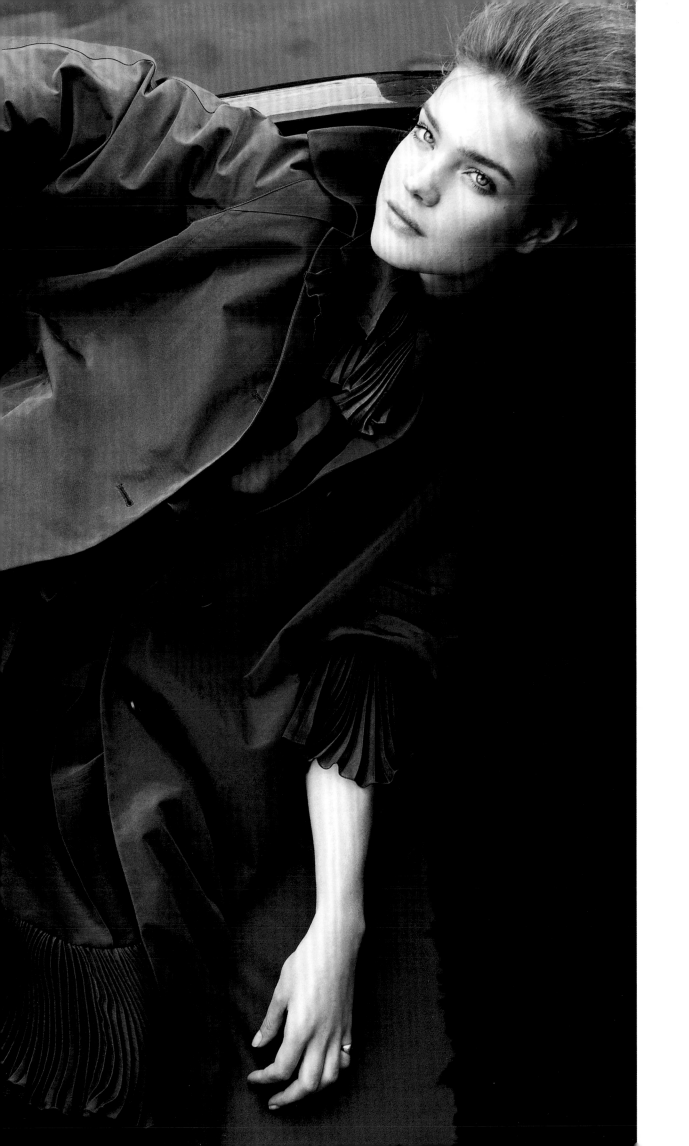

I HAD ARRIVED ON A ONE-WAY TICKET with savings from the banking job I'd quit a month before. A man I knew, a jet-setter, had introduced me to two kind and well-connected Italian women before I arrived. I planned to stay and learn the language. I'd dreamed of going to Italy and living there and most of all of belonging. When I was in elementary school, I watched *Cinema Paradiso* 22 times and memorized the dialogue. In the movie, everyone had a place, even the bum who thought he owned the piazza. Eccentricities were celebrated, and no one was isolated. There was tradition and camaraderie, and all of it seemed more fulfilling than what I'd had growing up in Palo Alto, California. Italy was where the soul went to find calm and love, and I wanted to hold the best of it in the palm of my hand....

We skied on the slopes of Cortina, where the rose-quartz mountains glow pink. We sat in the front row at a turn in the track at the Palio di Siena, where the spindle-legged horses passed full tilt in a furious, muddy cloud and I lost my breath. We went to parties. Men wore tailored suits, tight and loose in the right places, and flocks of women in gowns reflecting the warm light wore diamonds handed down from their mothers or grandmothers, old stones against new skin. The talk—varied, buoyant—flitted to the next subject just when it touched ground, like a half-filled helium balloon. In summer, *lucciole* sparked in olive groves. We ate with silver. Everyone did. What was the point of saving it? For what? If at first I worried that each party would be the last, the most exquisite, I soon understood that there was no scarcity of beauty....

One day I walked to the architect Brunelleschi's Cappella dei Pazzi near Santa Croce. There was no one else in the vast, domed room. I sang a note. The inside of the dome was constructed to hold notes for a long time—as if by providence, not physics—and soon after the first note I sang another one, a third above the last, and the two notes joined above me and were sustained, locked together in a buzzing consonance. It was a metaphor, I thought: Here in Italy I was in harmony with myself.

LISA BRENNAN-JOBS, 2008 TUSCAN HOLIDAY

OPPOSITE PAGE: Natalia Vodianova plays with pigeons in the Piazza San Marco. FOLLOWING PAGES: She steps out with some help from masked carnival-goers.
Photographed by Mario Testino, July 2005

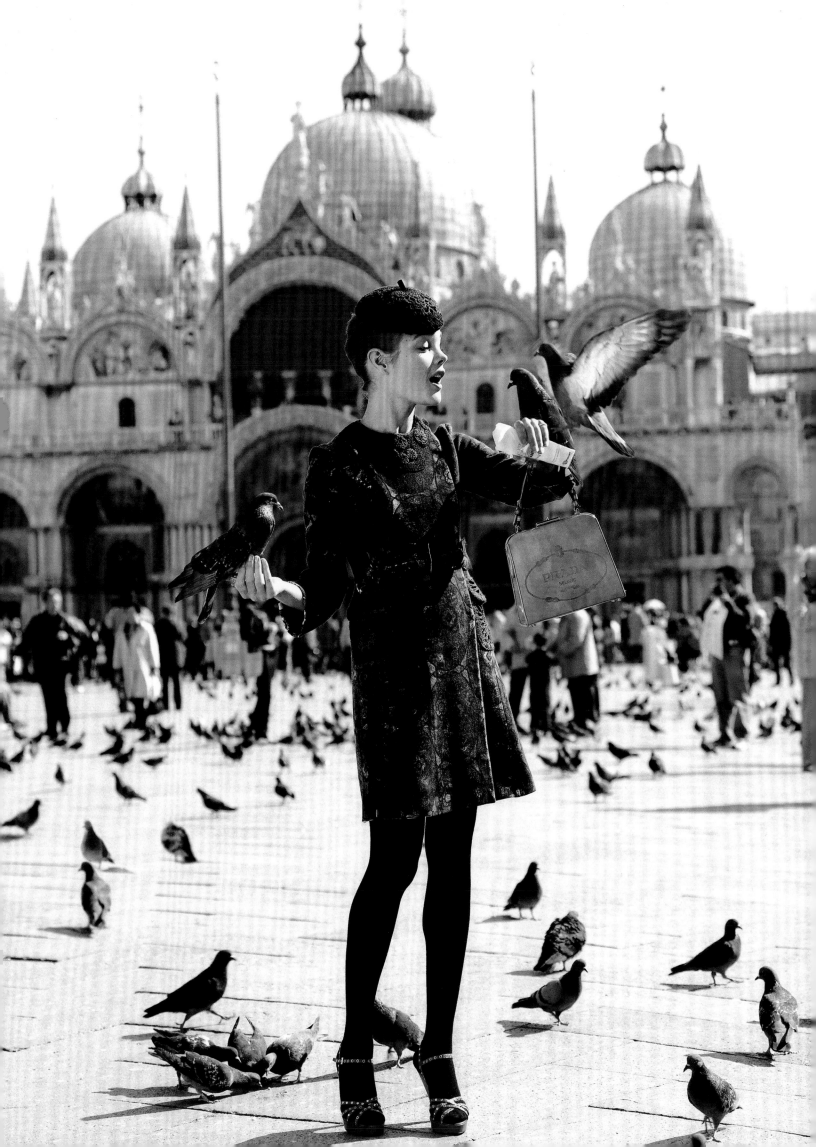

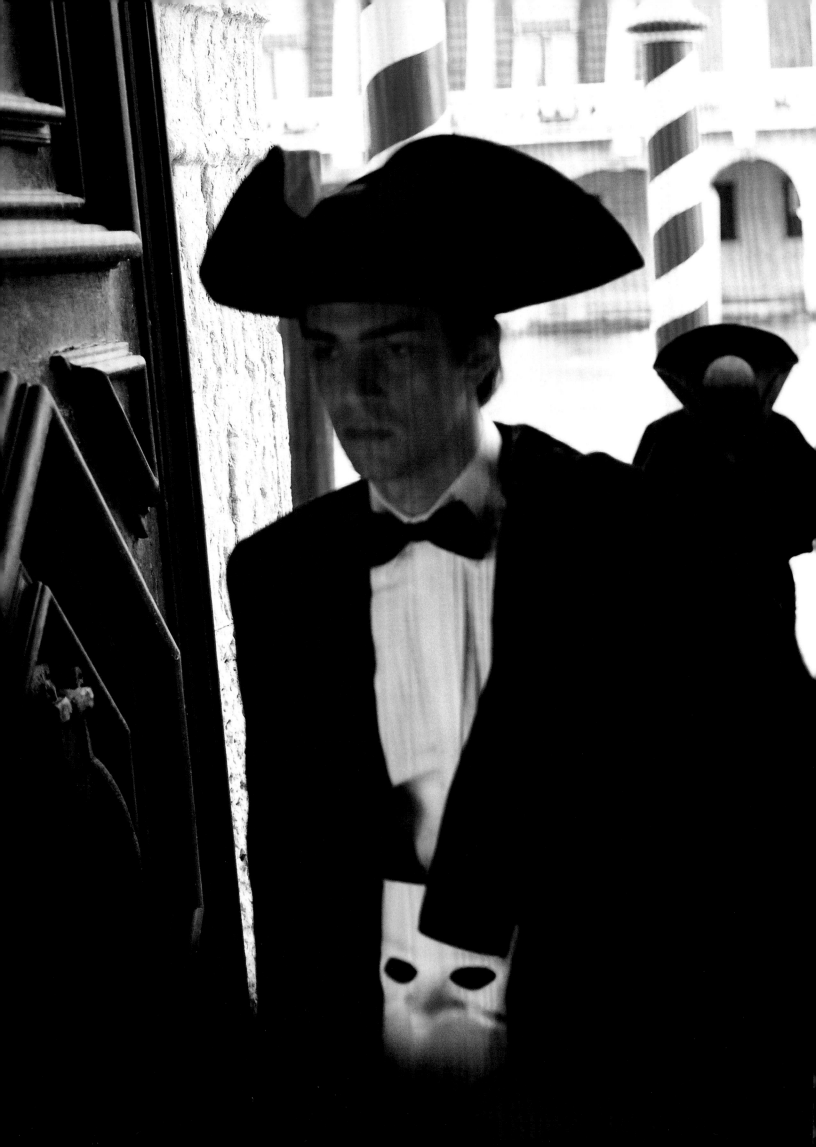

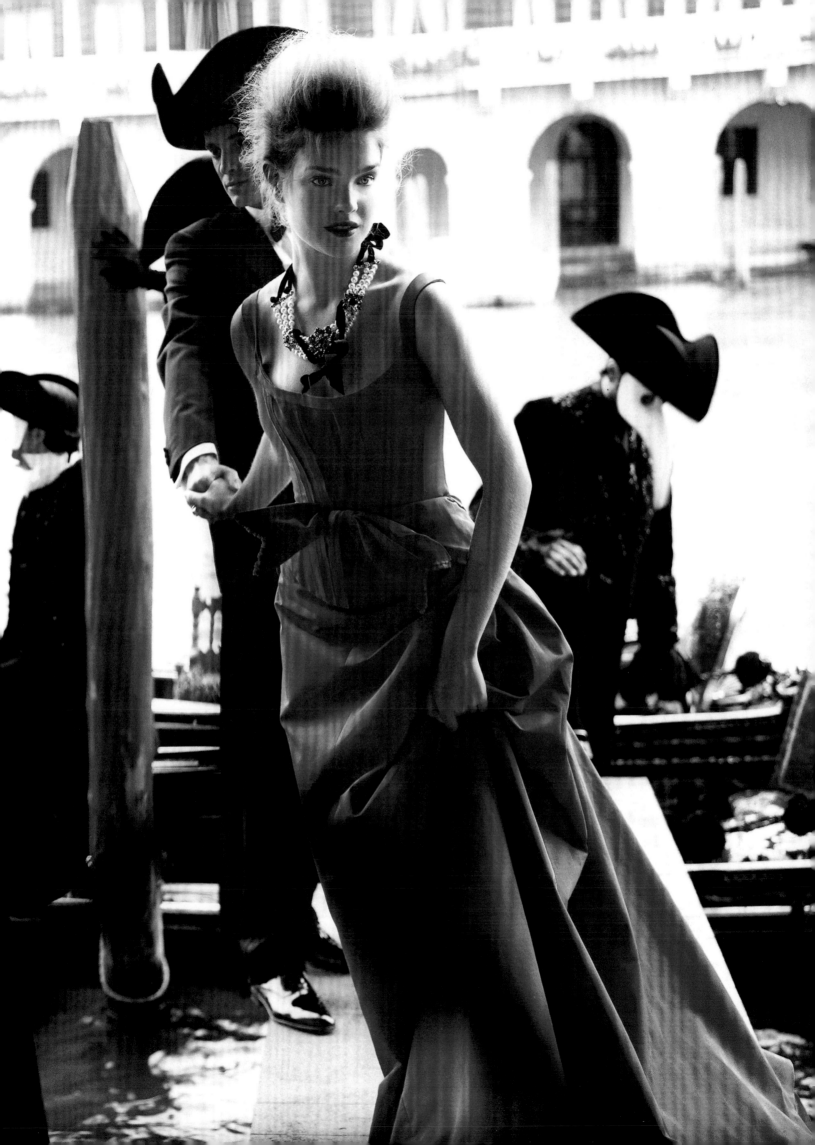

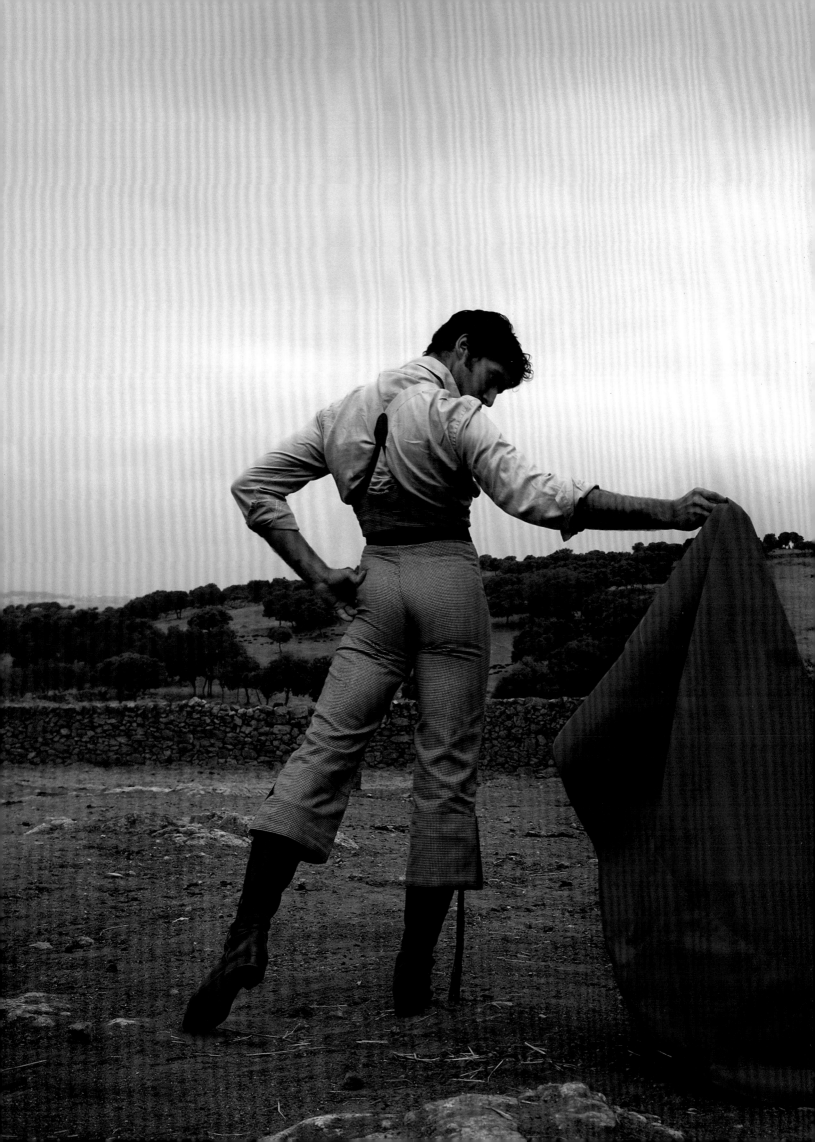

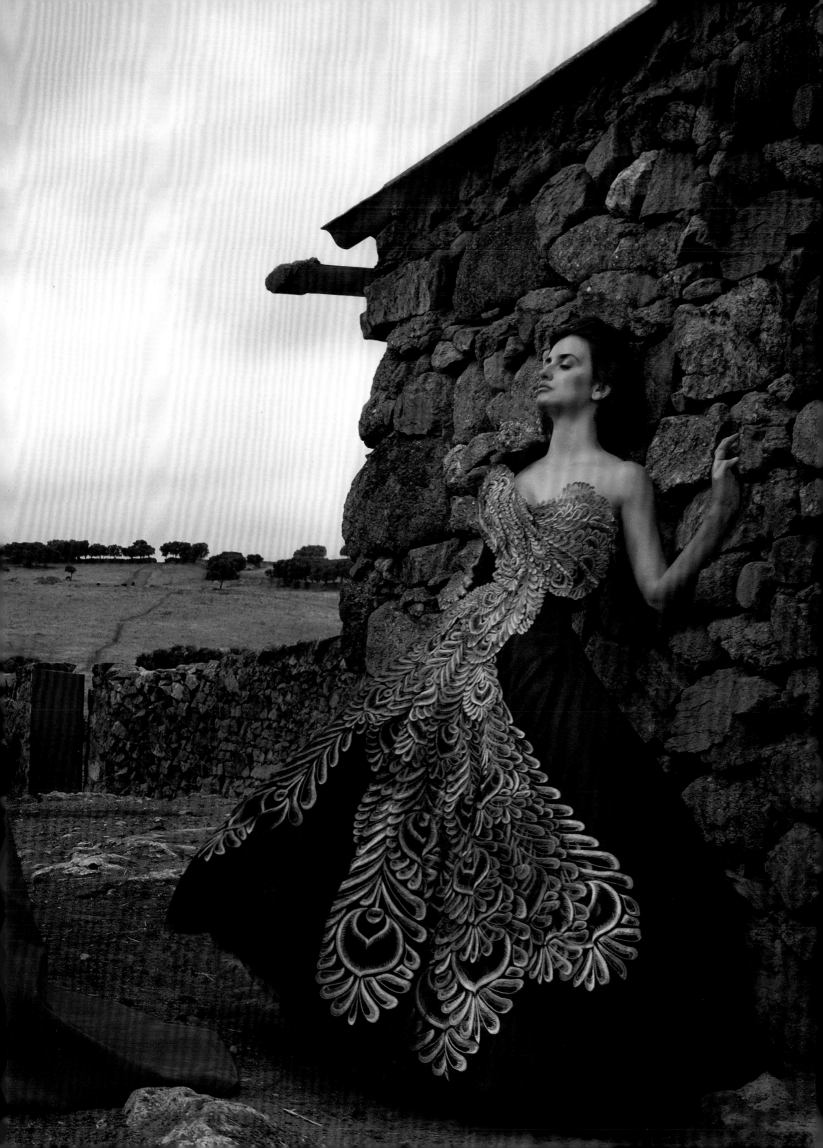

2007

Penélope Cruz offered *Vogue* a tour of Madrid, her hometown. THIS PAGE: Cruz and her sister, Mónica, soak in the sounds of Diego el Cigala and his band. PREVIOUS PAGES: Cruz faces off with bullfighter Cayetano Rivera Ordóñez. FOLLOWING PAGES: Cruz, with Rivera Ordóñez, wears a Goya-inspired dress.

Photographed by Annie Leibovitz, December 2007

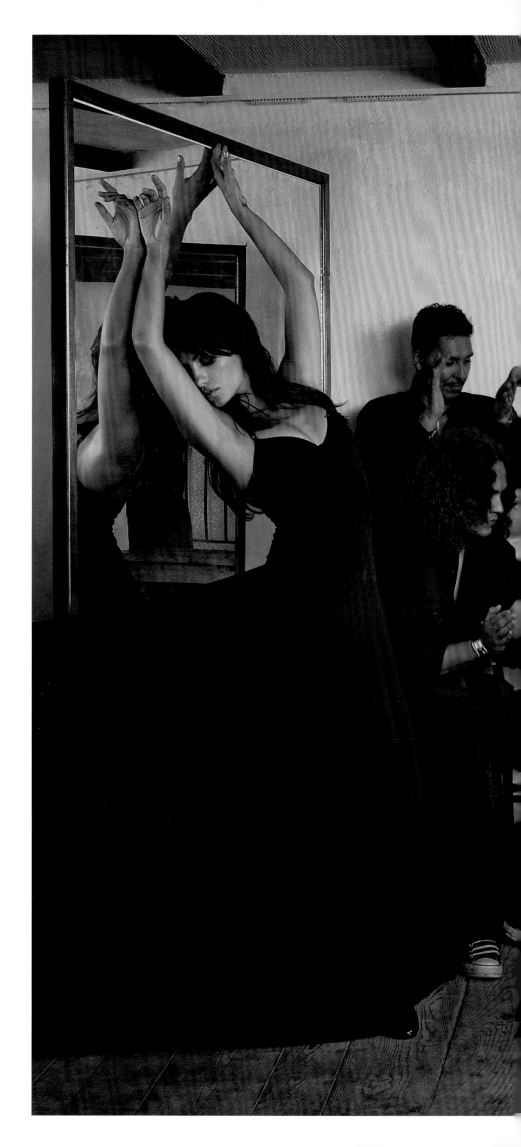

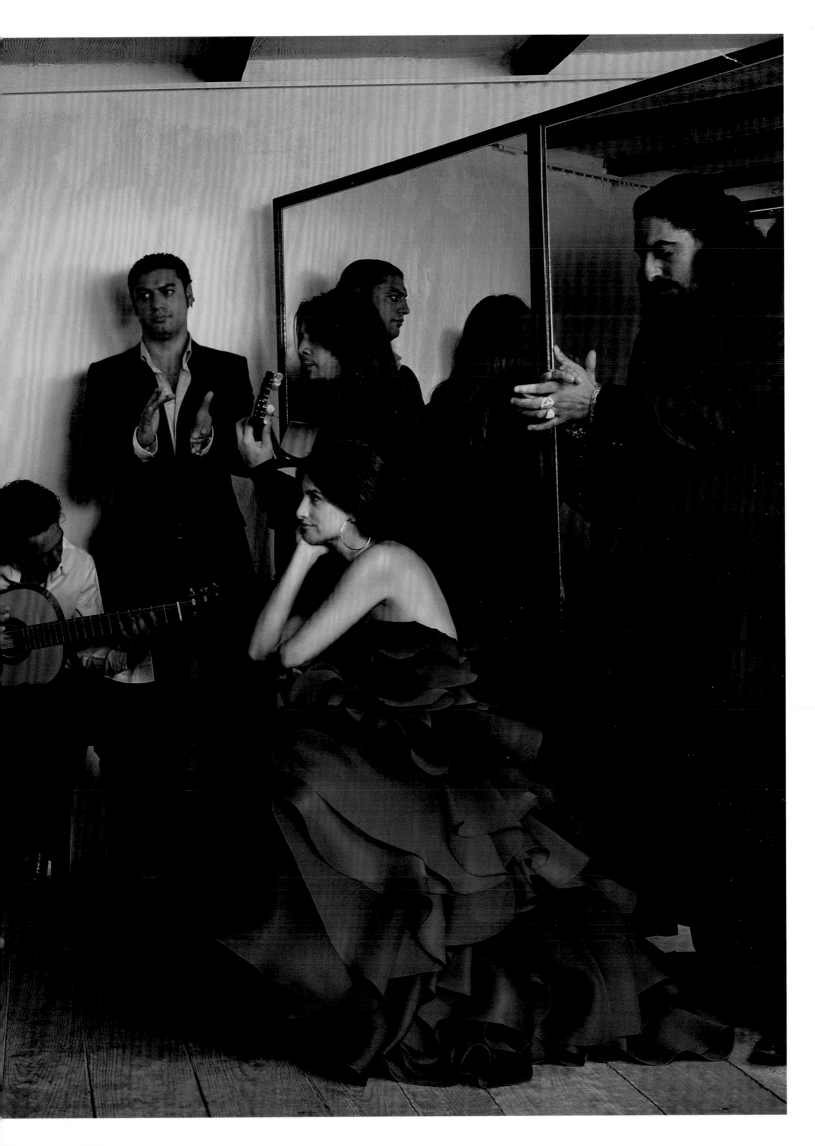

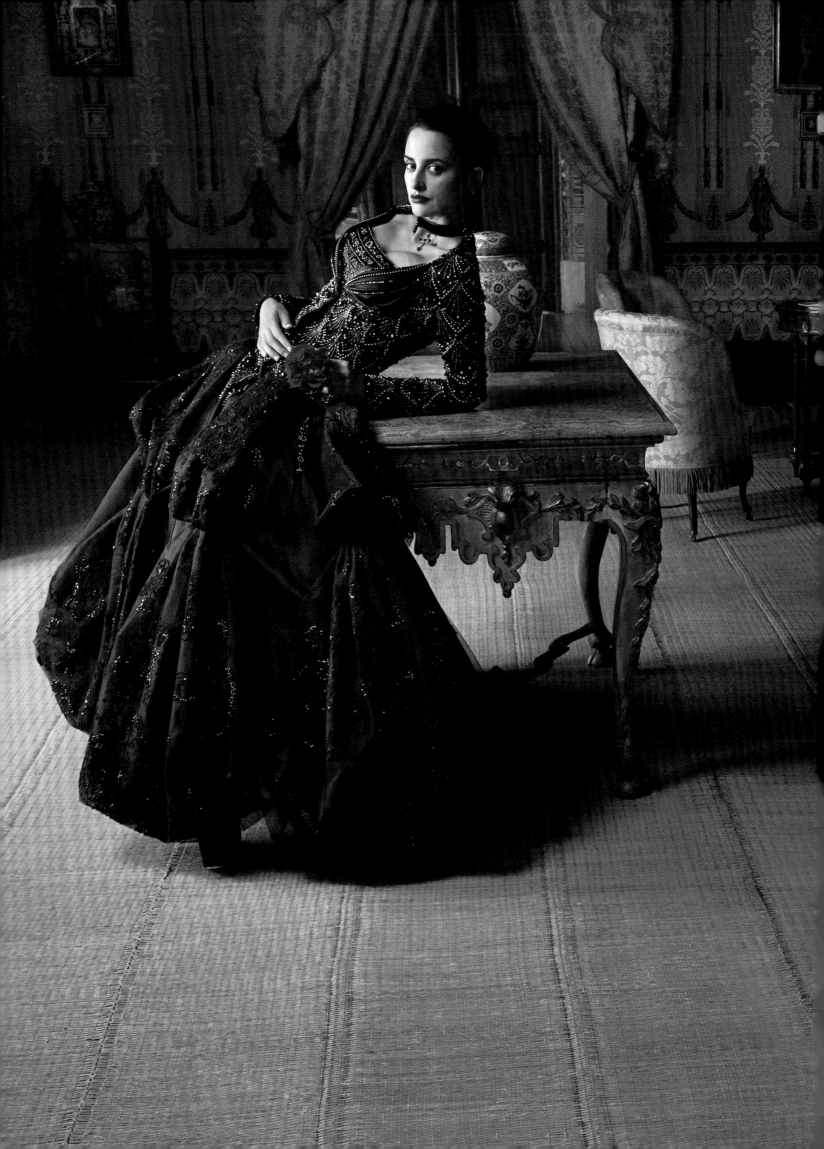

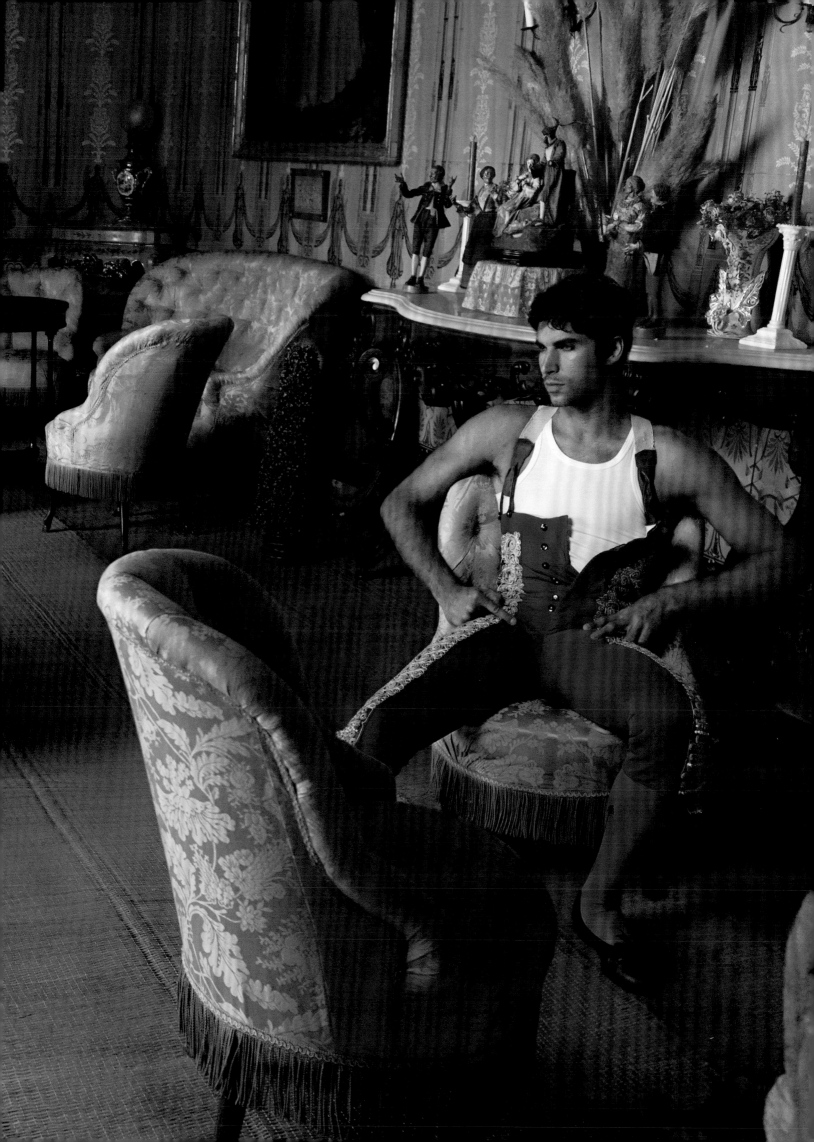

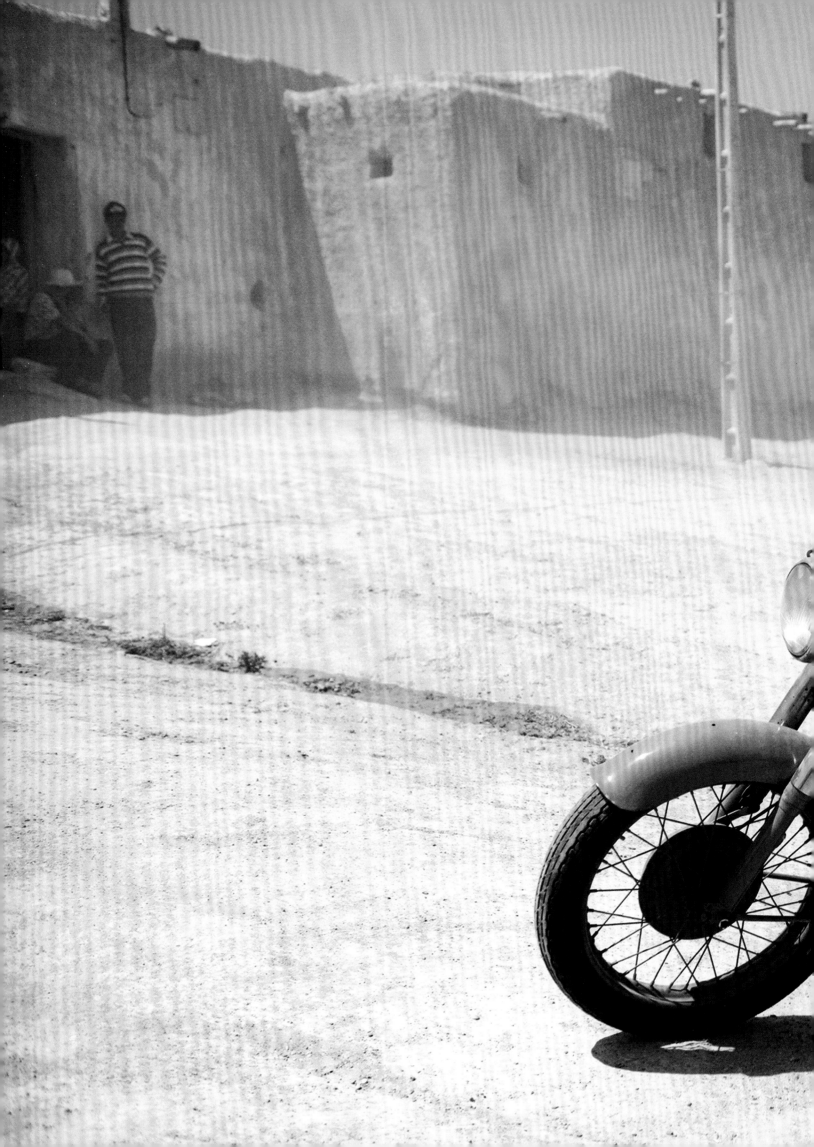

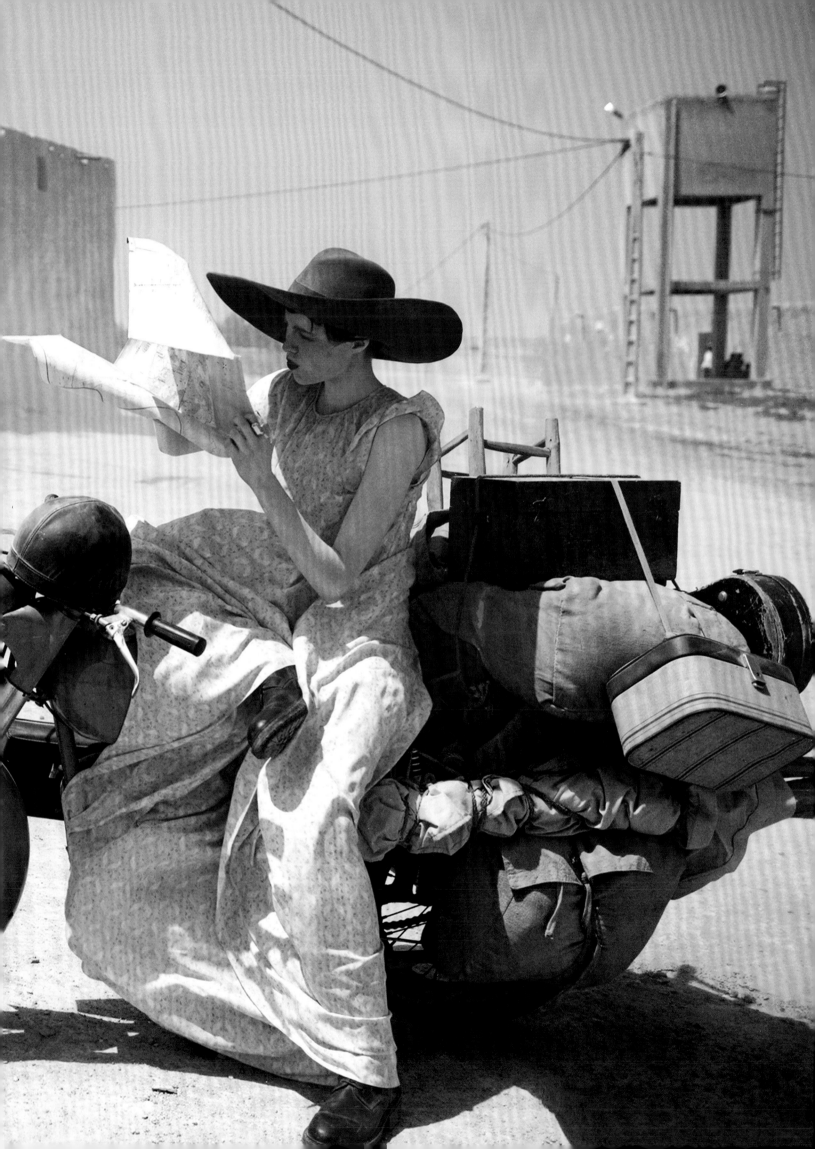

2013

Model Edie Campbell took a romantic road trip through Morocco in this 1930s-inspired fashion shoot. THIS PAGE: A pit stop in the desert. PREVIOUS PAGES: Campbell sets out from Marrakesh. FOLLOWING PAGES: She approaches a campsite, pauses to admire the Omar Benjelloun Foundation, and settles in at the Riad Madani hotel.

Photographed by Peter Lindbergh, June 2013

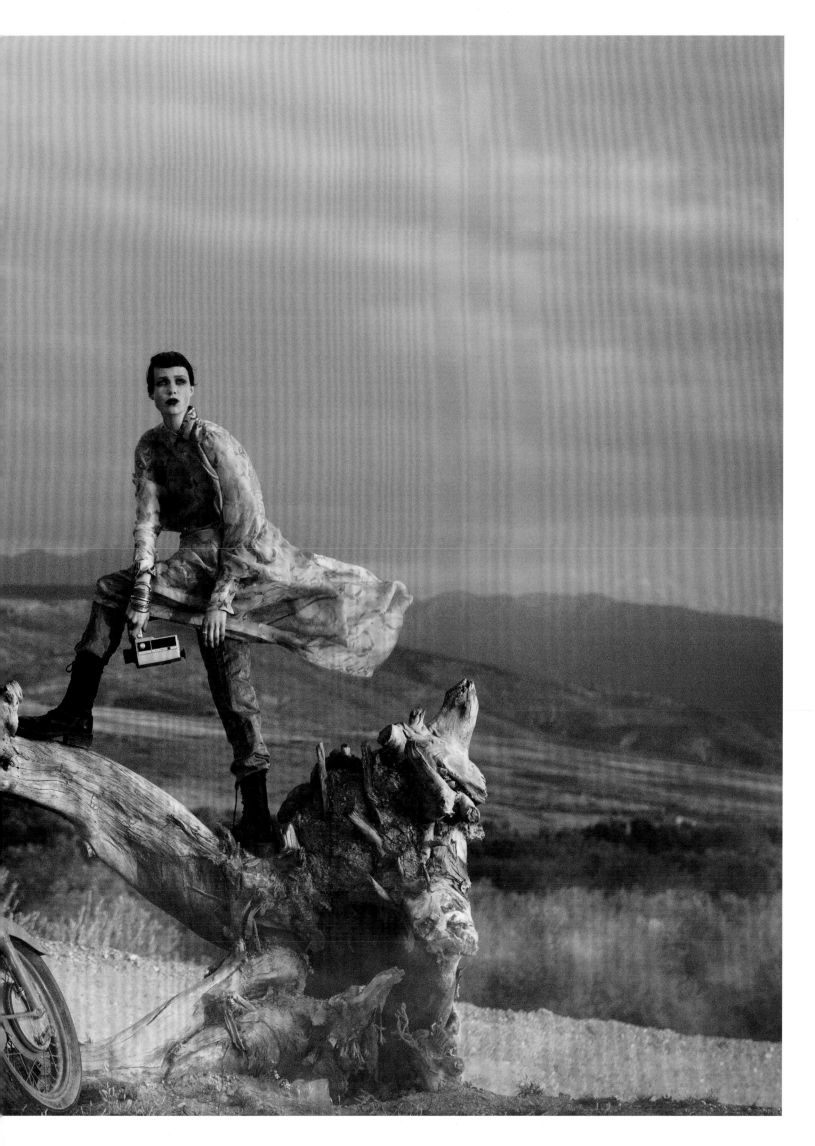

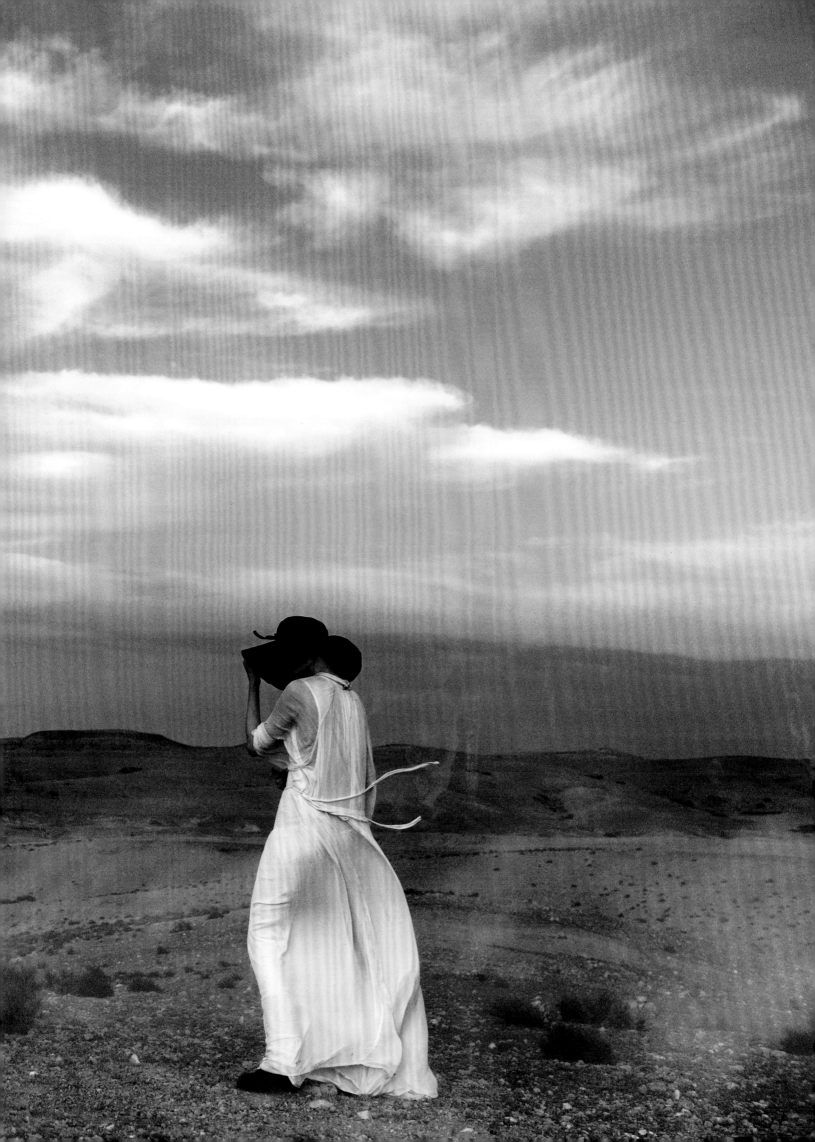

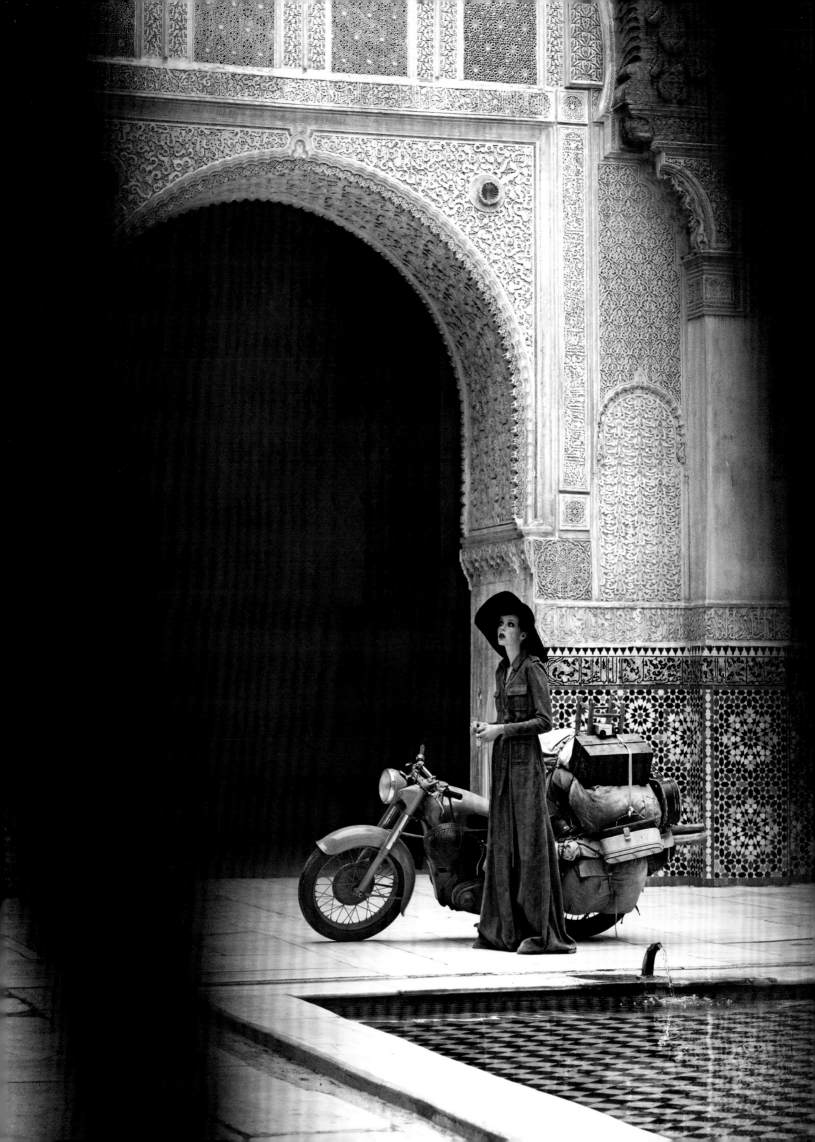

2015

THIS PAGE: The famously rocky Corsica coastline, where Olivier Marty and Karl Fournier (founders of architecture firm Studio KO) restored a centuries-old property. FOLLOWING PAGES: The village view from their living room, and their ground floor, which was converted from stables.

Photographed by François Halard, June 2015

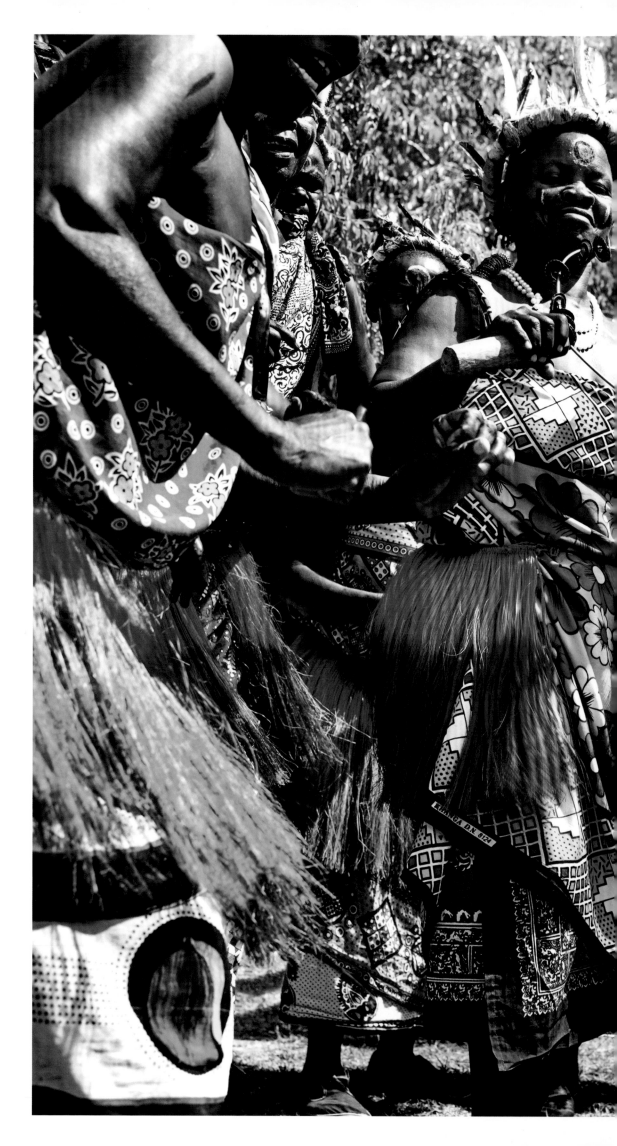

2016

"Her roots are strong, which is why she flies," says director Mira Nair of Lupita Nyong'o in a *Vogue* profile. The actress brought the magazine's team to her Kenyan village for the story. THIS PAGE: Nyong'o dances with her fellow Luo women in Kit Mikayi, Kisumu County. FOLLOWING PAGES: Nyong'o gazes out at Lake Victoria.

Photographed by Mario Testino, October 2016

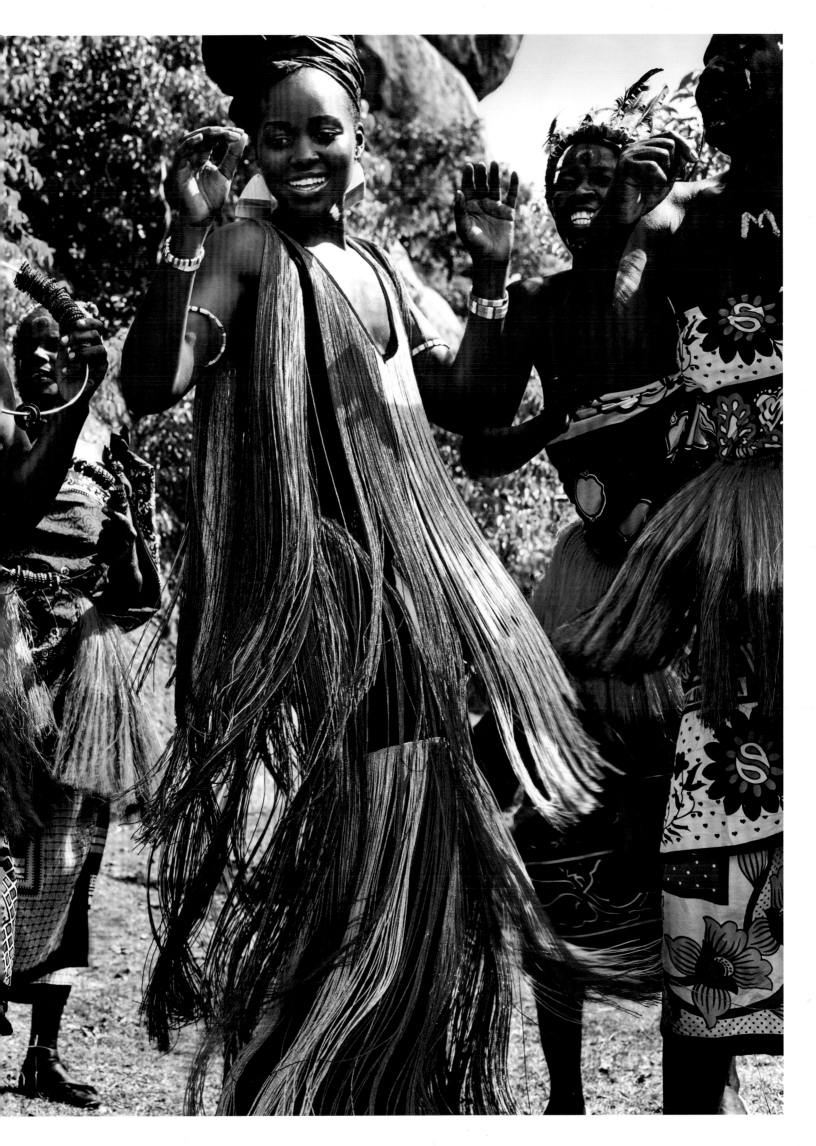

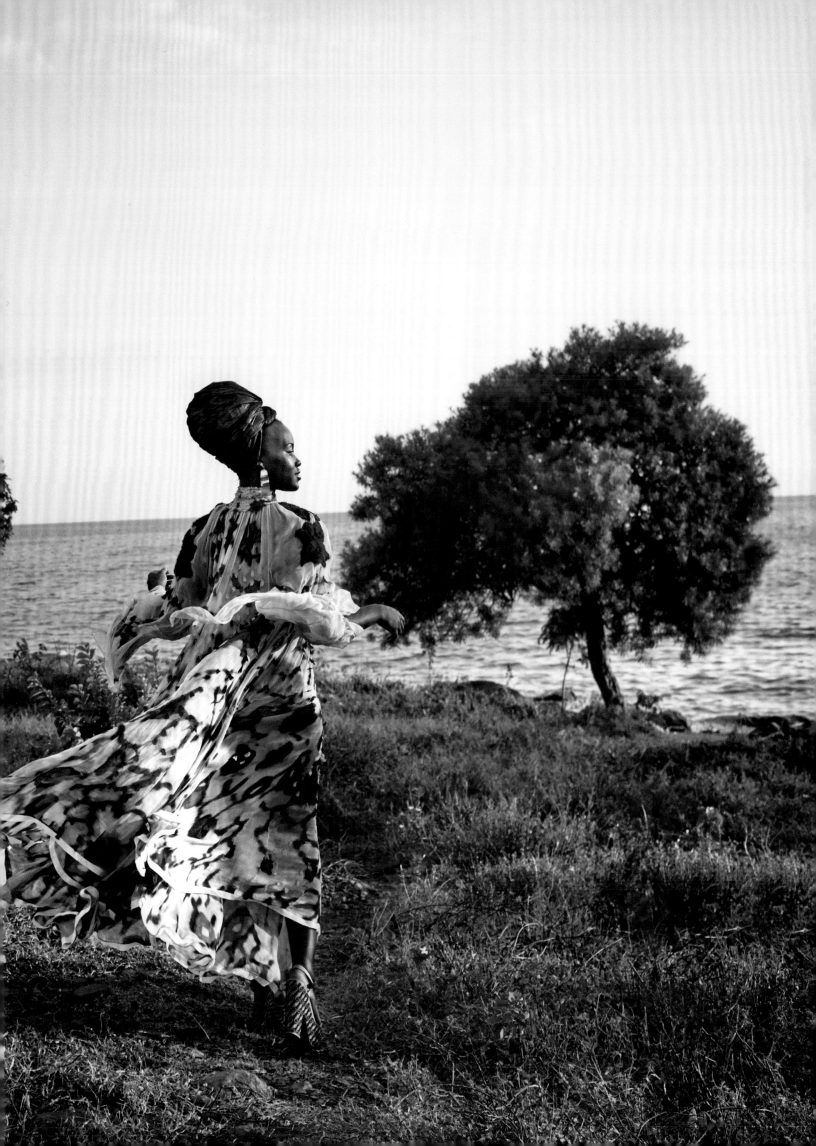

Acknowledgments

LIKE THE EPIC JOURNEYS IT DEPICTS, this book is the product of many hands and many minds. Raúl Martinez and David Sebbah provided invaluable support in shaping the photographic vision for the book, while Maureen Songco and Timothy Herzog spent countless hours in the archives, finding the visuals to assemble it. Lilah Ramzi, Elise Taylor, and Marley Marius also did their time in the archives, digging up texts. Laird Borrelli-Persson, Grace Coddington, Tonne Goodman, and Ivan Shaw offered indispensable insight when it came to understanding how *Vogue* operated in earlier decades, with Condé Nast librarian Stan Friedman providing additional assistance.

The designer of this book, Nobi Kashiwagi, saw the book through its many phases with patience and grace. David Byars, Alison Forbes, Diane Oatis, and Jason Roe made up the truly professional (and lovely) team that carried the book over the finish line. Thanks are also due to Chloe Malle, who shepherded the project during a parental leave hiatus, and to Rebecca Kaplan at Abrams for believing in the book from the beginning. Final appreciation is due to Anna Wintour for her guidance and judgment, and to all the editors, photographers, and writers whose adventurous spirit is both the inspiration and the substance of *Vogue on Location*.

—CHLOE SCHAMA AND RICHARD ALLEMAN

Credits

© The Helmut Newton Estate/Maconochie Photography: 86–88, 99–105, 110–115;
© The Irving Penn Foundation: 16–25; 28–35;
Photographs by Richard Avedon, © The Richard Avedon Foundation: 54–57, 76–83.

Excerpt on page 26 reprinted by permission of The Truman Capote Literary Trust.

Editor: Rebecca Kaplan
Design Manager: Danielle Youngsmith
Production Manager: Rebecca Westall
Managing Editor: Connor Leonard

Library of Congress Control Number: 2018958275

ISBN: 978-1-4197-3271-3
eISBN: 978-1-68335-661-5

Copyright © 2019 Condé Nast

Jacket © 2019 Abrams

Printed and bound in China
10 9 8 7 6 5 4 3 2 1

Abrams books are available at special discounts when purchased in quantity for
premiums and promotions as well as fundraising or educational use. Special editions
can also be created to specification. For details, contact specialsales@abramsbooks.
com or the address below.

Abrams® is a registered trademark of Harry N. Abrams, Inc.

ABRAMS The Art of Books
195 Broadway, New York, NY 10007
abramsbooks.com